ONE WEEK LOAN

ging

Fancy Packaging

THE PEPIN PRESS
AMSTERDAM & SINGAPORE

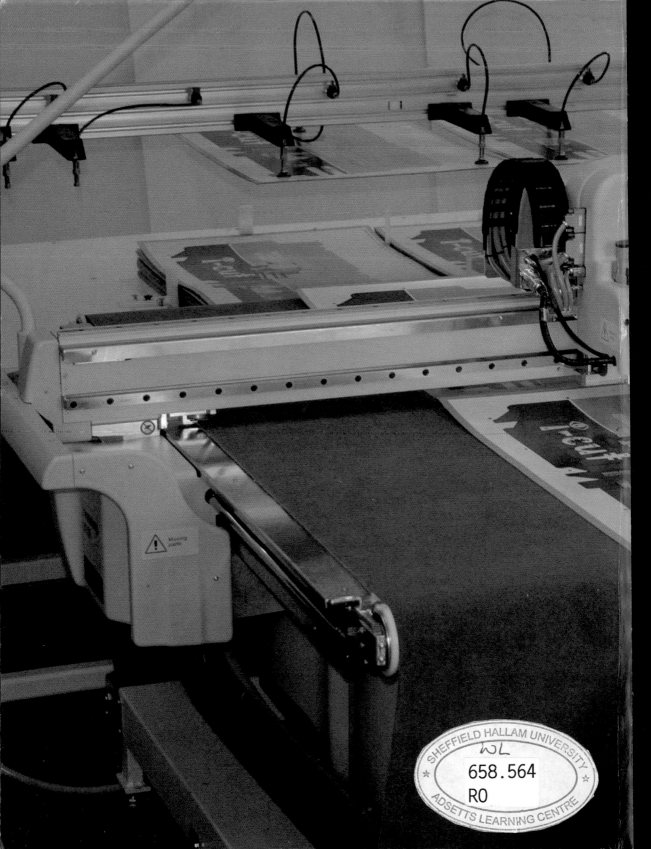

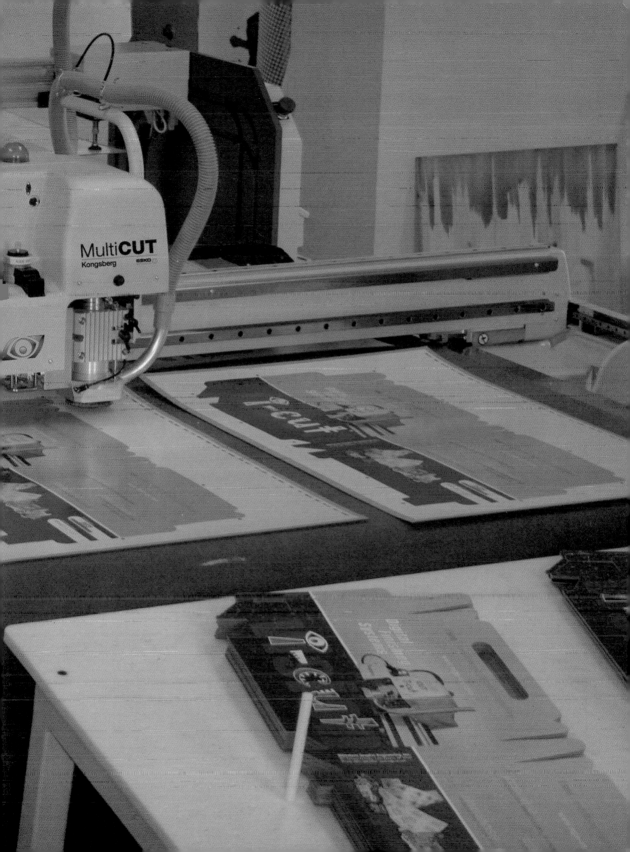

COLOPHON

The designs and drawings in this book and the templates and other files on the CD may be used to create new designs, but it is strictly forbidden to publish them, or having them published, in any form (including but not limited to websites and other digital media) without prior written permission from the publishers.

The CD in the back of this book is not for sale separately. The publishers do not accept any responsibility should the CD not be compatible with your computer system.

ISBN 978 90 5768 146 2

The Pepin Press BV
P.O. Box 10349
1001 EH Amsterdam, The Netherlands

+31 20 4202021
mail@pepinpress.com
www.pepinpress.com

Concept, master- & cover design:
 Pepin van Roojen
Text:
 Pepin van Roojen & Jakob Hronek
Drawings, mock-ups, layout & project management:
 Jakob Hronek
Photographs (except pages 2–3):
 Harm ten Brink
Translation co-ordinator:
 Kevin Haworth

10 9 8 7 6 5 4 3 2 1
2015 14 13 12 11 10

Manufactured in Singapore

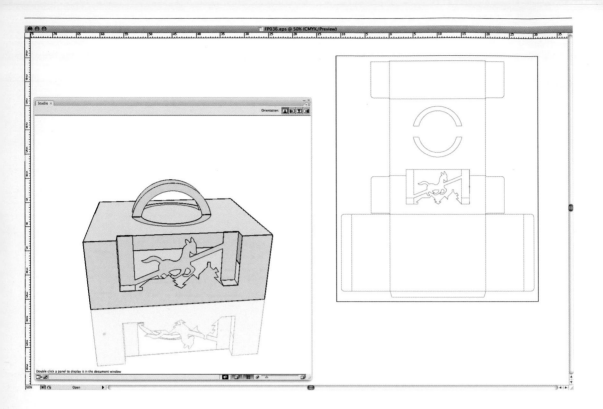

EskoArtwork Studio (Illustrator® plug-in)

CONTENTS

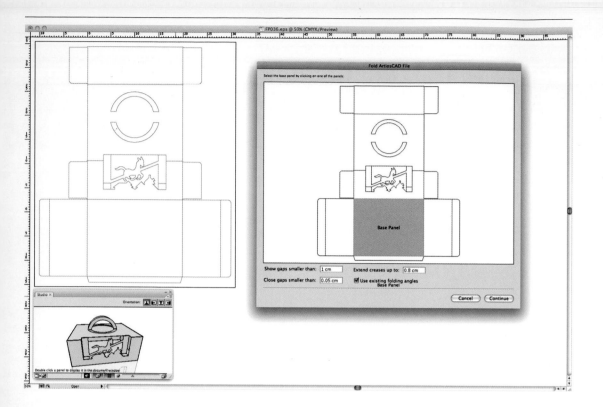

EskoArtwork Toolkit for Boxes (Illustrator® plug-in)

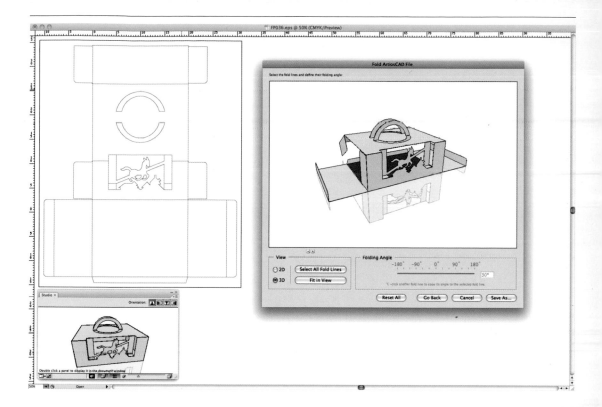

EskoArtwork Toolkit for Boxes (Illustrator® plug-in)

Structural package design

Packaging design technology has made enormous advances in recent years, largely due to continuing developments in digital capabilities, both in design and manufacturing. The content in this series of books was produced using the latest technology and this series aims to bring the benefits of these technical advances to the reader. The latest 3-D drafting and testing software was used to create and develop all of the designs and the prototype templates were cut and creased using digitally-driven cutting tables. All of this means that the accuracy of the designs is guaranteed; they are functional and fully scalable. However, do keep in mind that the thickness of the material used must be taken into consideration when designing any package. Adjustments to the designs will likely to be necessary when dimensions are changed or other materials are used.

Packaging standards

Several organizations worldwide publish sets of industry standards for the design of structural packaging. The most widely used are the design code established jointly by FEFCO (European Federation of Corrugated Board Manufacturers) and ESBO (European Solid Board Organization) and the category style characteristics defined by the PPC (American Paperboard Packaging Council).

Practically all of the standard designs defined by these organizations have been reproduced in **Basic Packaging** (with the reference codes provided in the descriptions). Throughout this series, we have also used FEFCO, ESBO and PPC terminology wherever possible.

Materials

In packaging design and manufacturing, a distinction is made between the following types of fibre-based materials:

paper: material with a weight of less than 225 gsm (grams per square meter)

paperboard: solid material with a weight of more than 225 gsm

cardboard: solid material with a weight between 150 and 600 gsm; more rigid than paper and often coated

corrugated board: fluted paper glued onto or between paper or board. The most common corrugated boards are:

single face: one layer of fluted paper glued onto one layer of paper or board

double face or **single wall:** one layer of fluted paper glued between two layers of paper or board

double wall: two layers of fluted paper glued between three layers of paper or board

triple wall: three layers of fluted paper glued between four layers of paper or board

In addition to the material and number of layers, corrugated board is defined by the type of flute. Flute type is generally designated using a letter code and is determined by the number of flutes per linear meter (or foot) and the flute thickness.

Three types of material were used for the prototypes in this book: 350 gsm cardboard, 1 mm G-flute corrugated board, and 1.5 mm E-flute corrugated board. For the FEFCO standard designs in **Basic Packaging**, 3 mm B-flute corrugated board was simulated in the 3-D images.

Technical considerations

When creasing for folds in solid board, the crease should be on the outside of the planned fold line, i.e. the fold folds away from the crease. However, for folds in corrugated board, the crease (or score) should be on the inside of the fold.

In many cases, the direction of the grain of the material

– or of the flutes in corrugated board – is important. The grain/fluting can affect the quality of a crease and the overall stability of a package. It is best to discuss this with materials suppliers and manufacturers before completing a design.

The surface of the material used is an important issue to consider when choosing the type and quality of printing and finishing. For example, rough board is not suitable for fine or high-contrast graphics, whereas high-quality paperboard or corrugated board (with at least one smooth, coated face) allows for high standards of offset printing, foil stamping, embossing, etc.

Packaging dimensions

When designing a package, the most important consideration is, of course, the dimensions of the product to be packaged. However, there are additional matters to consider, such as leaving space for protective padding or a liner, the outside dimensions of the package and how it can be stacked and/or fit onto a pallet, material waste during production, and production speed.

Package design

Like most other forms of structural design, most package design today is done using CAD (computer aided design) programs. These exist in many forms, from simple software that allows you to create basic structures, to highly advanced applications that manage complete production processes.

EskoArtwork is a world leader in the development of package design software. Their ArtiosCAD software has been used in the industry for decades. This cutting-edge program provides a complete solution for package design in a professional manufacturing environment. However, for graphic, packaging and product designers who do not need the full functionality of ArtiosCAD, EskoArtwork's software plug-ins for programs such as Adobe Illustrator® and Photoshop® are an excellent and more affordable alternative. All of the designs in this book were created using these plug-ins and a demo version of the software is included on the CD with this book.

Prototypes

Good software programs facilitate the thorough examination of designs and help reduce the need for physical testing. In EskoArtwork's Visualizer plug-in, for example, many types of graphics and special finishes can be simulated realistically. There is even the possibility of visualizing the product under different lighting conditions.

When a design is nearing its final production phase, however, it is essential that a prototype be made. Of course, this can be done by hand. But using a proof printer to print the graphics on the intended material and a digitally-driven cutting and creasing table to produce an accurate mock-up is a much better approach to generating a realistic prototype.

Cutting tables come in a variety of sizes and with a wide range of capabilities. Some models are even suitable for the output of small production runs.

Verpackungsformgebung

Die Verpackungsformgebung hat in den letzten Jahren sowohl fertigungs- als auch konstruktionstechnisch enorme Fortschritte gemacht, größtenteils dank der ständig weiter entwickelten Computertechnik. Unsere Buchreihe will den Lesern die Vorteile dieser technischen Fortschritte zugänglich machen; die Inhalte sind mit neuester Technologie erarbeitet. Alle Entwürfe wurden mit der neuesten 3-D-Design- und Testsoftware entwickelt und die Prototypen auf digital gesteuerten Schneidtischen zugeschnitten und gefalzt. Dadurch ist die Genauigkeit der Vorlagen garantiert; alle Designs funktionieren und sind voll skalierbar. Allerdings muss man beim Entwurf einer Verpackung die Materialstärke im Auge behalten. Denn variiert man die Dimensionen oder das Material, müssen meist auch die Vorlagen entsprechend angepasst werden.

Verpackungsstandards

Mehrere internationale Organisationen geben Standards zur Verpackungsformgebung für die Industrie heraus. Am verbreitetsten sind der zusammen von der FEFCO (Europäische Vereinigung der Wellpapphersteller) und der ESBO (Europäische Organisation für Vollpappe) erarbeitete Code und die vom PPC (American Paperboard Packaging Council) definierten Typenkategorien.
Standard-Verpackungsdesigns enthält fast alle von den drei Organisationen definierten Standardmuster (die Beschreibungen enthalten den jeweiligen Code). Unsere Buchreihe benutzt, wo immer möglich, die Terminologie von FEFCO, ESBO und PPC.

Materialien

Bei der Konstruktion und Fertigung von Verpackungen unterscheidet man folgende faserhaltige Materialien:
Papier: Materialien unter 225 g/m² (Gramm pro Quadratmeter)
Pappe: feste Materialien über 225 g/m²
Karton: feste Materialien zwischen 150 und 600 g/m²; steifer als Papier und oft beschichtet bzw. „gestrichen"
Wellpappe: gewelltes, zwischen Papier oder Karton geleimtes Papier. Die geläufigsten Wellpapptypen sind:

einseitige: eine Lage gewelltes Papier auf eine Lage Papier oder Karton aufgeleimt

zweiseitige oder **einwellige:** eine Lage gewelltes Papier zwischen zwei Lagen Papier oder Karton geleimt

zweiwellige oder **Duplex:** zwei Lagen gewelltes Papier zwischen drei Lagen Papier oder Karton geleimt

dreiwellige: drei Lagen gewelltes Papier zwischen vier Lagen Papier oder Karton geleimt

Außer nach Materialien und Anzahl der Lagen unterscheidet man Wellpappe auch nach Wellentypen. Wellentypen differenziert man meist nach der Anzahl der Wellen pro Meter (oder Fuß) bzw. ihrer Dicke und bezeichnet sie mit Buchstabencodes.
Für die Muster in diesem Buch haben wir drei Materialtypen verwendet: Karton mit 350 g/m², 1-mm-G-Wellen-Pappe und 1,5-mm-E-Wellen-Pappe. Für die 3-D-Grafiken der FEFCO-Standardmuster aus **Standard-Verpackungsdesigns** haben wir 3-mm-B-Wellpappe simuliert.

Technische Aspekte

Wird vor dem Falzen gerillt, muss bei festem Karton die Rillung auf der Außenseite der geplanten Falzlinie liegen, d. h. die Falz wird von der Rillung weg gebogen. Beim Falzen von Wellpappe dagegen sollte die Rille (oder Ritzung) auf der Falzinnenseite liegen.
Häufig ist die Faserlaufrichtung des Materials – bei Wellpappe die Wellenlaufrichtung – entscheidend. Die

Faser- bzw. Wellenlaufrichtung kann die Qualität einer Rillung und die Stabilität der Verpackung insgesamt beeinflussen. Am besten klärt man dies noch vor Fertigstellung des Entwurfs mit dem Materialzulieferer bzw. Hersteller.

Bei der Entscheidung über Art und Qualität von Aufdrucken und Finishs ist auf jeden Fall die Oberfläche des verwendeten Materials zu berücksichtigen. So ist etwa grober Karton für detaillierte und kontrastreiche Grafiken ungeeignet, während hochwertiger Karton oder Wellpappe (mit mindestens einer glatten, gestrichenen Seite) hohe Qualität bei Offsetdruck, Prägung, Folienprägung etc. ermöglichen.

Verpackungsabmessungen

Das Wichtigste beim Entwurf einer Verpackung sind natürlich die Maße des zu verpackenden Produkts. Doch ist noch mehr zu berücksichtigen – z. B. eventueller Platzbedarf für Schutzpolster oder Zwischenfutter, die Außenmaße der Verpackung und ihre Eignung zum Verstauen bzw. Stapeln auf Paletten, die Materialabfallmenge bei der Fertigung und die Produktionsgeschwindigkeit.

Verpackungsformgebung

Wie bei Konstruktionsentwürfen üblich, werden die meisten Verpackungsdesigns heutzutage mit CAD-Programmen (CAD = computer-aided design) erstellt. Es gibt sie in allen möglichen Formen von einfacher Software für Standarddesigns bis hin zu Hightech-Anwendungen, die komplette Fertigungsabläufe verwalten.

EskoArtwork ist ein weltweit führender Entwickler von Verpackungsdesign-Software. EskoArtworks CAD-Software ArtiosCAD wird seit Jahrzehnten in der Industrie eingesetzt und bietet State-of-the-Art-Komplettlösungen für die industrielle Verpackungsentwicklung. Für Grafik-, Verpackungs- und Produktdesigner, die nicht alle Funktionen von ArtiosCAD brauchen, sind EskoArtworks Plug-Ins für Programme wie Adobe Illustrator® und Photoshop® eine perfekte – und erschwinglichere – Alternative. Alle Entwürfe in diesem Buch haben wir mit diesen Plug-Ins erstellt; eine Demoversion der Software liegt dem Buch auf CD-ROM bei.

Prototypen

Gute Software erleichtert das gründliche Überprüfen der Entwürfe und ersetzt einen Teil der Praxistests. Mit EskoArtworks Visualizer-Plug-In etwa lassen sich alle möglichen Grafiken und spezielle Finishs realistisch simulieren. Man kann damit sogar das Aussehen des Produkts unter verschiedenen Lichtverhältnissen darstellen.

Ist ein Entwurf bis kurz vor Anlauf der Produktion gediehen, muss auf jeden Fall ein Prototyp angefertigt werden. Das geht natürlich auch manuell. Ein wesentlich besseres Verfahren, realistische Prototypen zu bekommen, ist aber ein genaues Modell mit einem Testdrucker, der das vorgesehene Material bedruckt, und einer digital gesteuerten Rill- und Stanzmaschine herzustellen.

Schneid- bzw. Stanzmaschinen gibt es in verschiedenen Größen und mit unterschiedlichsten Funktionen. Einige eignen sich sogar zur Fertigung von Kleinserien.

Modèles structuraux de conditionnement

En matière de modèles de conditionnement, la technologie a accompli de formidables avancées au cours de ces dernières années, en grande partie grâce aux progrès permanents dans le domaine numérique, à la fois en termes de conception et de fabrication. Le contenu de cette série de manuels a été conçu à l'aide des technologies les plus récentes et cette série a pour but de faire bénéficier le lecteur de ces avancées techniques. La création et le développement de tous les modèles ont été réalisés à l'aide du tout dernier logiciel de test et de dessin en 3D. Les patrons des prototypes ont été découpés et refoulés en utilisant des tables de découpe à commande numérique. Cette exigence dans le choix des outils est la garantie de modèles de précision, à la fois fonctionnels et entièrement modulables. Toutefois, n'oubliez pas que l'épaisseur du matériau utilisé doit être prise en considération lors de la conception de tout produit de conditionnement. Les modèles devront vraisemblablement être ajustés en cas de modification des dimensions ou d'utilisation d'autres matériaux.

Normes de conditionnement

À l'échelle internationale, plusieurs organisations éditent des corpus de normes industrielles relatives à la conception de conditionnements structuraux. Les plus répandues sont d'une part le code de conception établi conjointement par la FEFCO (European Federation of Corrugated Board Manufacturers) et l'ESBO (European Solid Board Organization) et d'autre part les caractéristiques des types de catégorie définies par le PPC (American Paperboard Packaging Council).

Pratiquement tous les modèles standard définis par ces organisations ont été reproduits dans le manuel « **Modèles de base** » (avec codes de référence correspondant aux descriptions). Cette série a été rédigée avec le souci de respecter le plus fidèlement possible la terminologie FEFCO, ESBO et PPC.

Matériaux

En matière de conception et de fabrication de produits de conditionnement, il convient de faire la distinction entre les types de matériaux à base de fibres suivants :

papier : matériau d'un grammage inférieur à 225 g/m² (grammes par mètre carré)

papier-carton : matériau solide d'un grammage supérieur à 225 g/m²

carton : matériau solide d'un grammage compris entre 150 et 600 g/m²; plus rigide que du papier et souvent couché

carton ondulé : papier cannelé collé sur ou entre du papier ou du carton. Les cartons ondulés les plus courants sont les suivants :

simple face : une couche de papier cannelé collée sur une couche de papier ou de carton

double face ou **simple cannelure :** une couche de papier cannelé collée entre deux couches de papier ou de carton

double cannelure : deux couches de papier cannelé collées entre trois couches de papier ou de carton

triple cannelure : trois couches de papier cannelé collées entre quatre couches de papier ou de carton

Outre le matériau et le nombre de couches, le carton ondulé est défini par le type de cannelure. Le type de cannelure est généralement désigné à l'aide d'une lettre-code et est déterminé par le nombre de cannelures par mètre linéaire (ou pied) et par l'épaisseur de la cannelure.

Dans ce manuel, trois types de matériaux sont utilisés pour les prototypes : 350 g/m² de carton, 1 mm de carton ondulé en cannelure G et 1,5 mm de carton ondulé en cannelure E. Pour les modèles standard FEFCO du

manuel **Modèles de base**, la simulation des images en 3D a été effectuée en prenant pour hypothèse 3 mm de carton ondulé en cannelure B.

Considérations techniques

Lors de l'opération de rainage visant à créer des plis dans un carton solide, le rainage doit être à l'extérieur de la ligne de pliure prévue, c'est-à-dire que le pliage se replie à partir de la pliure. Toutefois, dans le cas de pliages effectués dans du carton ondulé, la pliure (ou ligne de refoulage) doit être à l'intérieur du pli.

Dans de nombreux cas, le sens du grain du matériau – ou des cannelures dans le carton ondulé – est important. Le grain/la cannelure peut en effet affecter la qualité du refoulage et amoindrir la stabilité globale d'un conditionnement. Il est préférable de consulter les fournisseurs et les fabricants des matériaux avant de réaliser un modèle.

La surface du matériau utilisé est un point important à prendre en considération lors de la sélection du type et de la qualité d'impression et de finition. Par exemple, un carton rêche n'est pas approprié pour des graphismes exigeant finesse et forts contrastes, alors que le papier-carton de haute qualité ou le carton ondulé (avec au moins une face couchée et lisse) permet des normes élevées d'impression offset, de dorure à la presse, de gaufrage, etc.

Dimensions de conditionnement

Lors de la conception d'un produit de conditionnement, l'aspect le plus important à prendre en considération porte, bien entendu, sur les dimensions du produit à conditionner. Toutefois, des impératifs supplémentaires doivent être considérés, comme la nécessité de laisser suffisamment d'espace pour le rembourrage de protection ou une doublure, les dimensions extérieures de l'emballage et la façon dont il peut être empilé et/ou placé sur une palette, les déchets des matériaux générés au cours de la production et la vitesse de production.

Conception de produits de conditionnement

A l'instar de la plupart des autres formes de conception structurelle, la plupart des modèles de conditionnement sont réalisés aujourd'hui à l'aide de programmes CAO (conception assistée par ordinateur – CAD en anglais). Ceux-ci existent sous de nombreuses formes : du simple logiciel qui vous permet de créer des structures de base jusqu'à des applications hautement avancées qui gèrent des processus de production complets.

EskoArtwork est un leader mondial en matière de développement de logiciel de conception de produits de conditionnement. Leur logiciel CAO « ArtiosCAD » est utilisé dans l'industrie depuis des décennies. Ce programme de pointe fournit une solution complète pour la conception de produits de conditionnement dans un environnement de fabrication professionnel. Toutefois pour des concepteurs de graphismes, de conditionnements et de produits qui n'ont pas besoin de l'intégralité des fonctionnalités d'ArtiosCAD, les plug-ins du logiciel d'EskoArtwork conçus pour des programmes tels que Adobe Illustrator® et Photoshop® constituent une excellente alternative tout en étant plus abordables. Tous les modèles de ce manuel ont été créés en utilisant ces plug-ins et une version de démonstration du logiciel est incluse sur le CD fourni avec ce manuel.

Prototypes

Les programmes logiciels de bonne qualité facilitent l'examen approfondi des modèles et aident à réduire le besoin d'essai physique. Dans le plug-in d'EskoArtwork « Visualizer », par exemple, un grand nombre de types de graphismes et de finitions spéciales peut être simulé de manière réaliste. Il existe même la possibilité de visualiser le produit sous différents éclairages.

Toutefois, lorsqu'un modèle approche de sa phase de production finale, il est essentiel de réaliser un prototype. Bien entendu, ceci peut être effectué à la main. Mais l'utilisation d'une imprimante à épreuves pour imprimer les graphismes sur le matériau souhaité et d'une table de découpe et de refoulement à commande numérique pour produire une maquette précise est une bien meilleure approche pour générer un prototype réaliste.

Les tables de découpe sont disponibles dans une grande variété de tailles et dans un large éventail de capacités. Certains modèles sont même appropriés pour la production de petits tirages.

Diseño de estructuras para embalajes

La tecnología del diseño de embalajes avanza a pasos agigantados, en buena parte gracias a las continuas innovaciones digitales en los ámbitos del diseño y la producción. El contenido de esta colección se ha creado con la tecnología más reciente para hacer llegar las ventajas de estos avances técnicos al lector. Cada uno de los diseños se ha concebido y desarrollado con el *software* de dibujo en 3D y de pruebas más innovador, y los prototipos se han cortado y hendido con mesas de corte digitales. Estos aspectos garantizan la precisión de los diseños, todos ellos funcionales y de escala modificable. No obstante, a la hora de diseñar un embalaje hay que tener en cuenta el grosor del material. Si se cambian las dimensiones o se utilizan materiales distintos puede que sea preciso ajustar las plantillas.

Estándares para el embalaje

Algunas organizaciones internacionales publican una serie de estándares para el diseño de estructuras para embalajes. El principal referente es el código de diseño concebido por la FEFCO (Federación Europea de Fabricantes de Cartón Ondulado) y la ESBO (Organización Europea de Cartón Sólido), así como las características estilísticas por categorías definidas por el PPC (Consejo para Embalajes de Cartón norteamericano).

Prácticamente todos los diseños estándar definidos por estas organizaciones se han reproducido en **Diseños básicos** (las descripciones incluyen los códigos de referencia correspondientes). Asimismo, en la medida de lo posible se ha utilizado la terminología de la FEFCO, la ESBO y el PPC.

Materiales

En los ámbitos del diseño y la fabricación de embalajes se distingue entre los siguientes tipos de materiales de fibra:

papel: material con un gramaje inferior a 225 g/m²

cartulina: material sólido con un gramaje superior a 225 g/m²

cartón: material sólido con un gramaje de 150 a 600 g/m², más rígido que el papel y a menudo tratado

cartón ondulado: papel ondulado pegado sobre una o dos hojas de papel o de cartón. Los cartones ondulados más habituales son:

de simple cara: una capa de papel ondulado pegada sobre una capa de papel o de cartón

de doble cara: una capa de papel ondulado pegada entre dos capas de papel o de cartón

de doble-doble cara: dos capas de papel ondulado pegadas entre tres capas de papel o de cartón

de triple cara: tres capas de papel ondulado pegadas entre cuatro capas de papel o de cartón

El cartón ondulado no solo depende del material y la cantidad de capas, sino también del tipo de onda. Esta tipología varía en función de la cantidad de ondas por metro lineal y del grosor, y suele indicarse mediante letras.

Para los prototipos de este libro se han utilizado tres tipos de material: cartón de 350 g/m2, cartón ondulado onda G de 1 mm y cartón ondulado onda E de 1,5 mm. En el caso de los diseños estándar de la FEFCO de **Diseños básicos**, las imágenes en 3D se simularon con cartón ondulado onda B de 3 mm.

Aspectos técnicos

Al doblar cartón sólido, el pliegue debe quedar por fuera de la línea o, dicho de otro modo, el doblez debe realizarse hacia el exterior. Por el contrario, al doblar cartón ondulado el doblez debe realizarse hacia el interior.

También hay que tener en cuenta la dirección del grano del material o, en el caso del cartón ondulado, de las ondas. El grano o las ondas pueden afectar a la calidad del pliegue y a la estabilidad del embalaje. Antes de acometer un diseño se recomienda consultar con el fabricante y el proveedor del material.

Para poder elegir el tipo y la calidad de la impresión y el acabado es necesario valorar la superficie del material. Por ejemplo, el cartón sin tratar no es apto para los gráficos definidos o con mucho contraste, mientras que el cartón sólido u ondulado de alta calidad (con una cara lisa tratada como mínimo) permite aplicar las técnicas más avanzadas de impresión en *offset*, estampado en caliente o gofrado, entre otras.

Dimensiones del embalaje

Lógicamente, lo más importante a la hora de diseñar un embalaje es tener en cuenta las dimensiones del producto. Aun así, hay otros aspectos que merecen atención, como el espacio para el acolchado de protección o el revestimiento, las dimensiones externas del embalaje y la forma de apilarlo y/o almacenarlo en un palé, la merma de material en la fase de producción y la velocidad de la cadena de montaje.

Diseño del embalaje

Como muchos otros diseños, hoy en día los embalajes suelen crearse con programas de diseño asistido por ordenador (CAD). Existen todo tipo de versiones, desde sencillas aplicaciones de *software* que permiten crear estructuras básicas, hasta programas de última generación que gestionan todo el proceso de producción.

EskoArtwork es uno de los principales desarrolladores de *software* para el diseño de embalaje. Su aplicación ArtiosCAD se utiliza en el sector desde hace décadas. Esta tecnología punta ofrece una solución integral para diseñar embalajes en un entorno profesional. Los diseñadores gráficos, de embalajes y de productos que no requieren todas las prestaciones de ArtiosCAD encontrarán una alternativa excelente y asequible en los *plug-ins* de EskoArtwork para programas como Adobe Illustrator® y Photoshop®. Todos los diseños de este volumen se han creado con estos *plug-ins*, que se incluyen en formato de versión de prueba en el CD adjunto.

Prototipos

Un buen programa de *software* debe facilitar la supervisión de los diseños y limitar la necesidad de realizar pruebas físicas. El *plug-in* Visualizer de EskoArtwork, por ejemplo, permite simular varios tipos de gráficos y acabados especiales con mucho realismo. Incluso existe la posibilidad de visualizar el producto con distintos tipos de iluminación.

Dicho esto, cuando un diseño entra en la fase de producción final resulta imprescindible fabricar un prototipo. Si bien puede hacerse a mano, lo más aconsejable es imprimir los gráficos sobre el material elegido con una impresora de prueba y a continuación procesarlos a través de una mesa de corte y hendido para generar una maqueta exacta del diseño.

En el mercado existen mesas de corte de todos los tamaños y prestaciones. Algunos modelos incluso están preparados para producir pequeñas tiradas.

Progettazione strutturale di imballaggi

La tecnologia di progettazione degli imballaggi ha fatto dei progressi enormi negli ultimi anni, special- mente grazie ai continui sviluppi delle capacità digitali di progettazione e produzione. Il contenuto di questa serie di libri è stato prodotto utilizzando le tecnolo- gie più recenti e mira ad offrire al lettore i vantaggi di questi progressi tecnologici. Per creare e sviluppare tutti i progetti è stato utilizzato il più recente software di creazione di bozze e testing 3-D, mentre i modelli dei prototipi sono stati tagliati e piegati utilizzando tabelle di taglio impostate in modo digitale. Tutto ciò significa che viene garantita la precisione dei progetti, i quali sono pienamente funzionali e scalabili. Tuttavia, è importante ricordare che in fase di progettazione dell'imballaggio è necessario tenere conto anche dello spessore del materiale utilizzato, ed è inoltre possibile che siano necessarie modifiche ai disegni quando si cambiano le dimensioni o si utilizzano altri materiali.

Standard di imballaggio

Diverse organizzazioni di tutto il mondo pubblicano una serie di standard industriali per la progettazione di imballaggi strutturali. Gli standard utilizzati in modo più diffuso sono rappresentati dal codice di progettazione stabilito in modo congiunto dalla FEFCO (Federazione europea dei fabbricanti di cartone ondulato) e dalla ESBO (Organizzazione europea del cartone solido), oltre che dalle caratteristiche di stile di categoria defi- nite dalla PPC (Consiglio americano per gli imballaggi in cartonato).

In pratica, tutti gli standard di progettazione defi- niti da queste organizzazioni sono stati riprodotti in **Imballaggi di base** (dove i codici di riferimento forni- scono le descrizioni). Per l'intera serie abbiamo anche utilizzato la terminologia FEFCO, ESBO e PPC laddove possibile.

Materiali

Nella progettazione e produzione degli imballaggi, si distinguono i seguenti tipi di materiali basati su fibre:

Carta: materiale con peso inferiore a 225 gsm (grammi per metro quadro)

Cartonato: materiale solido con un peso superiore a 225 gsm

Cartone: Materiale solido con un peso tra 150 e 600 gsm, più rigido della carta e spesso ricoperto

Cartone ondulato: carta scanalata incollata su o tra carta o cartone. I cartoni ondulati più comuni sono:

lato singolo: uno strato di carta scanalata incollato con uno strato di carta o cartone

lato doppio o **parete singola:** uno strato di carta scanalata incollato tra due strati di carta o cartone

parete doppia: due strati di carta scanalata incollati tra tre strati di carta o cartone

parete tripla: tre strati di carta scanalata incol- lati tra quattro strati di carta o cartone

Oltre che dal materiale e dal numero di strati, il cartone ondulato viene definito dal tipo di scanalatura. Il tipo di scanalatura viene in genere progettato utilizzando un codice alfabetico e viene determinato dal numero di scanalature per metro (o piede) lineare, oltre che dallo spessore della scanalatura.

Per i prototipi di questo libro sono stati utilizzati tre tipi di materiale: cartone da 350 gsm, cartone ondulato con scanalatura a G da 1 mm e cartone ondulato con scanalatura ad E da 1,5 mm. Per i disegni dello stan- dard FEFCO in **Imballaggi di base**, il cartone ondulato con scanalatura a B da 3 mm è stato simulato nelle immagini in 3-D.

Considerazioni tecniche

Quando si effettuano piegature con materiale di

cartone solido, la piega deve trovarsi all'esterno della riga di piegatura pianificata, ovvero la piegatura si svolge sviluppandosi dalla piega. Tuttavia, per le piegature con il cartone ondulato, la piega (o rigatura) deve trovarsi all'interno della piegatura.

In molti casi è importante la direzione della venatura del materiale o delle scanalature del cartone ondulato. La venatura/scanalatura può influire sulla qualità della piega e la stabilità complessiva di un imballaggio. Prima di completare un disegno, è pertanto preferibile discutere con i fornitori e i produttori dei materiali.

La superficie del materiale utilizzato è un problema importante da prendere in considerazione in fase di scelta del tipo e della qualità della stampa e della finitura. Ad esempio, il cartone grezzo non è adatto a grafica fine o ad alto contrasto, mentre il cartonato o il cartone ondulato di alta qualità (che abbia almeno un lato liscio e ricoperto) permette alti standard di stampa in offset, stampa di lamine, impressione a secco ecc.

Dimensioni degli Imballaggi

Quando viene progettato un imballaggio, la considerazione più importante riguarda ovviamente le dimensioni del prodotto da imballare. Tuttavia, è necessario prendere in considerazione altri aspetti, ad esempio lo spazio da lasciare per il materiale protettivo per l'imbottitura o un'eventuale calotta interna, le dimensioni esterne dell'imballaggio e le modalità con cui questo verrà accatastato e/o inserito in un pallet, oltre al materiale di scarto durante la produzione e la velocità di produzione.

Progettazione dell'Imballaggio

Allo stesso modo di altre forme di disegno strutturale, la maggior parte delle progettazioni degli imballaggi viene oggi effettuata utilizzando programmi CAD. Questi sono disponibili in diverse forme, da semplice software che consente di creare strutture di base, fino ad applicazioni altamente avanzate che gestiscono processi di produzione completi.

EskoArtwork è un'azienda leader mondiale nello sviluppo di software per la progettazione di imballaggi. Il software ArtiosCAD di questa società è stato utilizzato nel settore per decenni, dato che questo programma d'avanguardia offre una soluzione completa per la progettazione di imballaggi in ambienti di produzione professionali. Tuttavia, per i progettisti grafici, di imballaggi e di prodotti che non necessitano della piena funzionalità del software ArtiosCAD, i plug-in software di EskoArtwork per programmi quali Adobe Illustrator® e Photoshop® rappresentano un'alternativa eccellente e più economica. Tutti i progetti di questo libro sono stati creati utilizzando questi plug-in, mente una versione demo del software è inclusa nel CD fornito con questo libro.

Prototipi

Programmi software progettati in modo ottimale consentono un attento esame dei progetti e aiutano a ridurre la necessità di test fisici. Ad esempio, con il plug-in Visualizer di EskoArtwork è possibile simulare realisticamente diversi tipi di grafica e finiture speciali. Esiste anche la possibilità di visualizzare il prodotto in diverse condizioni di luce.

Tuttavia, quando un progetto si approssima alla propria fase di produzione finale, è essenziale creare un prototipo. Ovviamente questa operazione può essere effettuata a mano, ma l'uso di una stampante per bozze per stampare la grafica sul materiale di destinazione, oltre a una tabella di taglio e piega impostata in modo digitale per produrre un menabò preciso, rappresenta un approccio decisamente migliore per la creazione di un prototipo realistico.

Le tabelle di taglio vengono fornite in diversi formati e con un'ampia gamma di possibilità, mentre alcuni modelli sono adatti anche alle piccole produzioni.

Desenho de estruturas para embalagens

A tecnologia do desenho de embalagens revelou avanços notáveis nos últimos anos, em grande parte devido ao desenvolvimento das capacidades digitais, tanto ao nível do desenho como da produção. O conteúdo desta série de livros foi produzido utilizando as mais recentes tecnologias e tem como objectivo dar a conhecer as vantagens destes avanços tecnológicos ao leitor. Foi utilizado o *software* de desenho e teste em 3D mais avançado para criar e desenvolver todos os desenhos e os modelos do protótipo foram cortados e vincados utilizando mesas de corte digitais. Tudo isto significa que os desenhos são garantidamente precisos, funcionais e completamente escalonáveis. No entanto, tenha em atenção que a espessura do material utilizado deve ser tida em consideração quando se desenha uma embalagem. Provavelmente será necessário ajustar os desenhos quando são alteradas as dimensões ou os materiais utilizados.

Padrões de embalagem

Várias organizações em todo o mundo publicam conjuntos de normas industriais para o desenho de estruturas para embalagens. O mais utilizado é o código de desenho estabelecido conjuntamente entre a FEFCO (Federação Europeia dos Fabricantes de Cartão Canelado) e a ESBO (Organização Europeia de Cartão Compacto) e as características de estilo da categoria definidas pelo PPC (Conselho Americano para Embalagens de Cartão).

Quase todos os desenhos-padrão definidos por estas organizações foram reproduzidos em **Desenhos Básicos** (com os códigos de referência de acordo com as descrições). Ao longo desta série, também utilizámos a terminologia da FEFCO, ESBO e PPC sempre que possível.

Materiais

No desenho e produção de embalagens, é feita uma distinção entre os seguintes tipos de materiais à base de fibras:

papel: material com um peso inferior a 225 g/m² (gramas por metro quadrado)

cartão: material sólido com um peso superior a 225 g/m²

papelão: material sólido com um peso entre 150 e 600 g/m²; mais rígido do que o papel e muitas vezes revestido

cartão canelado: papel canelado colado a ou entre papel ou cartão. Os tipos de cartão canelado mais comuns são:

face simples: uma camada de papel canelado colada a uma camada de papel ou cartão

face dupla ou **parede simples:** uma camada de papel canelado colada entre duas camadas de papel ou cartão

parede dupla: duas camadas de papel canelado coladas entre três camadas de papel ou cartão

parede tripla: três camadas de papel canelado coladas entre quatro camadas de papel ou cartão

Além do material e do número de camadas, o cartão canelado é definido pelo tipo de canelura. O tipo de canelura é normalmente designado utilizando um código de letras e é determinado pelo número de caneluras por metro linear (ou pé) e pela sua espessura.

Foram utilizados três tipos de material para os protótipos presentes neste livro: papelão de 350 gm², cartão canelado de canelura G com 1 mm e cartão canelado de canelura E com 1,5 mm. Para os desenhos-padrão da FEFCO em **Desenhos Básicos**, foi simulado em 3D um cartão canelado de canelura B com 3 mm.

Considerações técnicas

Ao aplicar os vincos para dobra em cartão sólido, o vinco deverá estar na parte exterior da linha de dobra pretendida, ou seja, a dobra é efectuada no lado oposto ao vinco. No entanto, no caso das dobras em

cartão canelado, o vinco (ou corte) deverá estar no lado interior da dobra.

Em muitos casos, a direcção do grão do material – ou da canelura no caso do cartão canelado – é importante. O grão/canelura pode afectar a qualidade do vinco e a estabilidade geral da embalagem. É aconselhável discutir este aspecto com os fornecedores e fabricantes de materiais antes de completar um desenho.

A superfície do material utilizado é um aspecto importante a considerar na escolha do tipo e qualidade da impressão e acabamento. Por exemplo, o cartão áspero não é adequado para gráficos delicados ou de alto contraste, enquanto o cartão ou cartão canelado de alta qualidade (com, pelo menos, uma face suave e revestida) permite altos padrões de impressão em *offset*, estampagem com película metalizada, relevos, etc.

Dimensões das embalagens

Ao desenhar uma embalagem, a consideração mais importante é, sem dúvida, as dimensões do produto embalado. No entanto, existem outros aspectos a considerar, tais como deixar espaço adicional para enchimento de protecção ou revestimento, as dimensões exteriores da embalagem e como pode ser empilhada e/ou acomodada numa palete, os resíduos de materiais durante a produção e a velocidade de produção.

Desenho de embalagens

Tal como a maioria dos outros tipos de desenho de estruturas, grande parte do desenho de embalagens hoje em dia é feito utilizando programas CAD (desenho assistido por computador). Existe uma grande variedade de programas, desde um *software* simples que lhe permite criar estruturas básicas, a aplicações altamente avançadas que gerem todo o processo de produção.

A EskoArtwork é líder mundial no desenvolvimento de *software* para desenho de embalagens. O seu *software* ArtiosCAD tem sido usado no sector há décadas. Este avançado programa oferece uma solução completa para desenho de embalagens num ambiente de produção profissional. No entanto, para os *designers* gráficos, de embalagens e de produtos que não necessitam de todas as funcionalidades do ArtiosCAD, os *plug-ins*

de software EskoArtwork para programas como Adobe Illustrator® e Photoshop® são uma excelente alternativa económica. Todos os desenhos presentes neste livro foram criados utilizando estes *plug-ins* e está incluída uma versão de avaliação do *software* no CD que acompanha o livro.

Protótipos

Os bons programas de *software* facilitam uma avaliação exaustiva dos desenhos e ajudam a reduzir a necessidade de testes físicos. No *plug-in* Visualizer da EskoArtwork, por exemplo, podem ser simulados de forma realista muitos tipos de gráficos e acabamentos especiais. Existe ainda a possibilidade de visualizar o produto sob diferentes condições de iluminação.

Quando um desenho se aproxima da fase final de produção, contudo, é essencial realizar um protótipo. Obviamente, este pode ser feito manualmente. Mas, para criar um protótipo realista, é muito mais aconselhável utilizar uma impressora de prova para imprimir os gráficos no material pretendido e uma mesa de corte e vinco digital para produzir uma maqueta exacta.

As mesas de corte apresentam vários tamanhos e uma vasta gama de possibilidades. Alguns modelos estão até preparados para realizar pequenos ciclos de produção.

造形パッケージデザイン

パッケージデザイン技術は、近年大きな進歩を遂げました。特にデジタル技術における進歩が、パッケージのデザインと製造工程に大きな影響をおよぼしています。このシリーズは、パッケージのデザインにおける最新の技術を紹介し、これらの技術の進歩の恩恵を読者にもたらすことを目的に出版されました。デザインの作成と開発は、最新の3Dデザインおよび検査用ソフトウエアを使用して行われました。また、テンプレートは、デジタル制御のカット台で切断および折り曲げを行ったあと組み立てられました。このプロセスにより、デザインの精度が保証されるうえ、機能性と拡張性を備えたデザインが可能になりました。ただし、パッケージを設計する場合、使用する素材の厚さを考慮しなければなりません。寸法や素材の変更にともなうデザインの調整を行ってください。

パッケージ規格

世界中のいくつかの機構が造形パッケージのデザインのために業界規格を設けています。最も広く使用されているのは、FEFCO（European Federation of Corrugated Board Manufacturers）およびESBO（European Solid Board Organization）によって共同で確立された設計コードと、PPC（American Paperboard Packaging Council）により定義されている種別の特性です。

実際にこれらの機構によって定義されている標準デザインはすべて「**基本パッケージング**」（記述を提供する参照コードの）で再現されています。また、このシリーズでは、可能なかぎりFEFCO、ESBO、PPCで使われている用語を使用しました。

素材

パッケージのデザインと製造では、繊維素材を以下のように区別します。

紙：225 gsm（1平方メートルあたりのグラム数）未満の重さがある素材。
板紙：225 gsm以上の重さがある紙素材。
ボール紙：重さ150〜600 gsmの硬質素材。紙より堅くコーティングされているものもあります。
段ボール：紙や板紙の上または間に波形の紙素材の中芯（フルート）が接着されたもの。最も一般的な段ボールには以下4種類があります。

片面段ボール：波形の中芯にその中芯を保持するためのライナーと呼ばれる原紙を一枚張り合わせたもの。

両面段ボール：ライナー二枚の間に波形の中芯を一枚張り合わせたもの。

複両面段ボール：ライナー三枚の間にそれぞれ波形の中芯を二枚張り合わせたもの。

複々両面段ボール：ライナー四枚の間にそれぞれ波形の中芯を三枚張り合わせたもの。

素材と層の数に加えて、段ボールは波形の中芯の種類によっても区分されます。中芯のタイプは一般に、メートル（またはフィート）あたりの波形の数と中芯の厚さによりレターコードで分類されています。

本書では、次の三種類の素材をプロトタイプ（試作品）に使用しました。350 gsmの段ボール、1 mmのGフルート（薄型）段ボール、および1.5 mmのEフルート段ボール。また、「**基本パッケージング**」のFEFCO標準のデザインにおいては、立体イメージのシミュレーションに3 mmのBフルート段ボールを想定しました。

技術的考慮事項

板紙などに折り目をつける場合、折り目は折の外側（つまり山側）に付けます。しかし、段ボールの折り目（または、切り込み線）は折り目の内部に付けます。

多くの場合、素材の「きめ」（段ボールの場合は波形の中芯）の方向がデザインにとって重要です。きめや中芯の方向はパッケージの折りの仕上がりや構造上の安定性に影響します。デザイン作業にあたって、素材供給会社やメーカ

ーとこの点を話し合うことをお勧めします。

印刷と仕上げの種類と品質を考える場合、使用する素材の表面を考慮することが重要です。例えば、表面が粗い素材は、細かいハイコントラストのグラフィックスには適しません。オフセット印刷、箔押加工、エンボス加工などには、コーティングされた高品質の板紙または段ボールが適しています。

パッケージ寸法

パッケージデザインで最も重要な点は、もちろんパッケージされる製品の寸法です。しかし、保護目的のパッキングやライナーのための空間、パッケージ外寸、パッケージの積み重ねまたはパレット上での積み具合、生産時に発生する素材の無駄、生産速度などの追加要件もデザインする際に考慮する必要があります。

パッケージデザイン

他の造形デザインと同様、今日のほとんどのパッケージデザインにはCAD（コンピュータ支援設計）プログラムが使用されます。プログラムには、基本構造作成のための簡単なソフトウェアから、完全に生産過程を管理する非常に高度なアプリケーションもあります。

EskoArtworkはパッケージデザインソフト開発のグローバルリーダー的企業で、EskoArtworkのArtiosCADソフトウェアは長い間この業界で使用されています。この最先端のプログラムはプロの製造環境におけるパッケージデザインの完璧なソリューションといえます。しかし、すべてのArtiosCADの機能を必要としない、グラフィックデザイナー、パッケージデザイナー、および製品デザイナーのためのより手頃なツールとして、Adobe Illustrator®やPhotoshop®などのプログラムで使用できる様々なプラグインがEskoから提供されています。この本のデザインはすべて、これらのプラグインを使用して作成されました。また、これらソフトウェアのデモ版は付録のCDに収められています。

プロトタイプ

優れたソフトウェアプログラムにより、デザインの徹底的な検査が容易になり、手動によるテストの必要性が低減します。例えば、EskoArtworkのVisualizerプラグインを使って、様々なグラフィックスや特殊仕上げをリアルにシミュレートできます。異なった照明条件下でパッケージの仕上がりを仮想で事前に確認することも可能です。

しかし、デザインの最終的な生産段階では、プロトタイプの作成が不可欠です。もちろん、手作業でこれを作ることも可能ですが、校正プリンターを使用して対象となる素材にグラフィックスを印刷し、デジタル制御されたカット台と折り台を使用すると正確な実物模型を作成でき、よりリアルなプロトタイプが出来上がります。

カット台は様々なサイズと機能で選ぶことができます。小規模な制作工程での作成に適したモデルも販売されています。

结构包装设计

由于数字化功能的不断发展,近年来包装设计技术在设计和制造方面取得了巨大的进步。本系列丛书的内容使用最新技术制作,旨在为读者带来这些技术革新的好处。我们使用了最新的 3-D 绘图和测试软件创建和开发所有设计,并使用数字驱动裁床切割原型模板和制作折痕。所有这些工作意味着可以保证设计的精确度;设计具备应有功能并且可充分缩放。但请记住,在设计任何包装时必须考虑所使用材料的厚度。如果更改尺寸或使用其他材料,很可能需要调整设计。

包装标准

许多全球性组织发布了多个用于结构包装设计的行业标准。其中使用最广泛的是 FEFCO (European Federation of Corrugated Board Manufacturers, 欧洲瓦楞纸板制造商联合会) 和 ESBO (European Solid Board Organization, 欧洲硬纸板组织) 联合确立的设计准则以及 PPC (American Paperboard Packaging Council, 美国纸板包装协会) 规定的分类样式特征。

《基本包装》中几乎重现了所有这些组织定义的标准设计 (以及参考代码和说明)。我们还尽可能在本系列丛书中使用 FEFCO、ESBO 和 PPC 术语

材料

在包装设计和制造中,以下纤维材料类型之间存在区别:

纸张:重量小于 225 gsm (克/平方米) 的材料

纸板:重量大于 225 gsm 的实心材料

硬纸板: 重量介于 150 和 600 gsm 之间的实心材料;比纸张更坚硬,通常涂有涂层

瓦楞纸板: 胶粘在纸张或纸板上或之间的楞纸。最常用的瓦楞纸板包括:

单面:一层瓦楞纸粘在一层纸张或纸板上

双面或单瓦: 一层瓦楞纸粘在两层纸张或纸板上

双瓦:两层瓦楞纸粘在三层纸张或纸板上

三瓦:三层瓦楞纸粘在四层纸张或纸板上

除了材料和层数,瓦楞纸板还按照瓦楞纸的类型进行定义。瓦楞纸类型通常使用字母代码指定,并由每延米 (或英尺) 的瓦楞数量和瓦楞厚度决定。

本书中的原型使用三种材料: 350 gsm 硬纸板、1 mm G 级瓦楞纸板和 1,5 mm E 级瓦楞纸板。对于《基本包装》中的 FEFCO 标准设计,3-D 图像中模拟 3 mm B 级瓦楞纸板。

技术注意事项

在硬纸板中折叠折痕时，折痕应在计划折线外，即折叠从折痕开始。但是，对于瓦楞纸板中的折叠，折痕（或刻痕）应在折线内。

在许多情况下，材料纹理的方向 — 或瓦楞纸板中瓦楞的方向 — 很重要。纹理/瓦楞可以影响折痕的质量以及包装的总体稳定性。完成设计前，最好与材料供应商和制造商讨论这一点。

选择印刷和整饰的类型和质量时，所用材料的表面是一个值得注意的重要问题。例如，粗糙的纸板不适合精细或高对比度图案，而高质量纸板或瓦楞纸板（具有至少一个光滑涂层面）则允许高标准胶印、箔冲压、压印等处理。

包装尺寸

设计包装时，最重要的注意事项当然是要包装产品的尺寸。但是也要注意一些其他问题，例如为缓冲层或衬垫留出空间，包装的外部尺寸，如何堆放和/或放入货盘中，生产期间的材料浪费，以及生产速度。

包装设计

和大部分其他结构设计形式一样，现在的大部分包装设计使用 CAD（计算机辅助设计）程序完成。CAD 具有许多类型，从允许您创建基本结构的简单软件，到可以管理整个生产流程的高度先进的应用程序。

EskoArtwork 是开发包装设计软件的世界领先厂商。他们的 ArtiosCAD 软件已经在业内使用了数十年。这款先进的程序为专业制造环境中的包装设计提供一套完整的解决方案。但对于不需要 ArtiosCAD 的完整功能的图案、包装和产品设计人员来说，Esko 软件对 Adobe Illustrator® 和 Photoshop® 等程序的软件插件也是极为出色和更加经济的替代选择。本丛书中的所有设计均使用这些插件创建，附带的 CD 中提供该软件的演示版。

原型

优秀的软件程序方便彻底检查设计并有助于减少物理测试的需求。例如在 EskoArtwork 的 Visualizer 插件中，可以实际模拟许多图案和特殊修饰，甚至可以在不同照明条件下可视化产品。

但在设计接近最后生产阶段时，重要的是制作原型。当然可以手工制作原型。但使用打样打印机在预期材料上打印图案，并在数字驱动的裁剪折痕床制作精确的实物模型是比制作实际原型好得多的方法。

裁床具有多种大小和丰富的功能。一些型号甚至适合小型生产过程输出。

Cutting, Scoring and Perforation Die-Mould

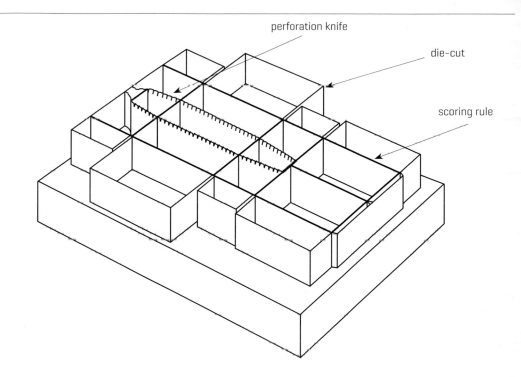

perforation knife

die-cut

scoring rule

Cutting, scoring and perforation die-mould

Schneide-, Rill- und Perforations-Stanzwerkzeug

Matrice de découpage, de rainage et de perforation

Molde de corte, hendido y perforación

Forma per fustellatura, cordonatura e perforatura

Molde para corte, marcação e perfuração

カッティング、スコアリング、パーフォレーションダイモールド

包装用的剪切、刻線與穿孔沖模

EN	DE	FR	ES	IT	PT	JP	CH
perforation knife for zip	Perforiermesser für Aufreißlaschen	lame de perforation pour dispositif de fermeture	cuchilla de perforación para el cierre	perforatore per strappo	lâmina de perfuração para o fecho	ジッパー用パーフォレーションナイフ	拉鏈穿孔刀
die-cut	Stanzmesser	outil de découpage à l'impor-te-pièce	troquelado	bordo	corte	ダイカット	沖切
scoring rule	Rillmesser	outil de rainage	regla de hendido	cordonatore	régua de marcação	スコアリングルール	刻線尺

Panel Names and Terminology

Panel Names and Terminology							
Seitenbezeichnungen und Terminologie				Nomi e terminologia del pannello			
Noms des panneaux et terminologie				Nomes dos painéis e terminologia			
Nombre de los paneles y terminología				各パネル名と用語			
						面板名称和术语	

	EN	DE	FR	ES	IT	PT	JP	CH
L	Length	Länge	Longueur	Longitud	Lunghezza	Comprimento	長さ	长度
W	Width	Breite	Largeur	Anchura	Larghezza	Largura	幅	宽度
D	Depth	Tiefe	Profondeur	Profundidad	Profondità	Altura	奥行き	高度
	Upper Tuck Flap	obere Einstecklasche	Pan rabattable supérieur	Solapa de cierre superior	Risvolto piega superiore	Aba de encaixe superior	上部差し込みフラップ	上褶边
	Lower Tuck Flap	untere Einstecklasche	Pan rabattable inférieur	Solapa de cierre inferior	Risvolto piega inferiore	Aba de encaixe inferior	下部差し込みフラップ	下褶边
	Top Closure Panel	obere Verschlussklappe	Panneau de fermeture supérieur	Panel de cierre superior	Pannello chiusura superiore	Painel de fecho superior	上閉じパネル	上挡板
	Bottom Closure Panel	untere Verschlussklappe	Panneau de fermeture inférieur	Panel de cierre inferior	Pannello chiusura inferiore	Painel de fecho inferior	下閉じパネル	下挡板
	Dust Flap	Staublasche	Pan de retenue	Solapa de protección	Risvolto antipolvere	Aba anti-pó	ダストフラップ	防尘襟片
	Glue Flap	Klebelasche	Pan encollé	Solapa de pegado	Risvolto colla	Aba de colagem	糊代	胶粘襟片
	Rear Panel	Rückwand	Panneau arrière	Panel posterior	Pannello posteriore	Painel traseiro	後パネル	后面板
	Front Panel	Vorderwand	Panneau avant	Panel anterior	Pannello anteriore	Painel frontal	前パネル	前面板
	Left Side Panel	linke Seitenwand	Panneau latéral gauche	Panel izquierdo	Pannello lato sinistro	Painel lateral esquerdo	左パネル	左面板
	Right Side Panel	rechte Seitenwand	Panneau latéral droit	Panel derecho	Pannello lato destro	Painel lateral direito	右パネル	右面板
	Shoulder	Kantenzugabe	Épaulement	Reborde	Spalla	Ombro	肩	肩
	Setback	Versatz	Décrochement	Distancia de separación	Rientranza	Folga	逃げ	缩进
α	Glue Flap Taper (usually 10° to 15°)	Klebelaschen-Anschrägung (meist 10°-15°)	Pan encollé biseauté (généralement, 10° à 15°)	Cuña de la solapa de pegado (in genere da 10° a 15°)	Conicità risvolto colla (in genere da 10° a 15°)	Bisel da aba de colagem (normalmente 10° a 15°)	糊代テーパー (通常10°〜15°)	胶粘襟片锥度 (通常 10° 至 15°)
β	Secondary Dust Flap Taper (usually 15°)	zweite Klebelaschen-Anschrägung (meist 10°-15°)	Pan de retenue biseauté secondaire (généralement 15°)	Cuña de la solapa de protección secundaria (en general 15°)	Conicità risvolto antipolvere secondario (in genere 15°)	Bisel da aba anti-pó secundária (normalmente 15°)	ダストフラップ二次テーパー (通常15°)	辅助防尘襟片锥度 (通常15°)
γ	Primary Dust Flap Taper (usually 45°)	erste Staublaschen-Anschrägung (meist 45°)	Pan de retenue biseauté principal (généralement 45°)	Cuña de la solapa de protección principal (en general 45°)	Conicità risvolto antipolvere primario (in genere 45°)	Bisel da aba anti-pó principal (normalmente 45°)	ダストフラップ一次テーパー (通常45°)	主要防尘襟片锥度 (通常 45°)
R, r	Tuck Flap Radius	Einstecklaschen-Eckradius	Rayon de pan rabattable	Radio de la solapa de cierre	Raggio risvolto piega	Raio da aba de encaixe	差し込みフラップ丸半径	褶边半径
	Setback and Shoulder depend on board caliper and carton size	Versatz und Kantenzugabe abhängig von Materialstärke und Seitenmaßen	Le décrochement et l'épaulement dépendent de l'épaisseur et de la taille du carton	La distancia de separación y el reborde dependen del calibre y el tamaño del cartón	La rientranza e la spalla dipendono dallo spessore e dal formato del cartone	As folgas e ombros dependem do calibre e do tamanho do cartão	逃げと肩の寸法はカリパスとカートンのサイズによります。	缩进和肩取决于纸板大小

Panel Names and Terminology

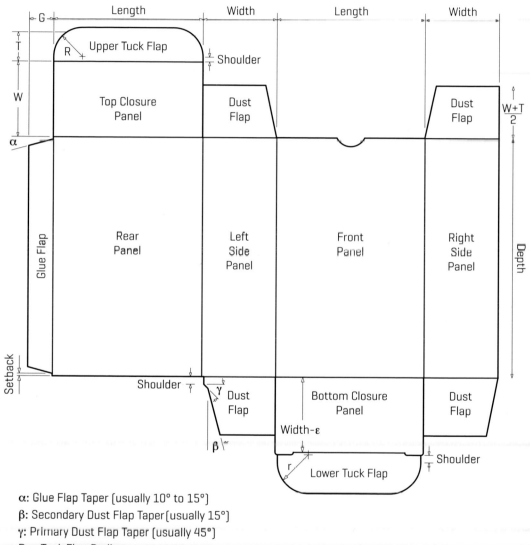

α: Glue Flap Taper (usually 10° to 15°)
β: Secondary Dust Flap Taper (usually 15°)
γ: Primary Dust Flap Taper (usually 45°)
R, r: Tuck Flap Radius
Setback and Shoulder depend on board caliper and carton size

EN	DE	FR	ES	IT	PT	JP	CH
Lock Tuck, Corner and Flap Styles	Typen von Einstecklaschen, Ecken und Laschen	Types de pan de fermeture, de coins et de rabats	Tipos de cierres, cantos y solapas	Stili di piega blocco, angolo e risvolto	Estilos de fecho, cantos e abas	ロック、差し込み、コーナー、フラップの形状	锁扣褶边、角和襟样式
Friction Lock Tuck	Einstecklasche mit Reibungsarretierung	Pan à montage par friction	Cierre deslizante	Piega blocco a frizione	Aba de fecho por fricção	差し込みフラップ	摩擦锁扣褶边
Slit Lock Tuck	Einstecklasche mit Schlitzarretierung	Pan à encoches de fermeture	Cierre ajustable	Piega blocco a fenditura	Aba de fecho por ranhura	切れ込み付き差し込みフラップ	切口锁扣褶边
Slot Lock Tuck	Einstecklasche mit Kerbarretierung	Pan à fentes de fermeture	Cierre con ranuras	Piega blocco a fessura	Aba de fecho por fissura	溝付き差し込みフラップ	槽口锁扣褶边
Length	Länge	Longueur	Longitud	Lunghezza	Comprimento	長さ	长度
Width	Breite	Largeur	Anchura	Larghezza	Largura	幅	宽度
Corner Radius	Eckradius	Rayon du coin	Radio del canto	Raggio angolo	Raio do canto	コーナー半径	角半径
Shoulder	Kantenzugabe	Épaulement	Reborde	Spalla	Ombro	肩	肩
Setback	Versatz	Décrochement	Distancia de separación	Rientranza	Folga	逃げ	缩进
Taper	Anschrägung	Biseau	Bisel	Conicità	Bisel	テーパー	锥度
Corner Styles	Ecktypen	Types de coins	Tipos de cantos	Stili angolo	Tipos de canto	コーナー形状	角样式
Square	rechteckig	Carré	Cuadrado	Quadrato	Quadrado	角	直角
Chamfer	abgeschrägt	Chanfreiné	Biselado	Smussato	Chanfro	面取り	削角
Rounded	abgerundet	Arrondi	Redondo	Arrotondato	Redondo	丸	圆角
Flap Styles	Laschentypen	Types de rabats	Tipos de solapas	Stili risvolto	Tipos de aba	フラップ形状	襟样式
Square	rechteckig	Carré	Cuadrada	Quadrato	Quadrada	角	方形
Square with Taper	trapezförmig, angeschrägt	Carré avec biseau	Cuadrada en forma de cuña	Quadrato con conicità	Quadrada com bisel	テーパー付き角	梯形
Rounded	rechteckig, abgerundet	Arrondi	Redonda	Arrotondato	Redonda	丸	带圆角方形
Rounded with Taper	trapezförmig, abgerundet	Arrondi avec biseau	Redonda en forma de cuña	Arrotondato con conicità	Redonda com bisel	テーパー付き丸	带圆角梯形

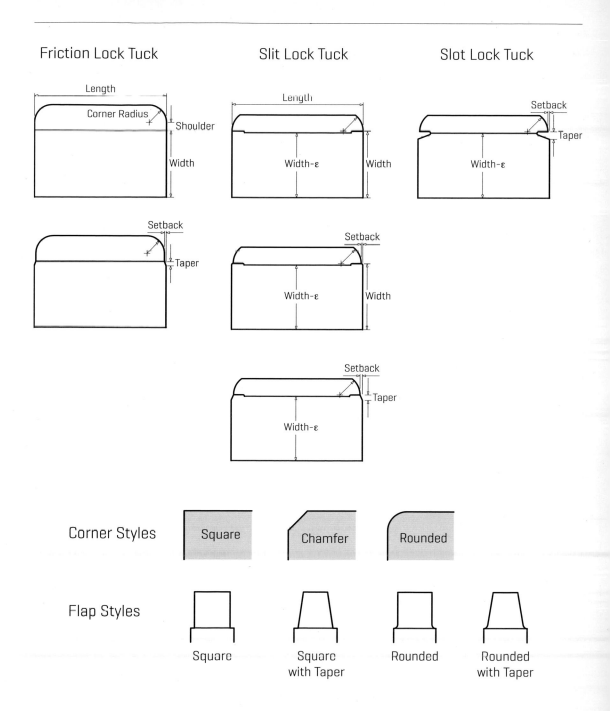

Friction Lock Tuck

Length
Corner Radius
Shoulder
Width

Setback
Taper

Slit Lock Tuck

Length
Width-ε
Width

Setback
Width-ε
Width

Setback
Width-ε
Taper

Slot Lock Tuck

Setback
Taper
Width-ε

Corner Styles

Square

Chamfer

Rounded

Flap Styles

Square

Square
with Taper

Rounded

Rounded
with Taper

Dust Flap Styles

EN	DE	FR	ES	IT	PT	JP	CH
Dust Flap Styles	**Staublaschen-typen**	**Types de pans de retenue**	**Solapas de protección**	**Stili risvolto antipolvere**	**Estilos de abas anti-pó**	ダストフラップ形状	**防尘襟片样式**
Friction Lock Tuck Dust Flaps	Einstecklasche mit Reibungsar-retierung	Pan à montage par friction	Solapas con cierre deslizante	Piega blocco a frizione	Aba de fecho por fricção	差し込みフラップのダストフラップ	摩擦锁扣褶边
Slit Lock Tuck Dust Flaps	Einstecklasche mit Schlitzarre-tierung	Pan à encoches de fermeture	Solapas con cierre ajustable	Piega blocco a fenditura	Aba de fecho por ranhura	切れ込み付き差し込みフラップのダストフラップ	切口锁扣褶边
Shoulder	Kantenzugabe	Épaulement	Reborde	Spalla	Ombro	肩	肩
Setback	Versatz	Décrochement	Distancia de separación	Rientranza	Folga	逃げ	缩进
Offset	Versatz	Décalage	Distancia de separación	Rientranza	Folga	オフセット	偏差

Dust Flap Styles

Friction Lock Tuck Dust Flaps

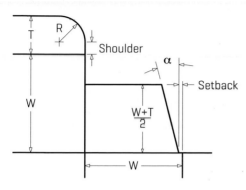

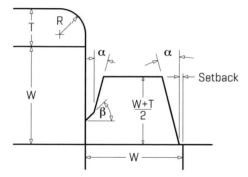

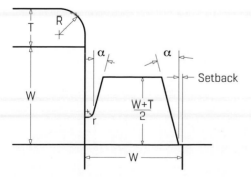

Slit Lock Tuck Dust Flaps

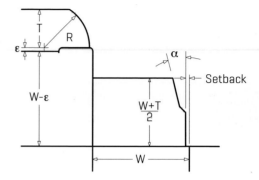

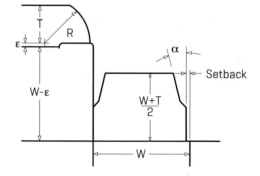

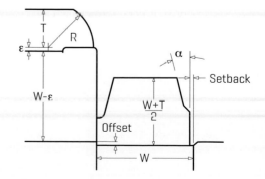

FN	Cardboard / 350 gsm	Corrugated board / G flute / 1 mm	Corrugated board / E flute / 1.5 mm
DE	Karton / 350 g/m²	Wellpappe / G-Welle / 1 mm	Wellpappe / E-Welle / 1,5 mm
FR	Carton / 350 g/m²	Carton ondulé / cannelure G / 1 mm	Carton ondulé / cannelure E / 1,5 mm
ES	Cartón / 350 g/m²	Cartón ondulado / onda G / 1 mm	Cartón ondulado / onda E / 1,5 mm
IT	Cartone / 350 gsm	Cartone ondulato / Scanalatura a G / 1 mm	Cartone ondulato / Scanalatura a E / 1,5 mm
PT	Papelão / 350 g/m²	Cartão canelado / canelura G / 1 mm	Cartão canelado / canelura E / 1,5 mm
JP	段ボール / 350 gsm	段ボール / Gフルート / 1 mm	段ボール / Eフルート / 1.5 mm
CH	硬纸板 / 350 gsm	瓦楞纸板 / G 级 / 1 mm	瓦楞纸板 / E 级 / 1,5 mm

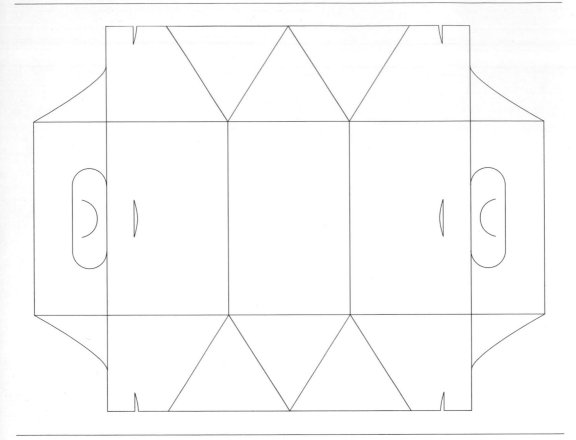

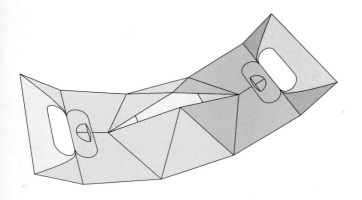

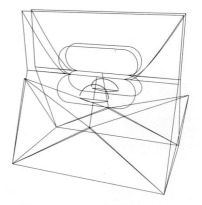

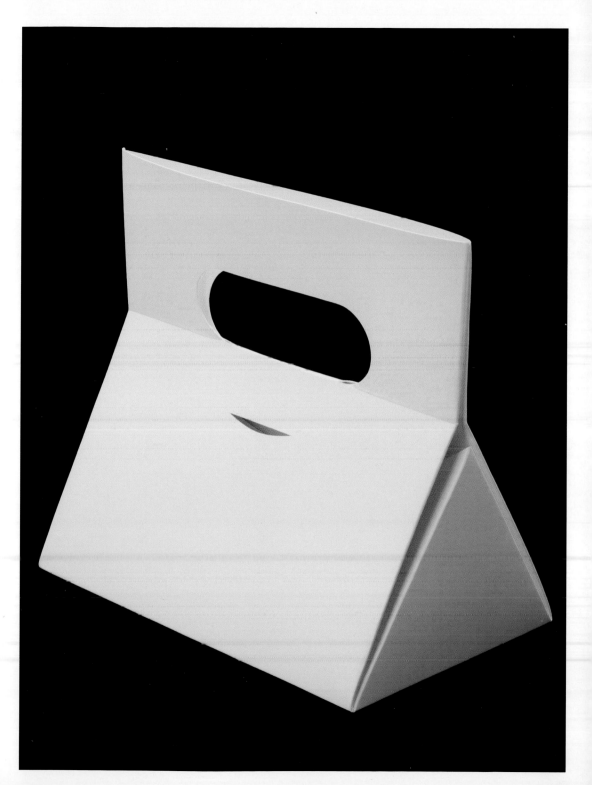

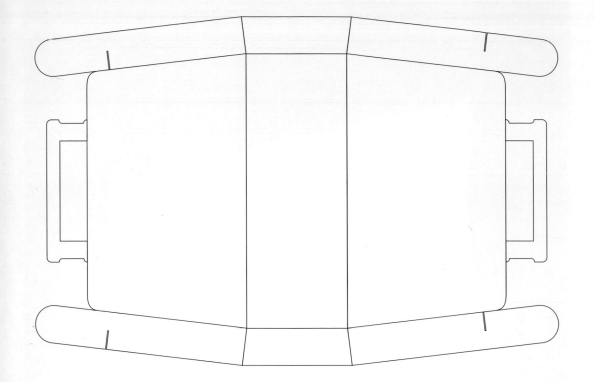

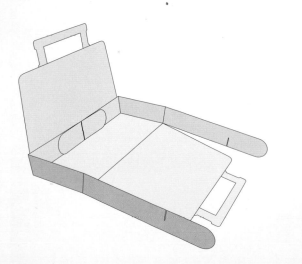

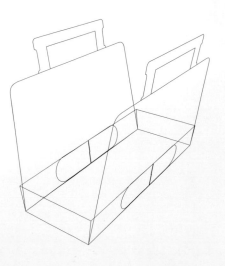

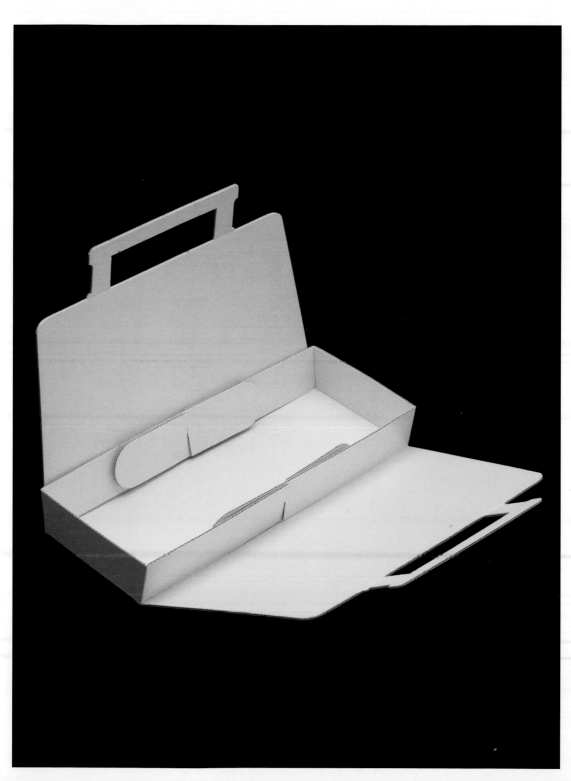

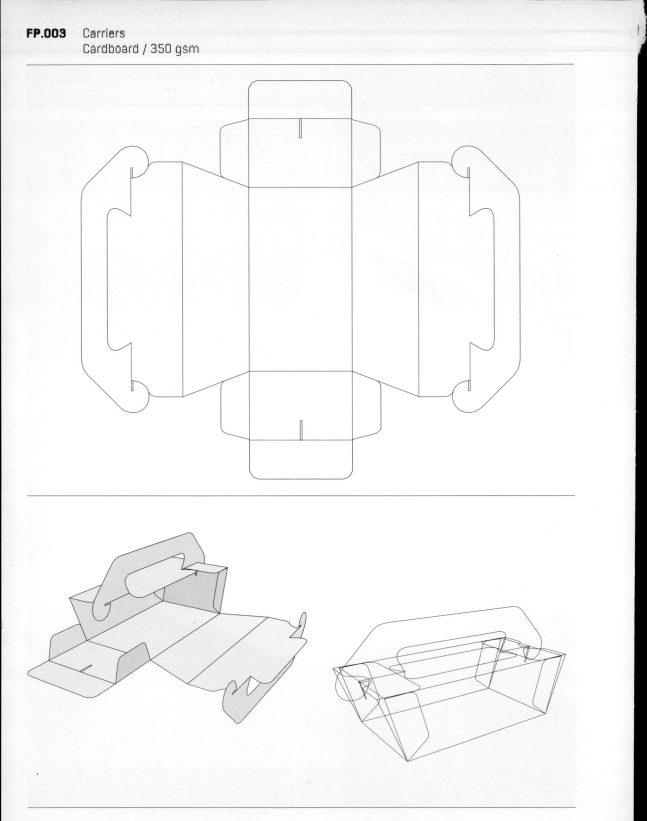

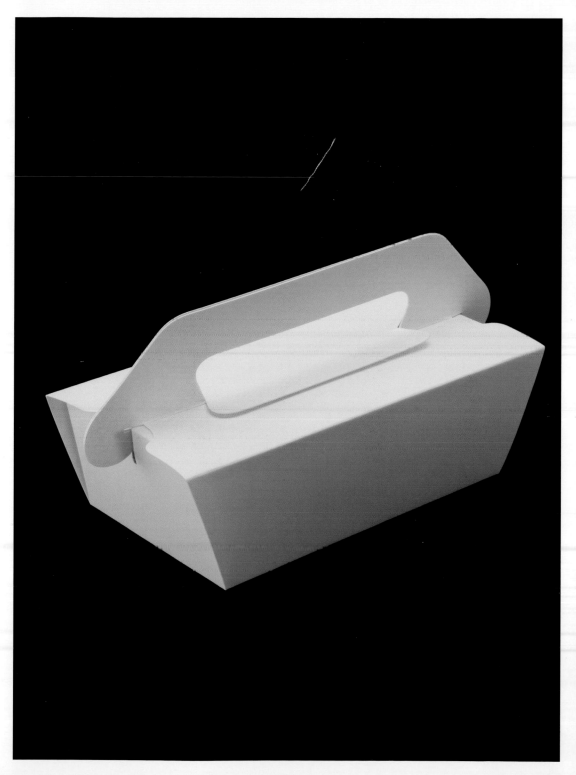

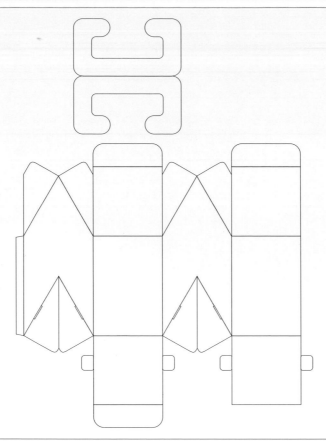

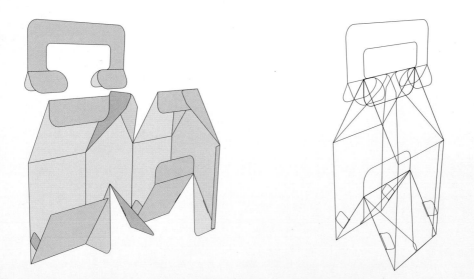

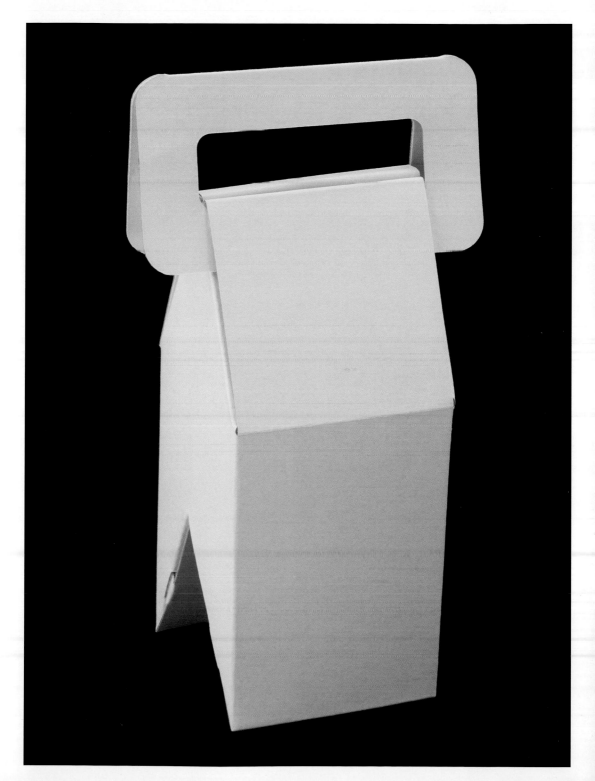

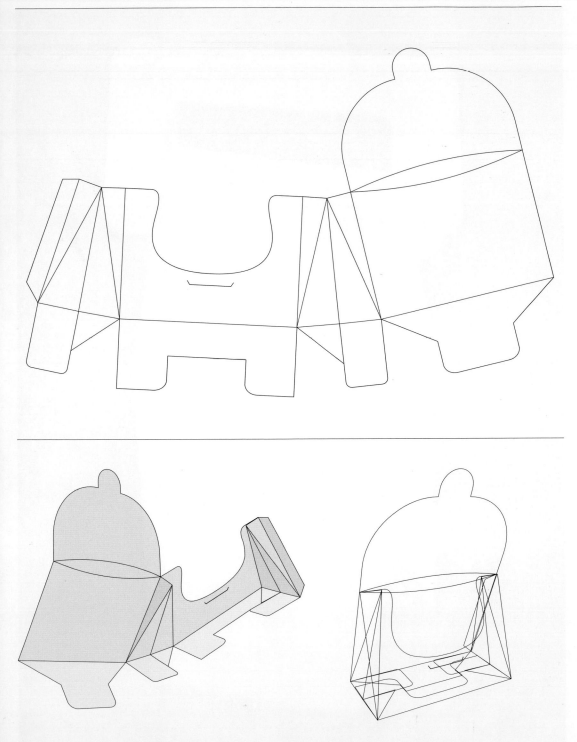

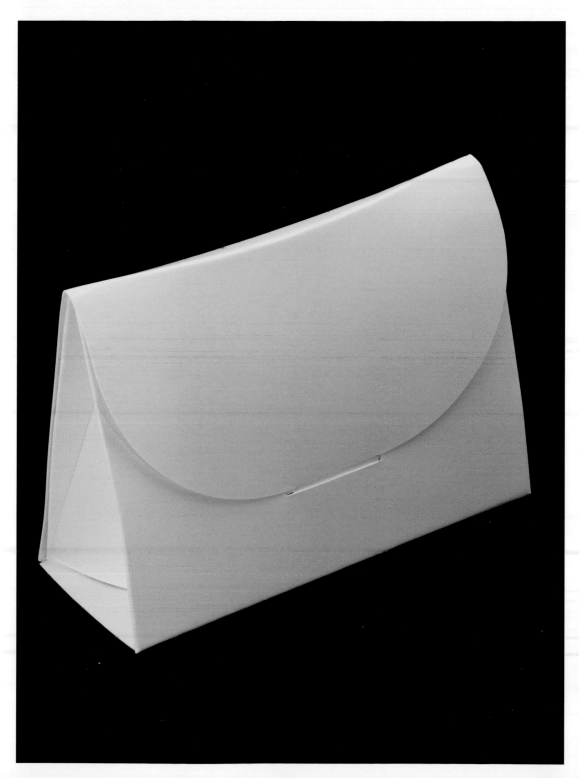

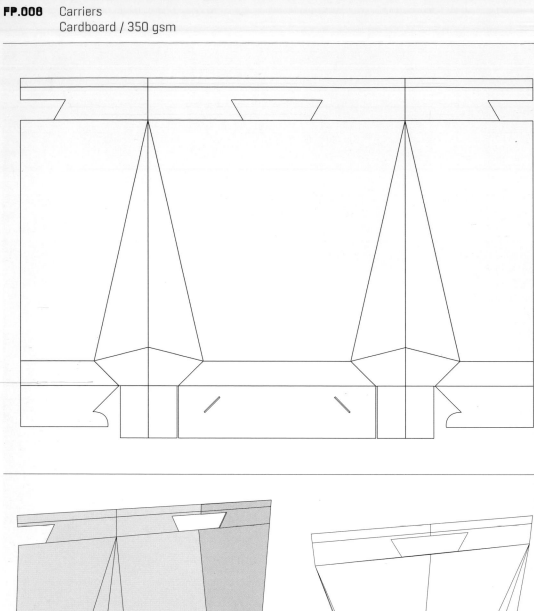

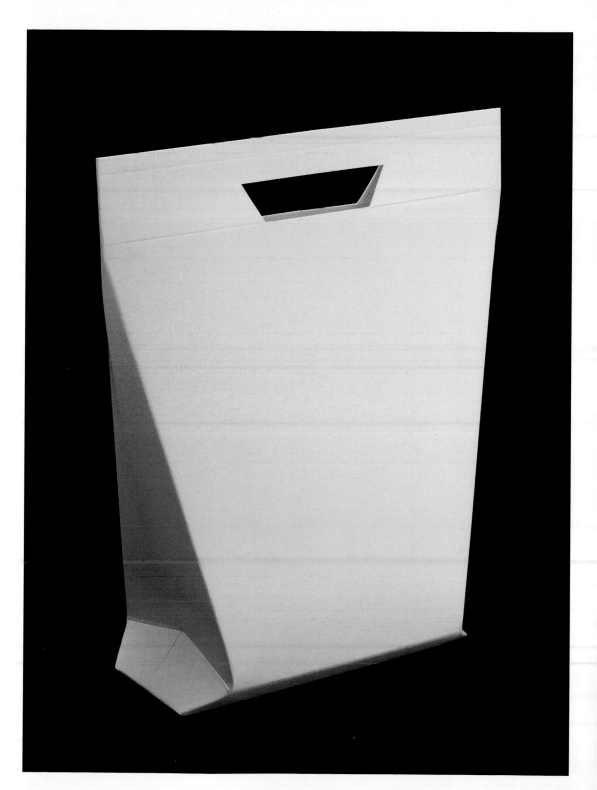

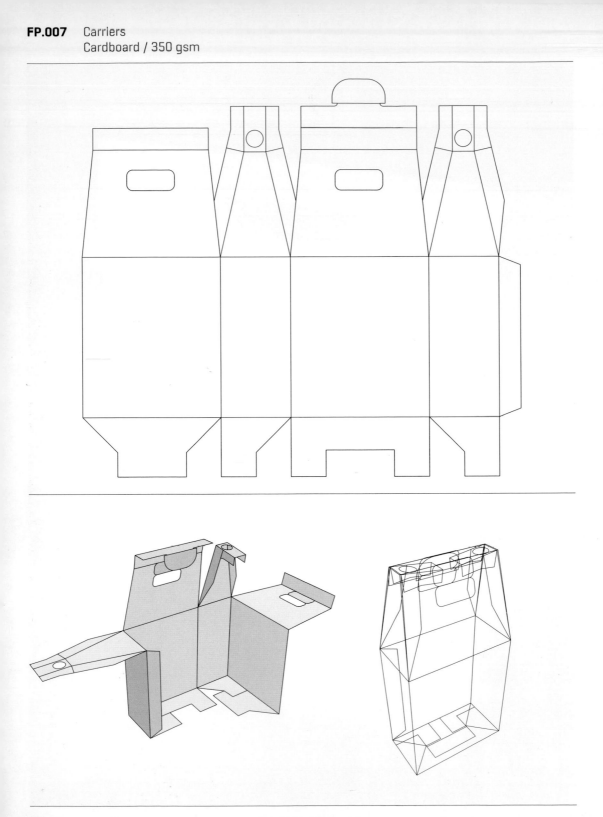

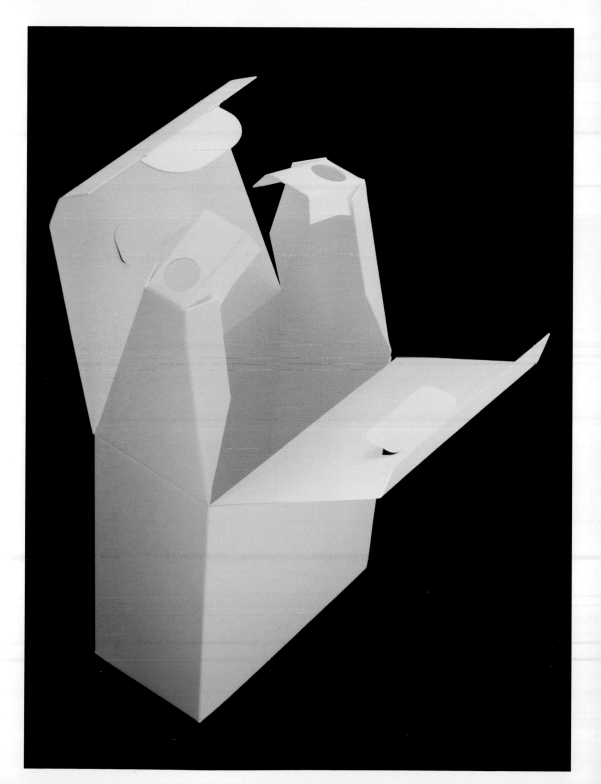

49

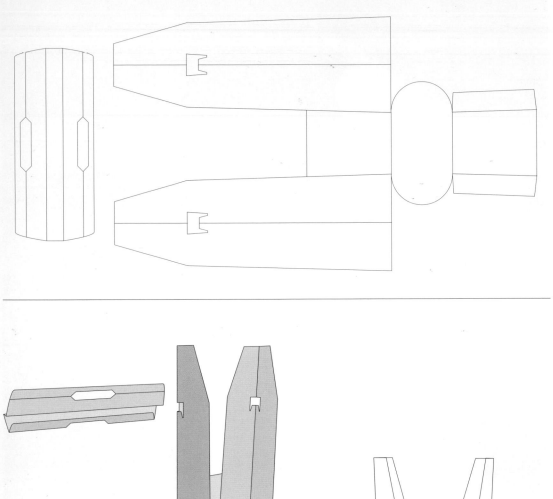

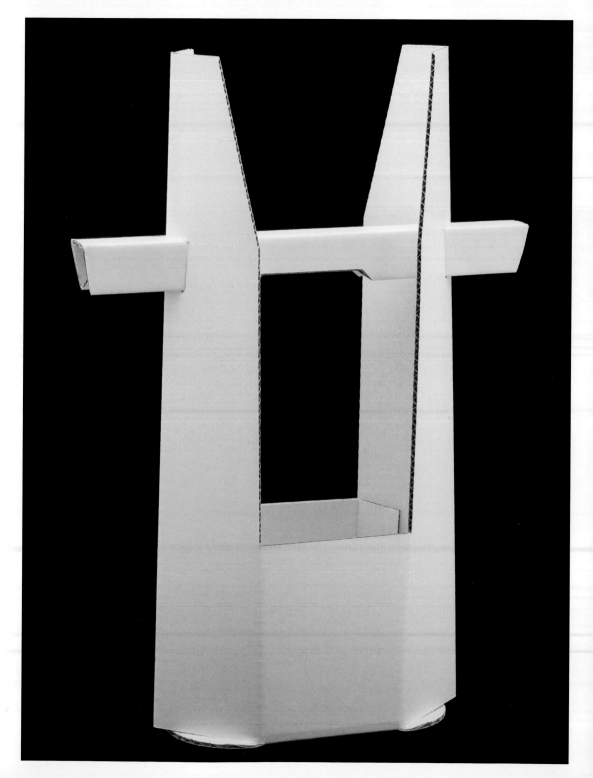

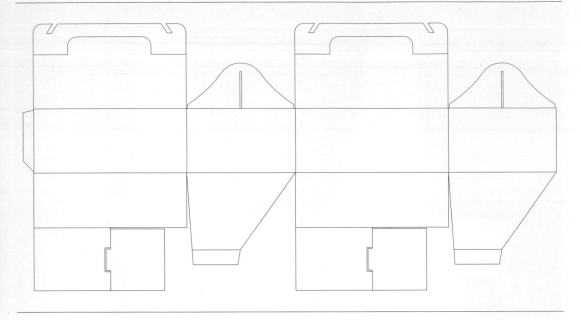

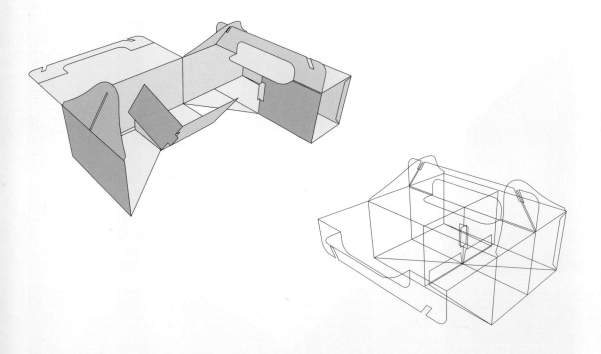

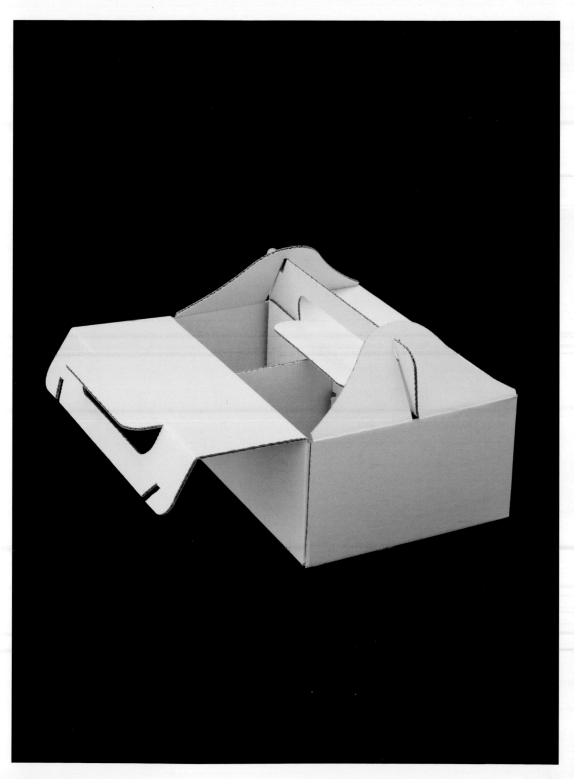

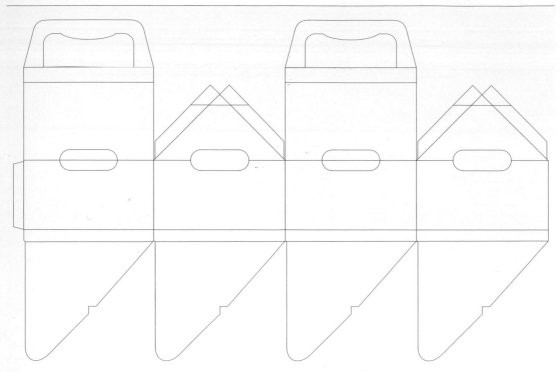

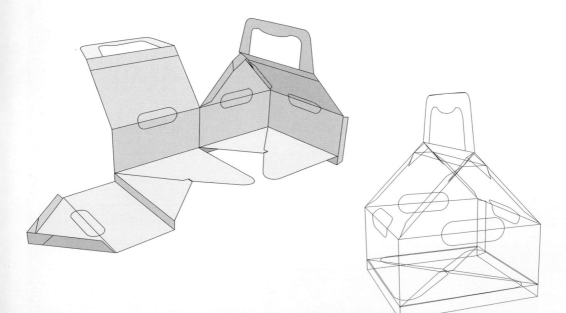

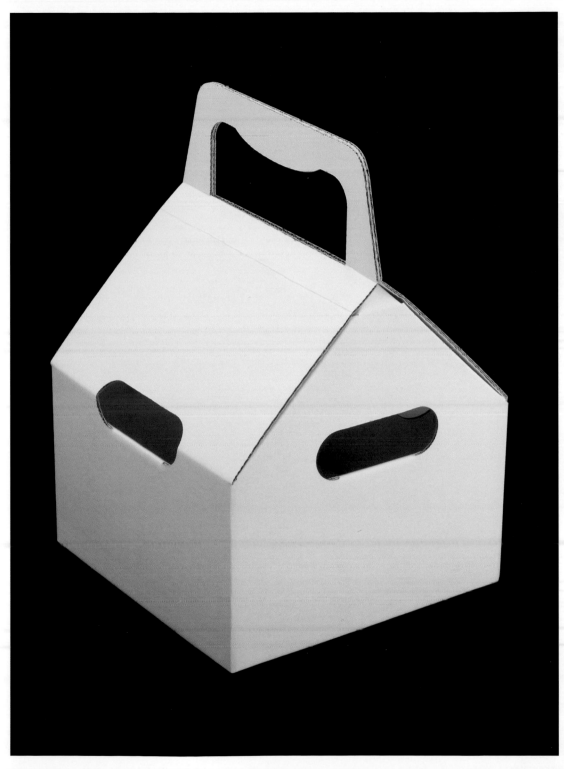

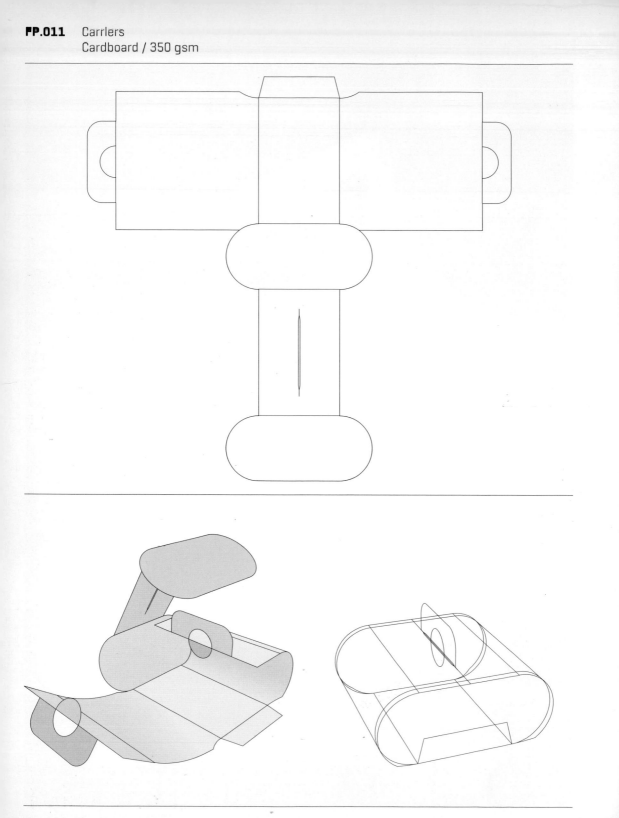

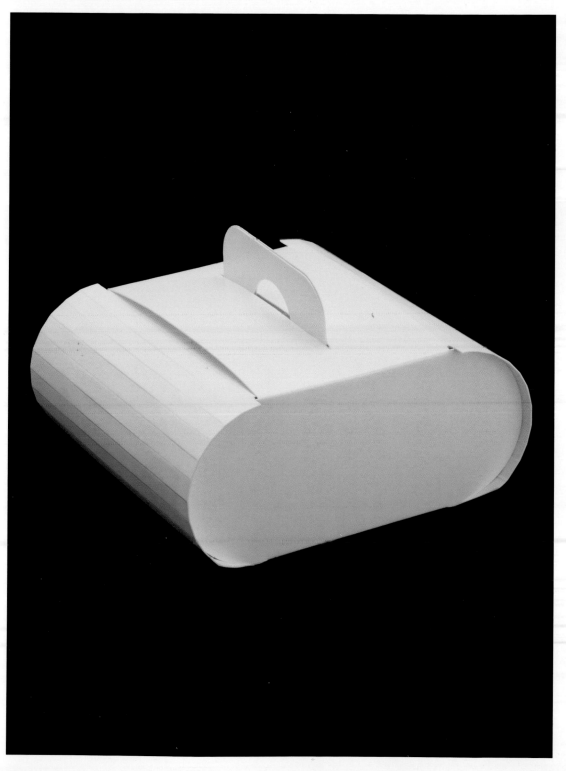

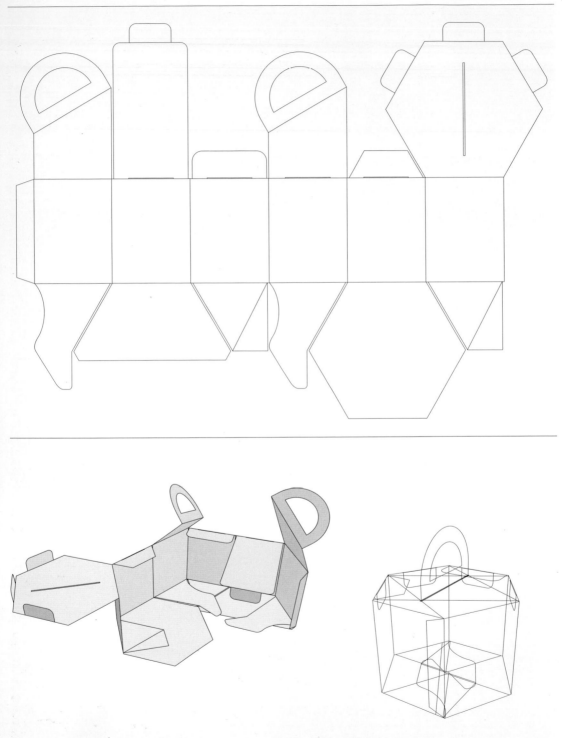

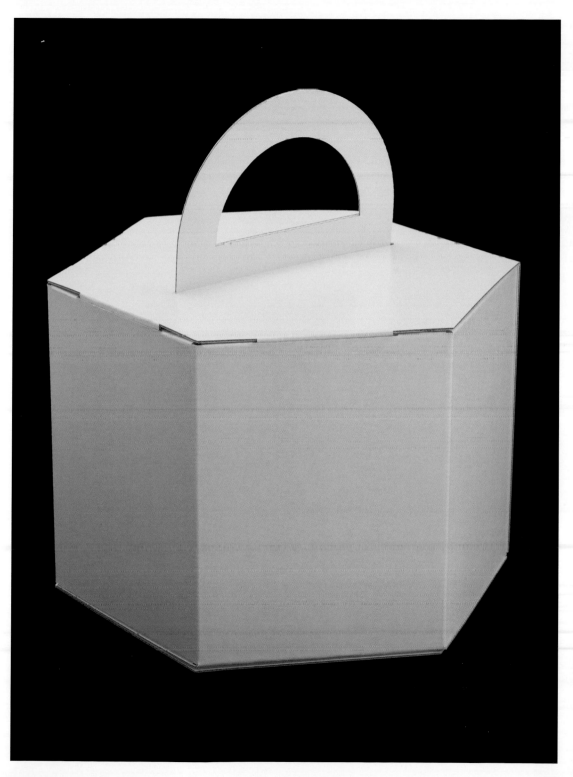

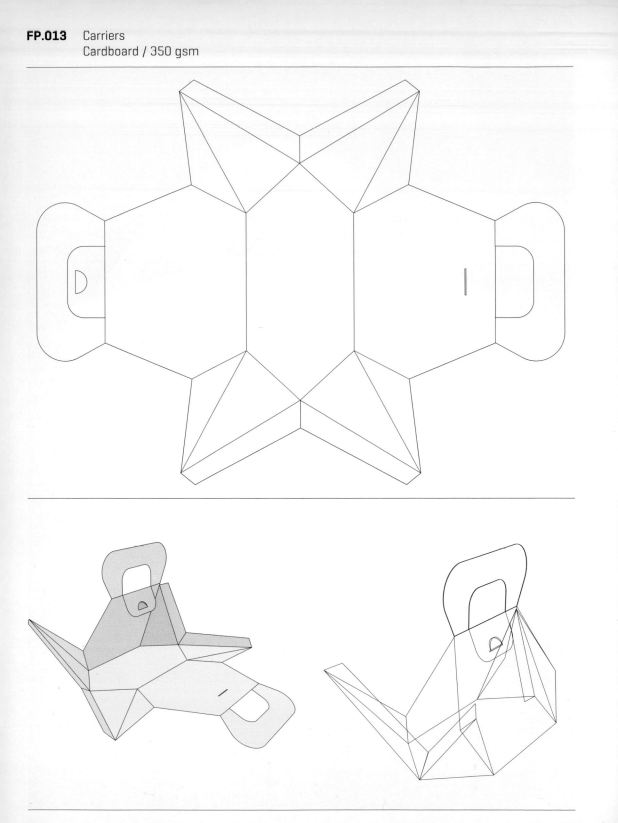

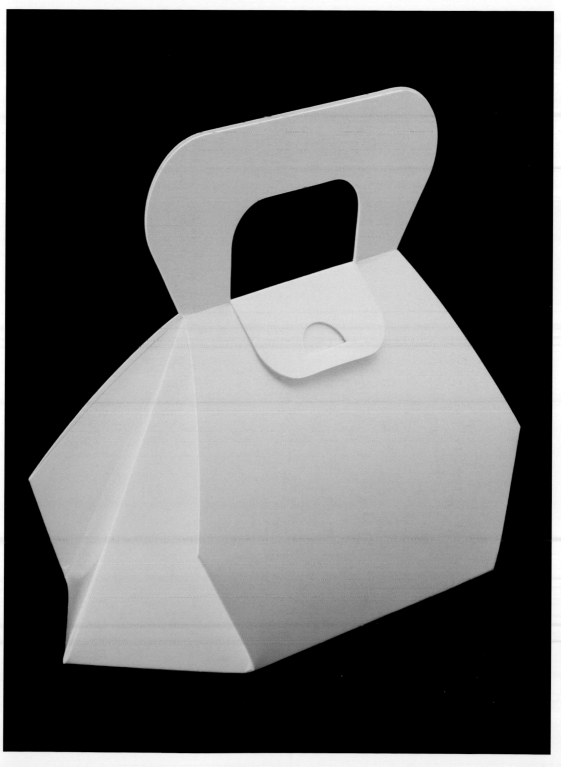

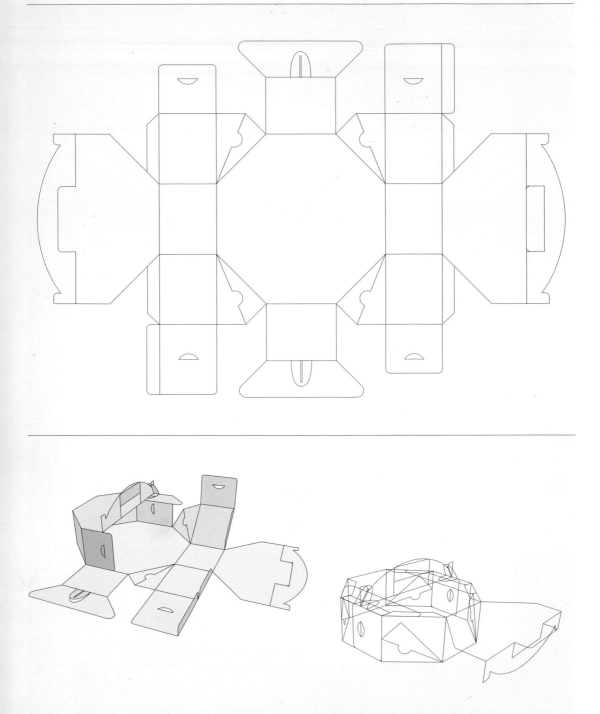

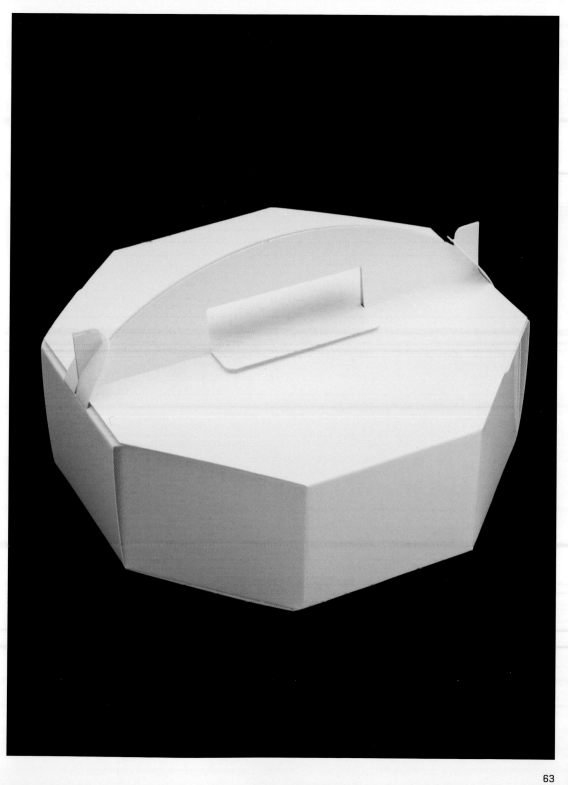

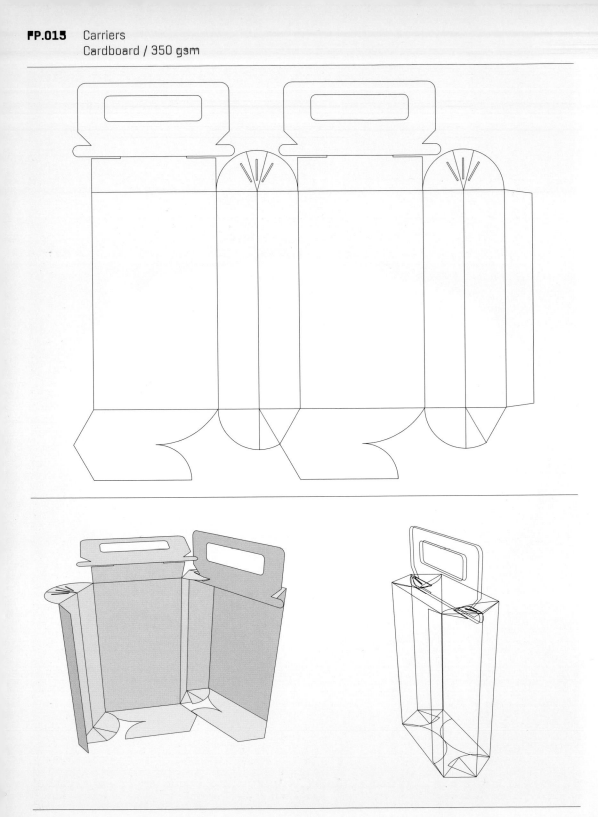

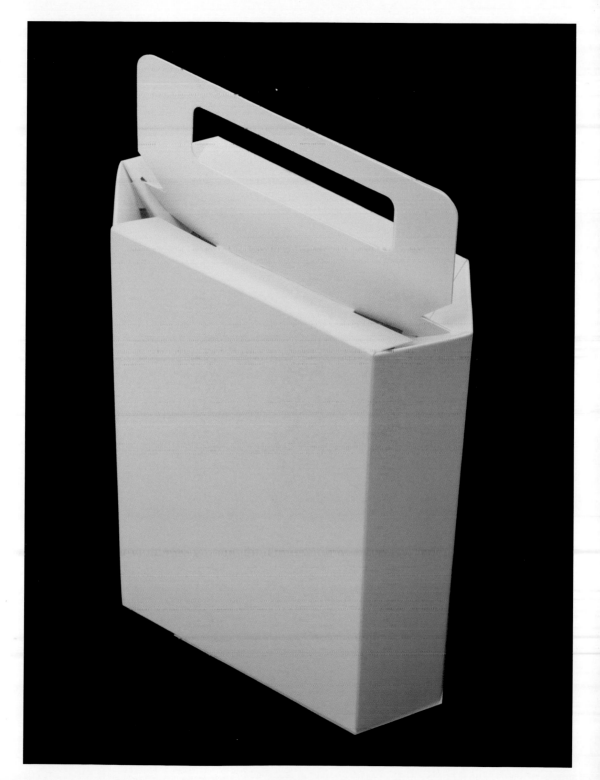

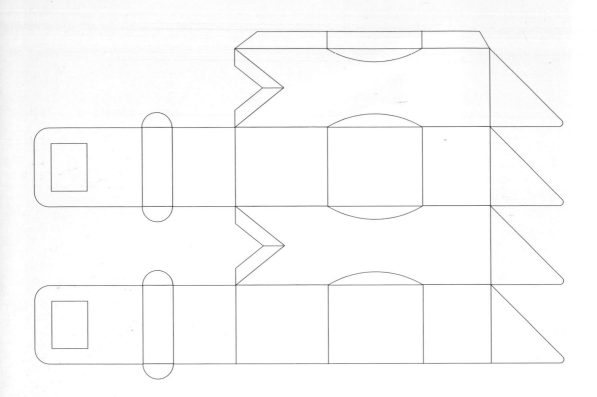

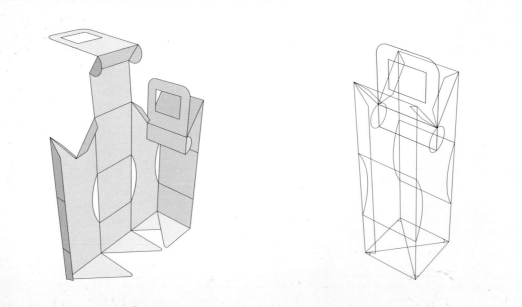

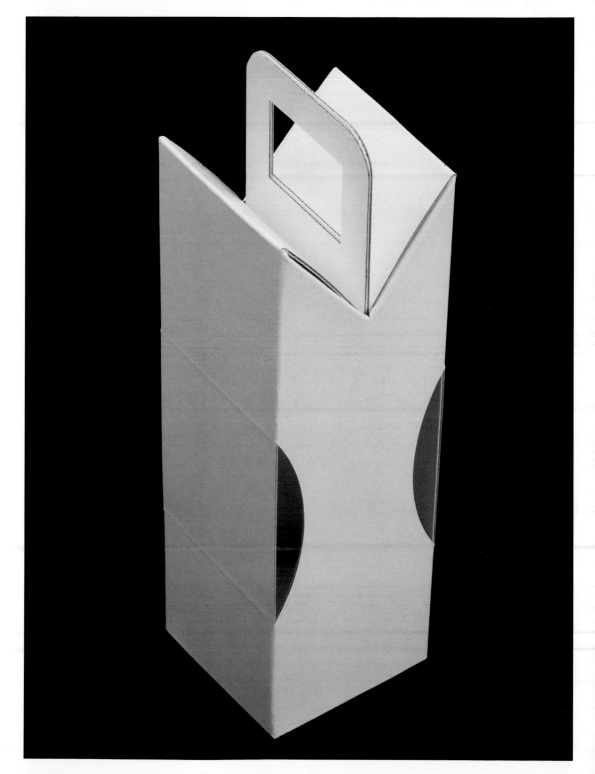

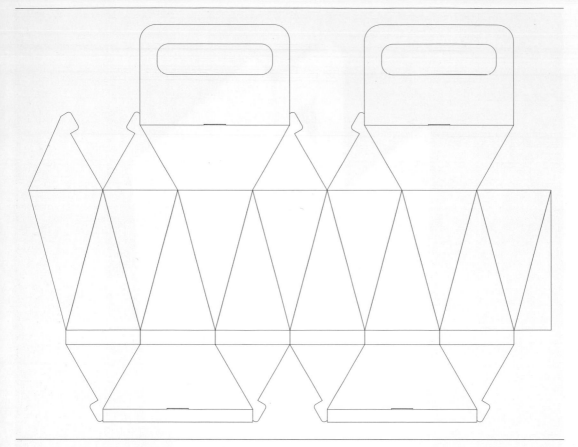

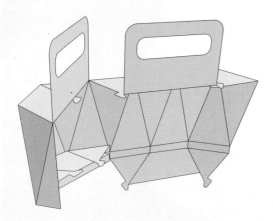

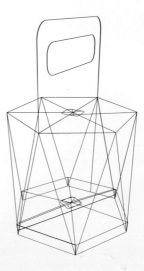

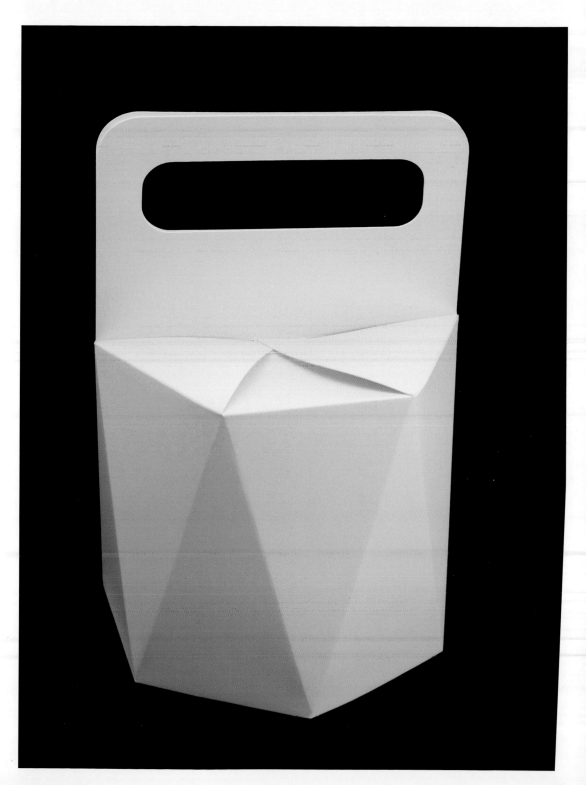

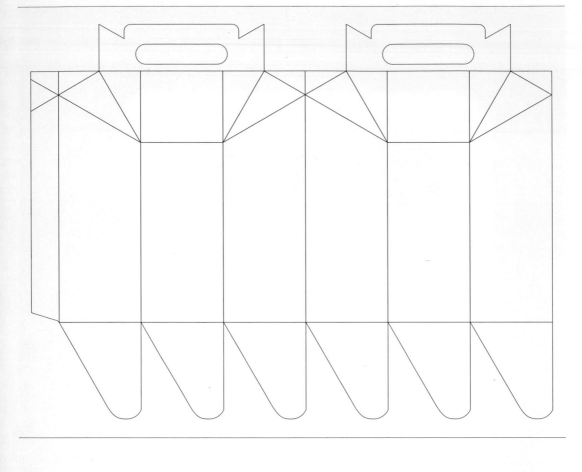

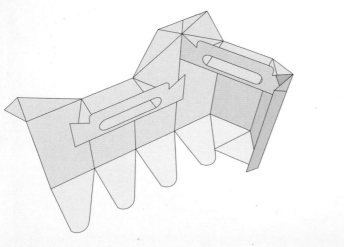

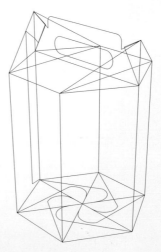

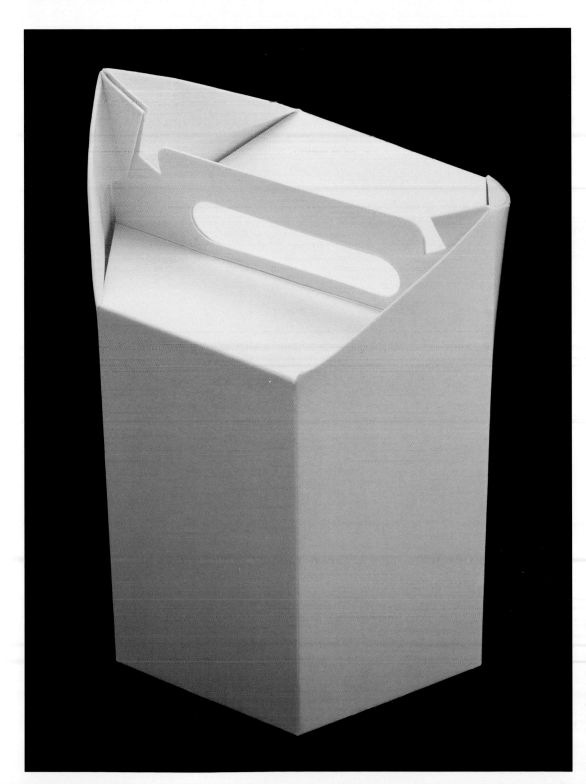

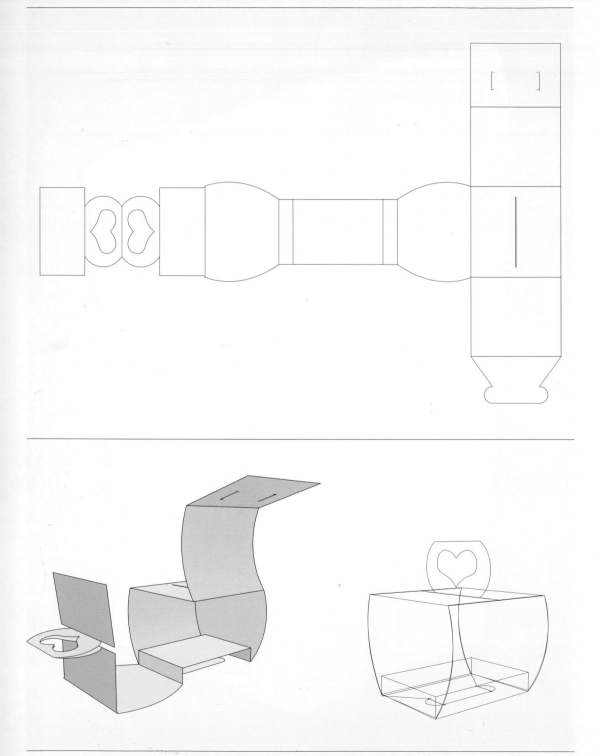

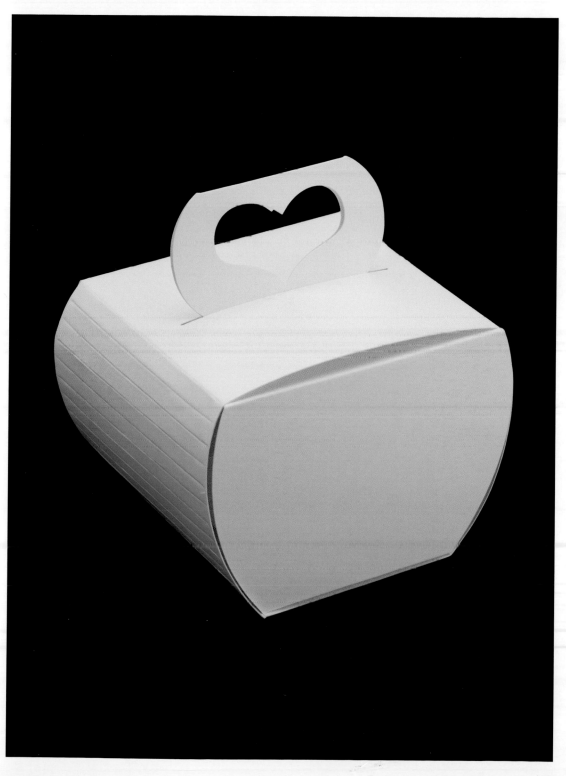

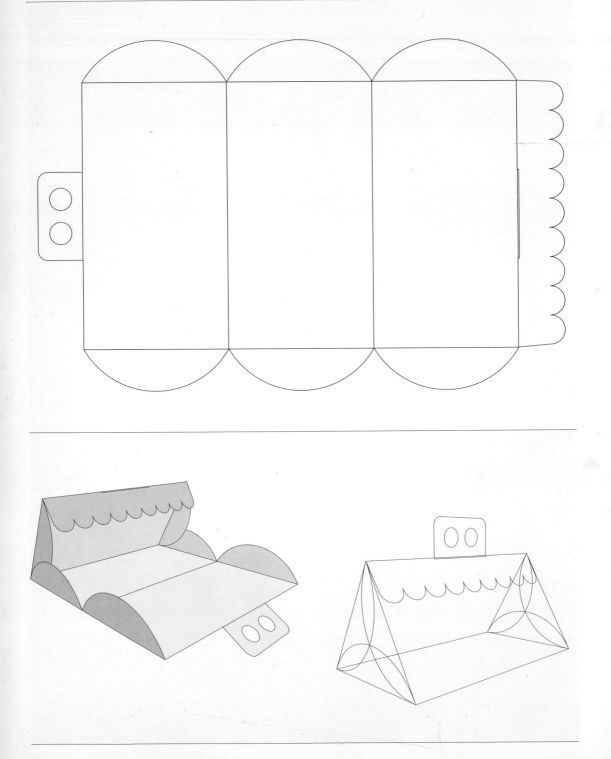

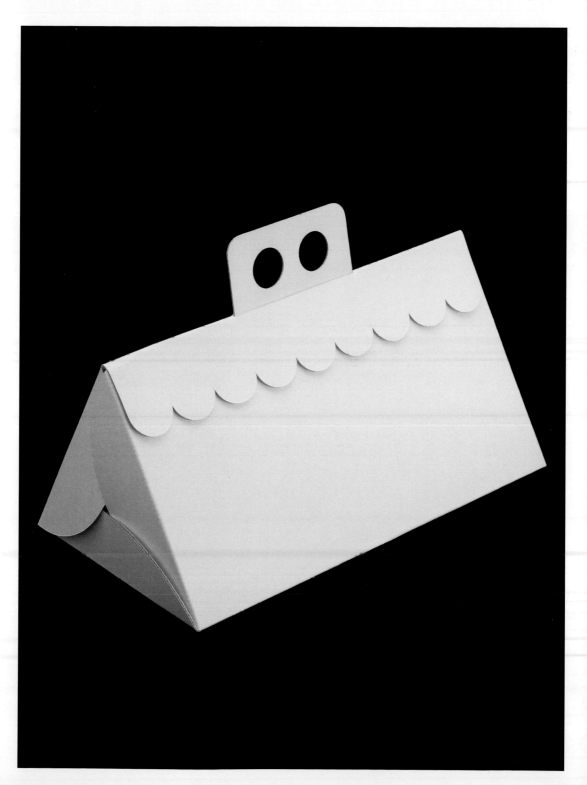

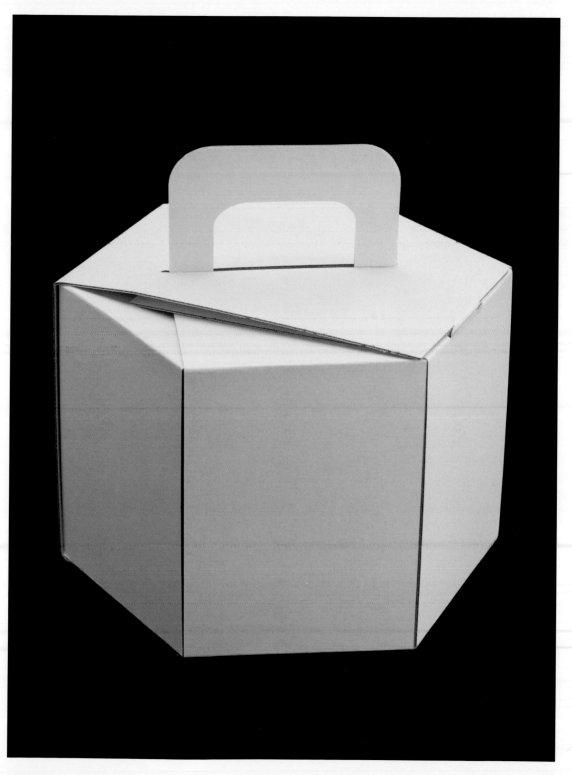

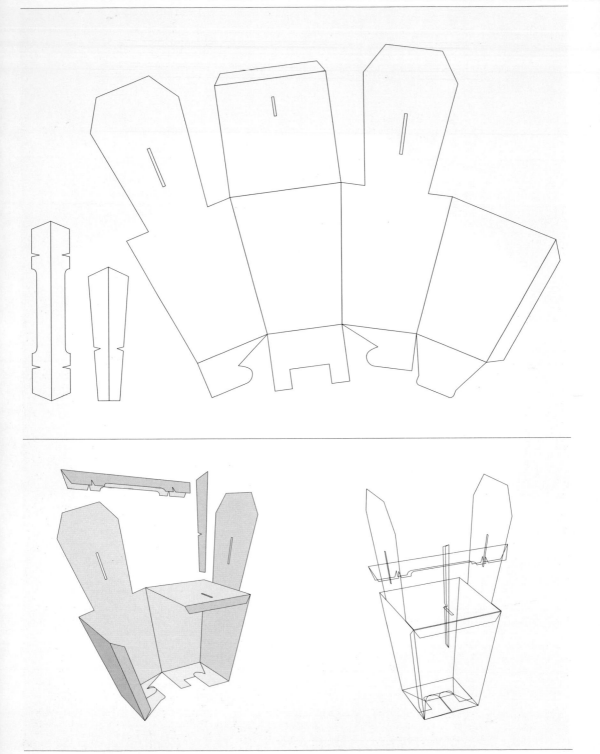

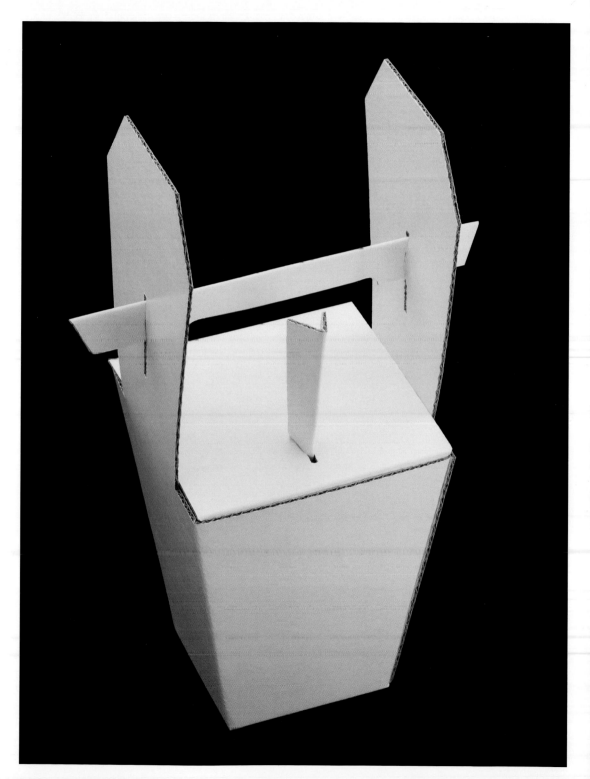

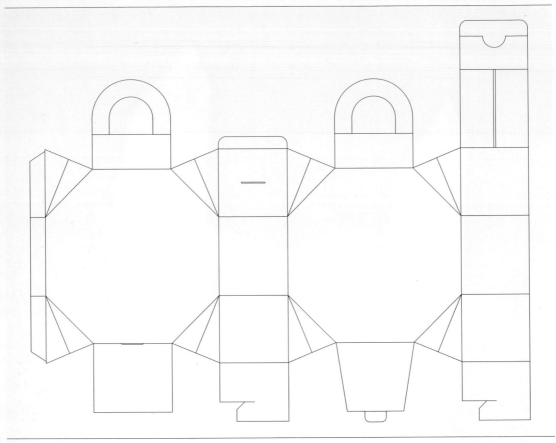

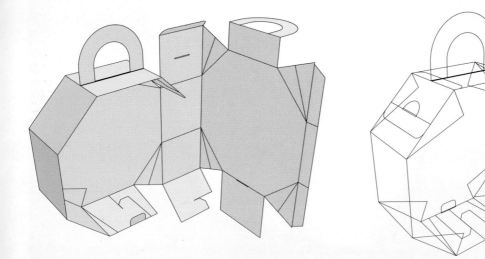

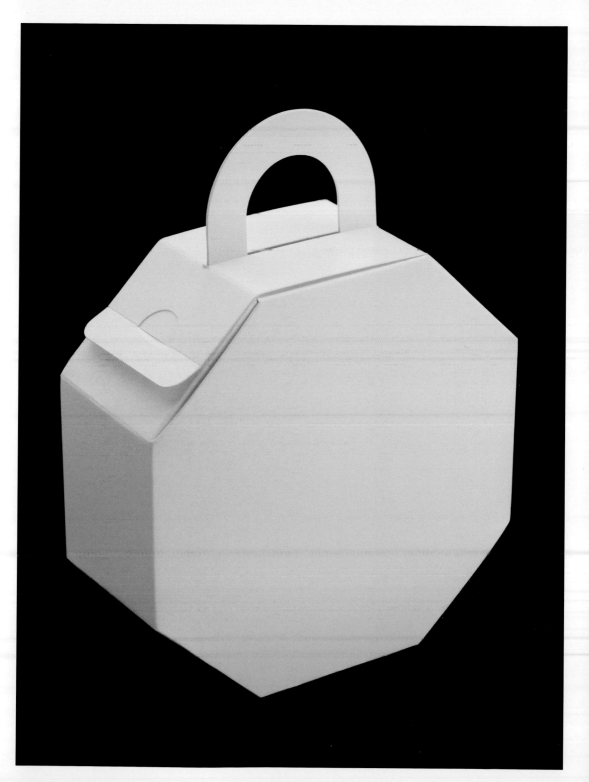

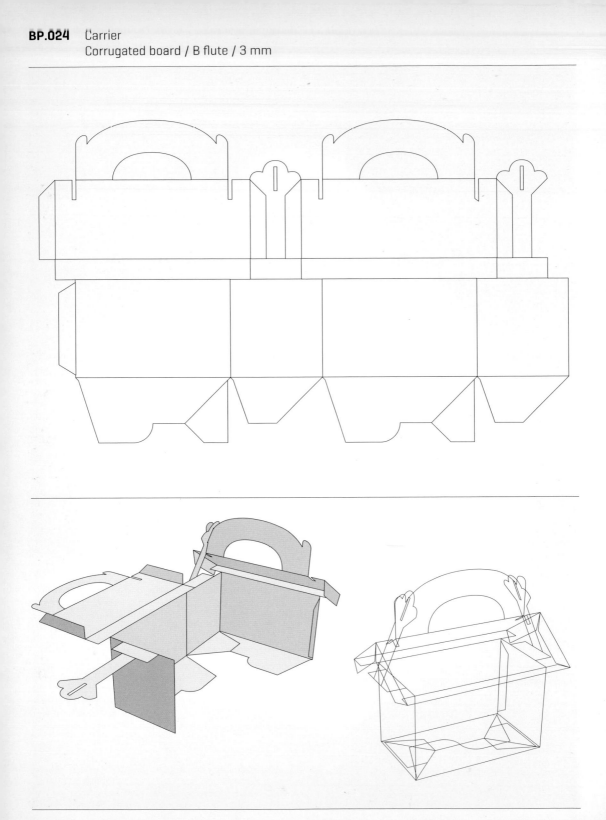

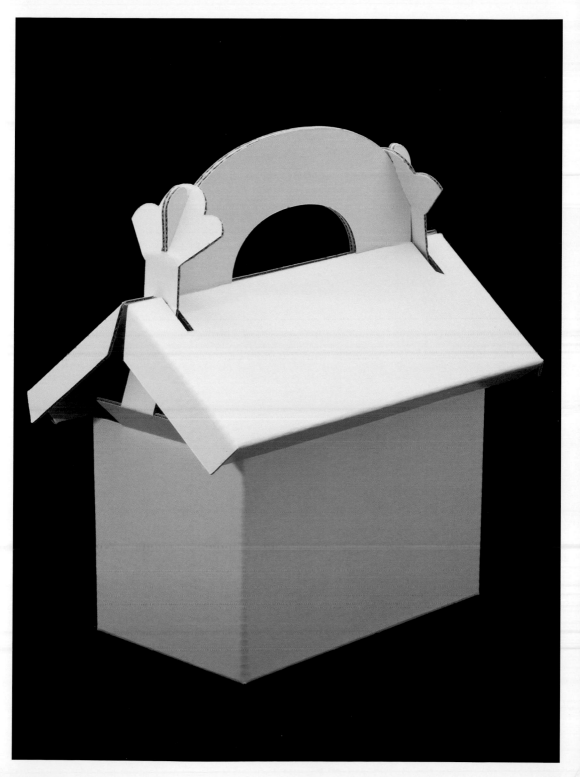

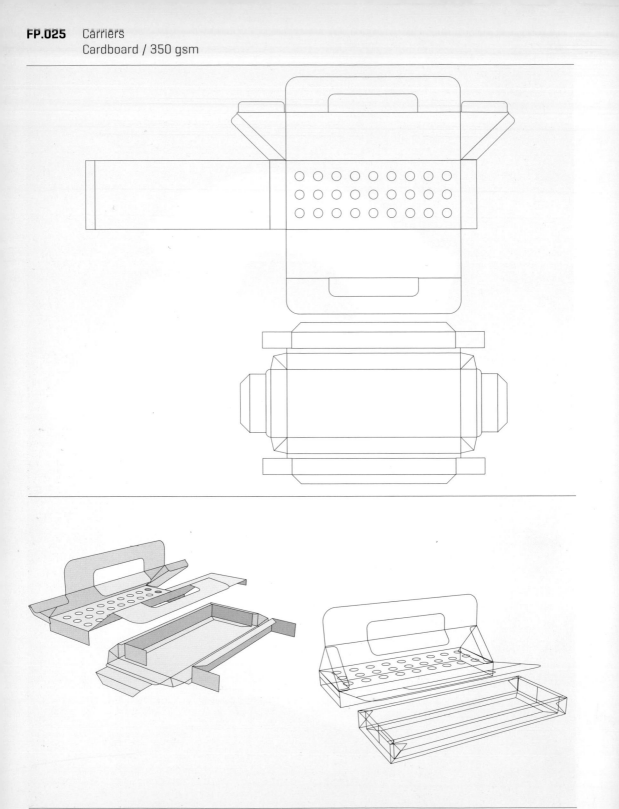

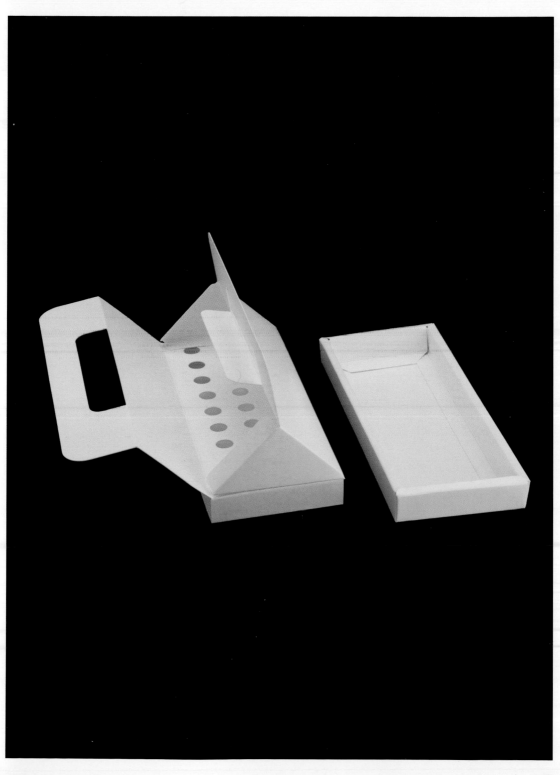

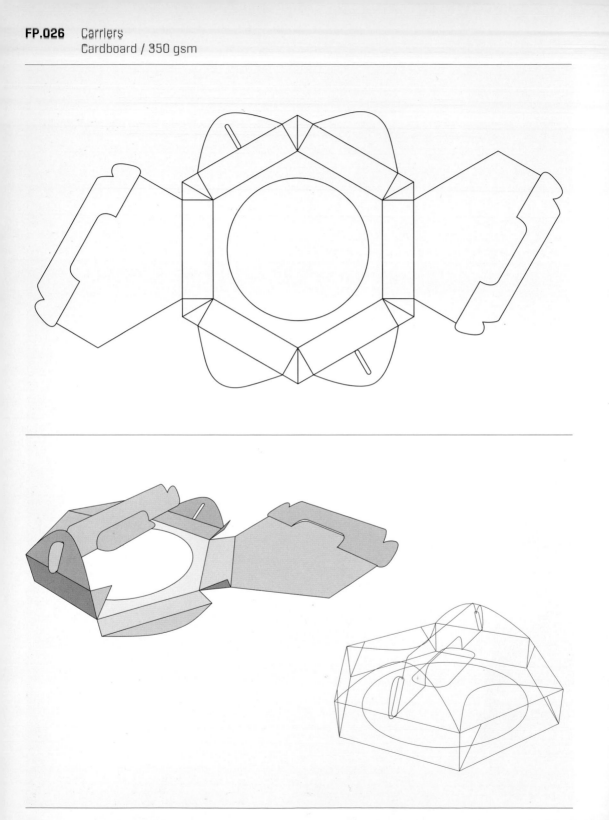

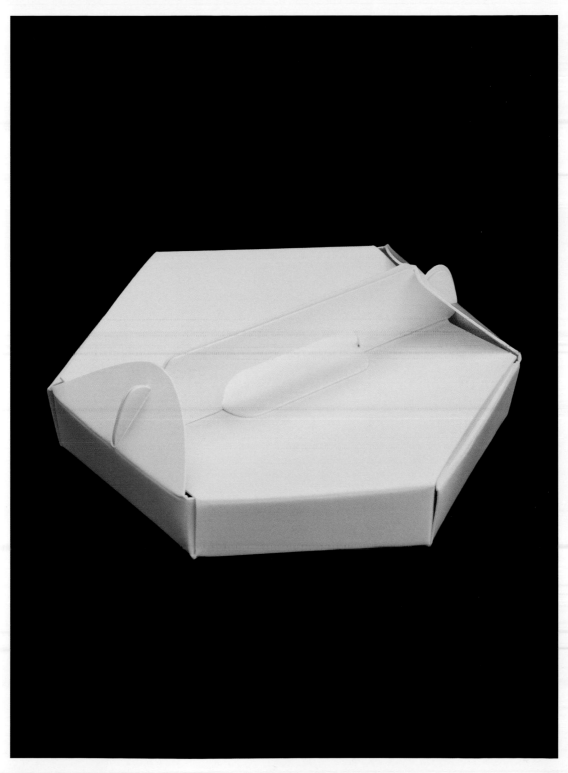

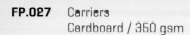

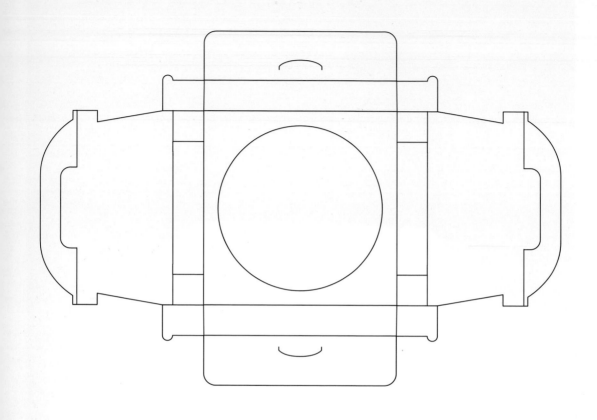

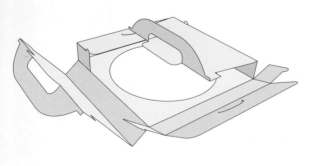

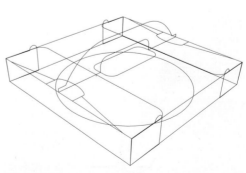

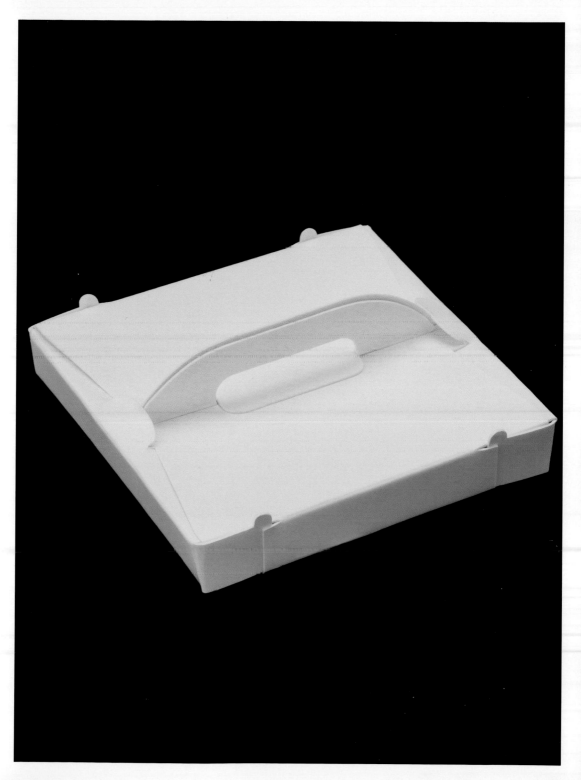

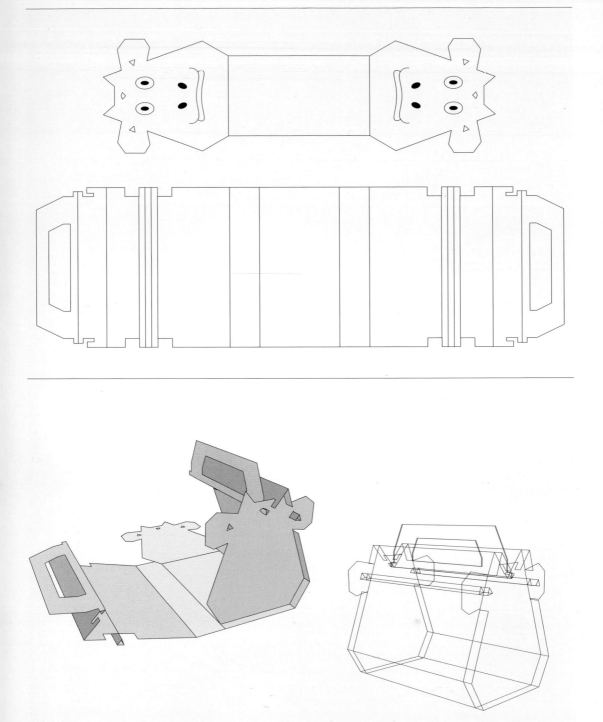

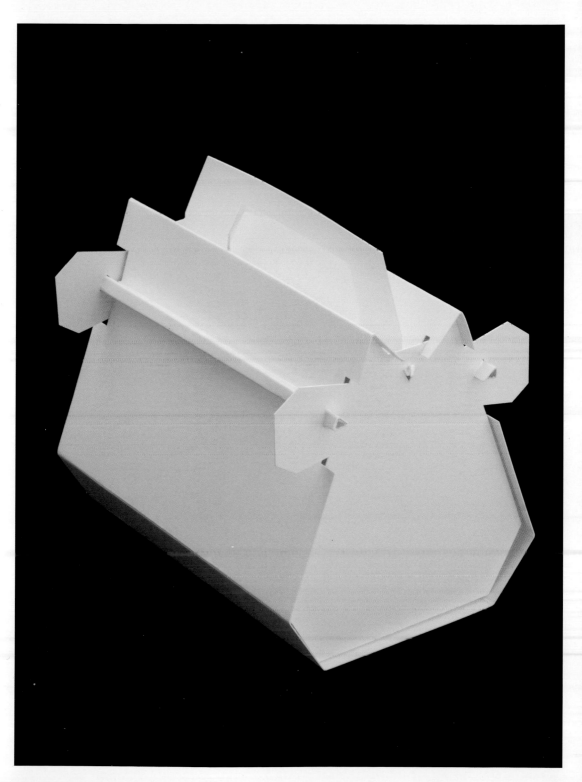

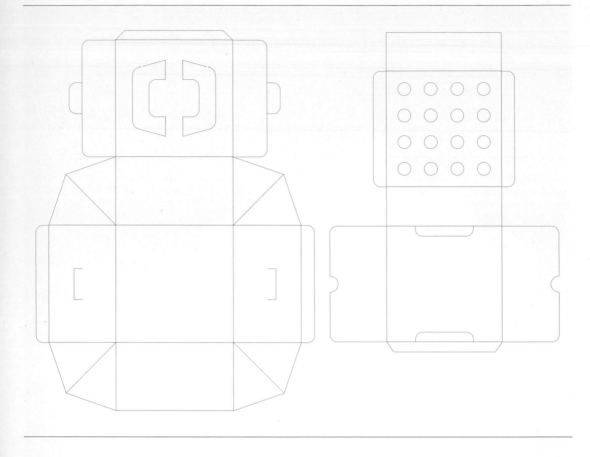

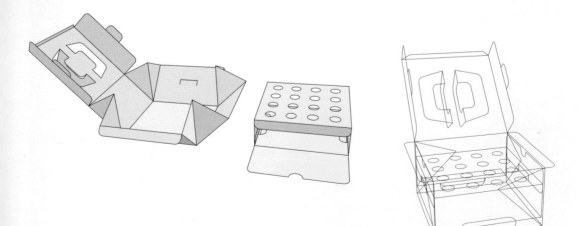

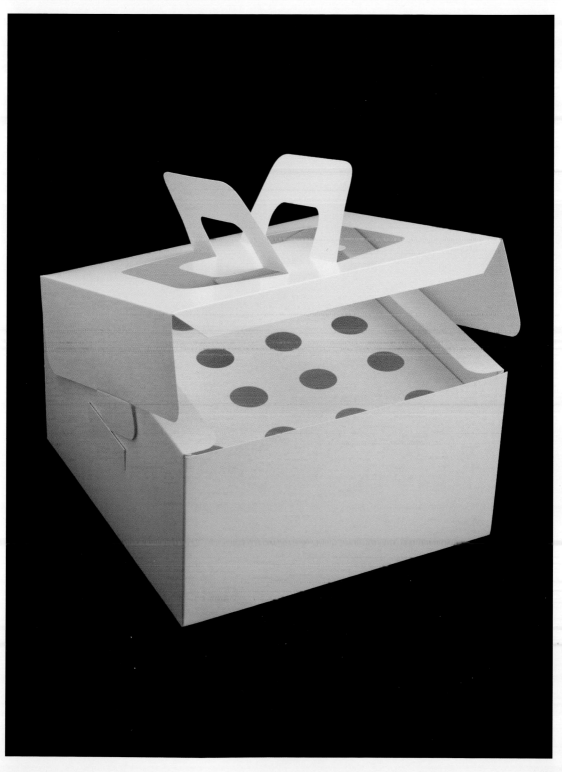

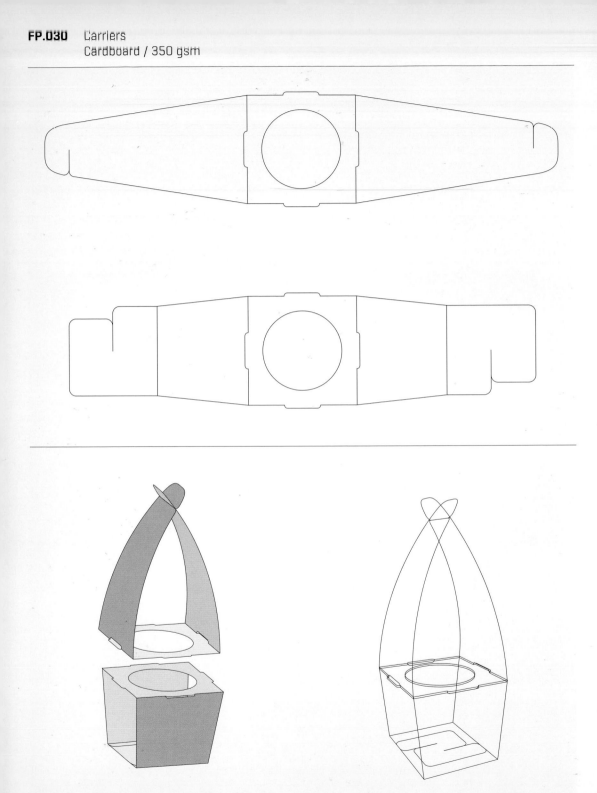

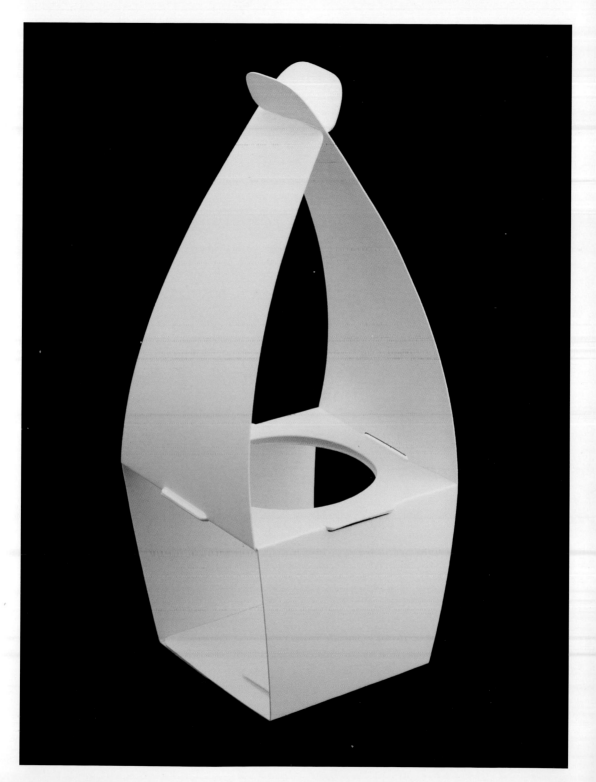

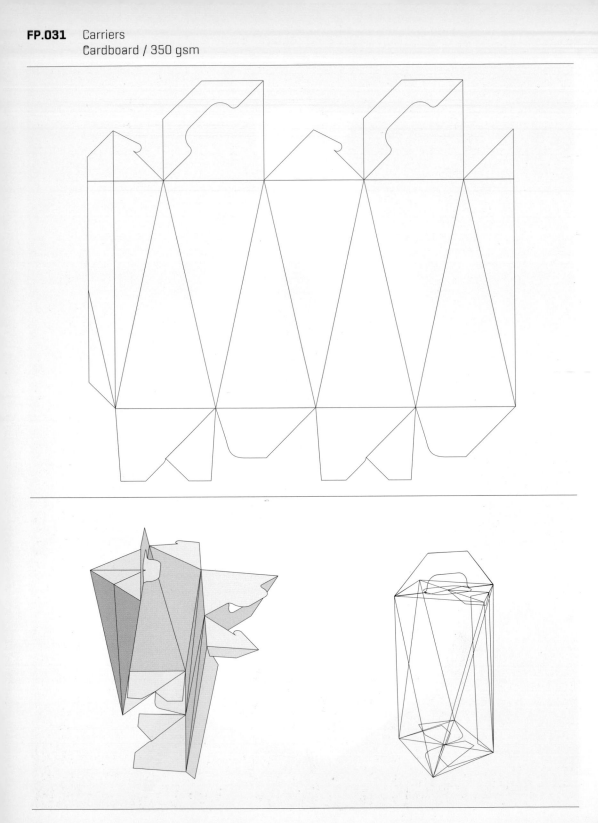

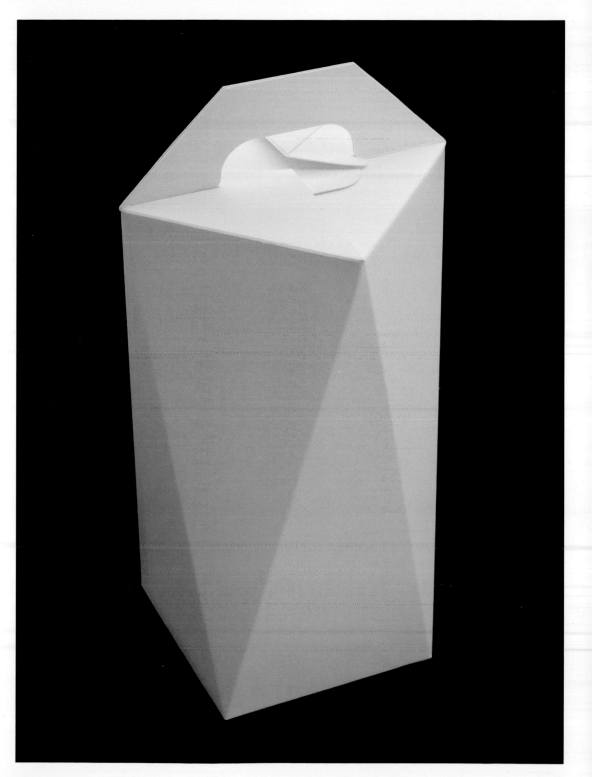

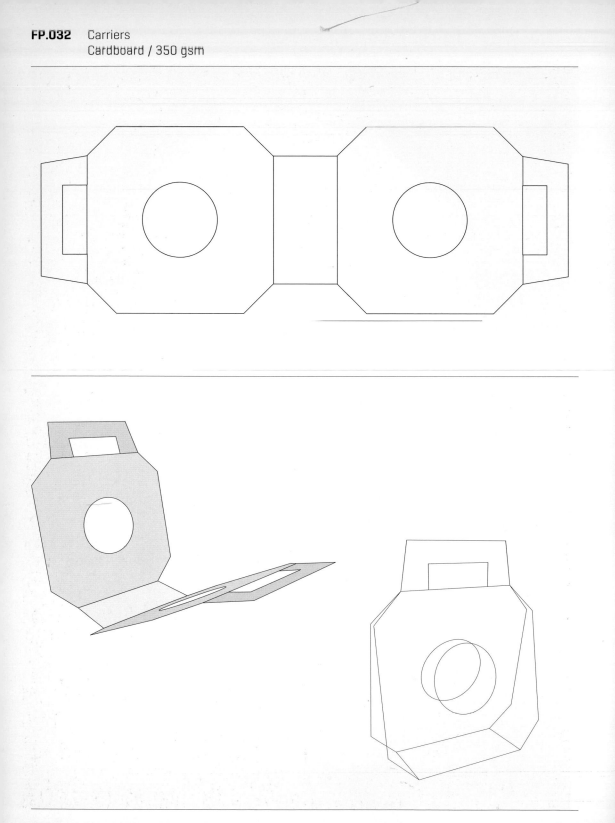

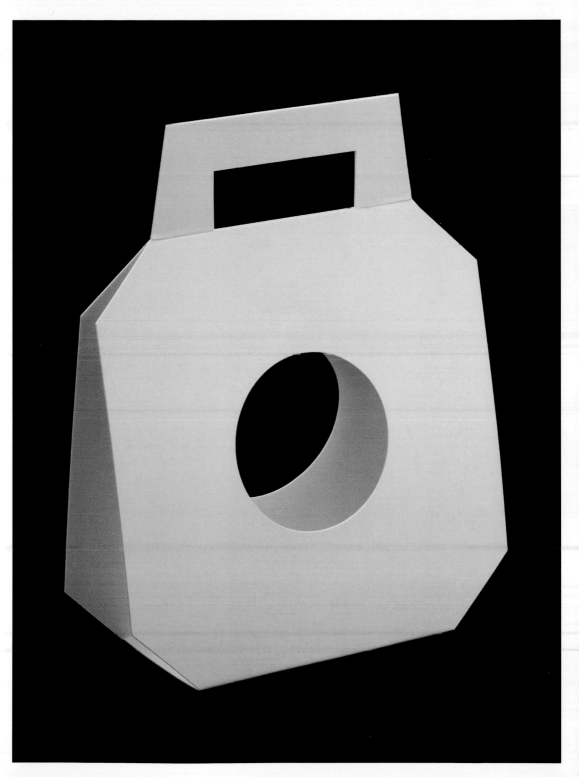

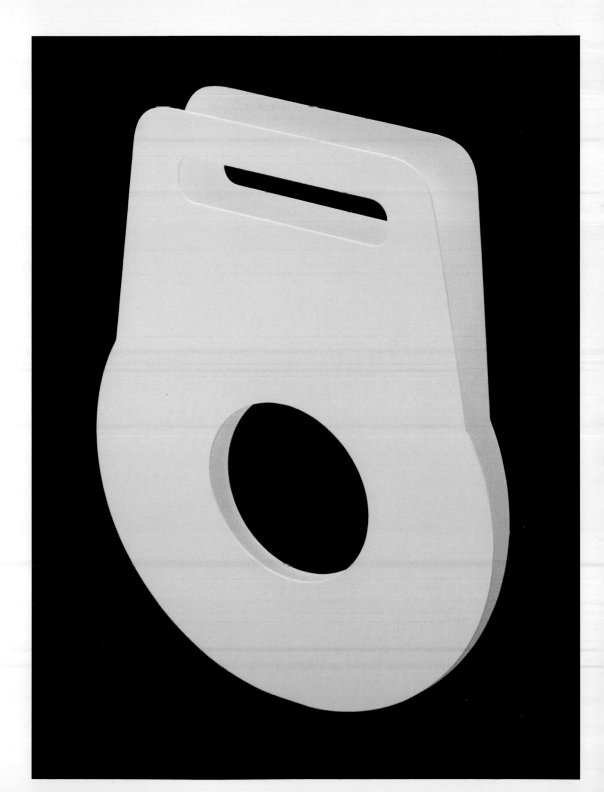

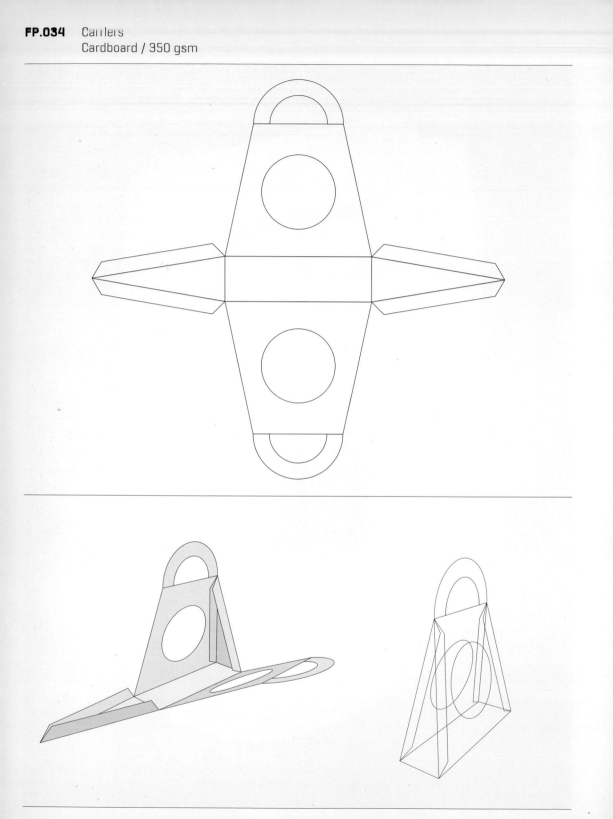

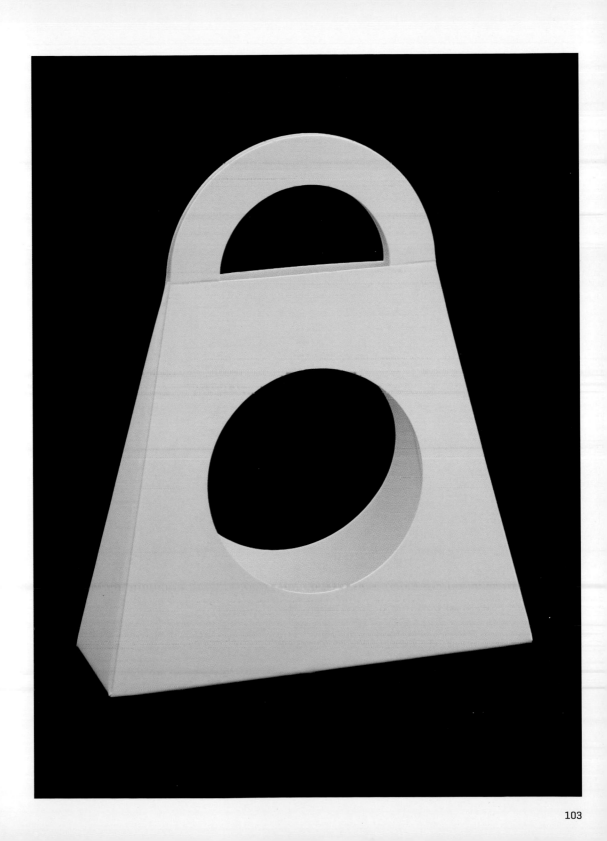

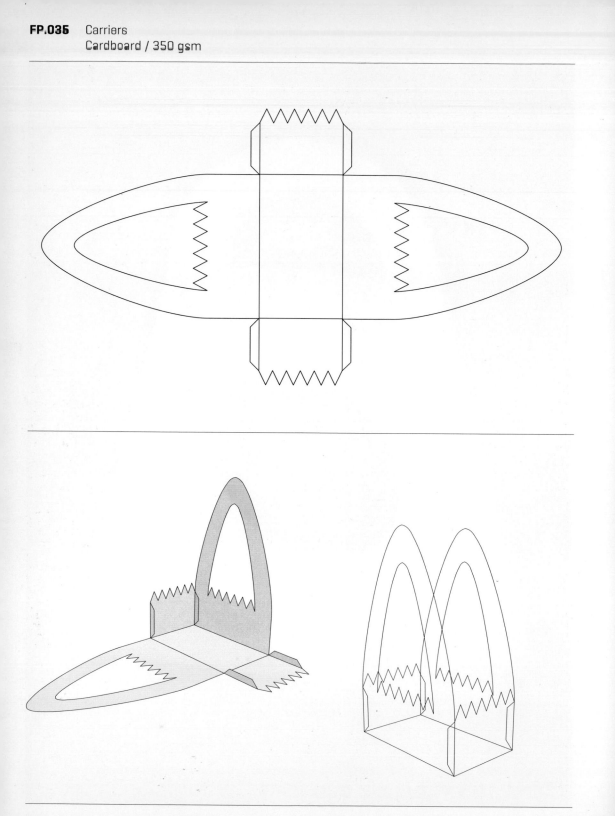

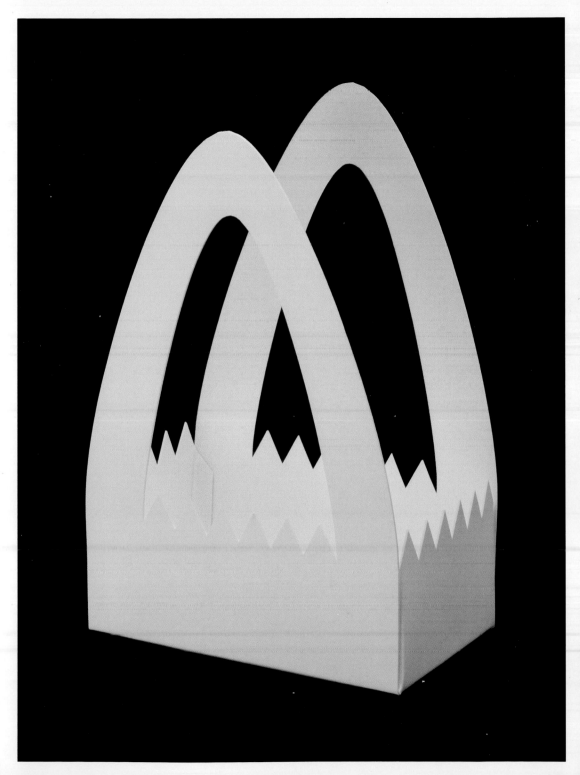

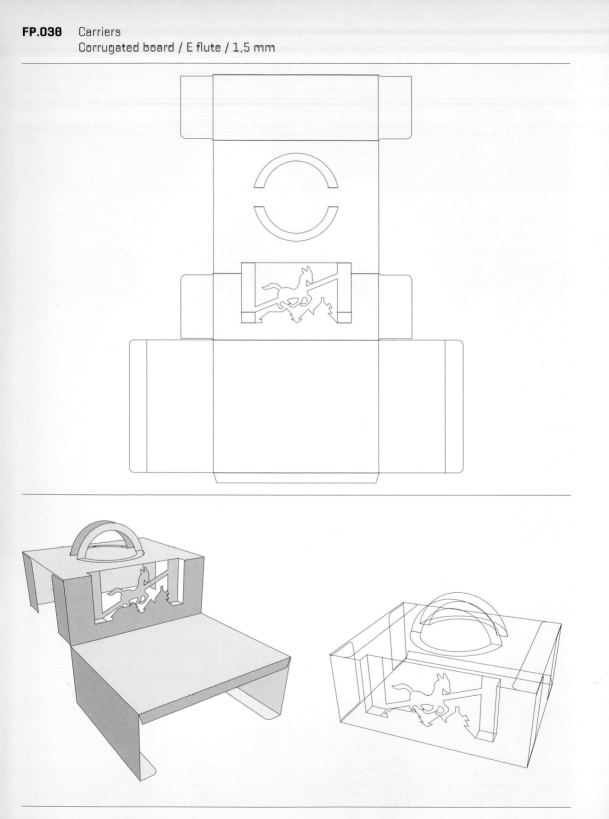

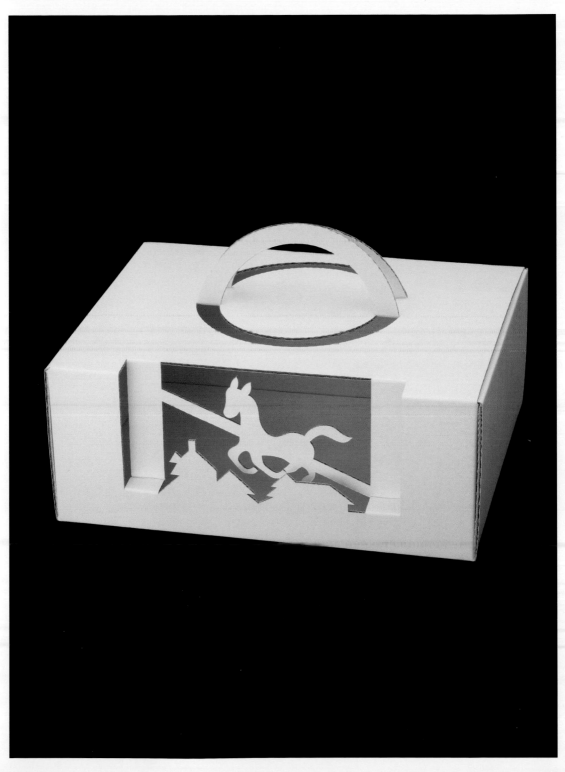

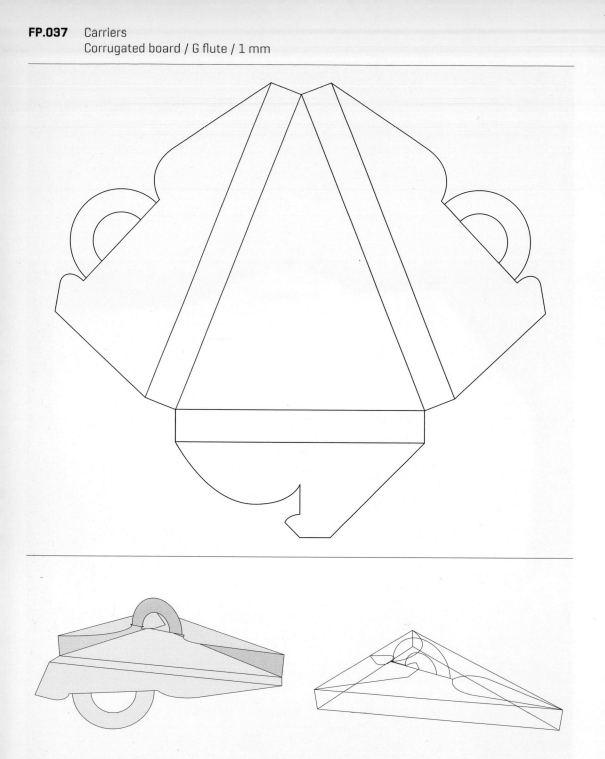

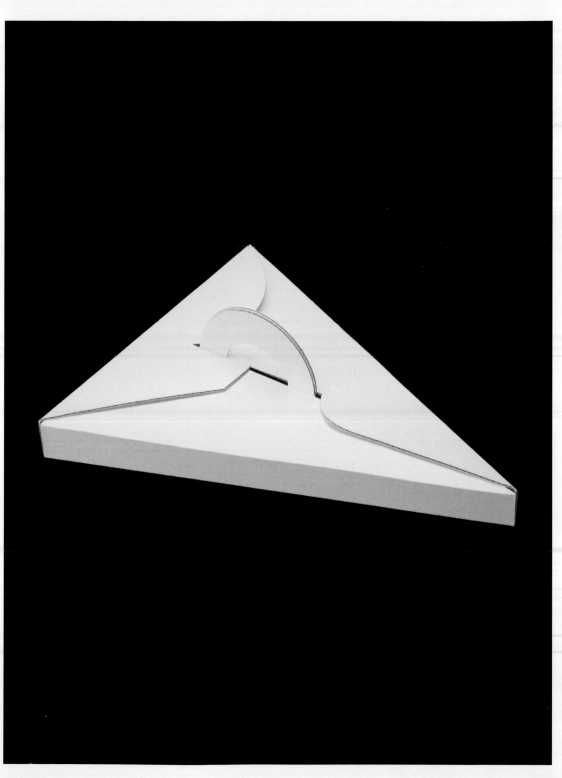

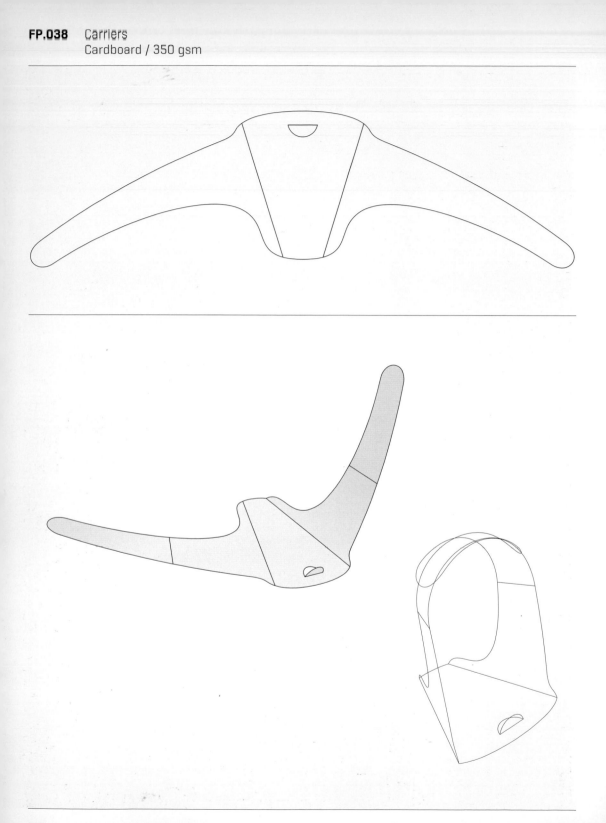

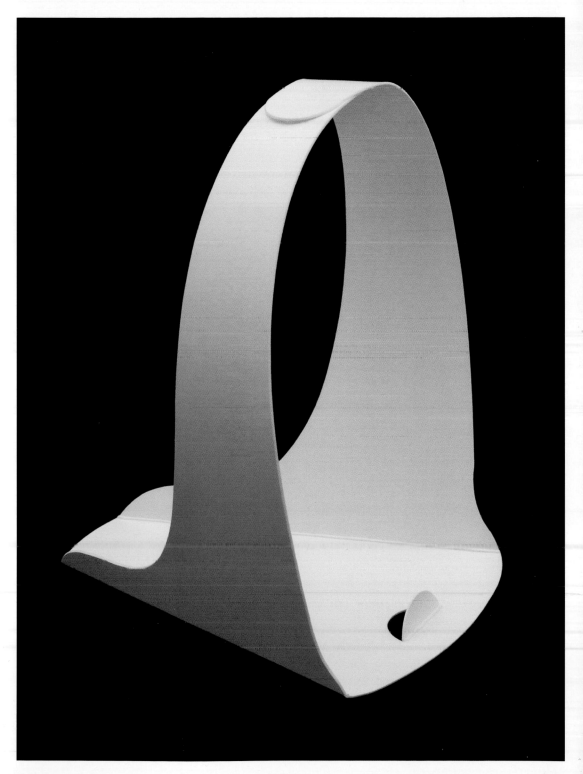

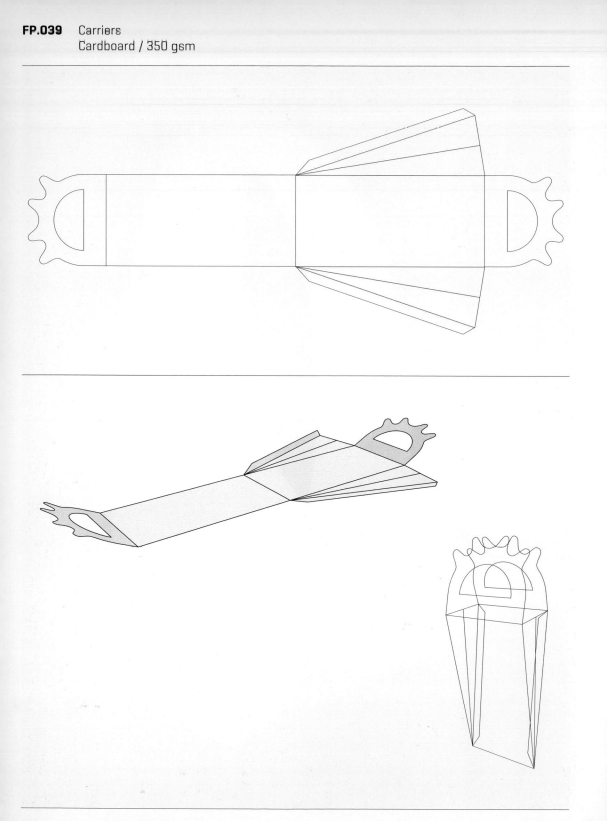

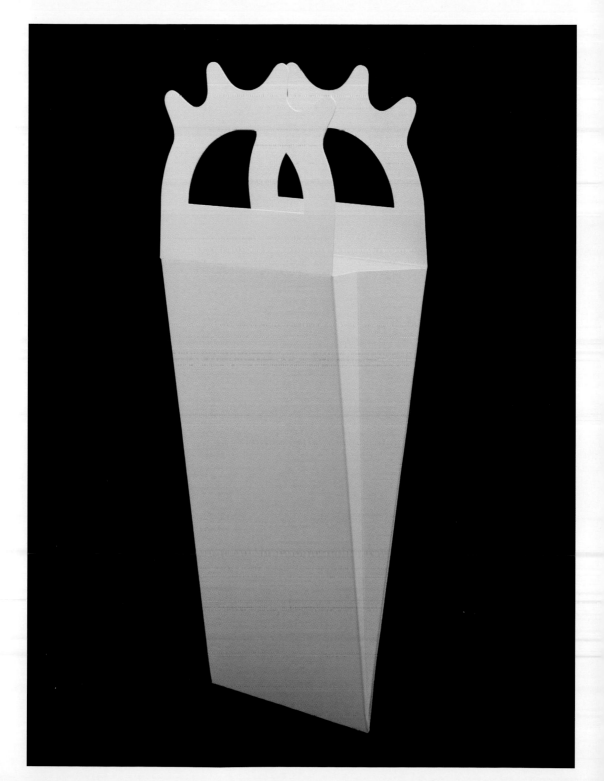

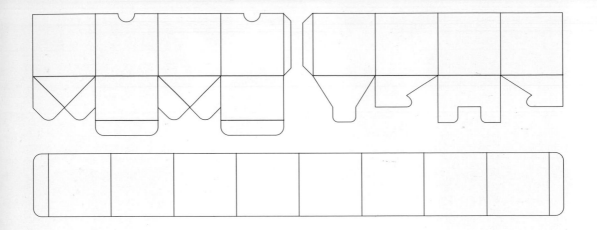

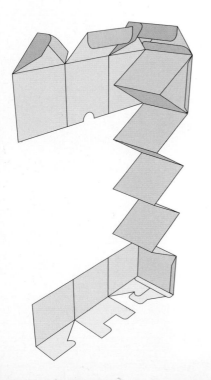

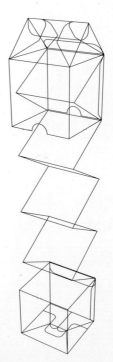

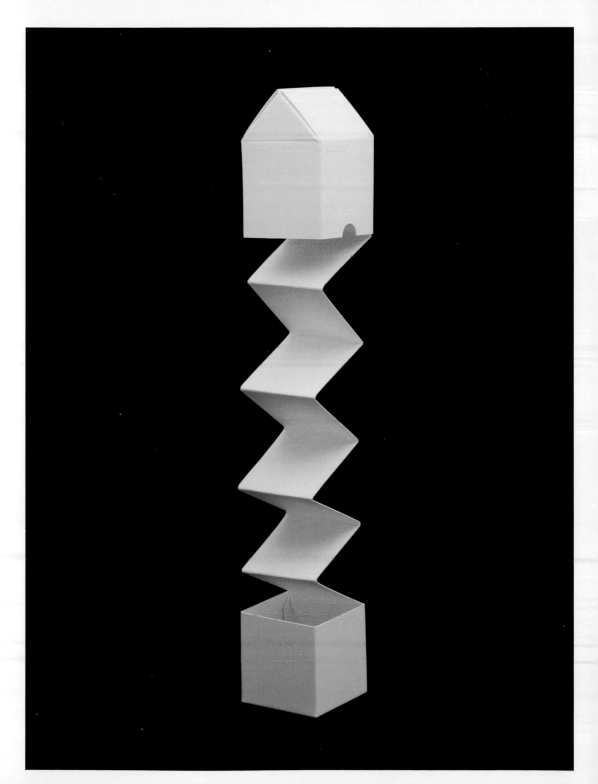

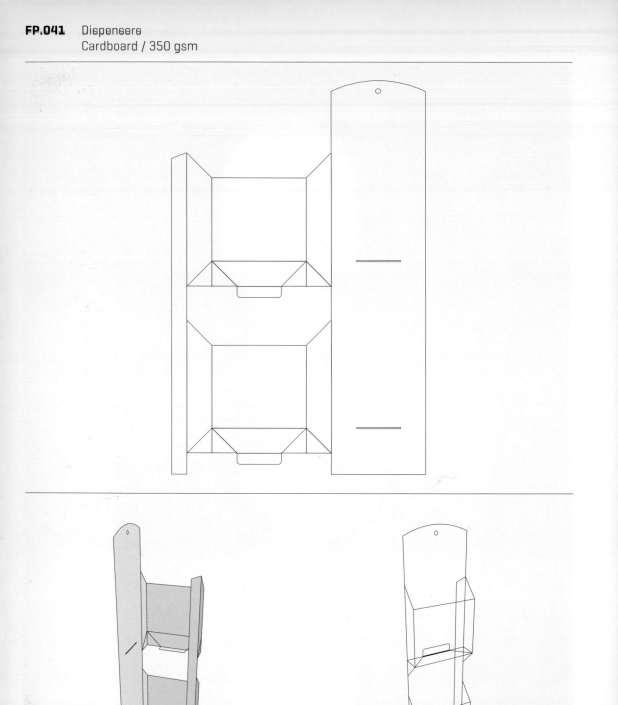

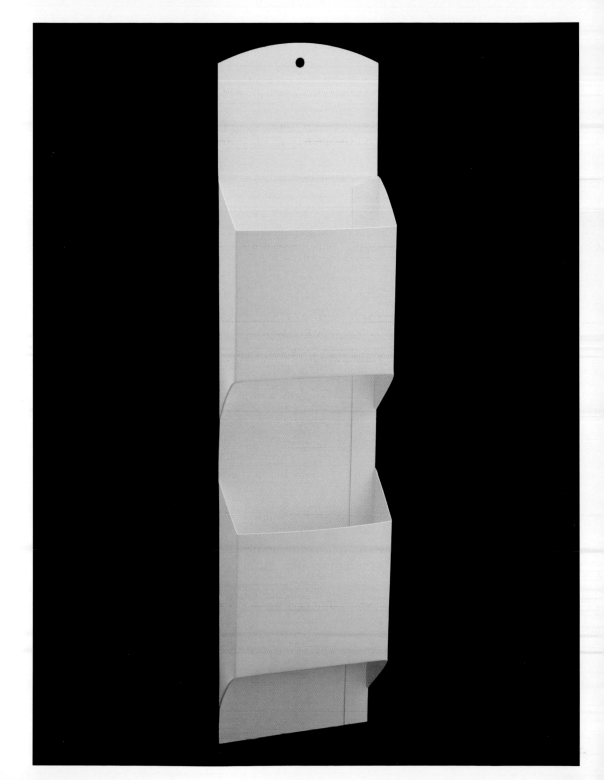

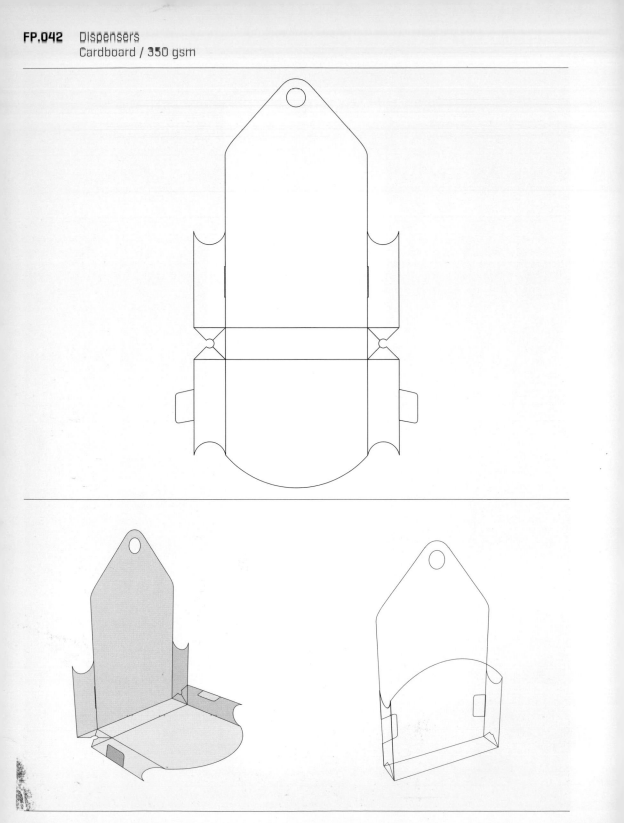

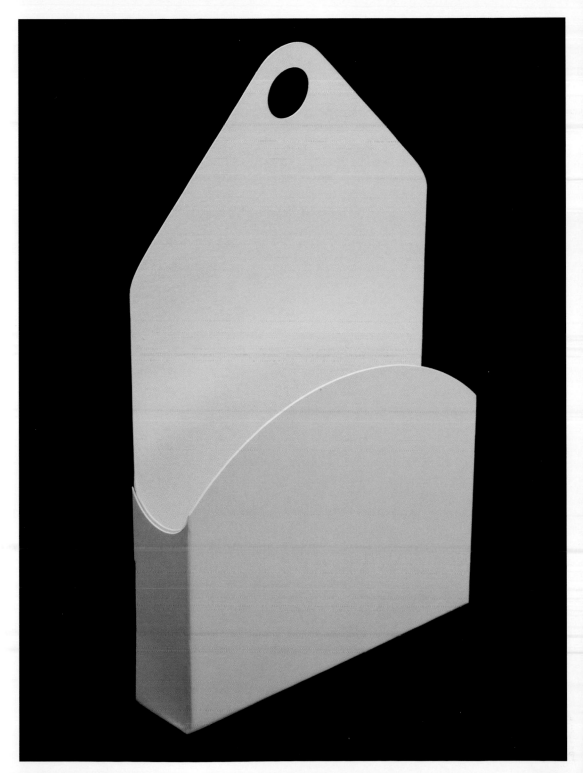

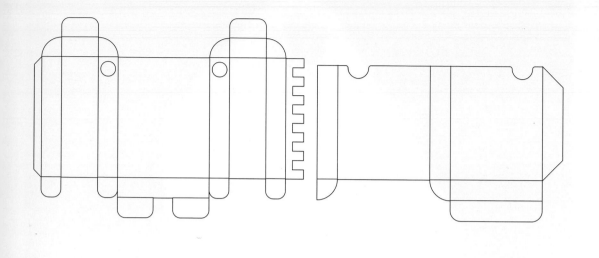

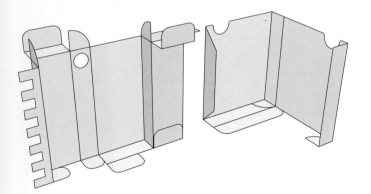

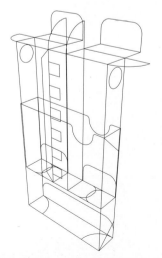

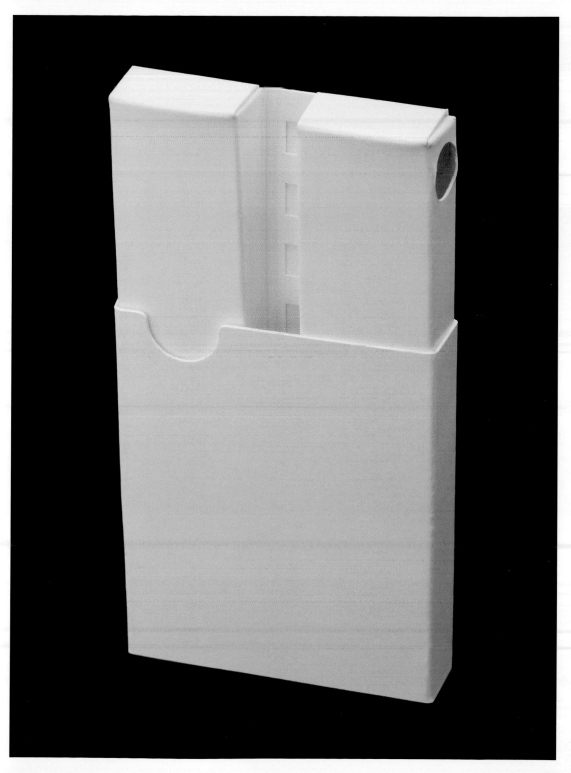

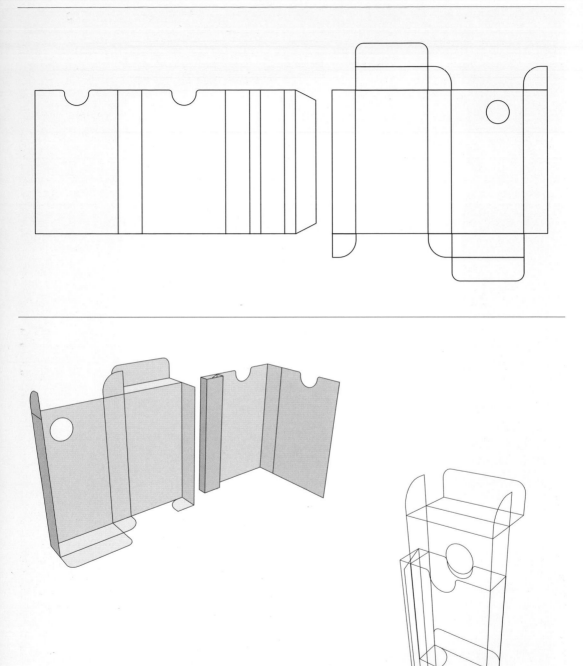

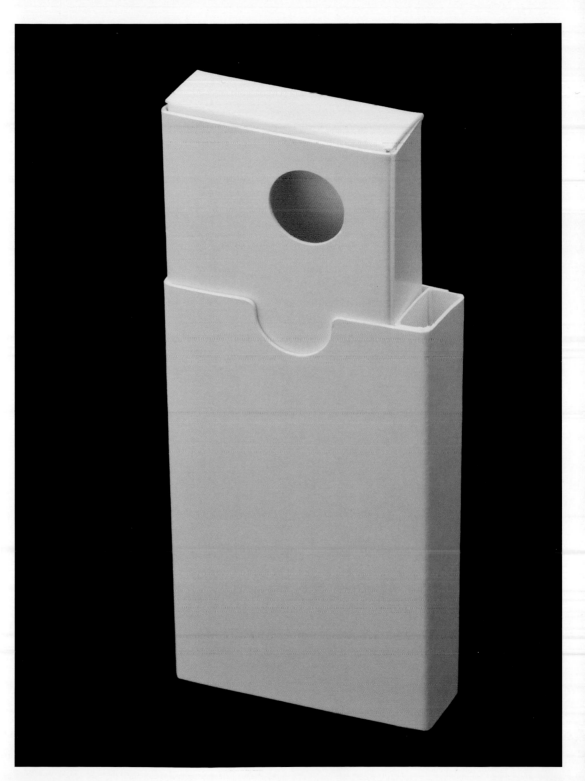

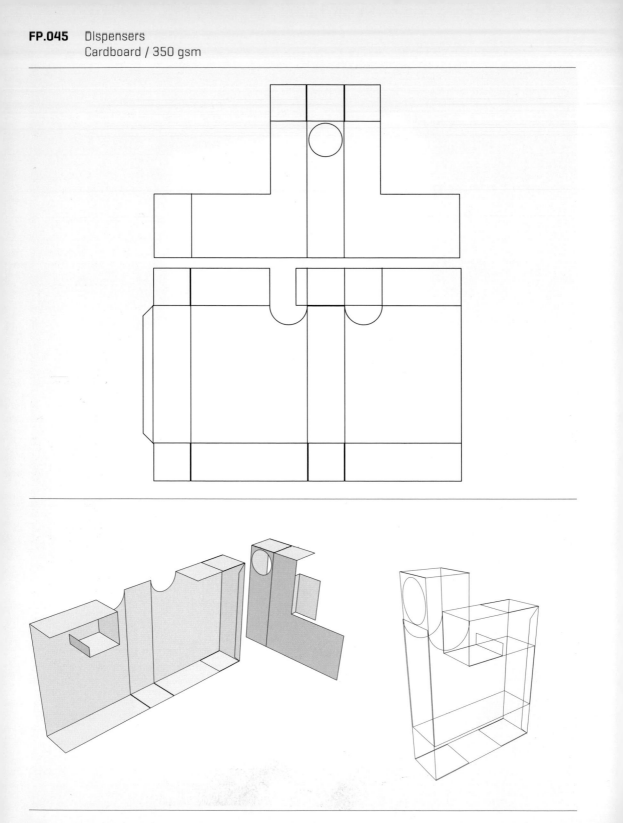

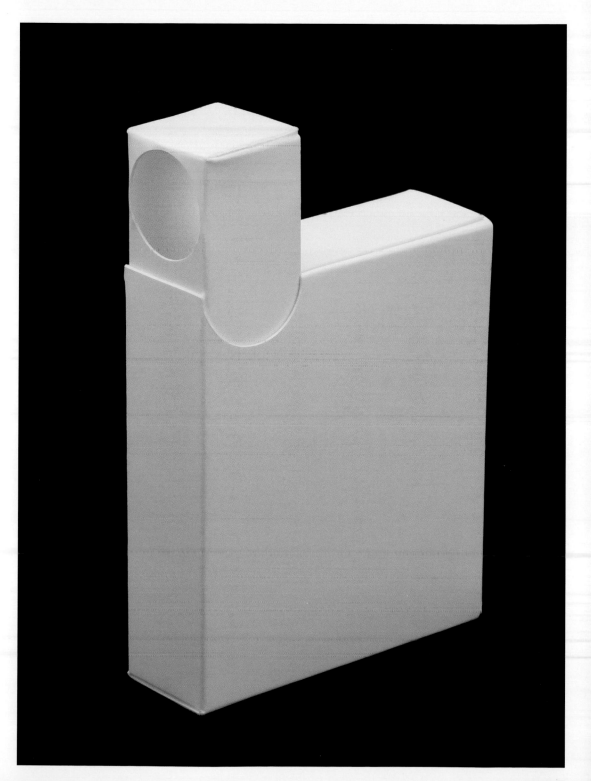

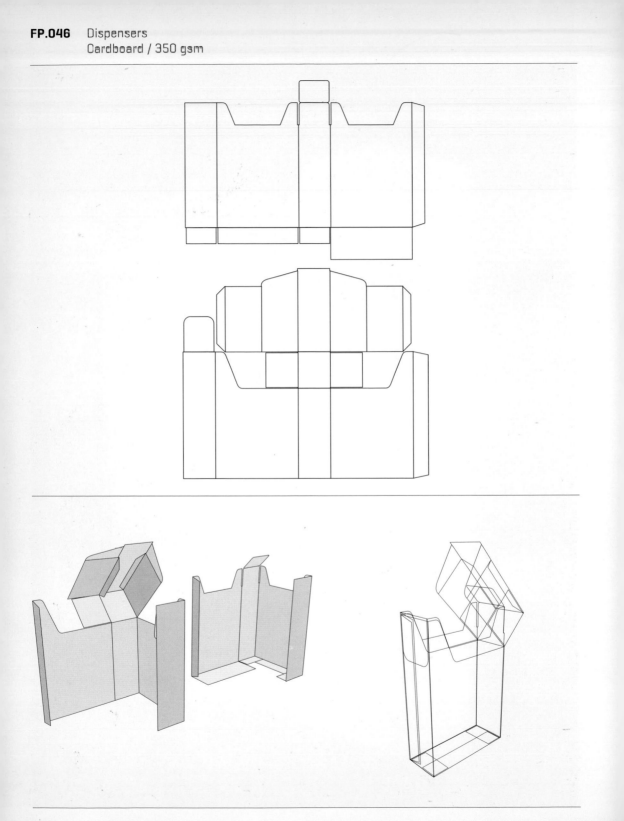

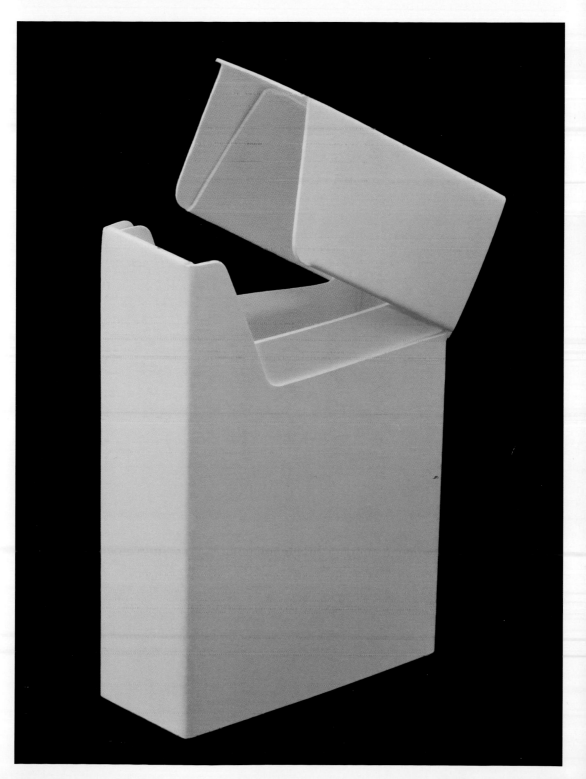

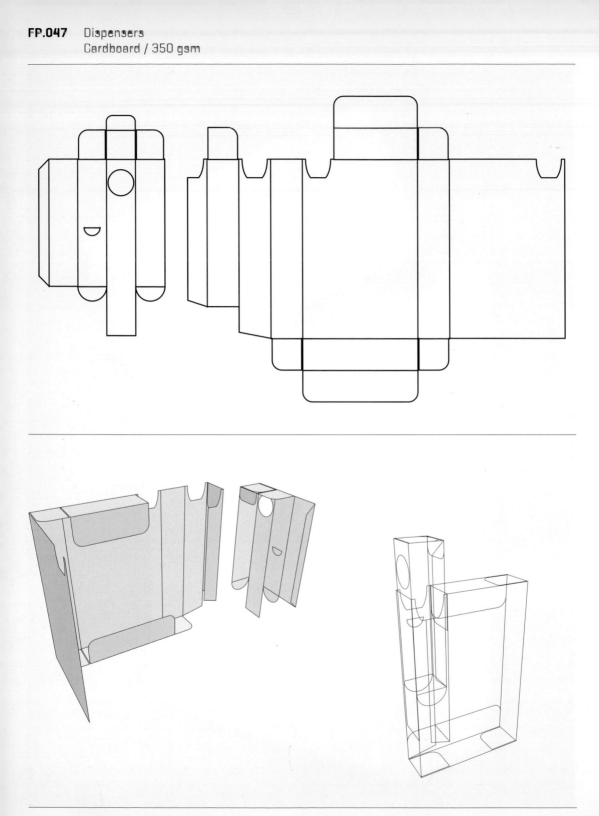

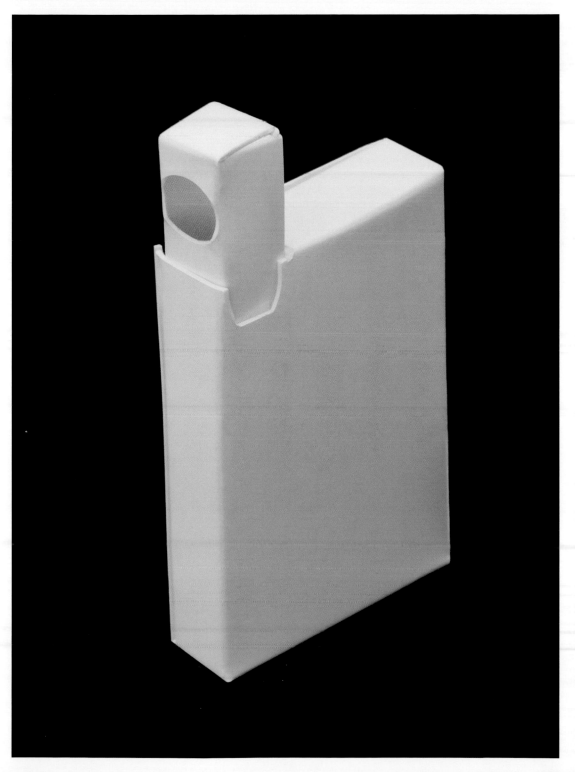

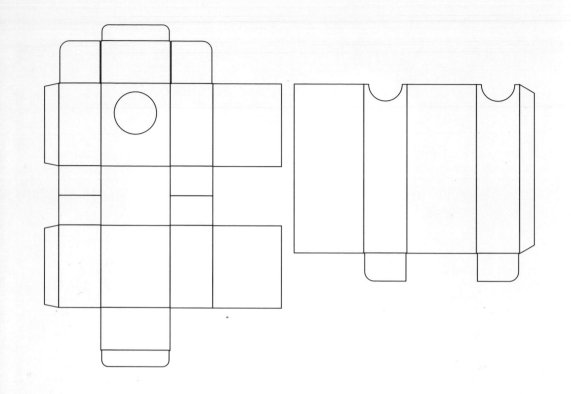

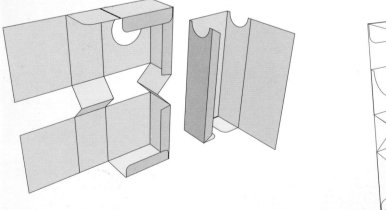

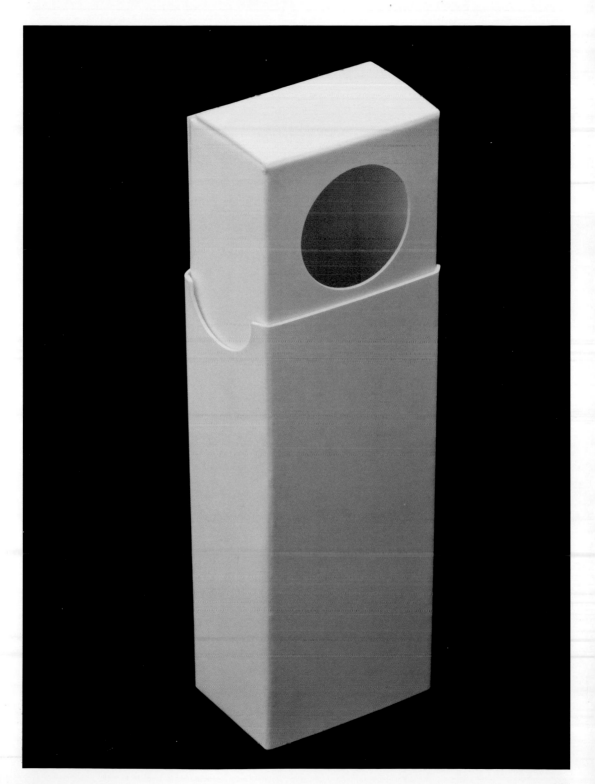

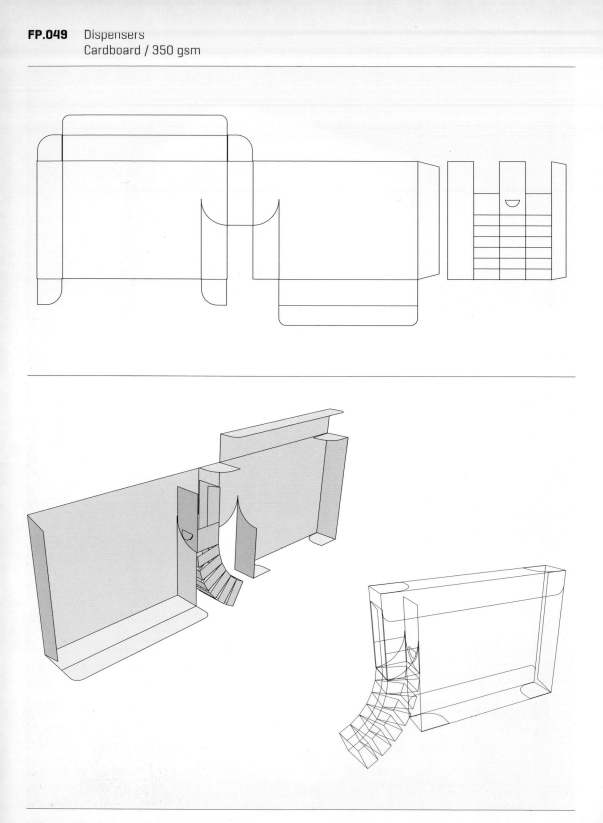

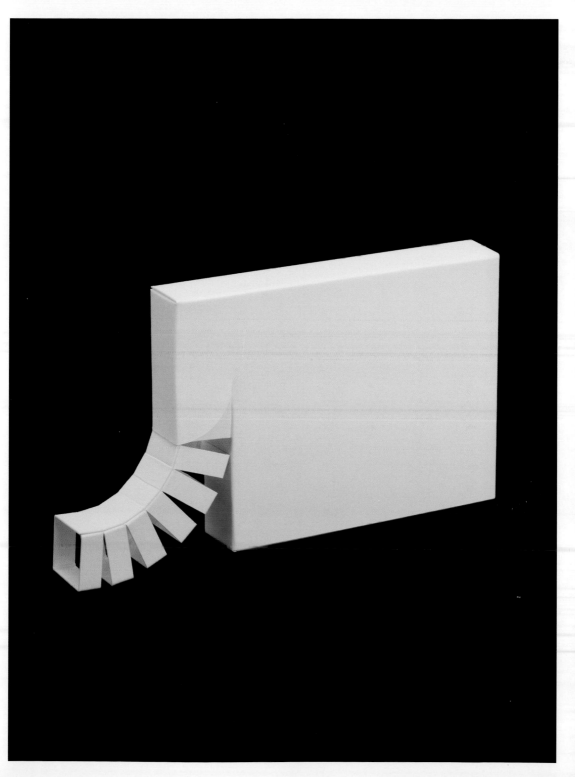

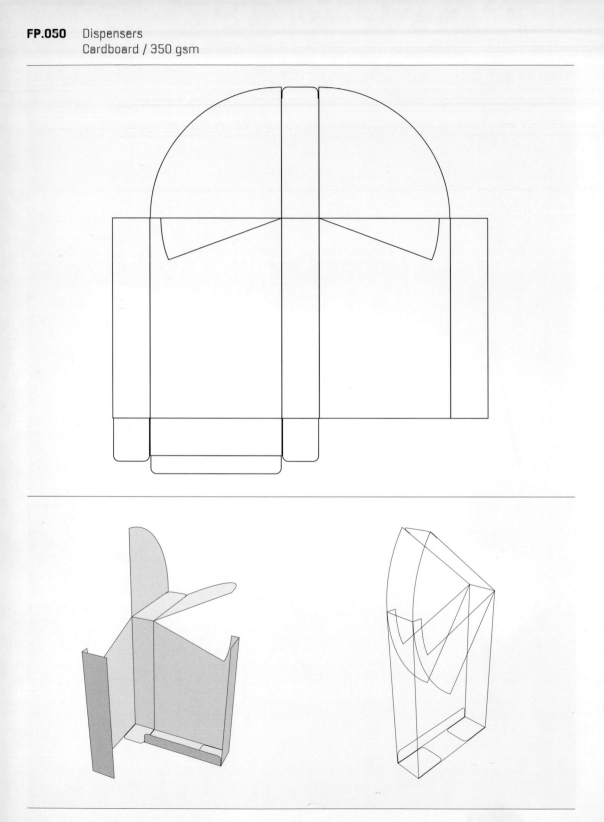

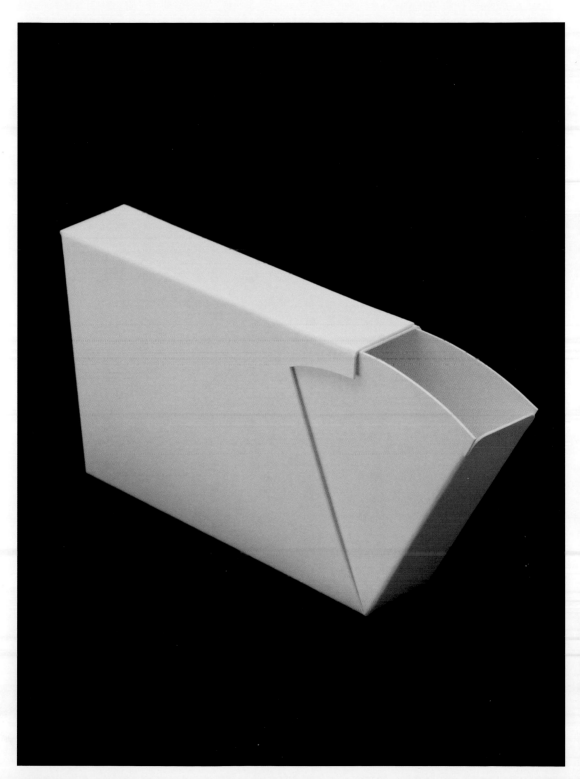

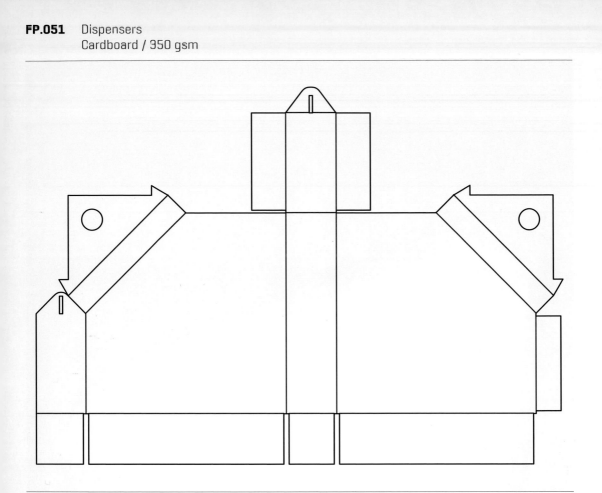

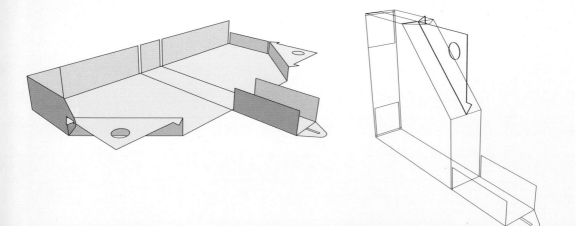

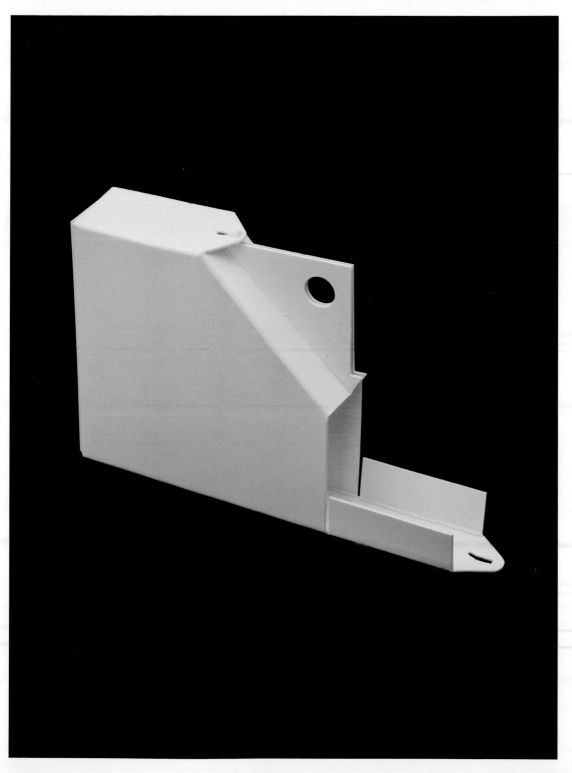

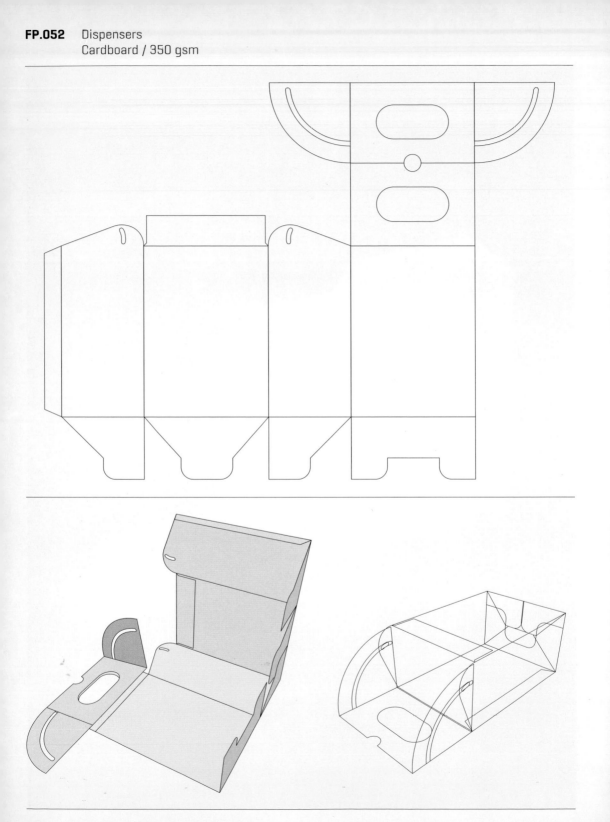

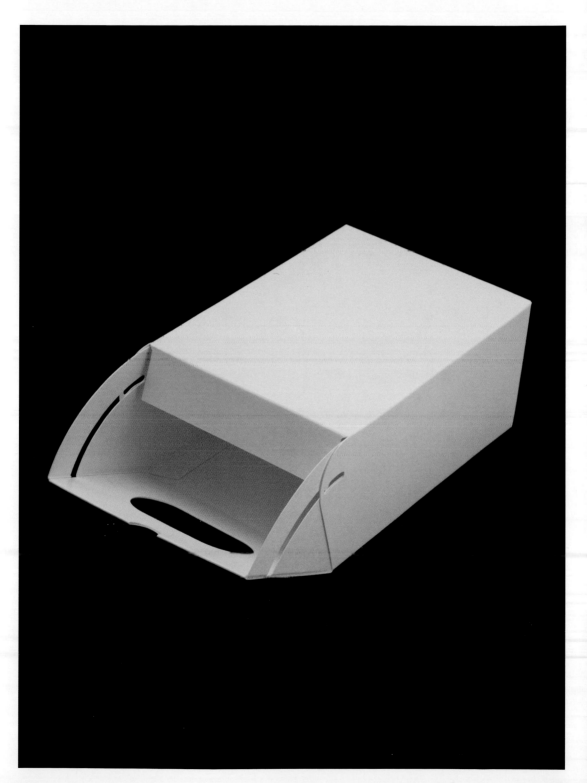

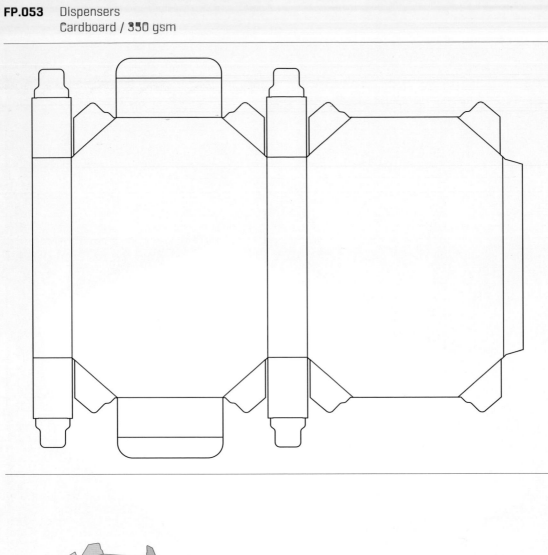

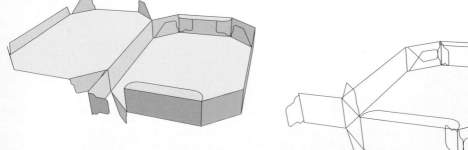

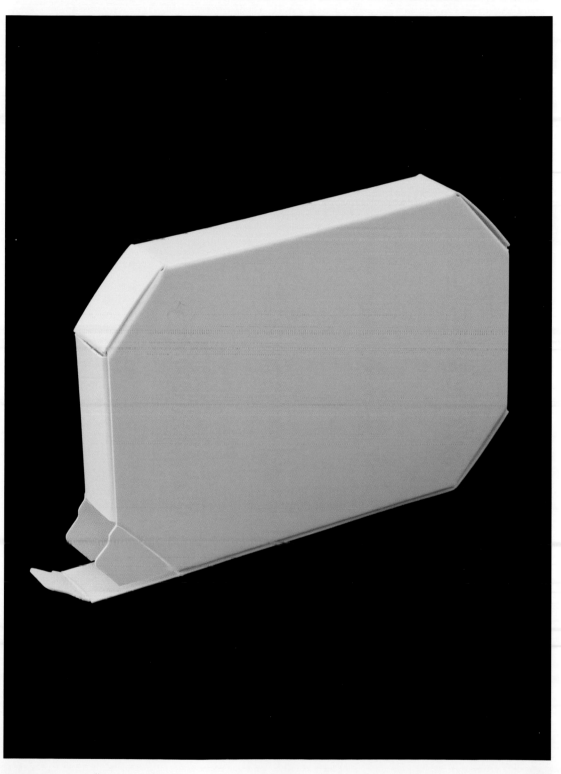

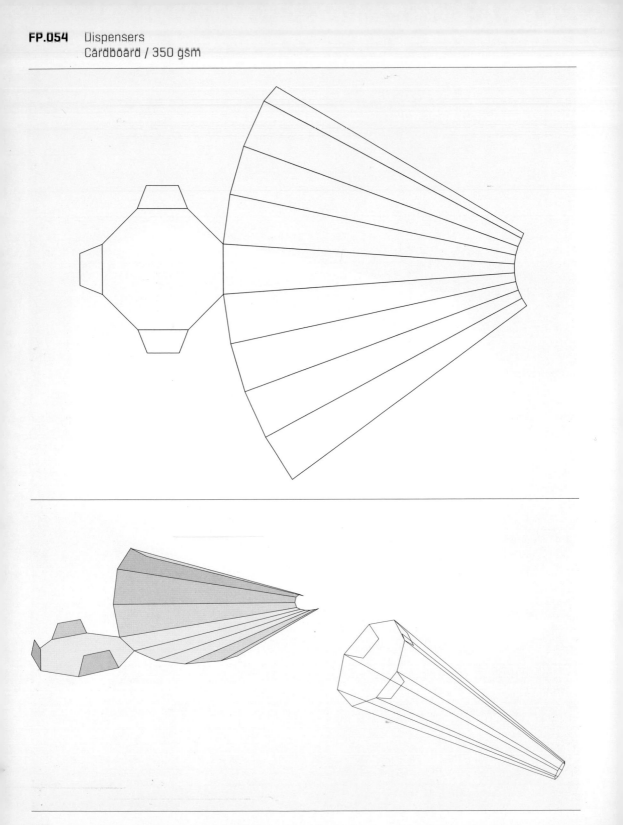

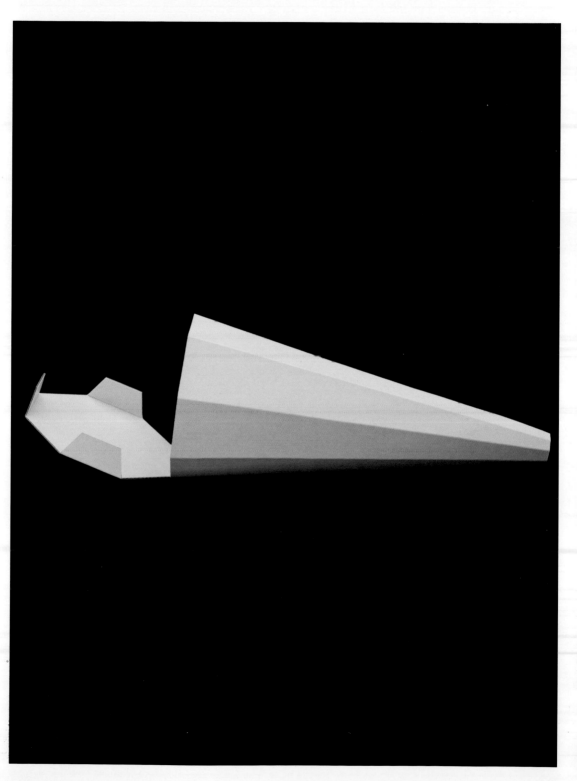

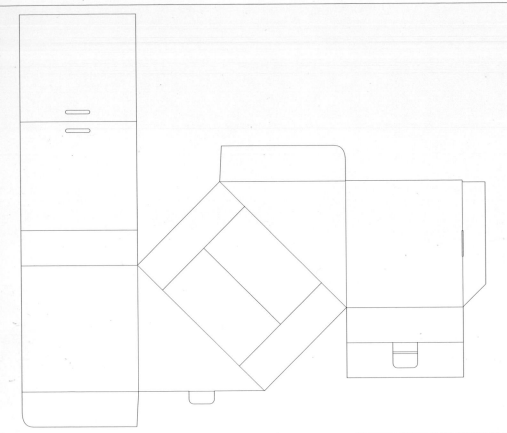

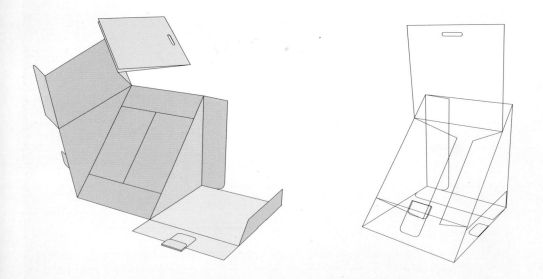

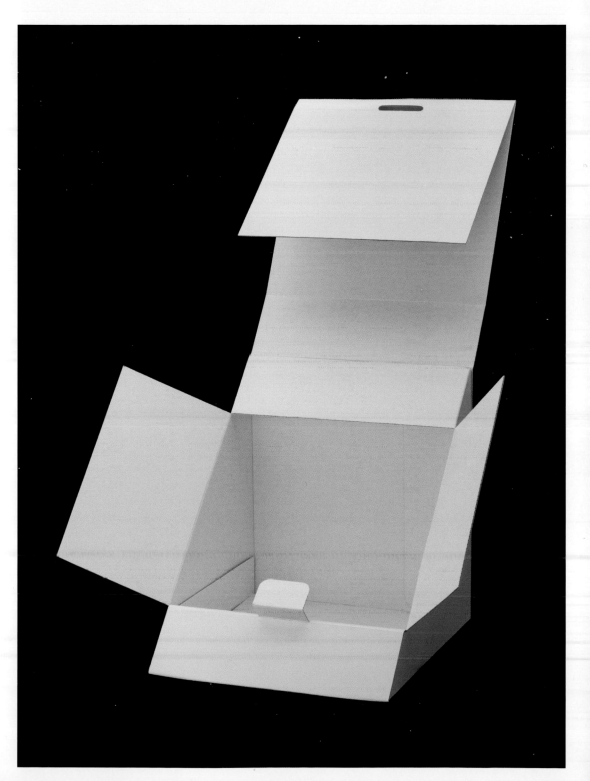

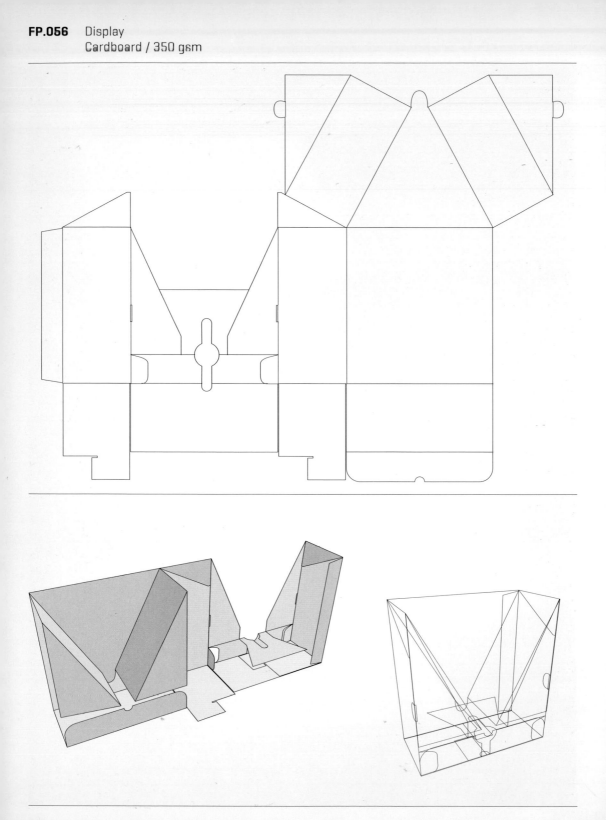

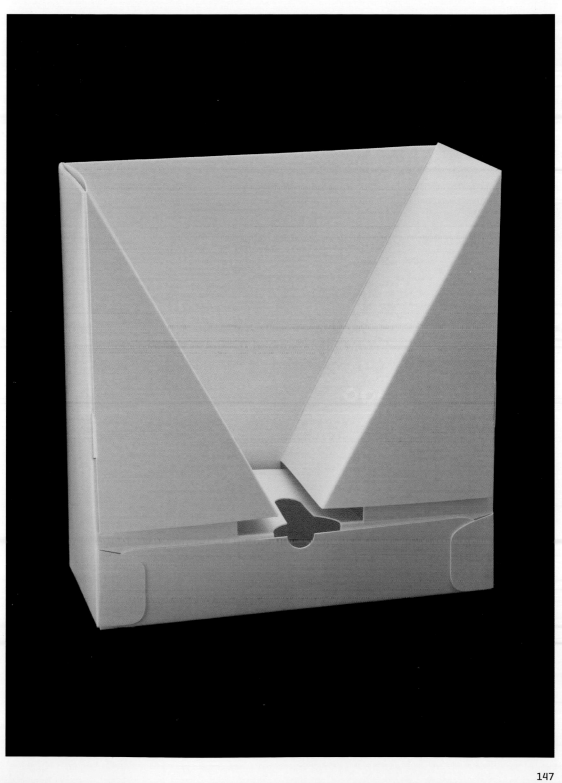

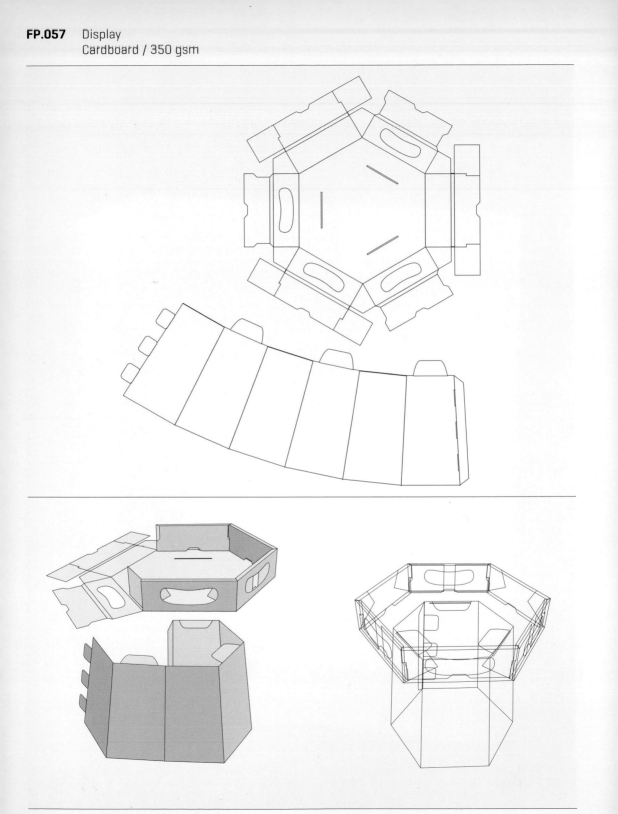

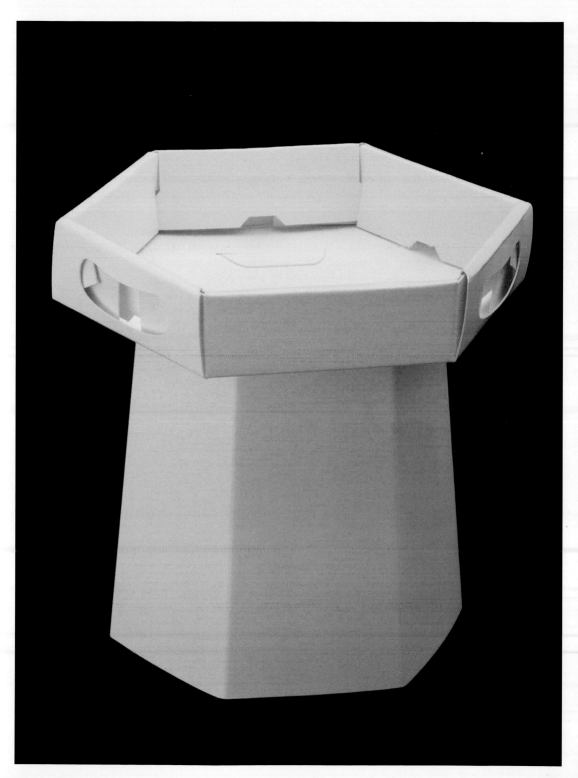

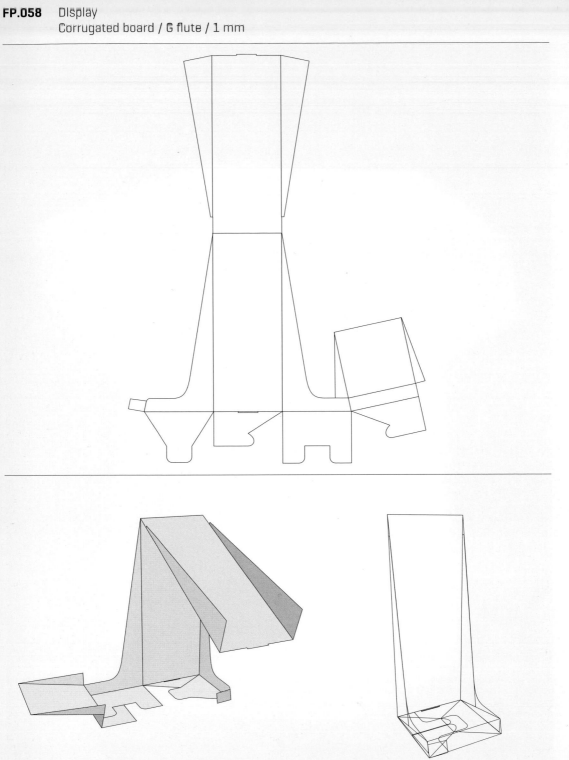

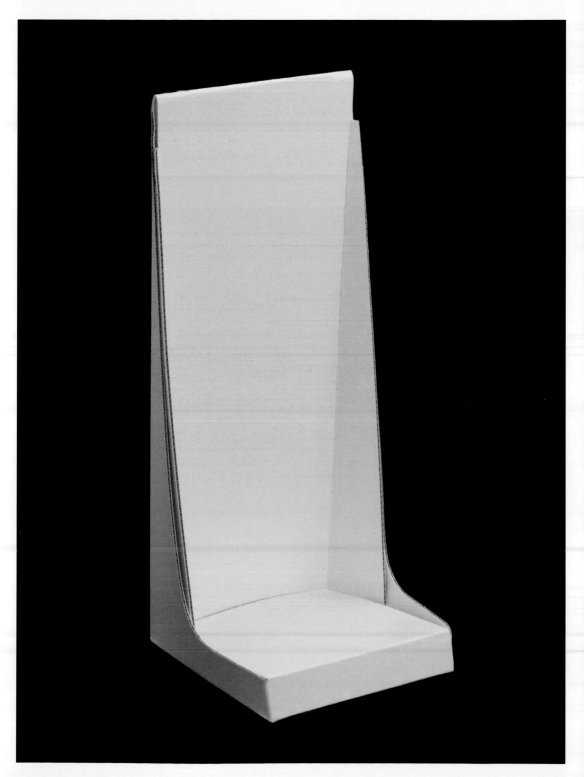

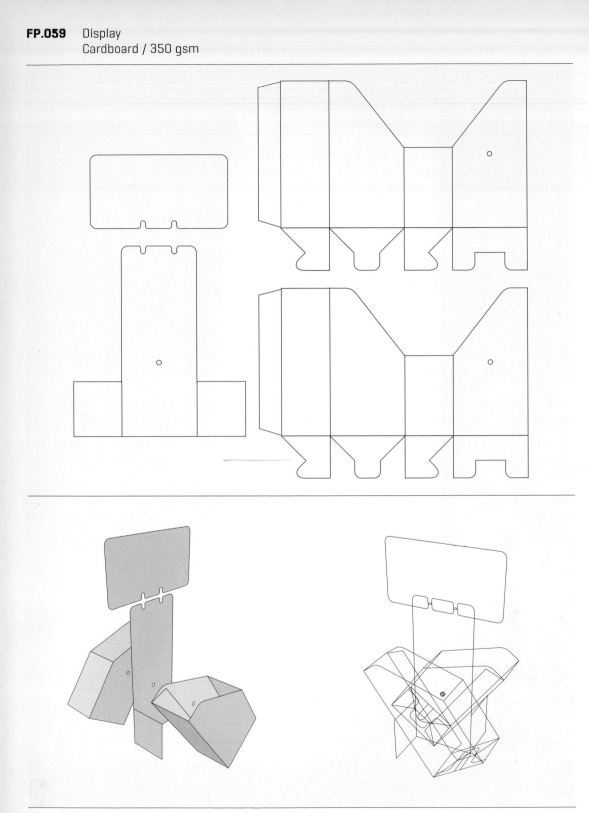

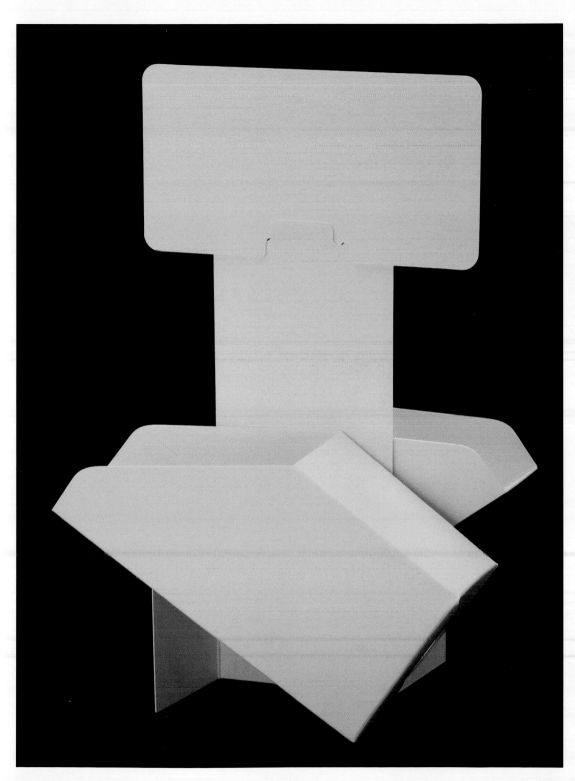

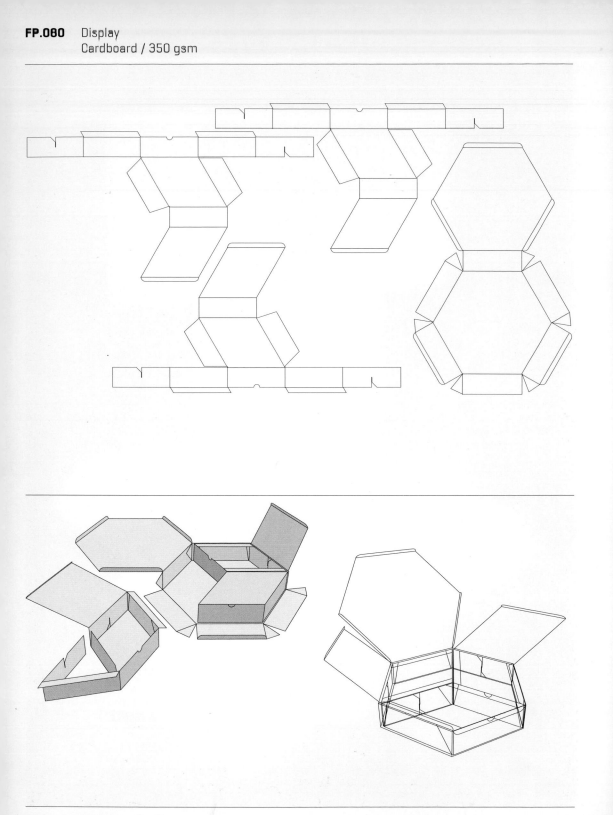

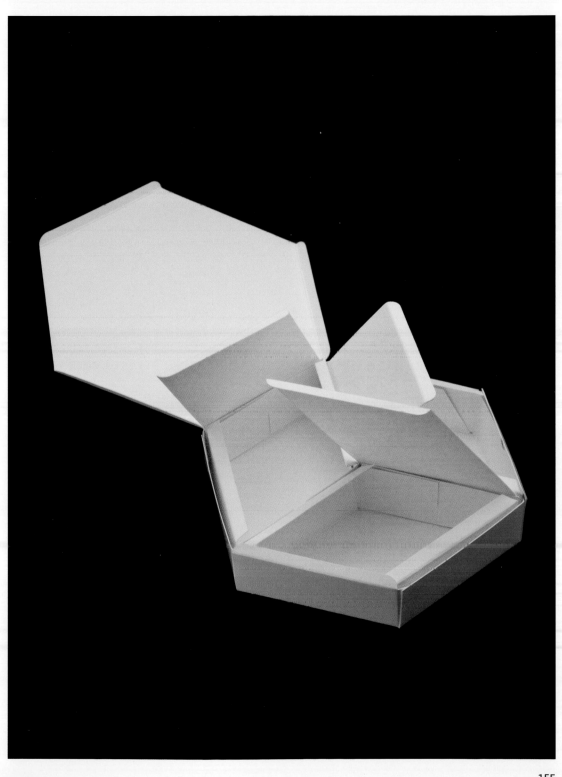

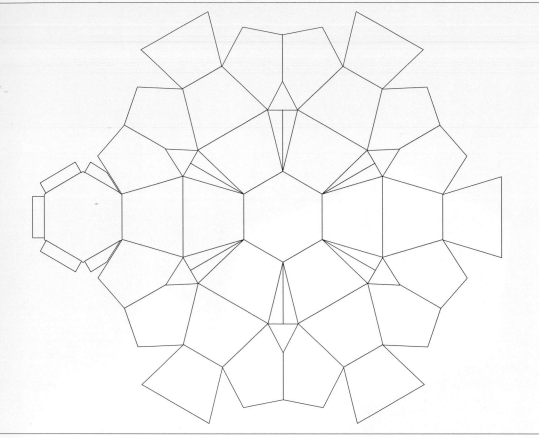

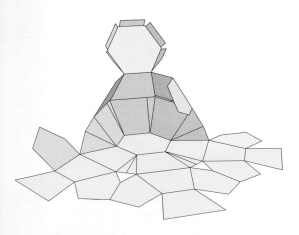

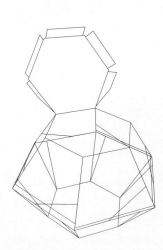

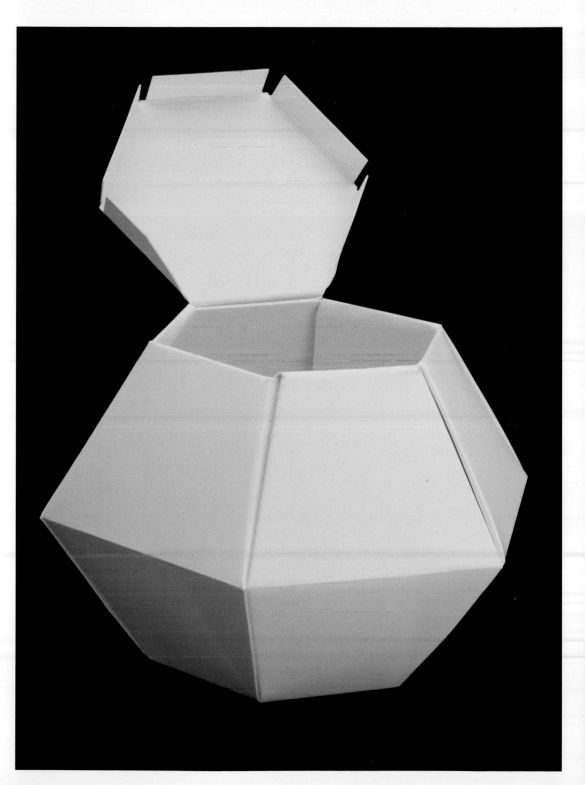

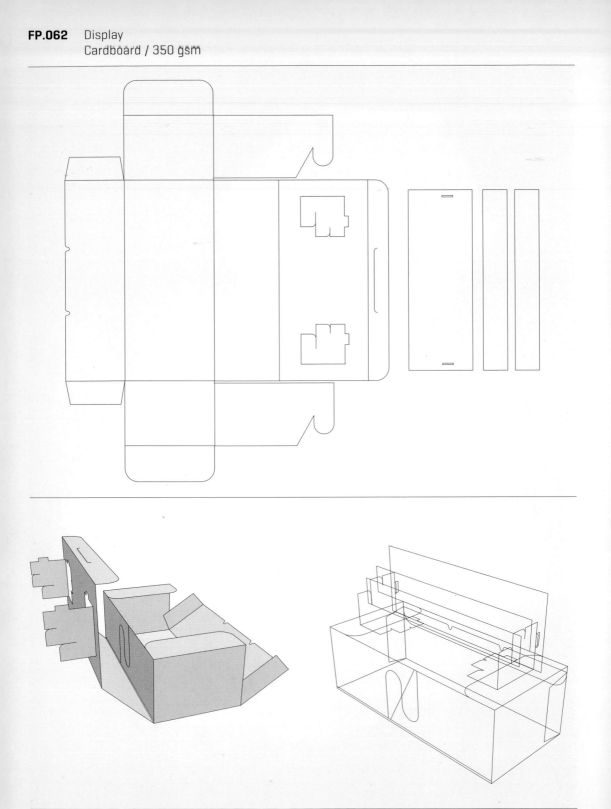

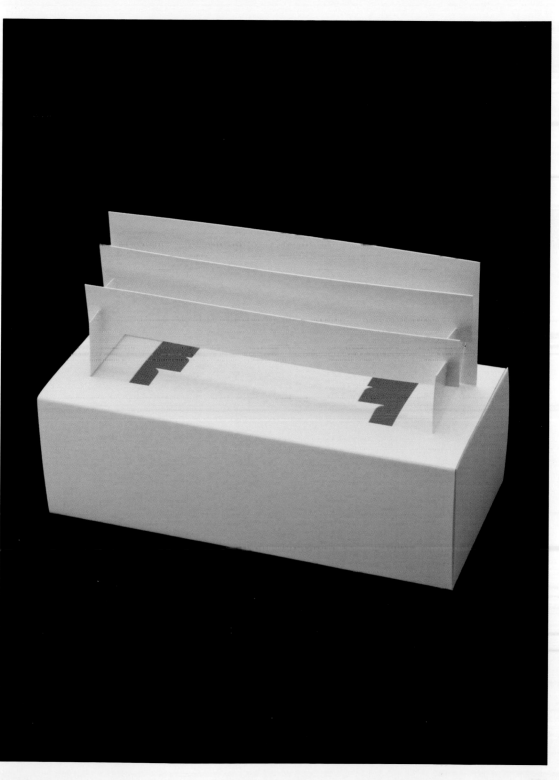

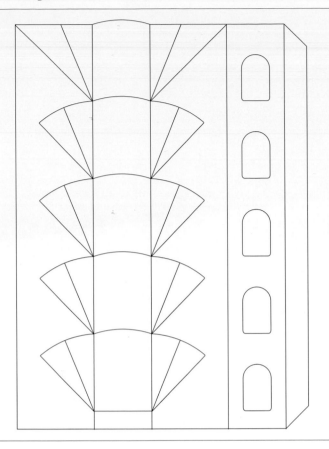

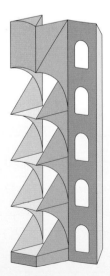

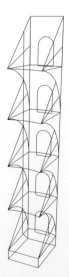

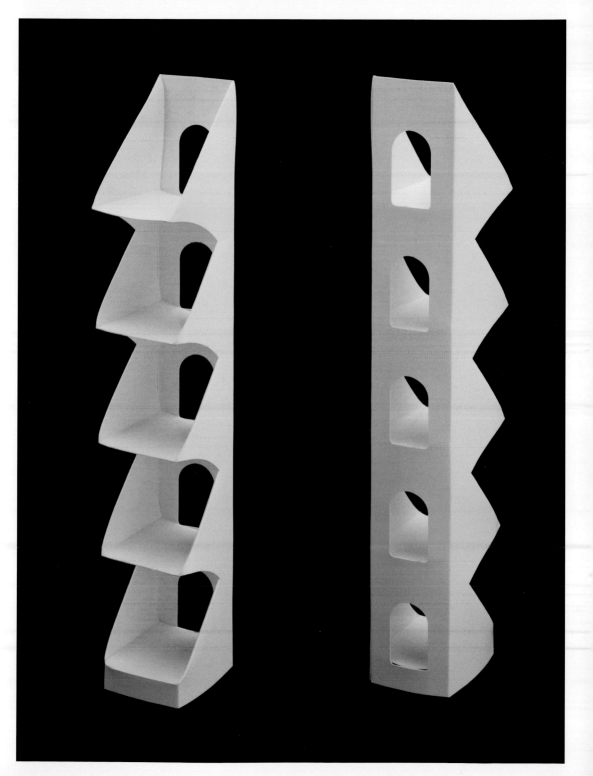

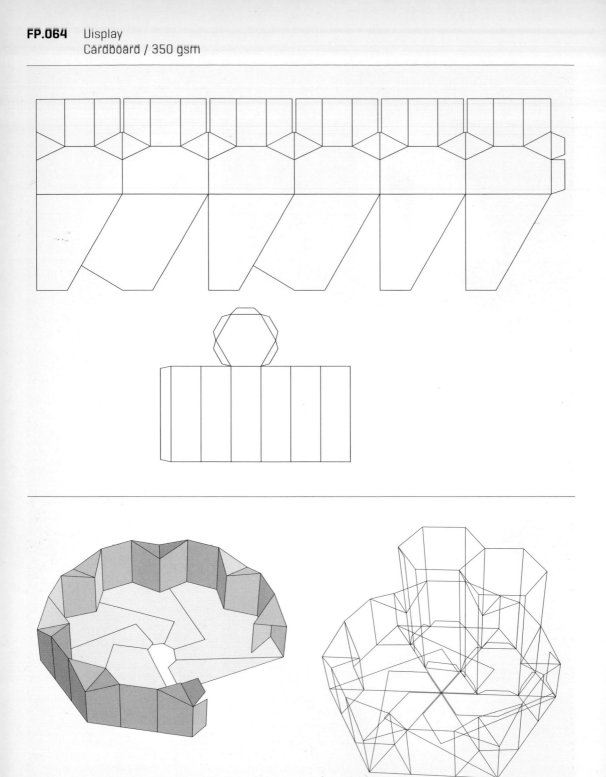

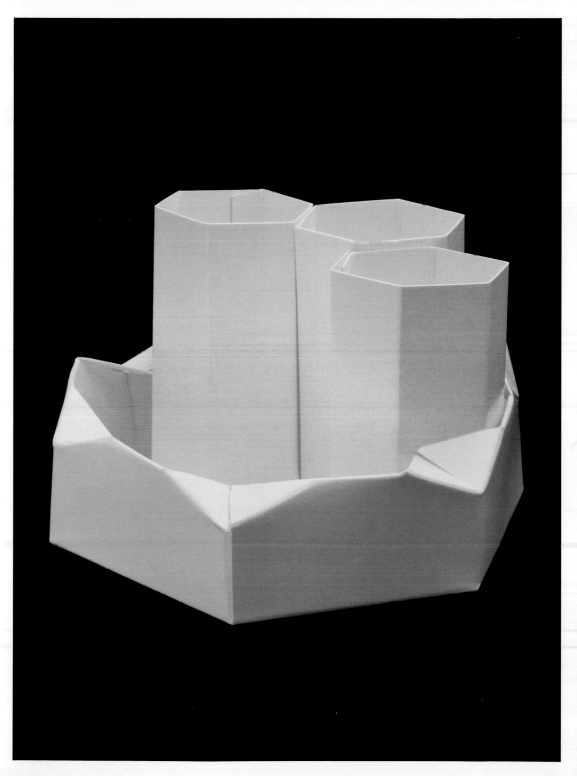

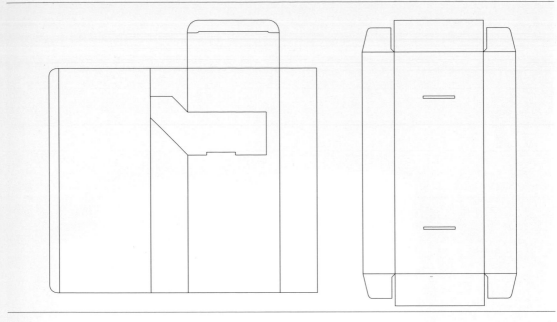

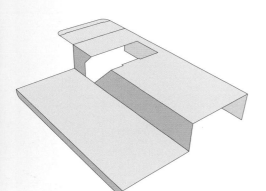

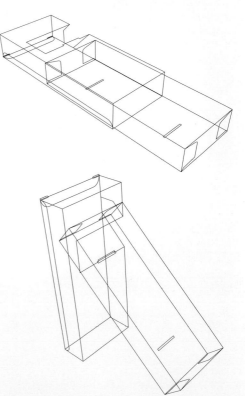

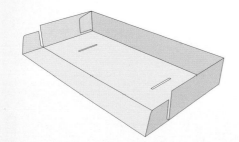

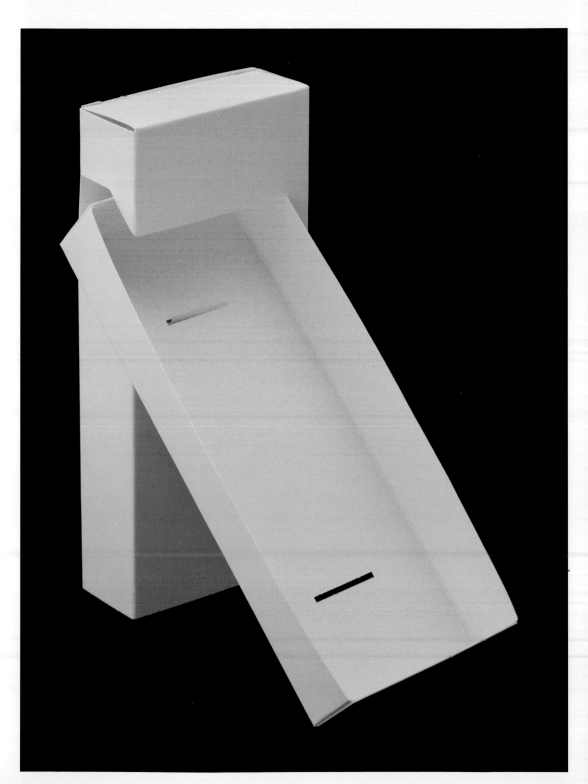

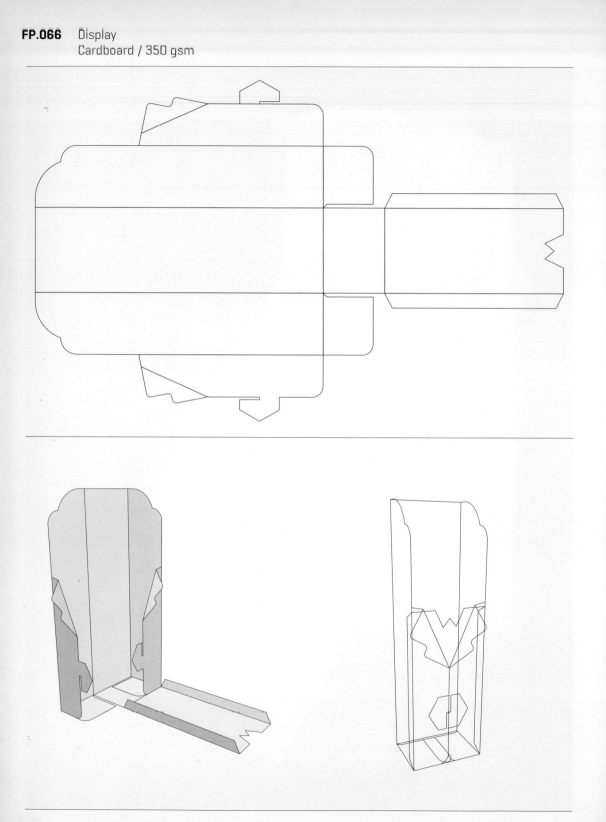

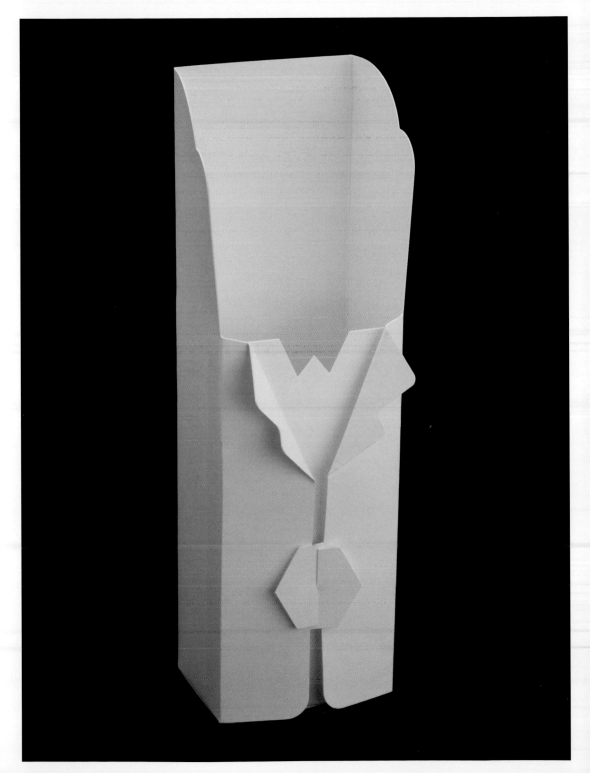

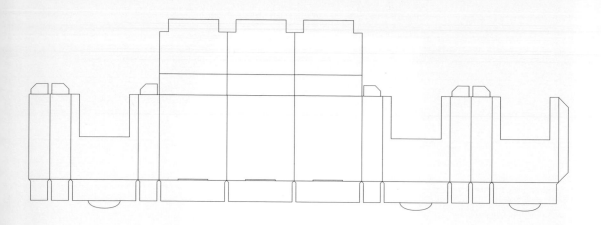

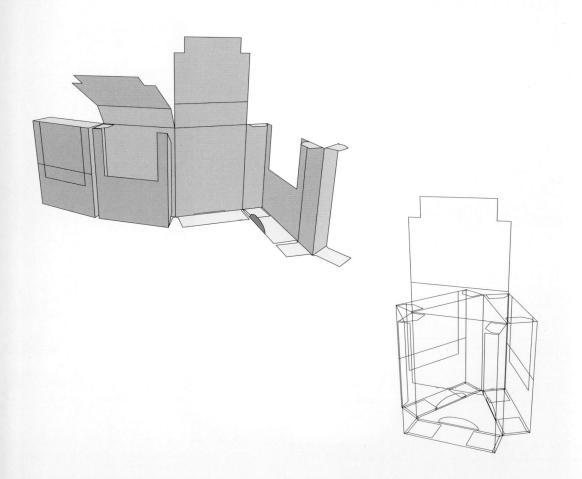

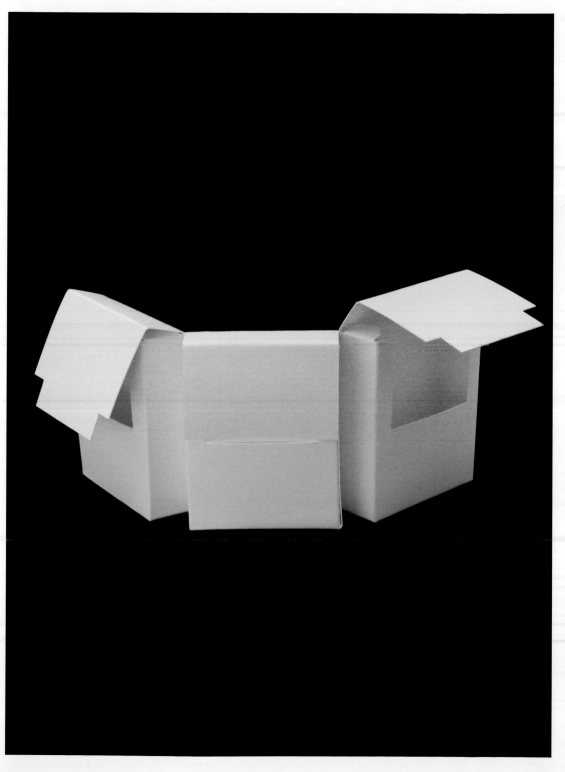

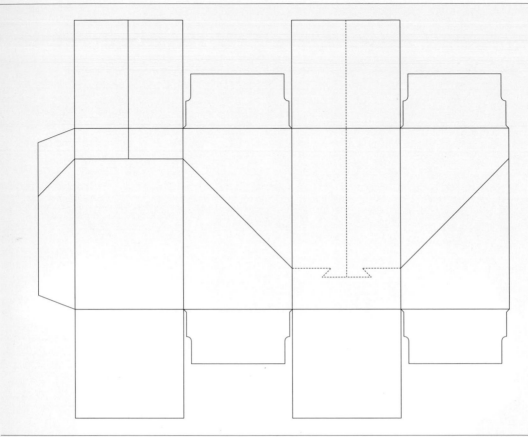

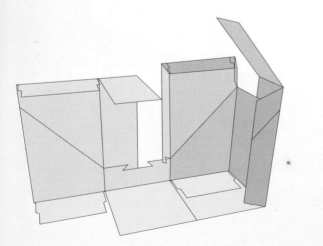

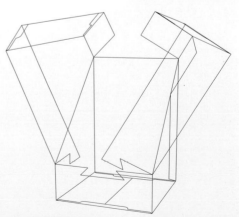

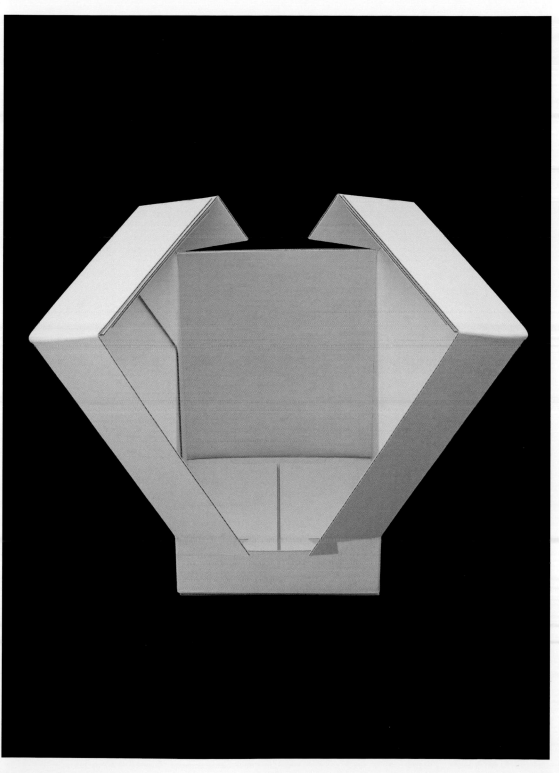

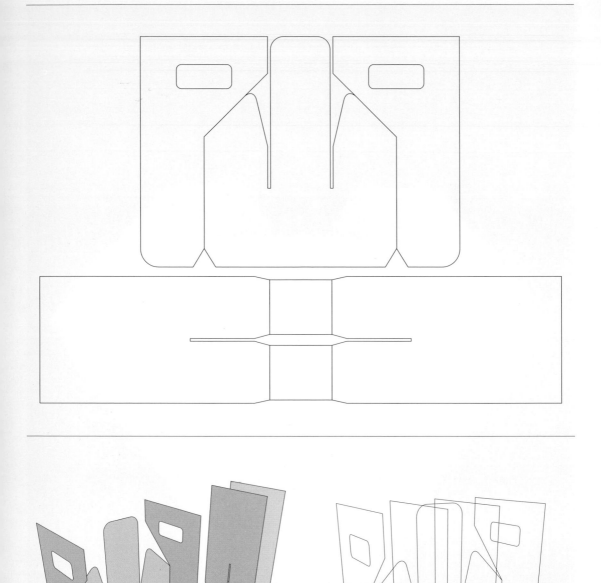

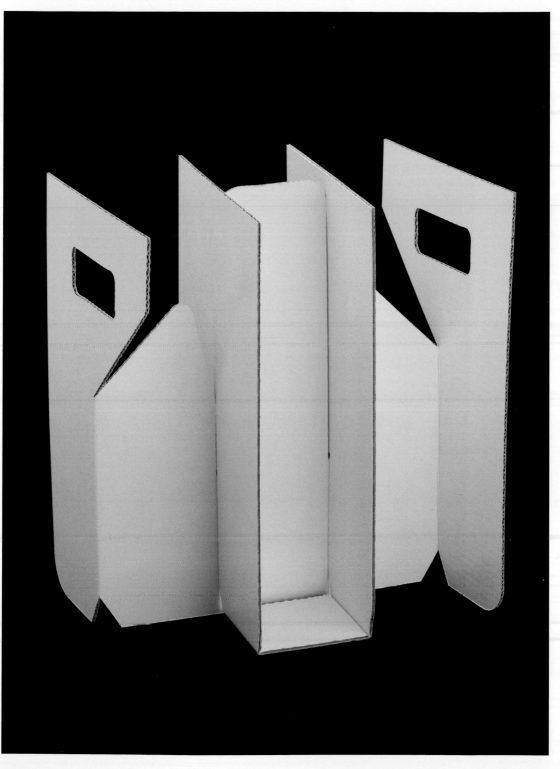

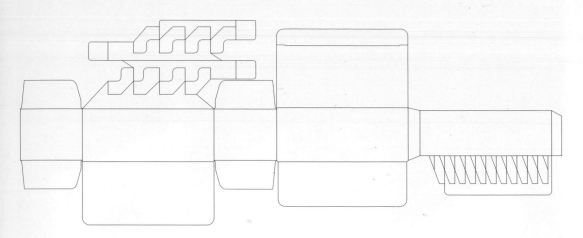

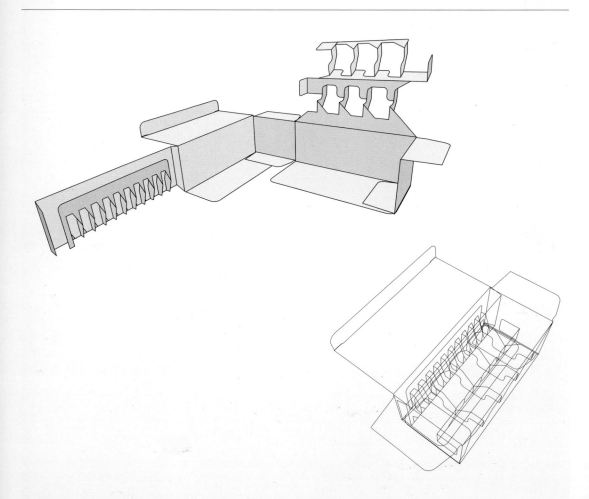

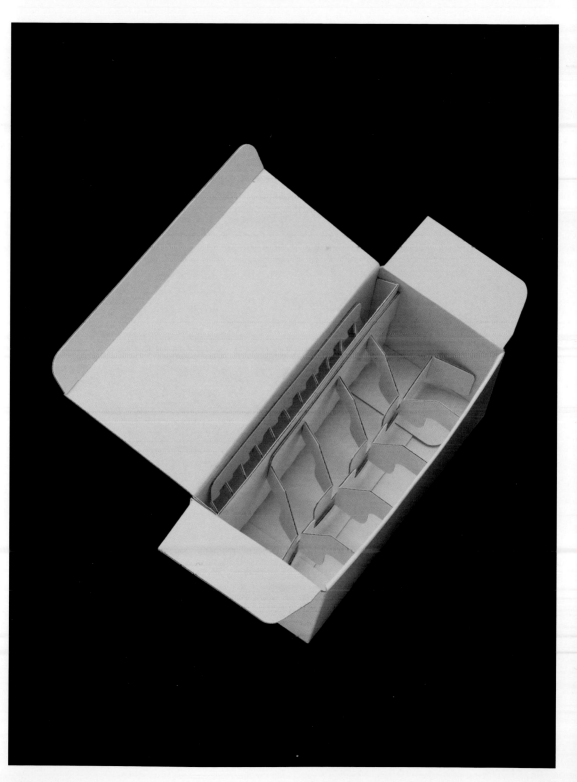

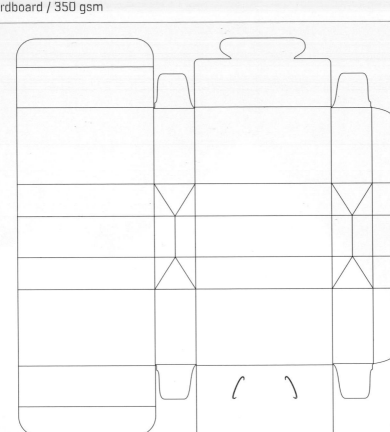

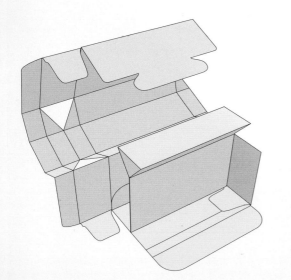

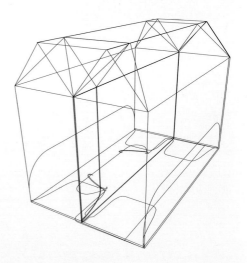

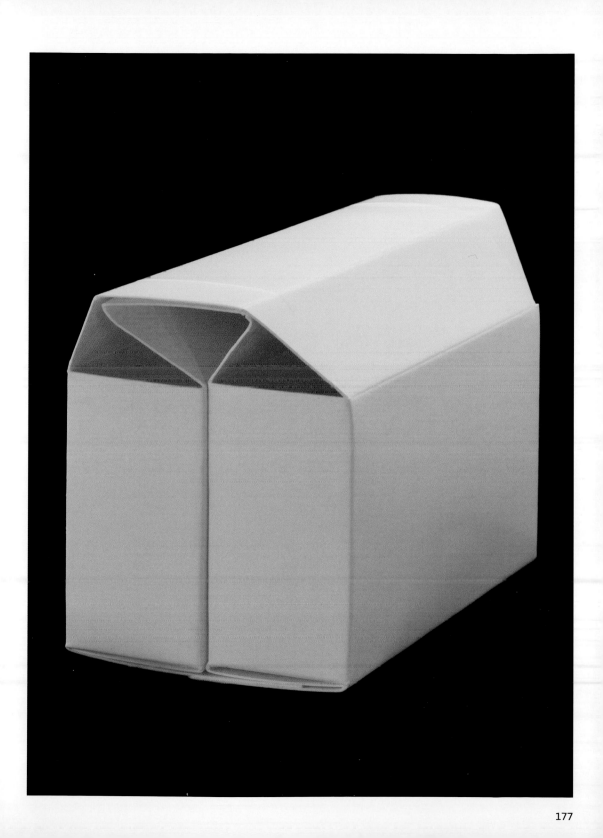

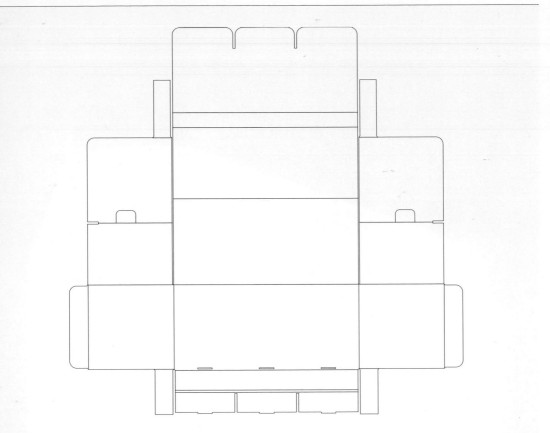

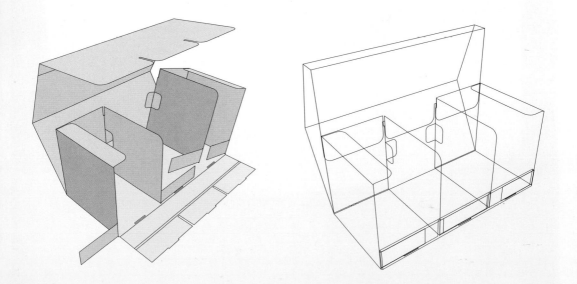

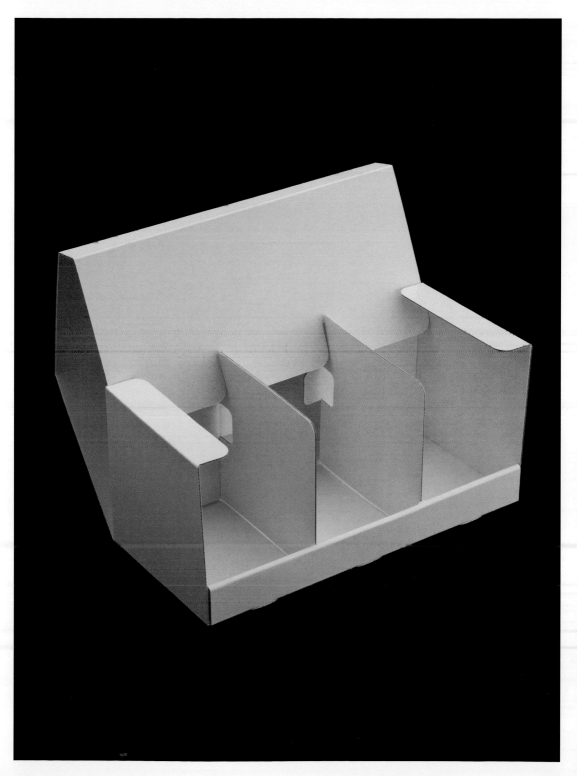

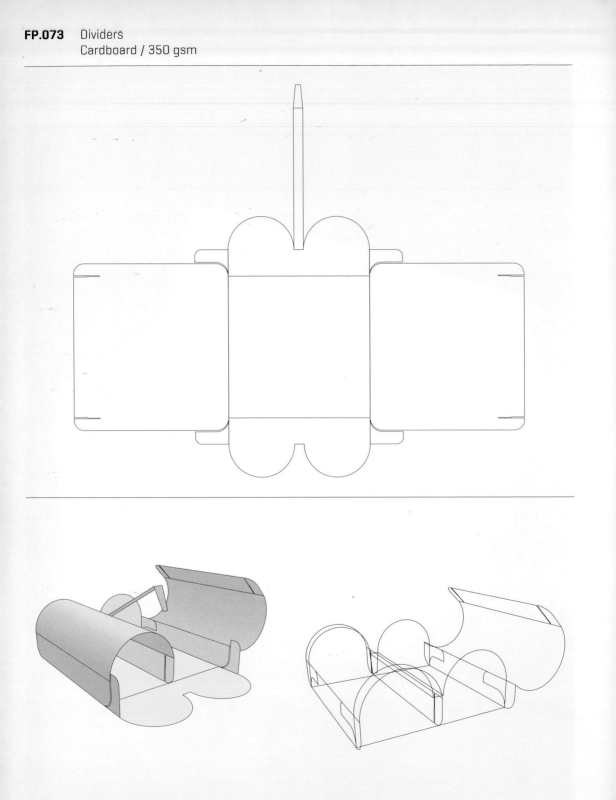

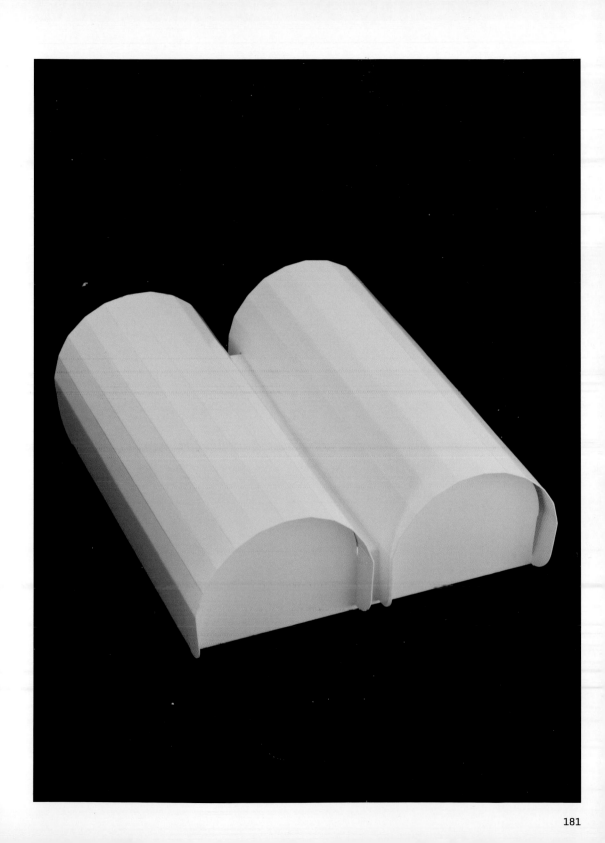

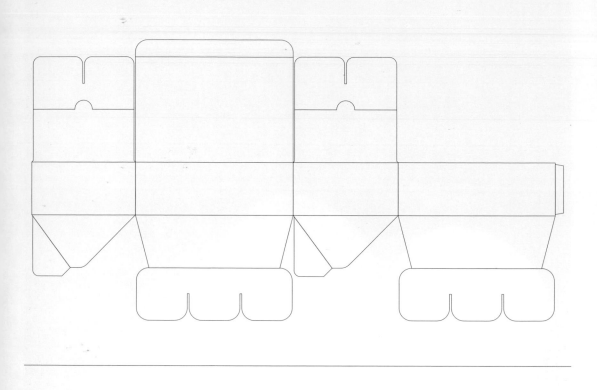

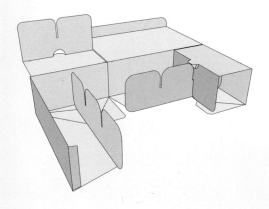

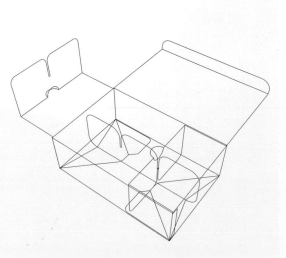

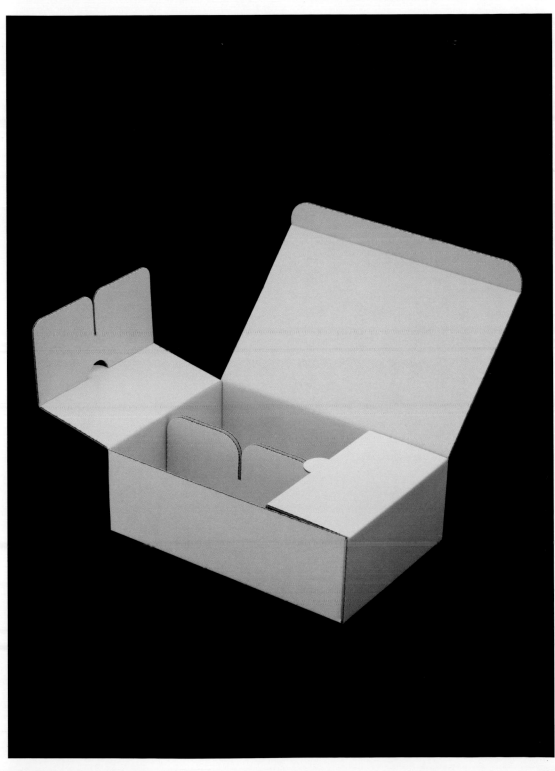

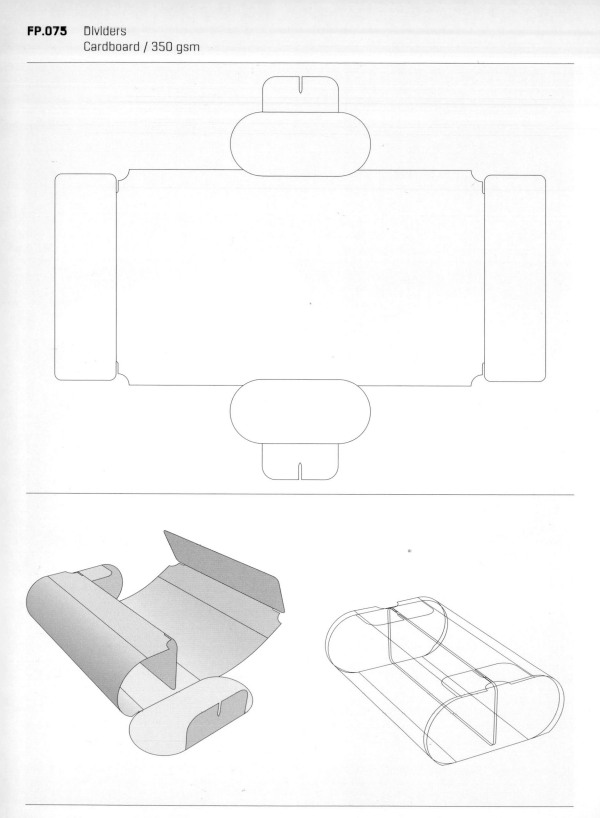

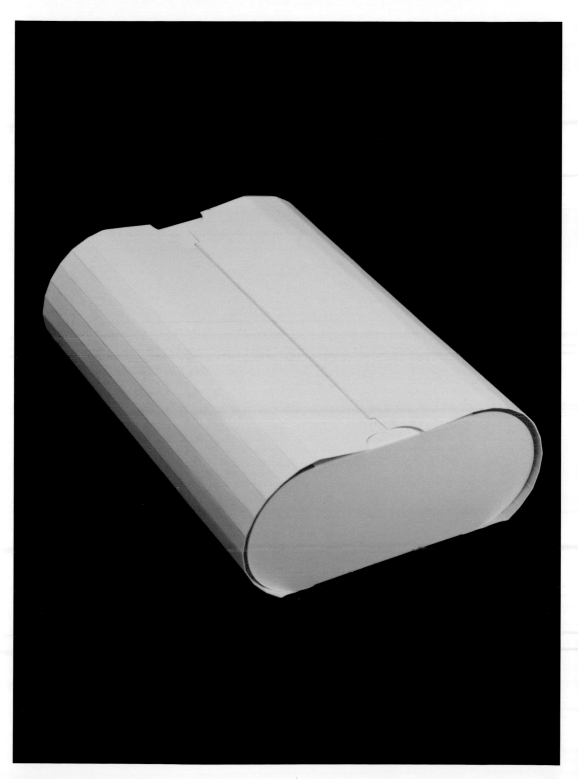

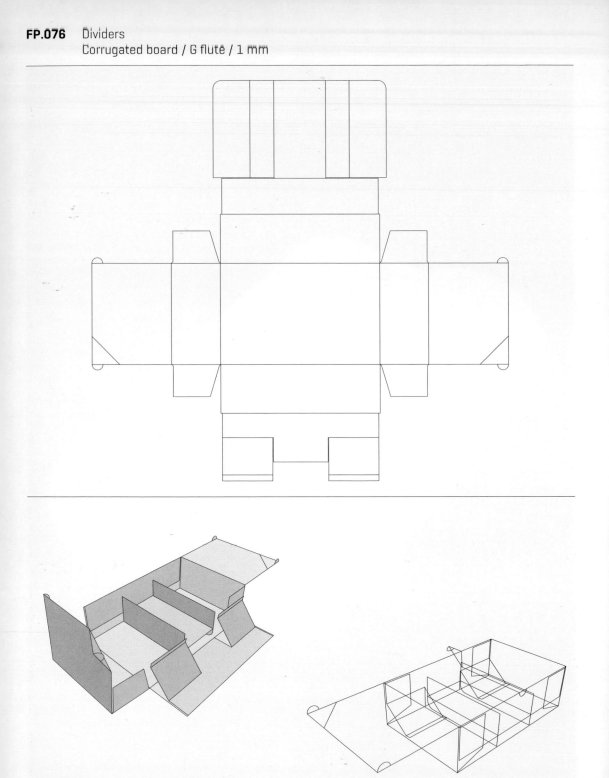

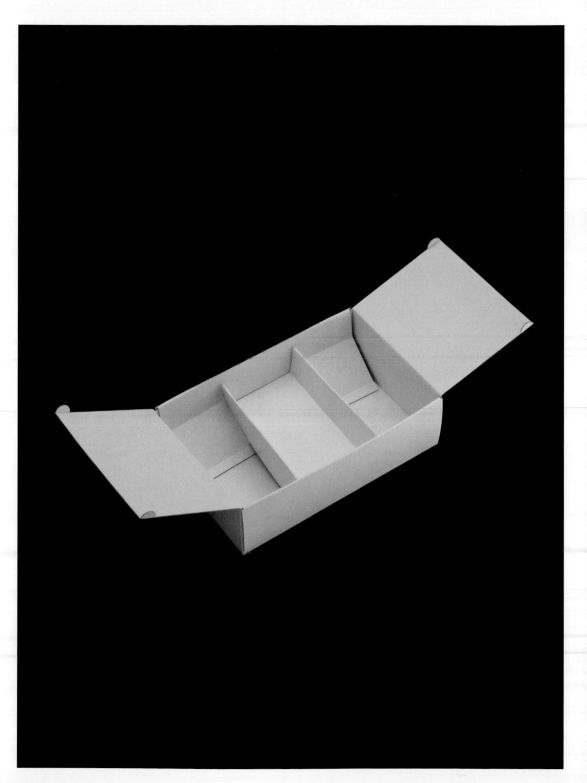

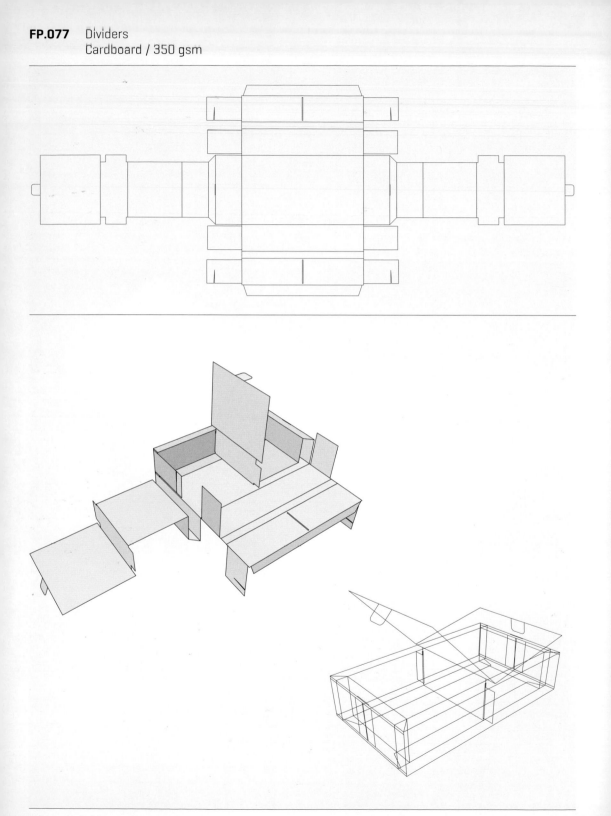

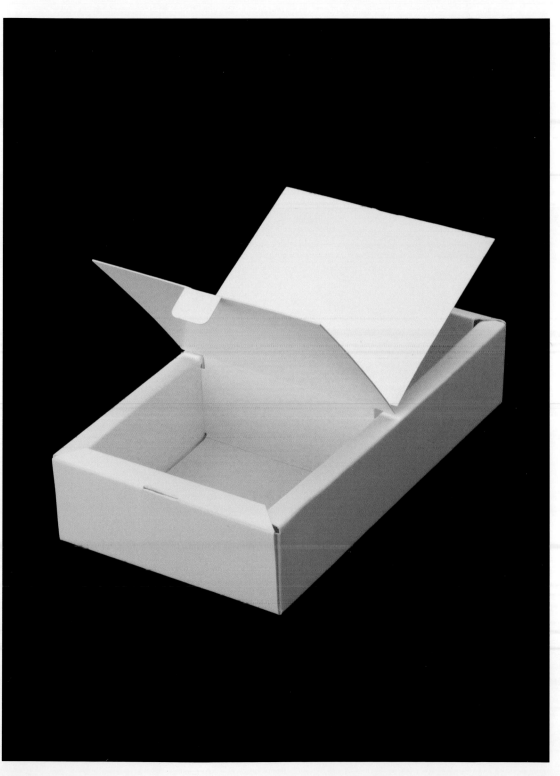

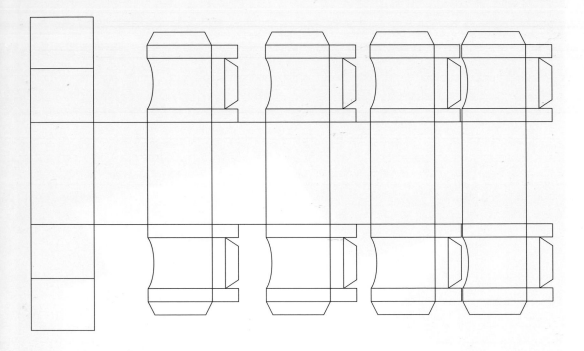

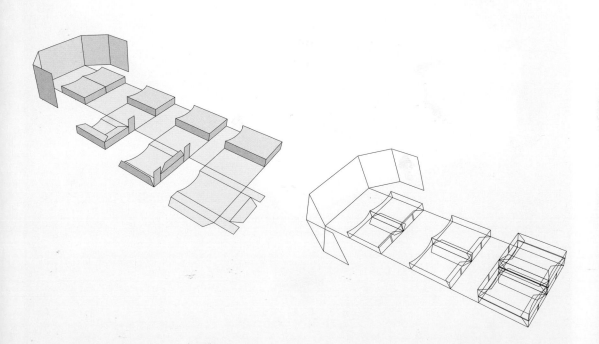

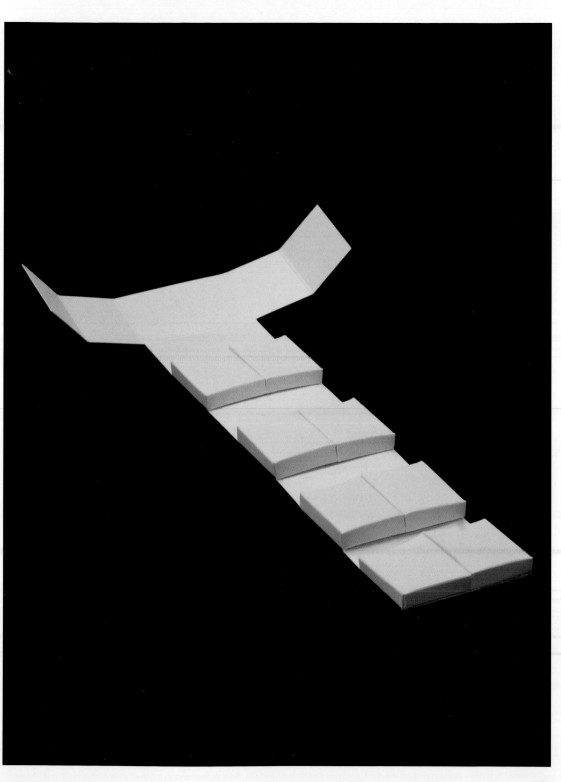

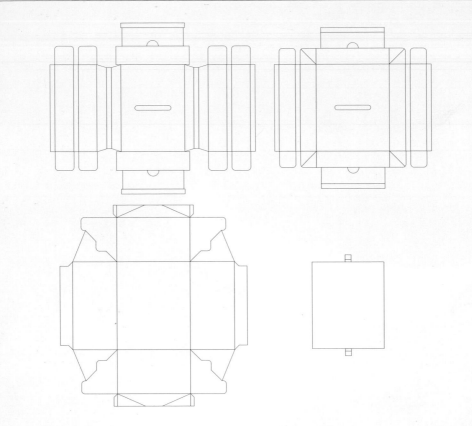

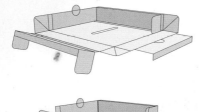

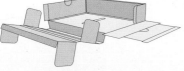

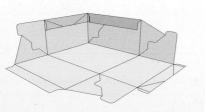

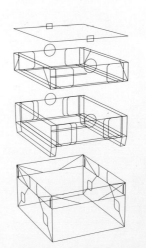

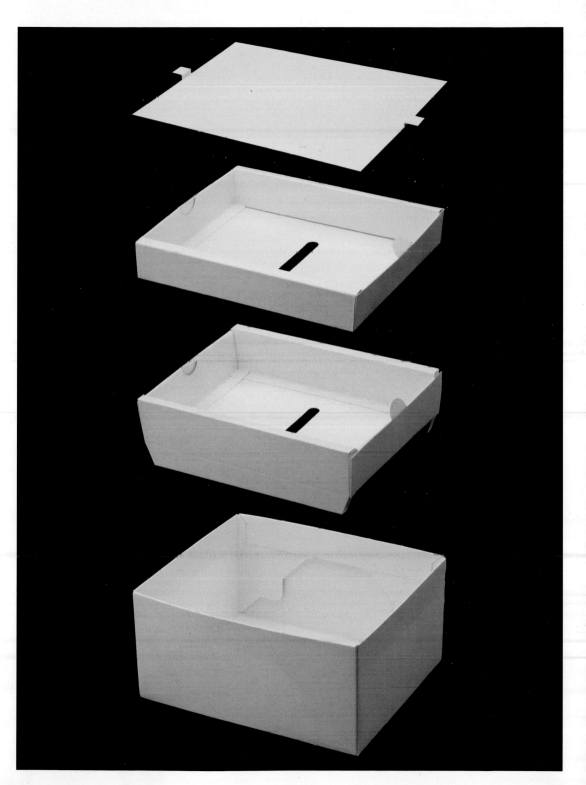

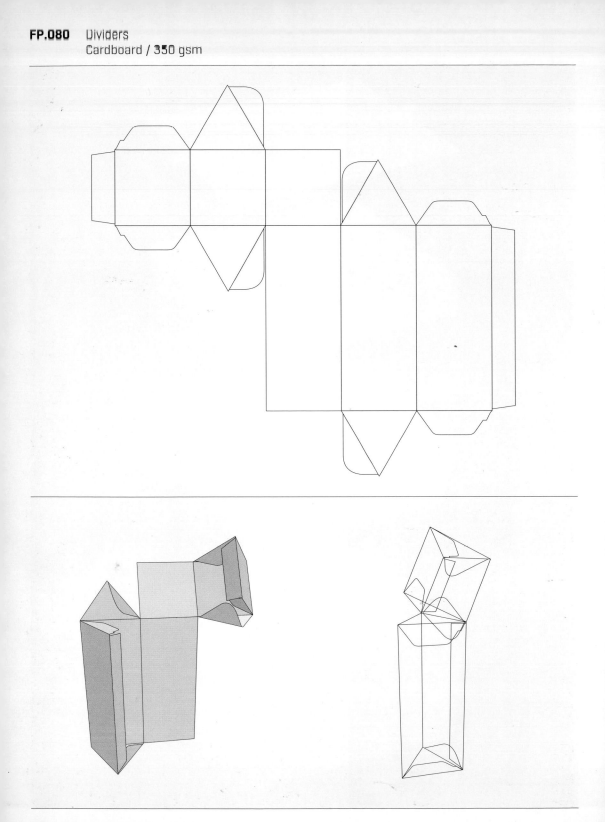

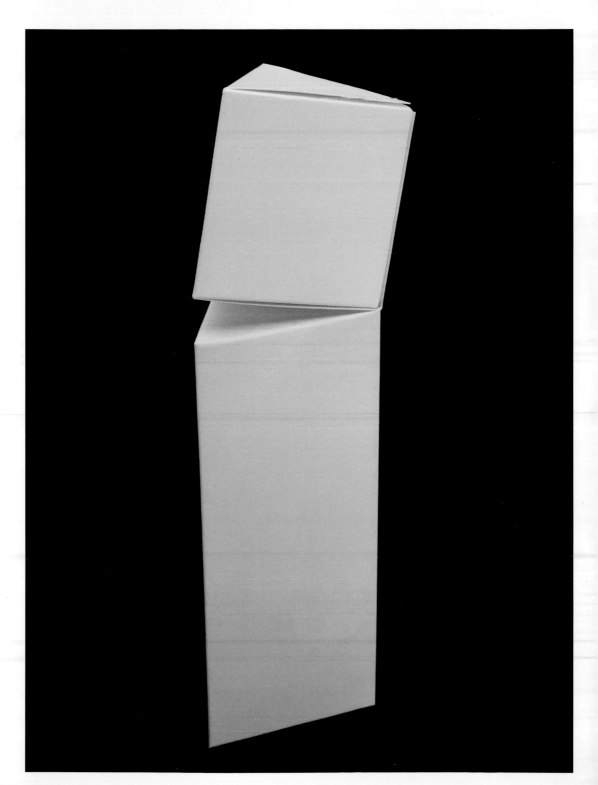

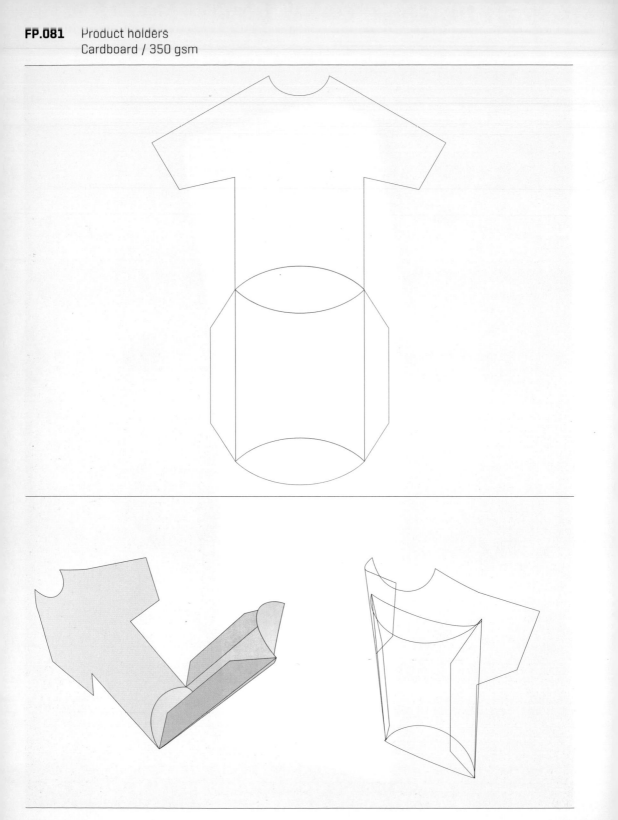

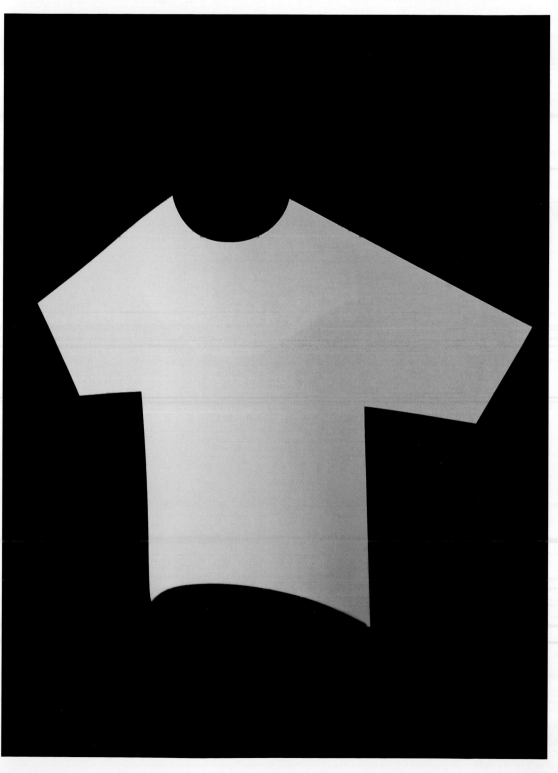

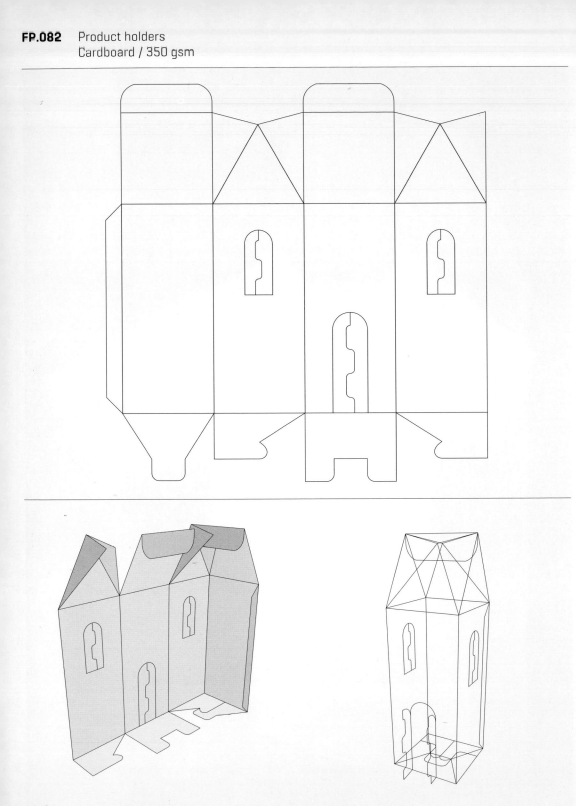

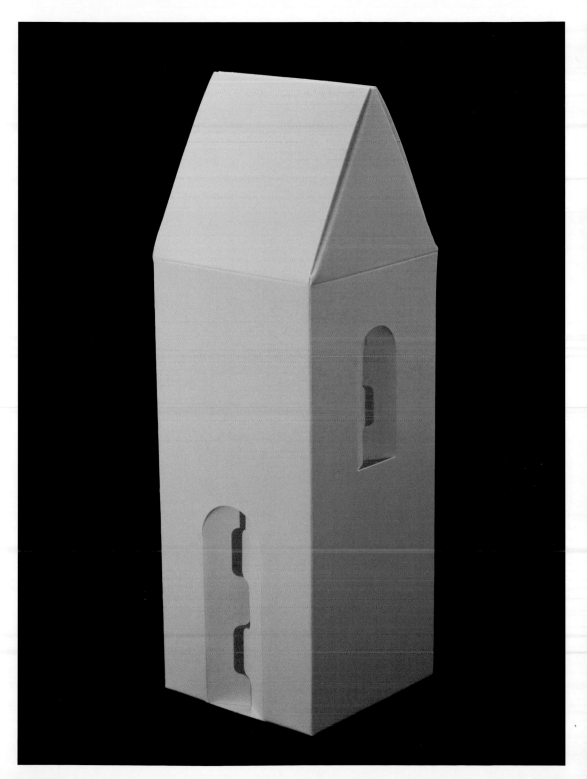

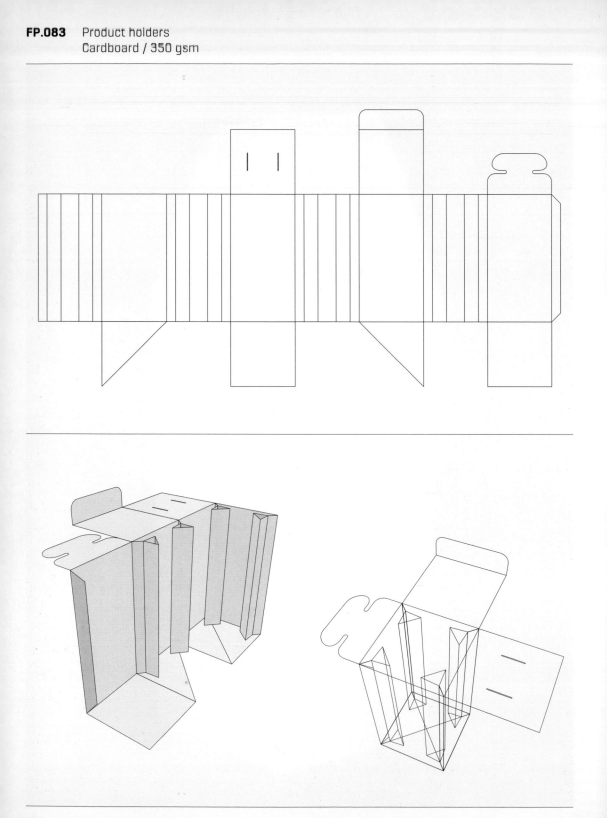

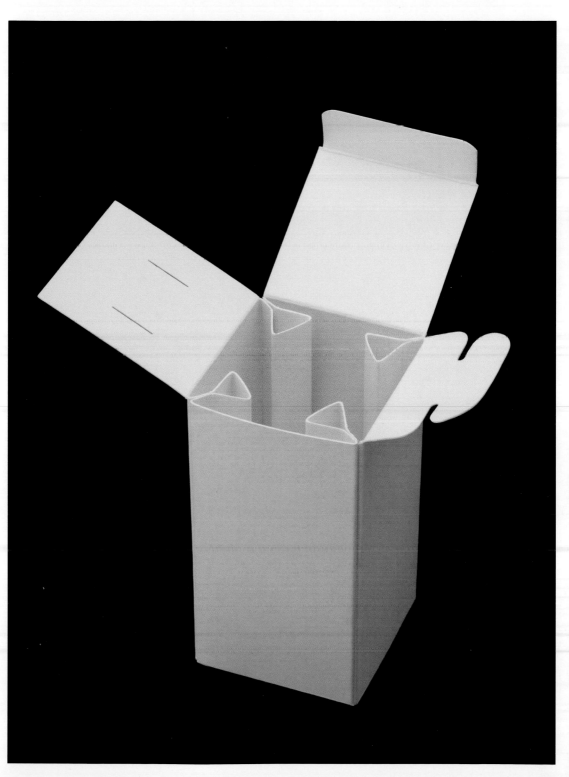

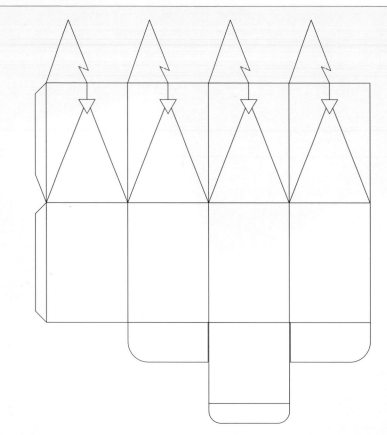

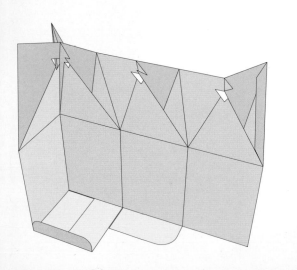

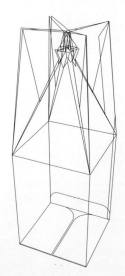

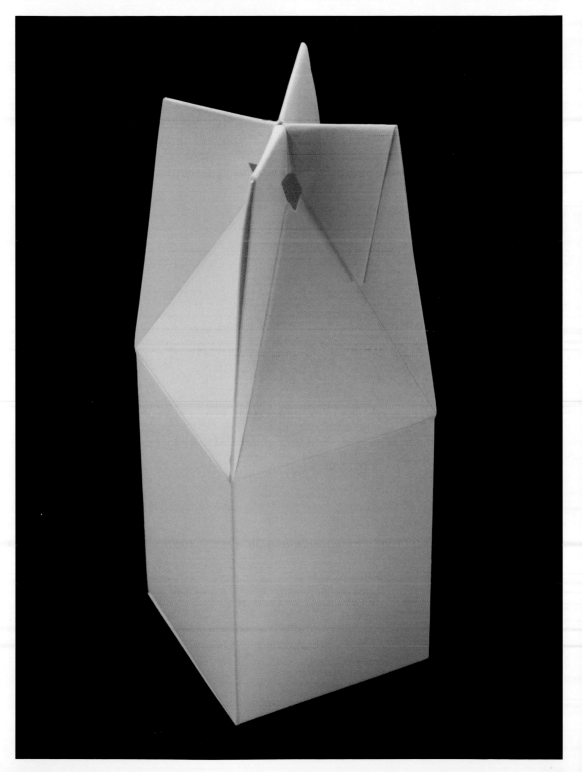

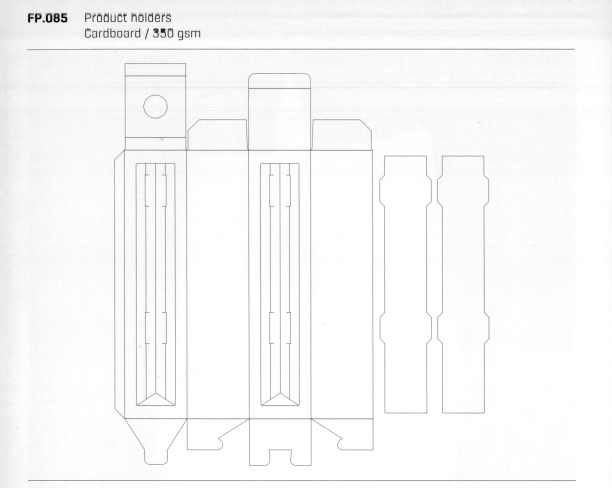

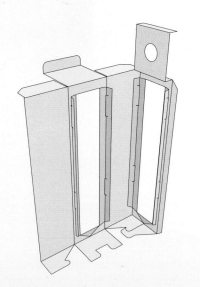

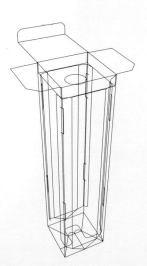

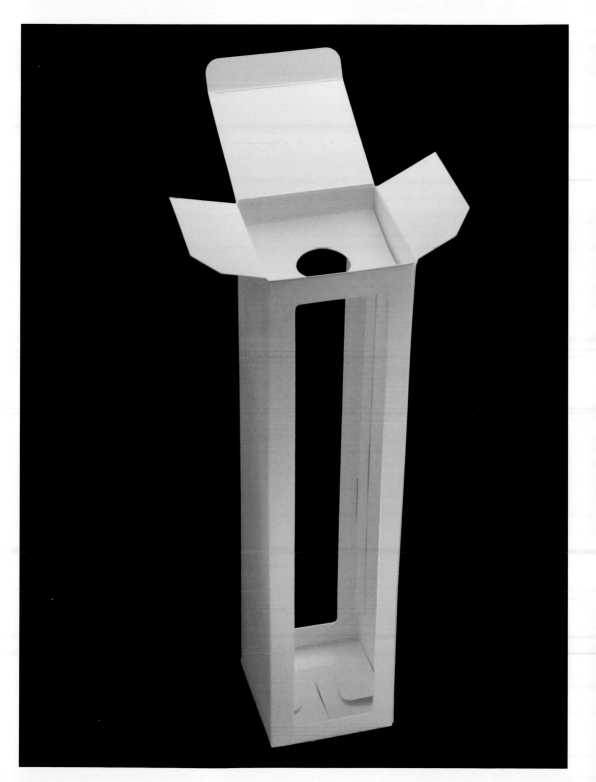

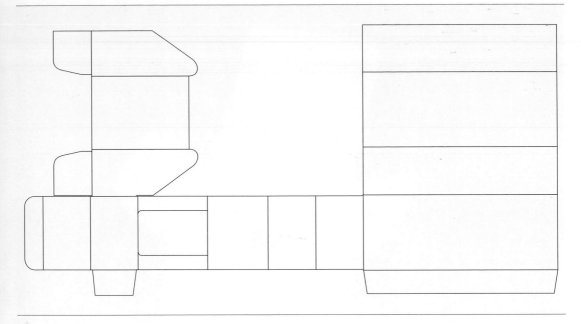

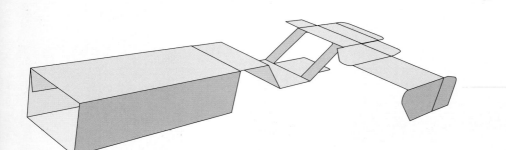

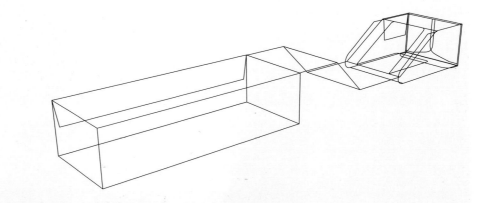

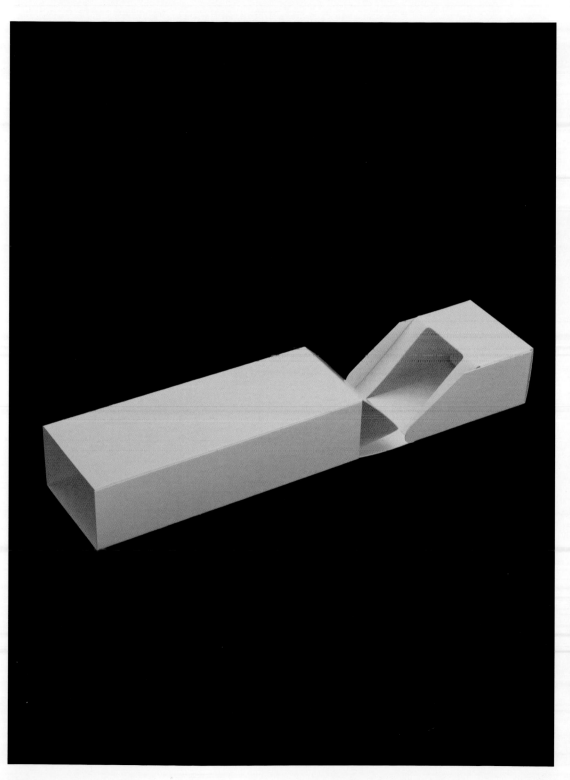

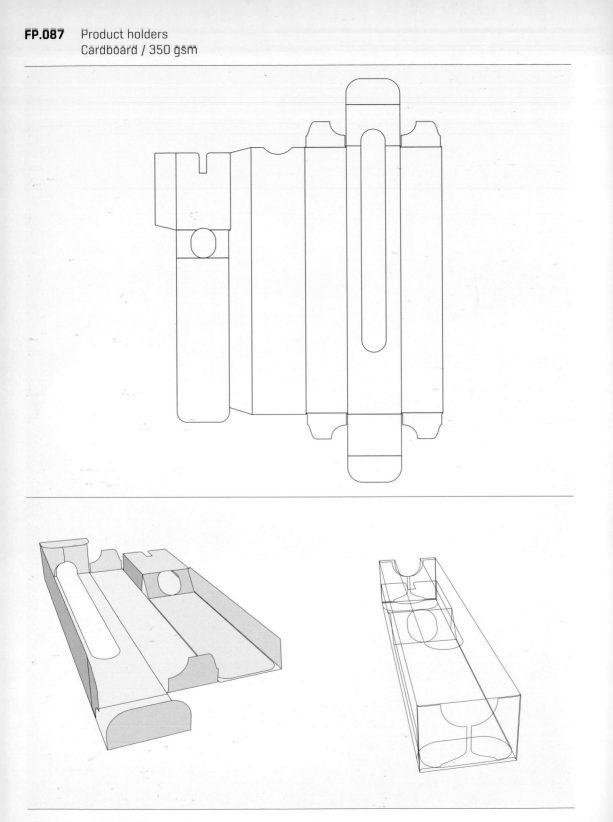

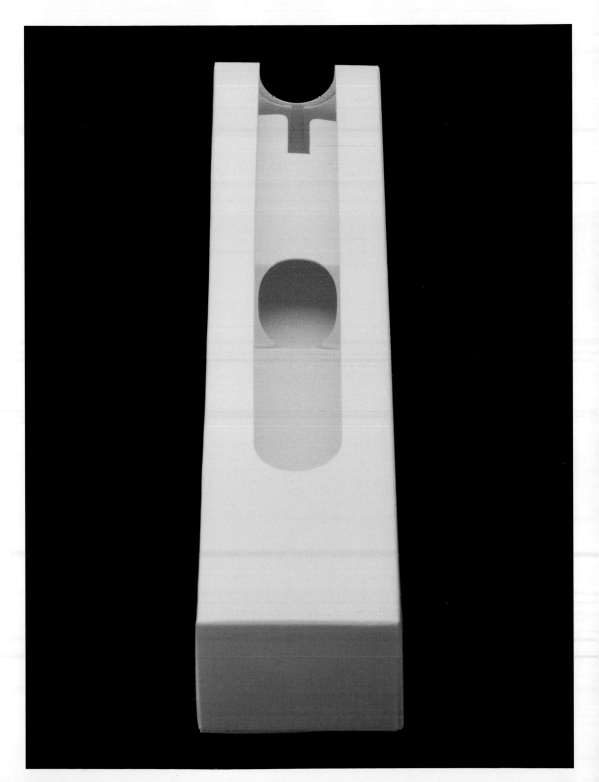

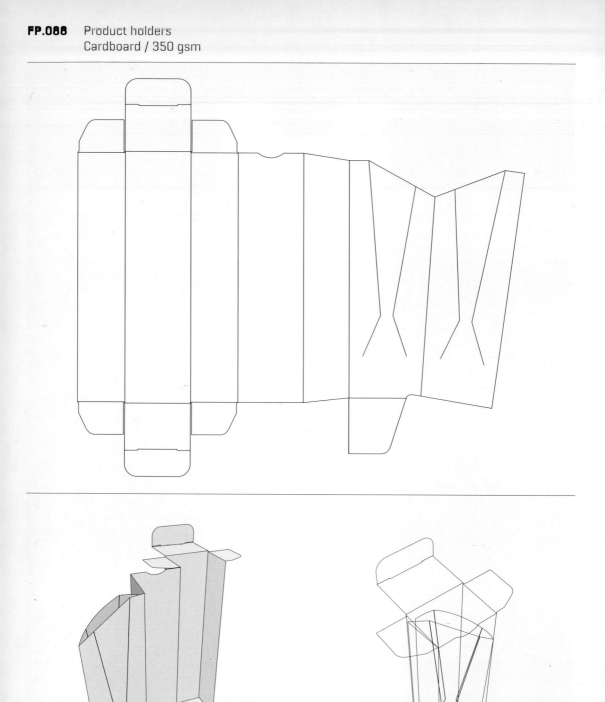

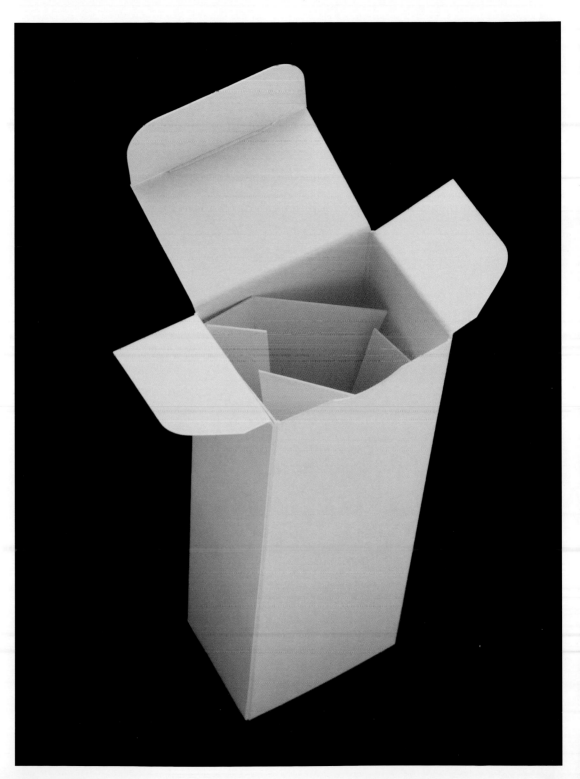

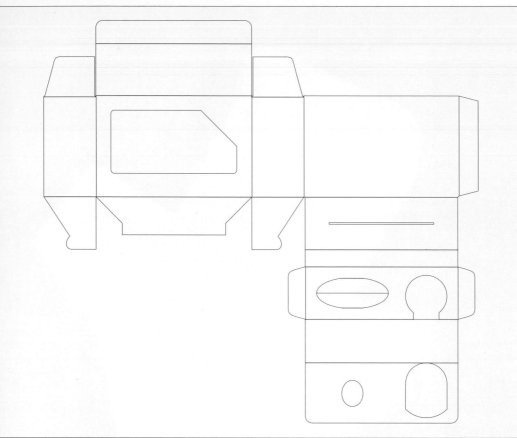

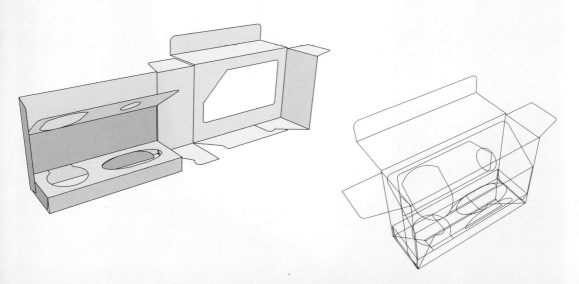

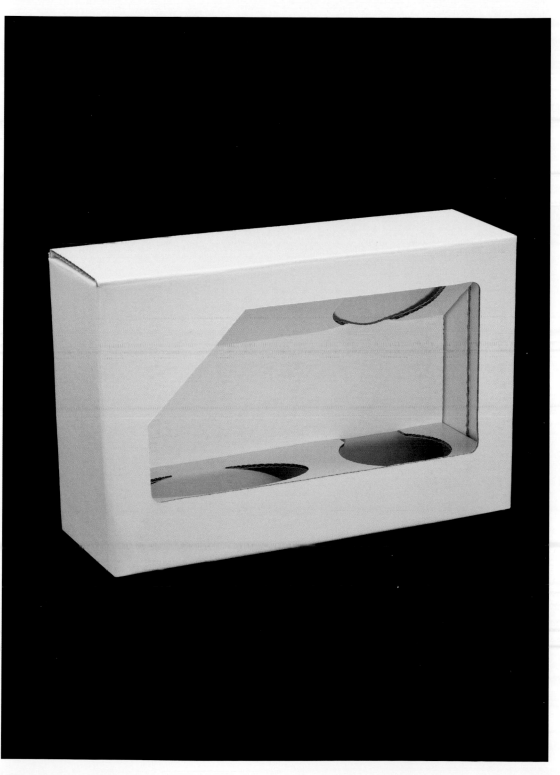

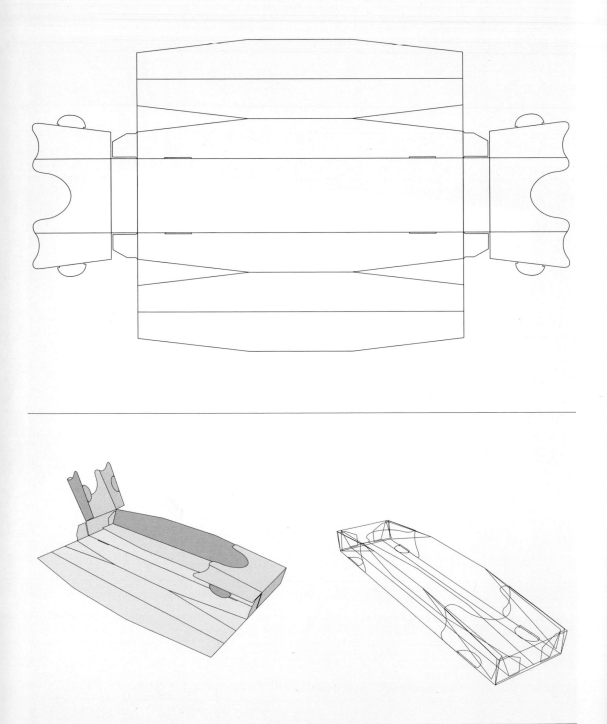

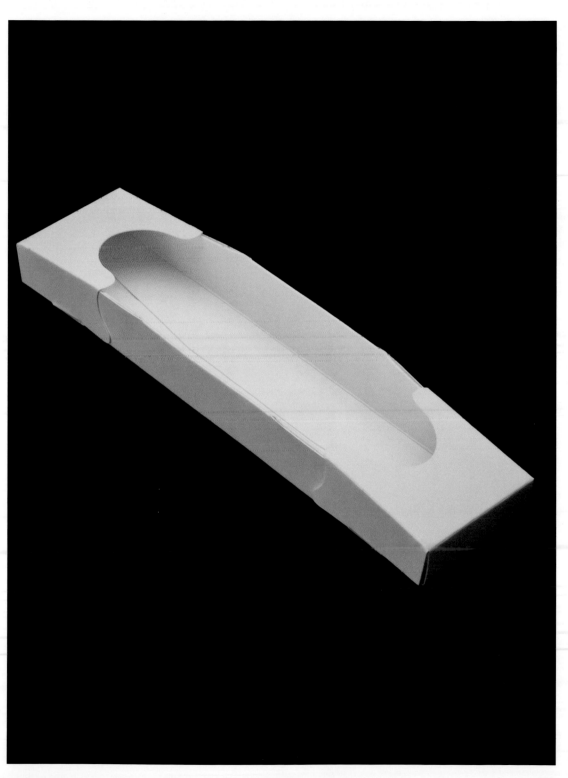

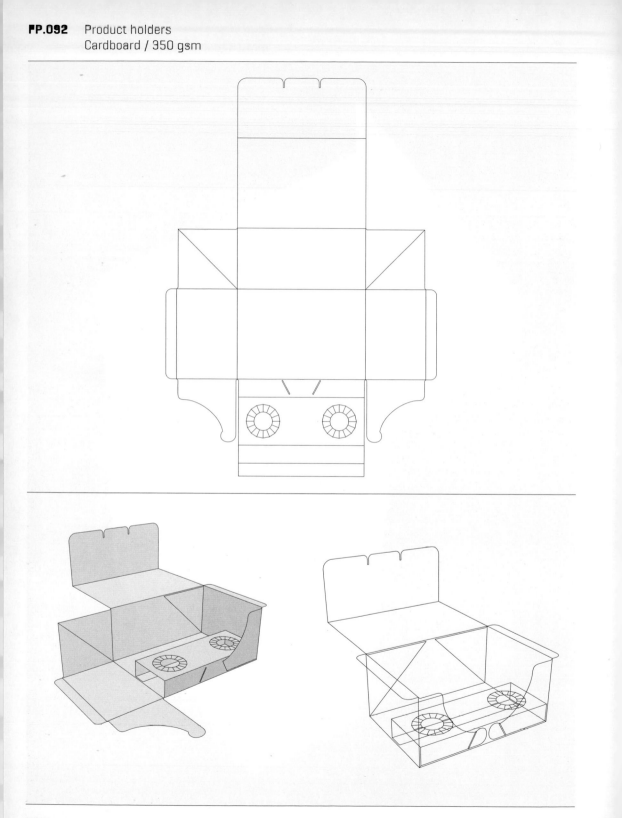

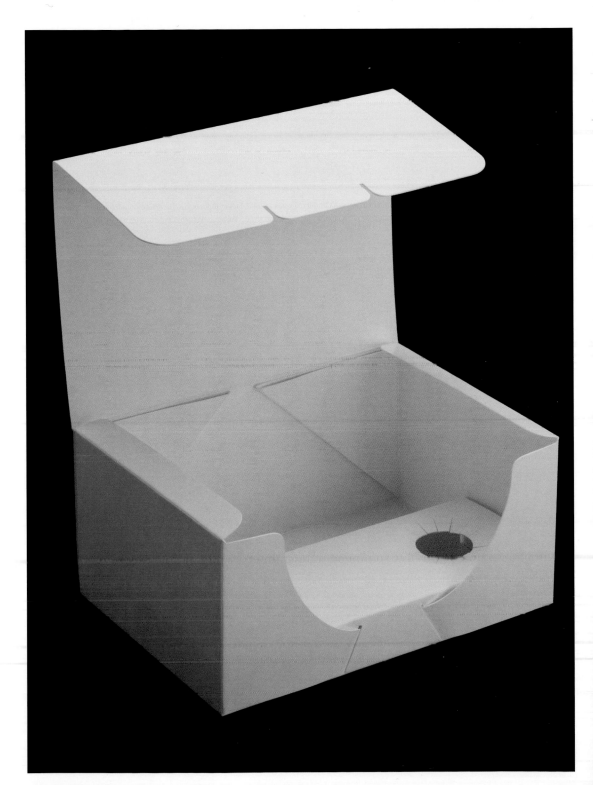

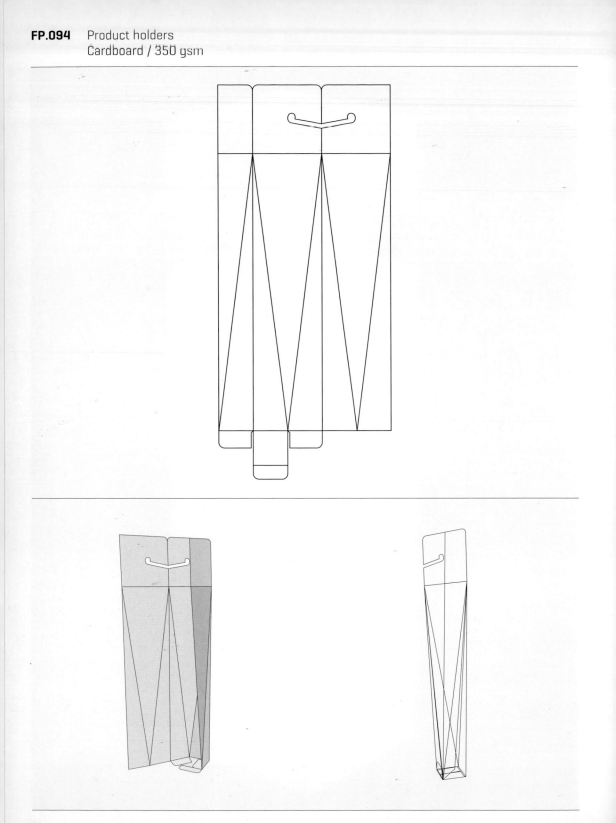

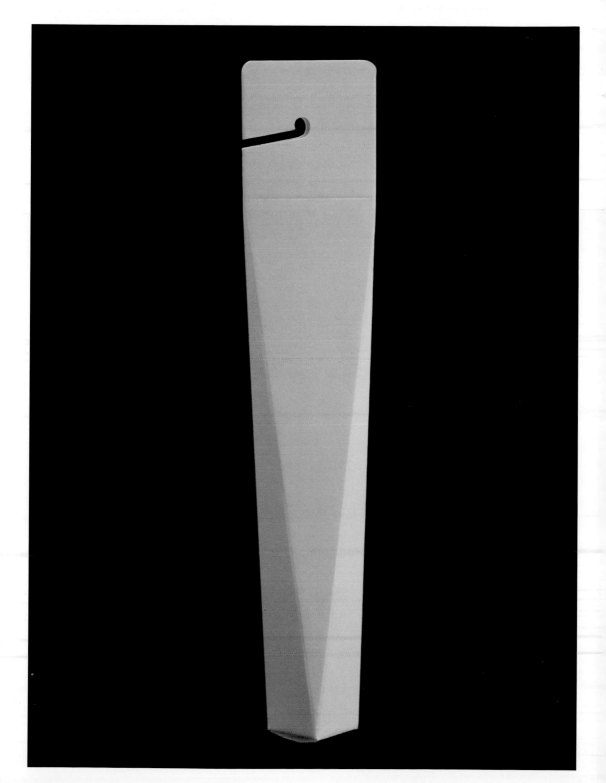

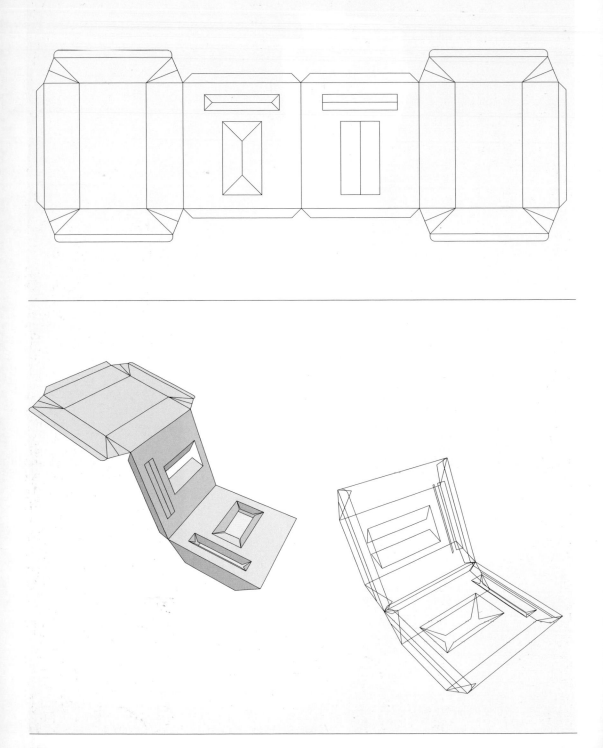

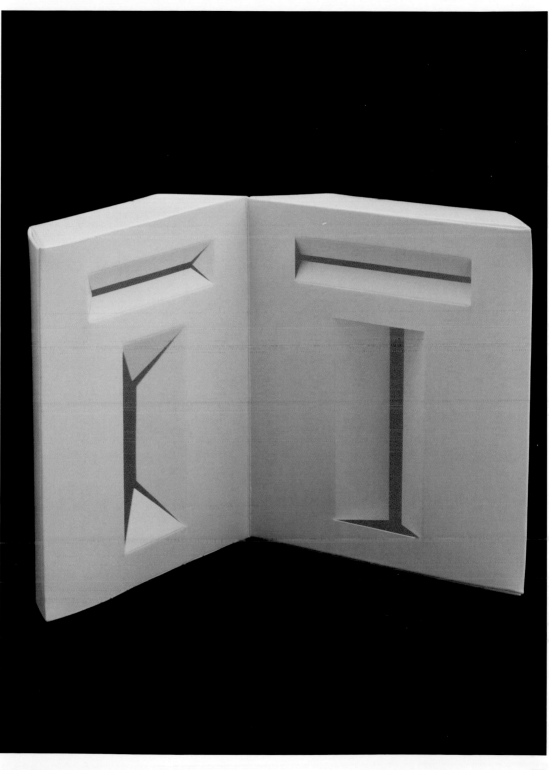

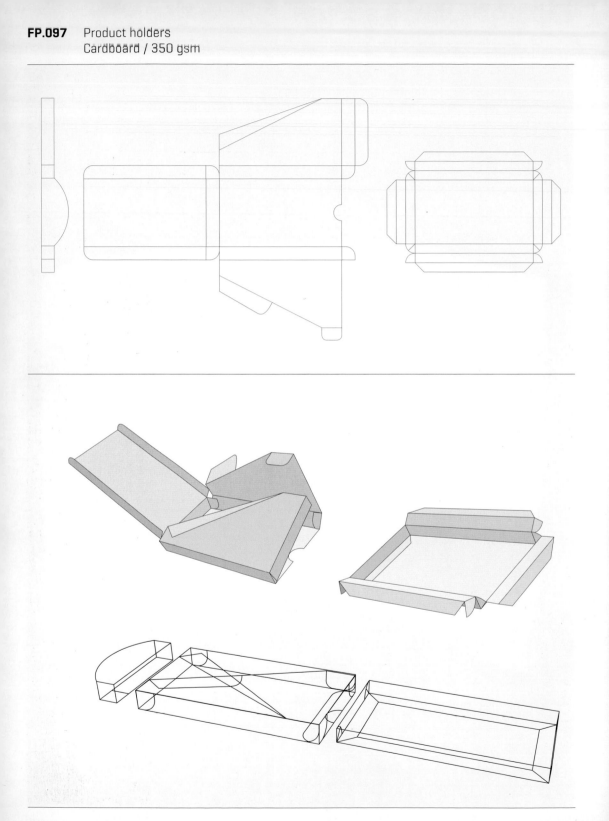

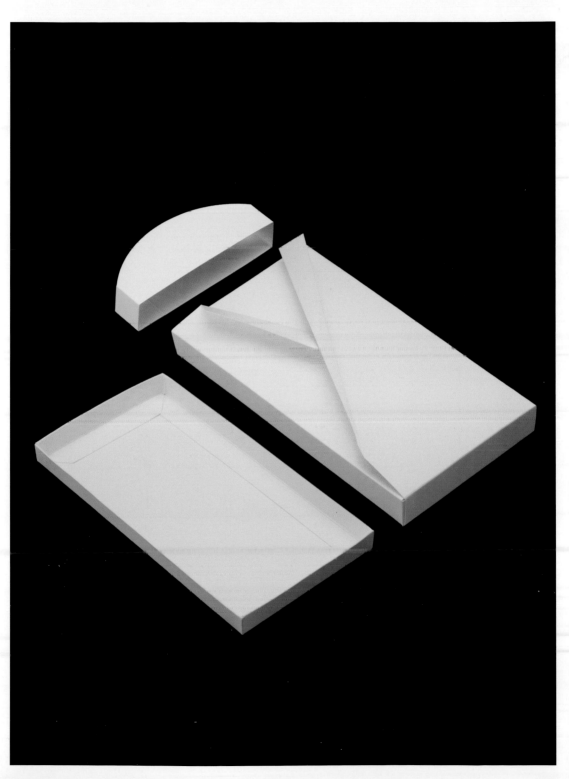

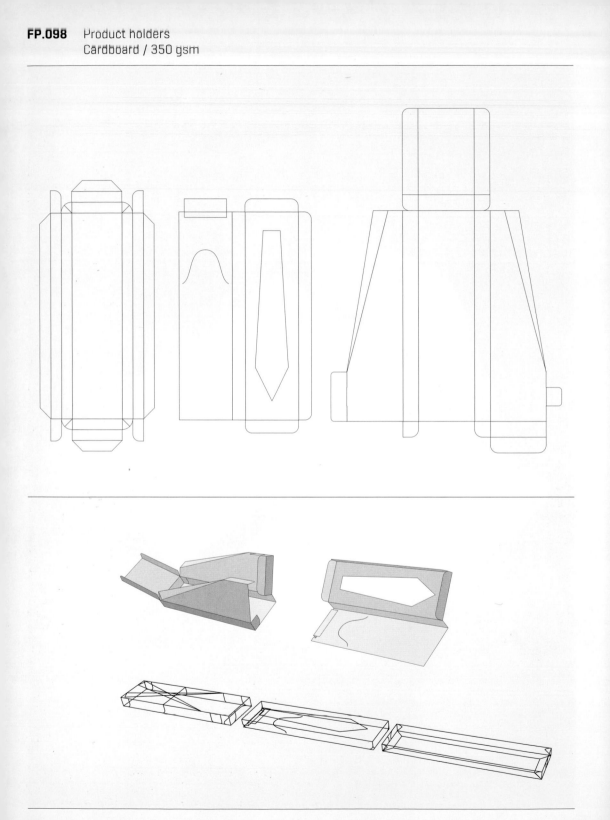

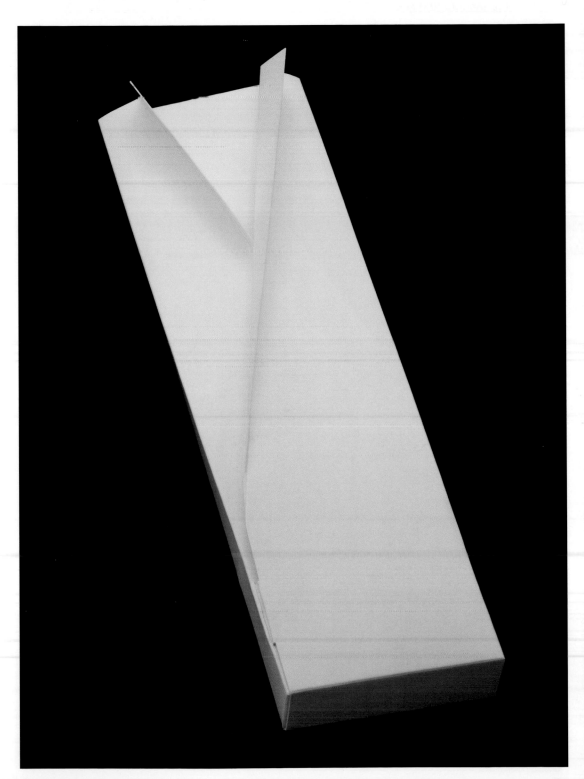

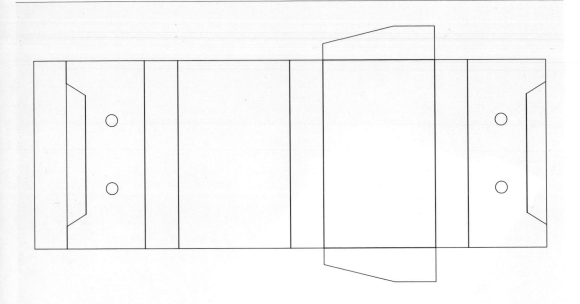

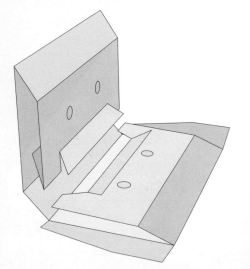

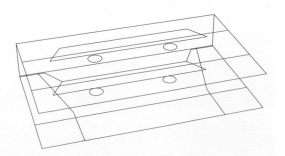

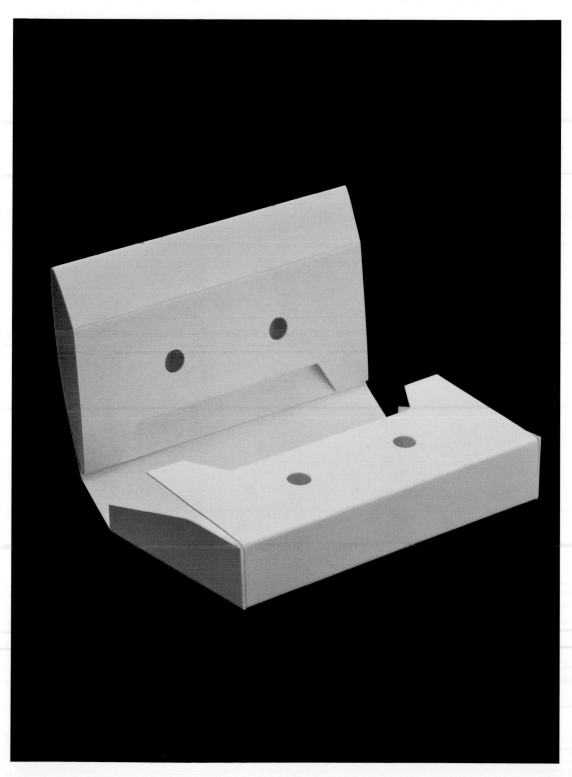

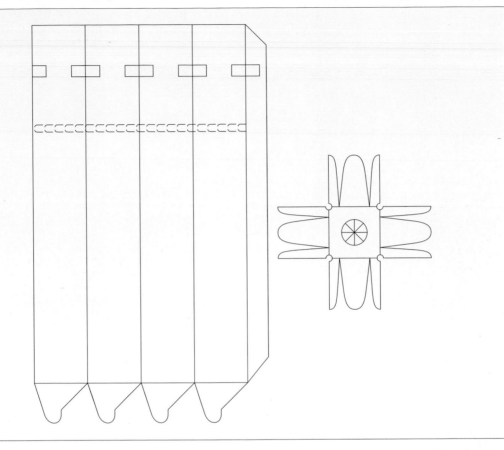

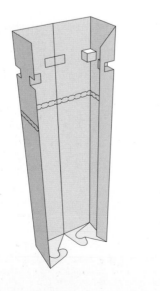

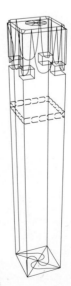

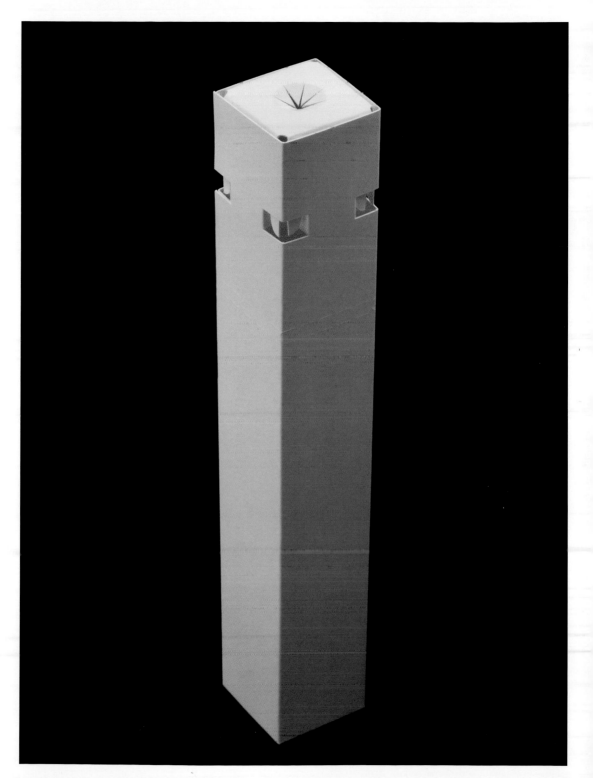

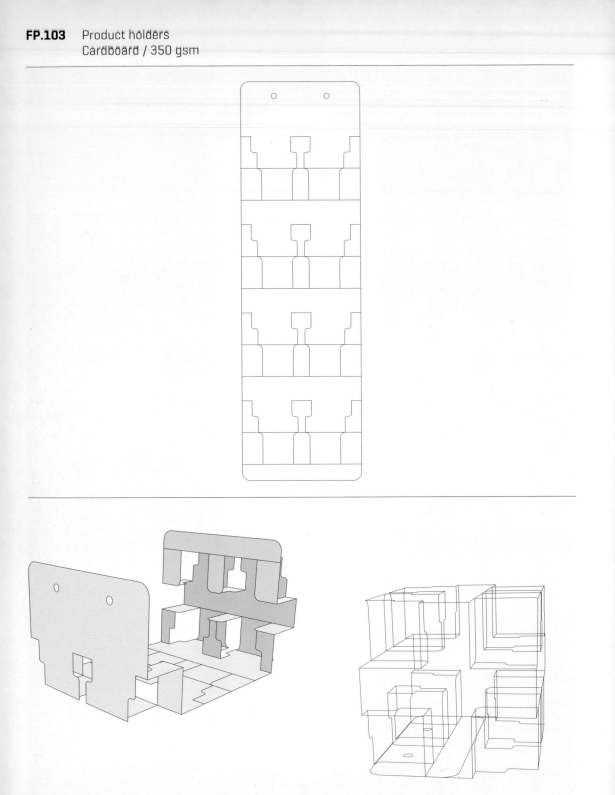

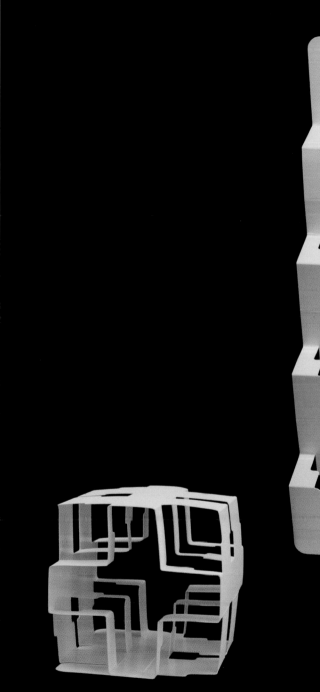
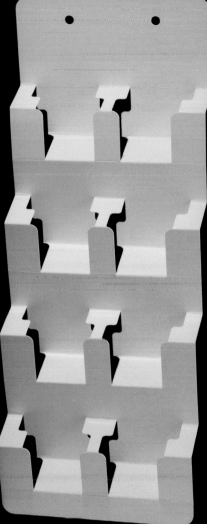

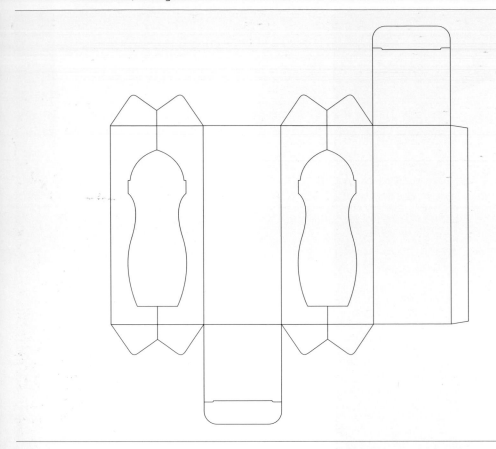

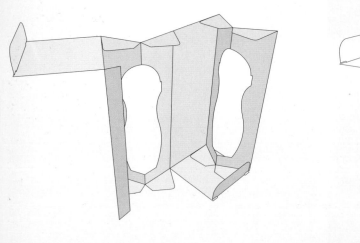

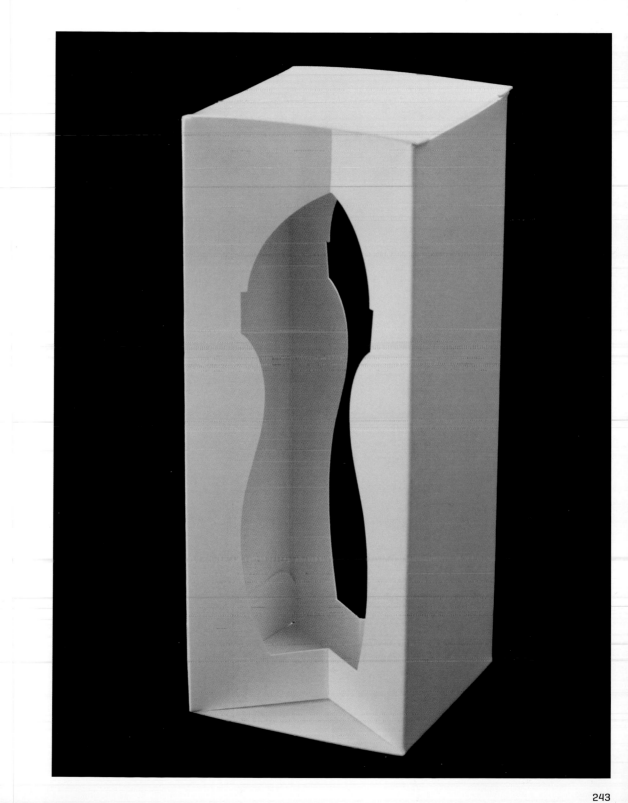

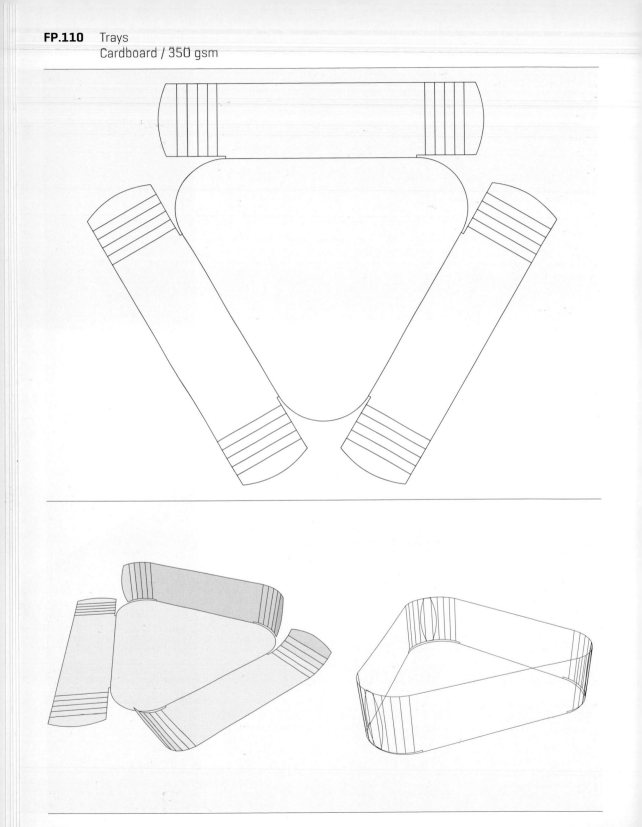

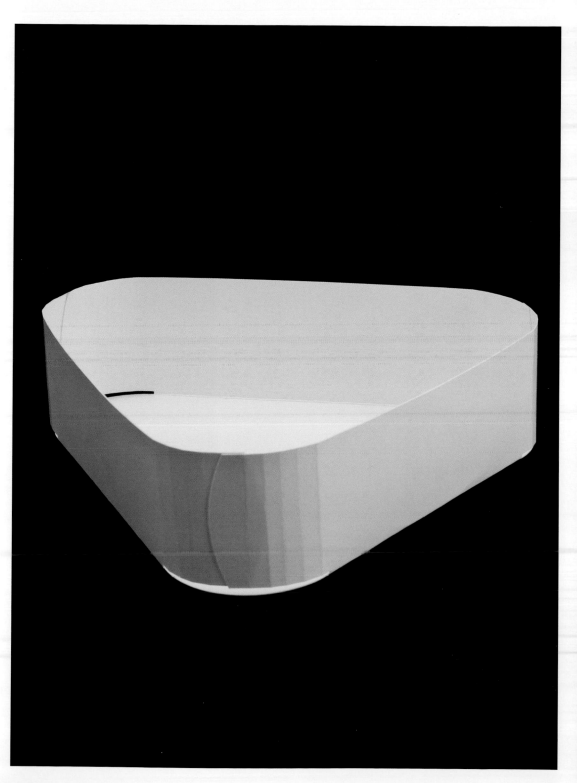

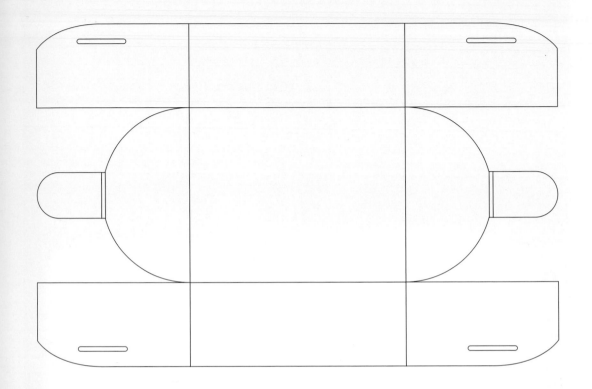

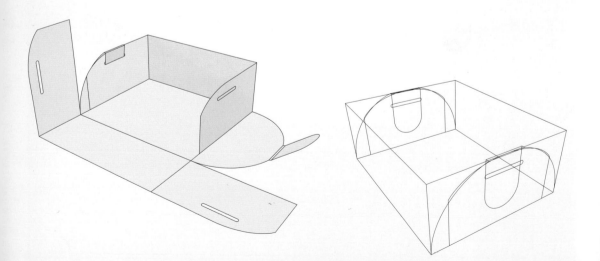

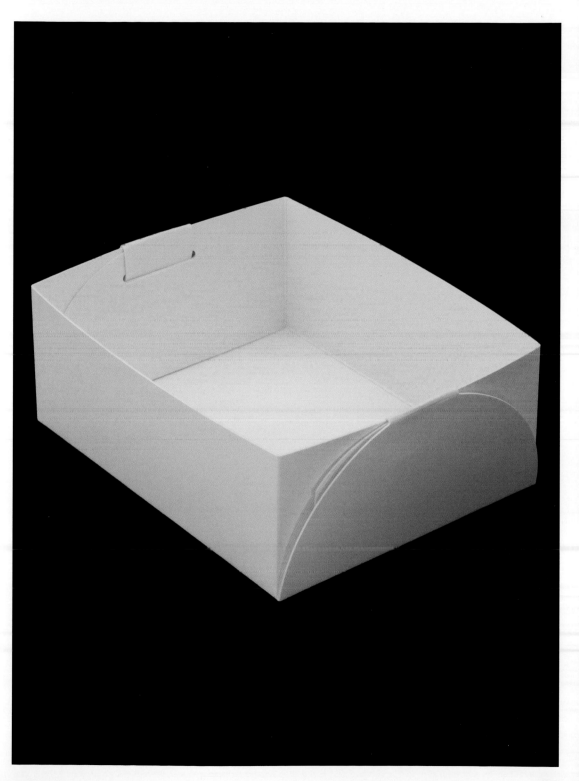

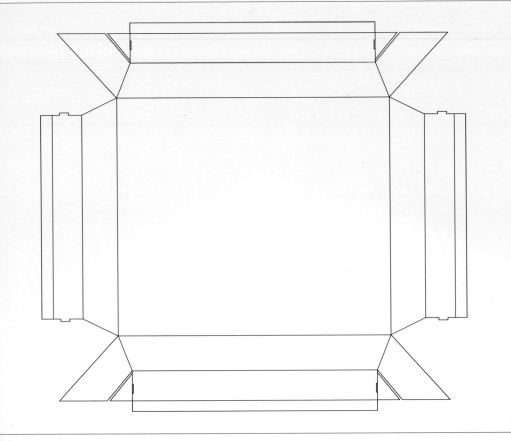

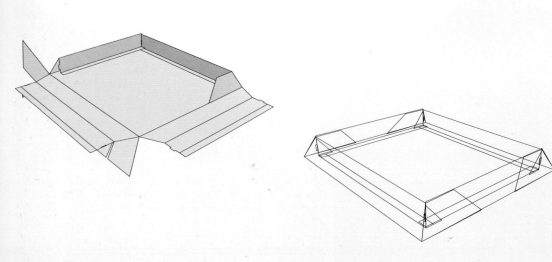

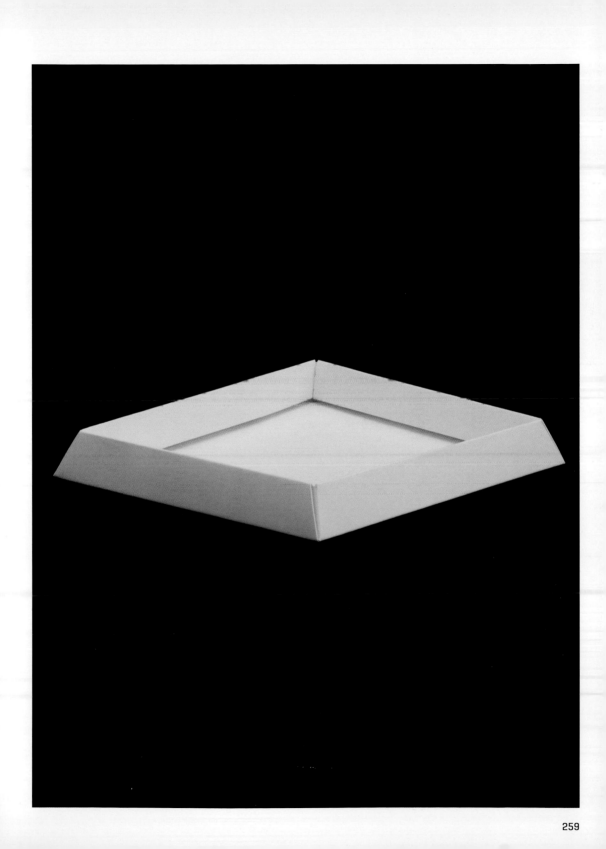

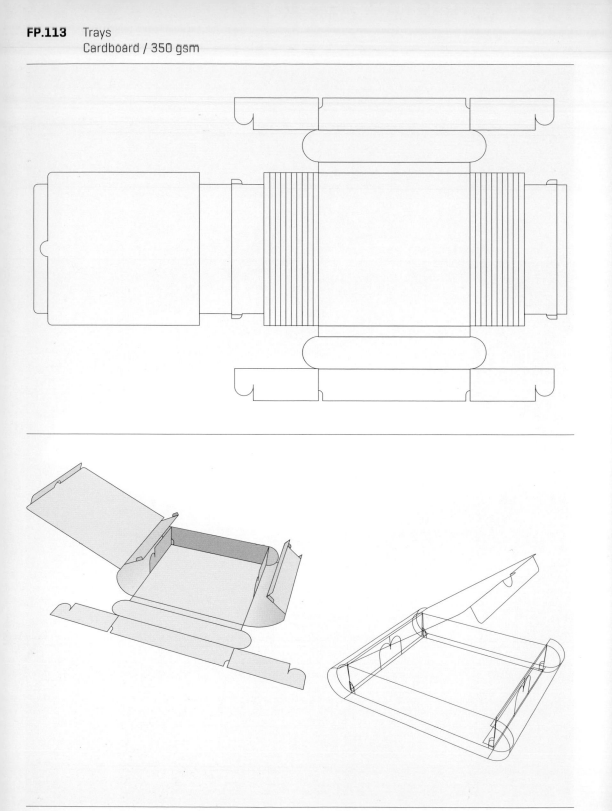

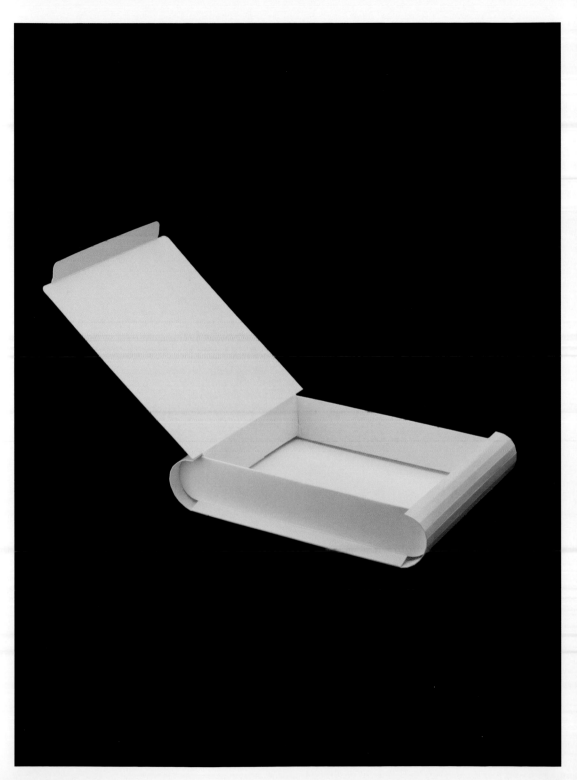

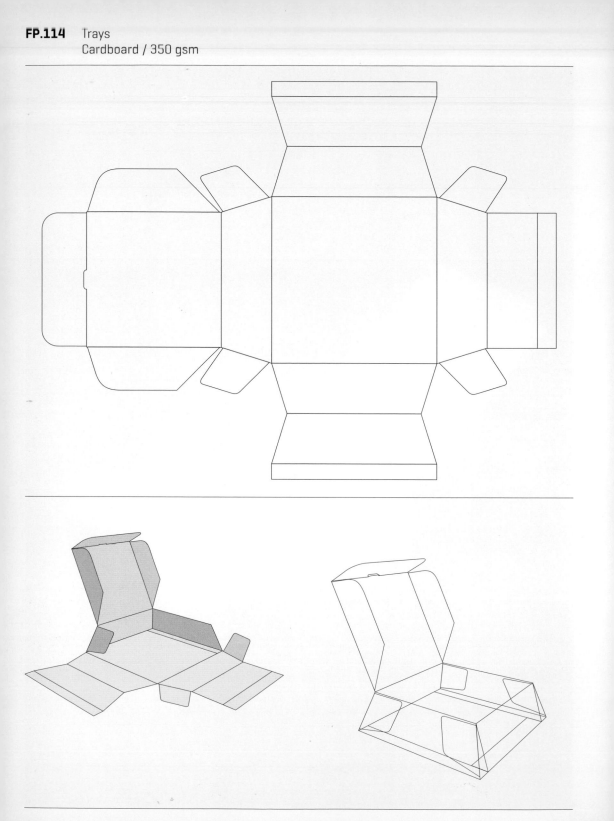

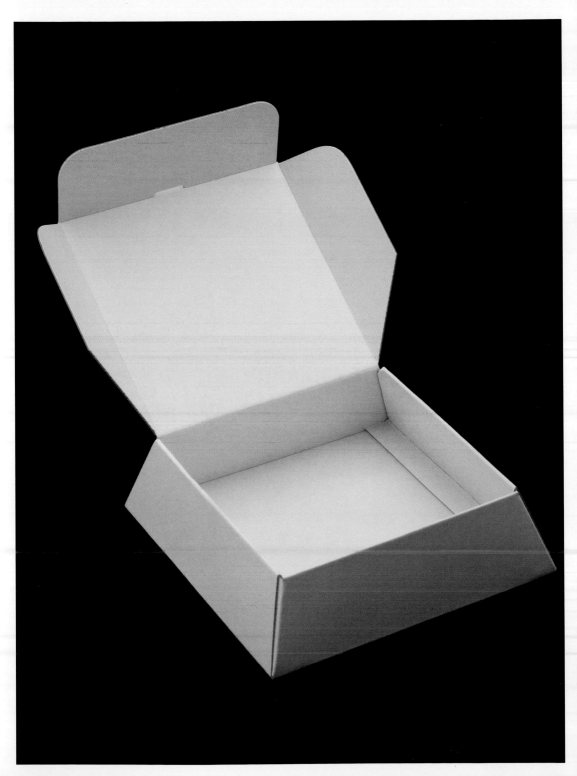

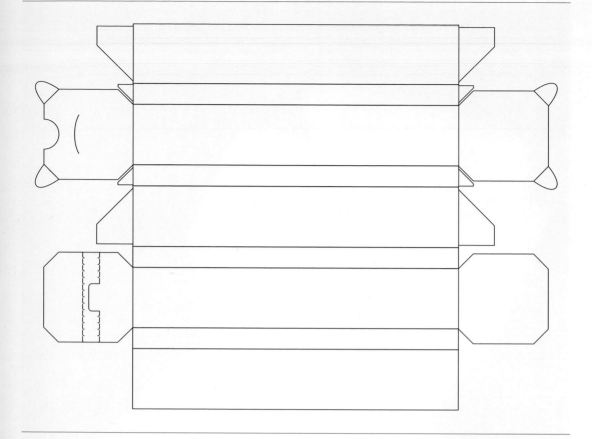

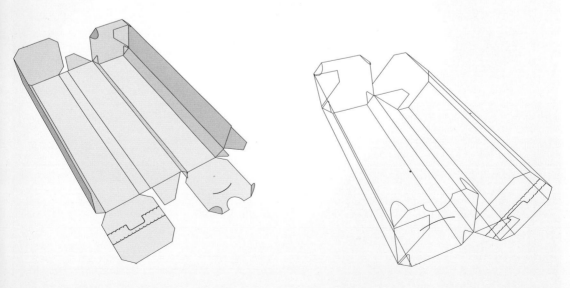

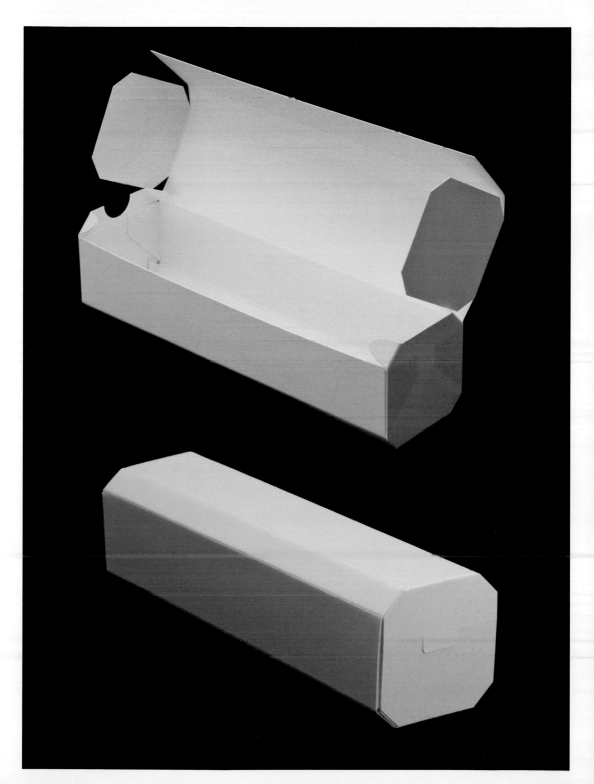

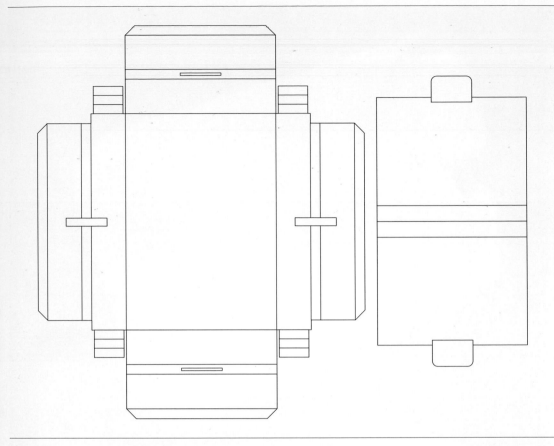

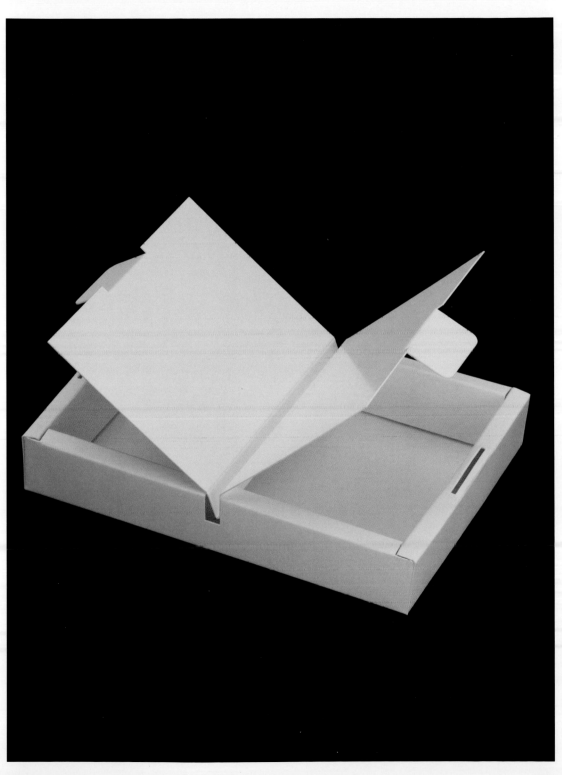

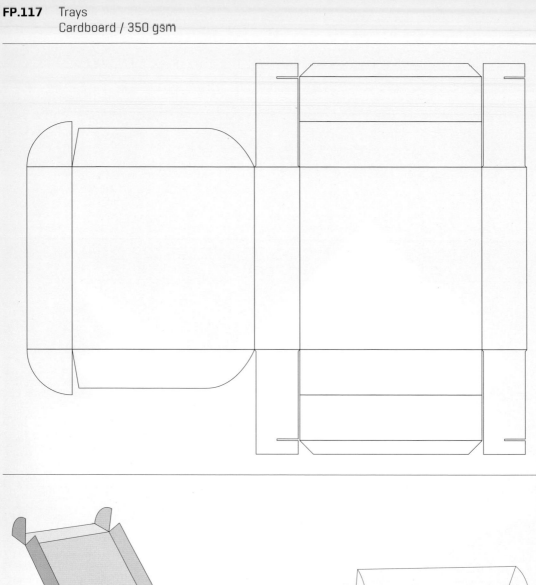

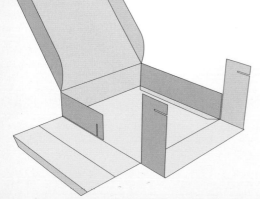

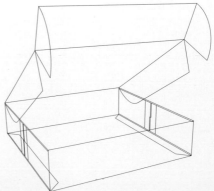

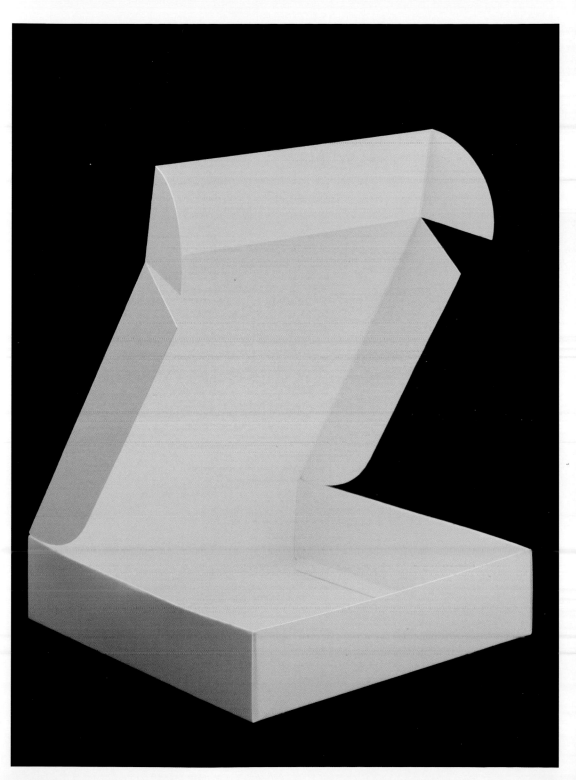

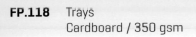

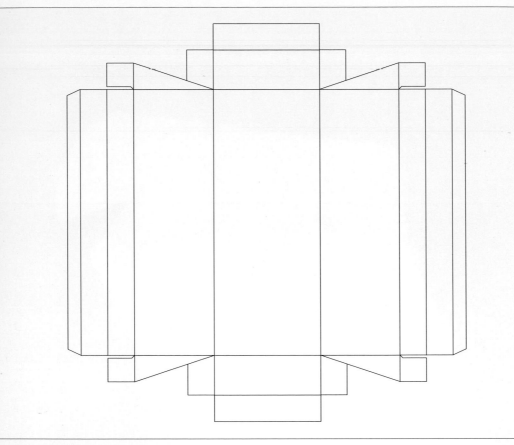

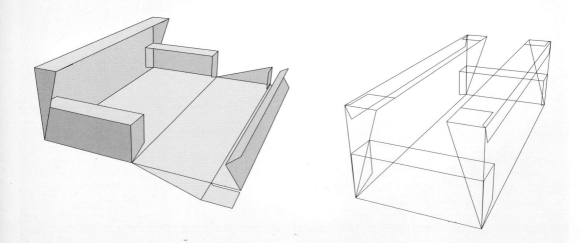

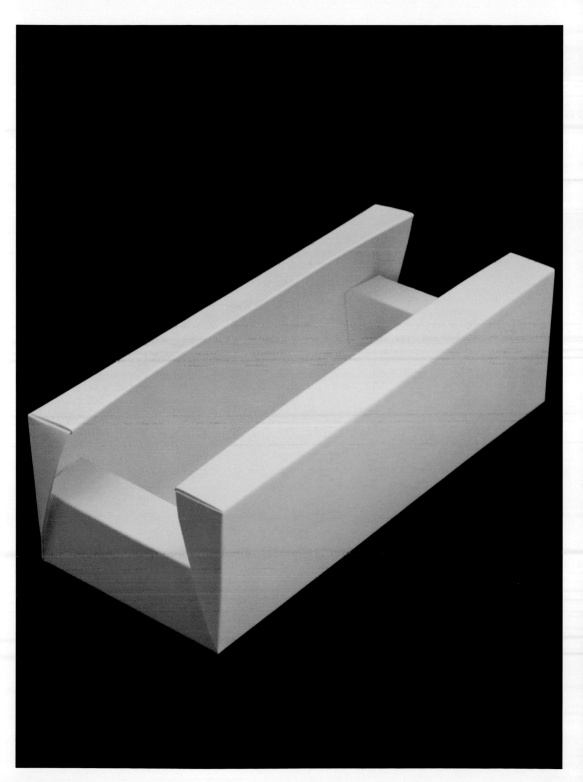

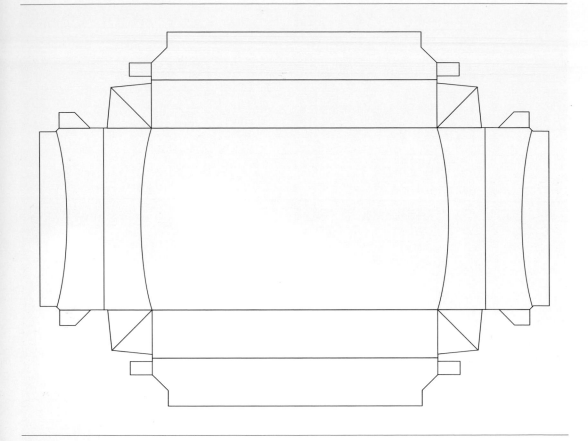

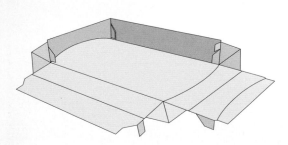

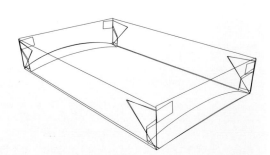

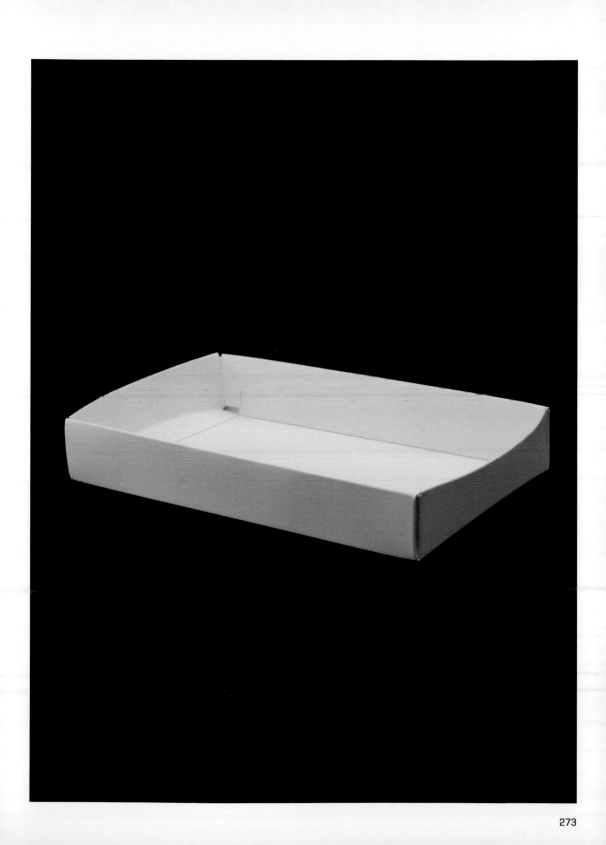

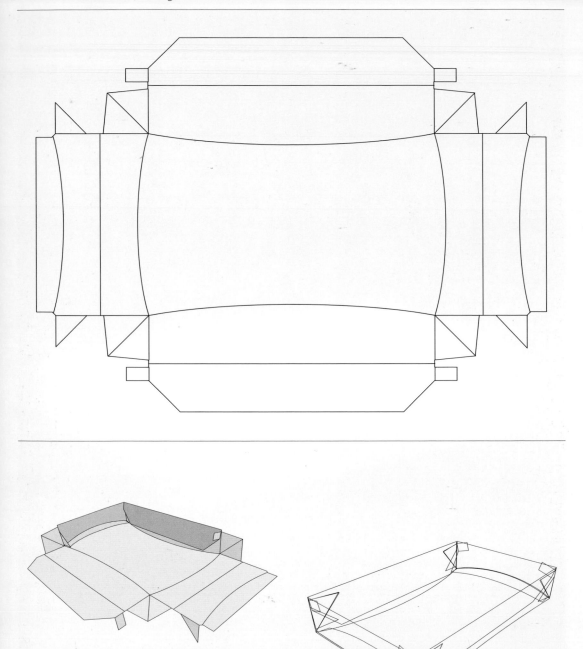

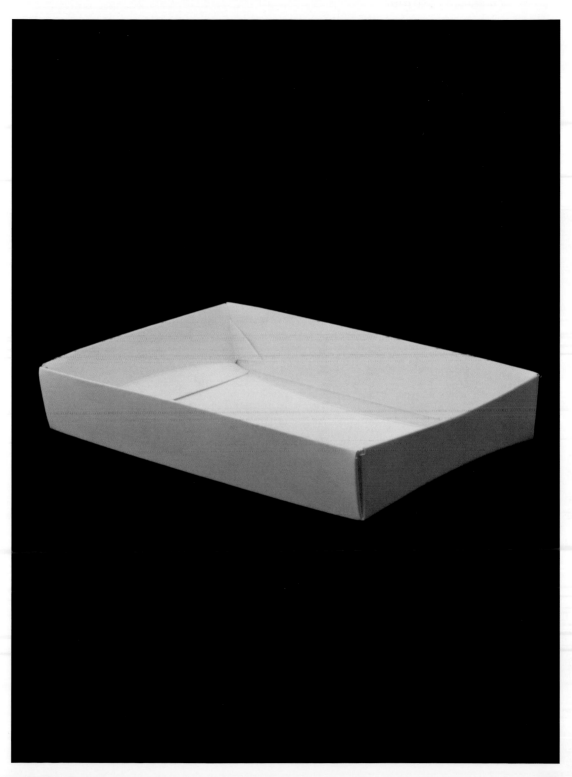

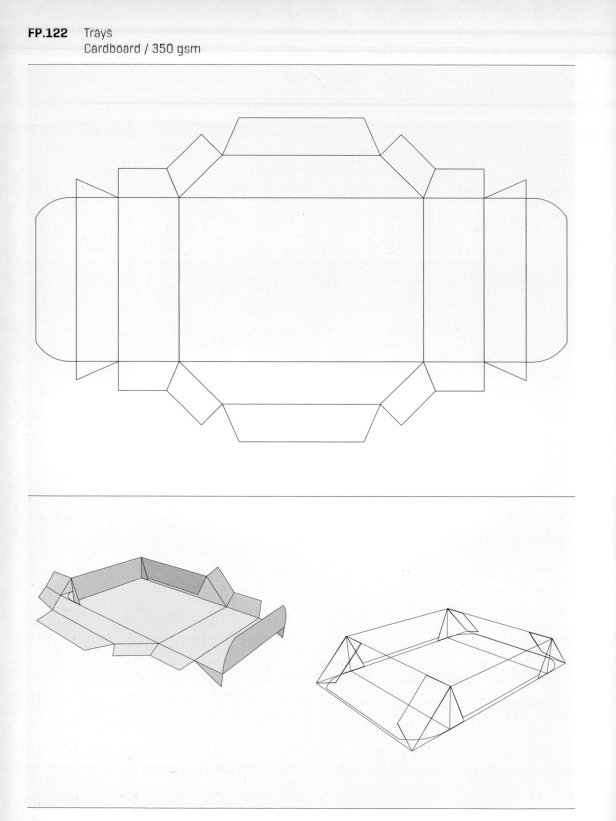

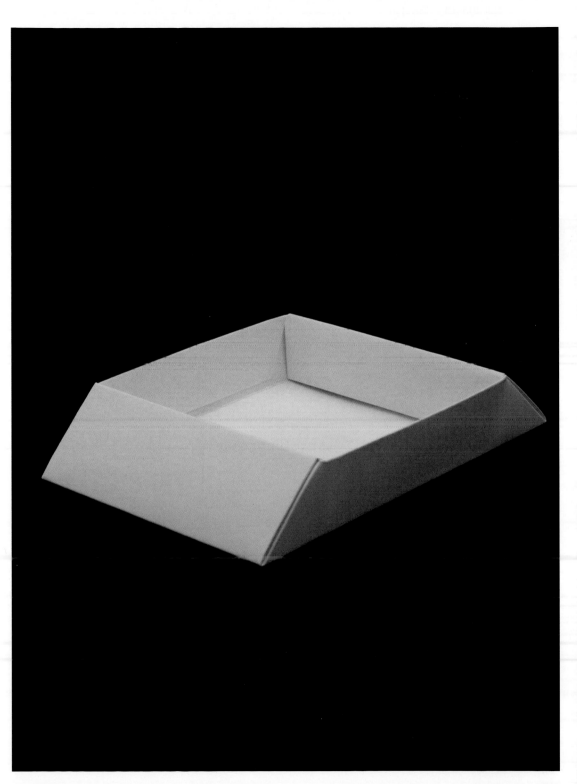

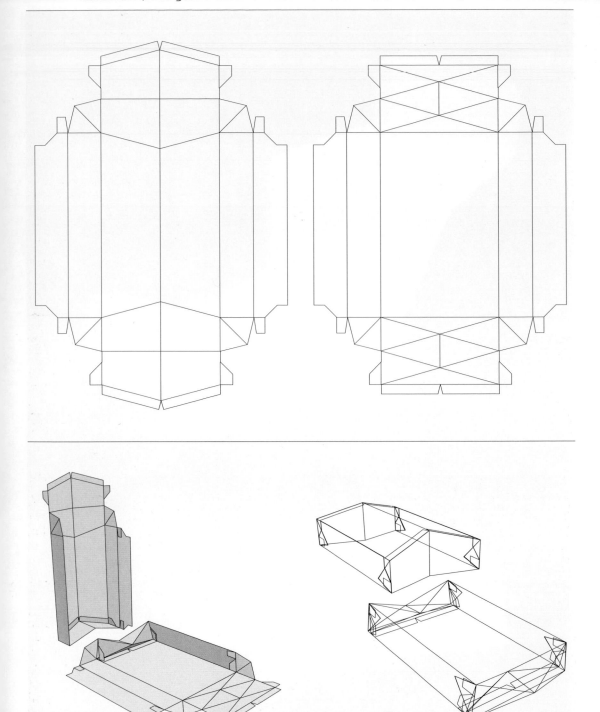

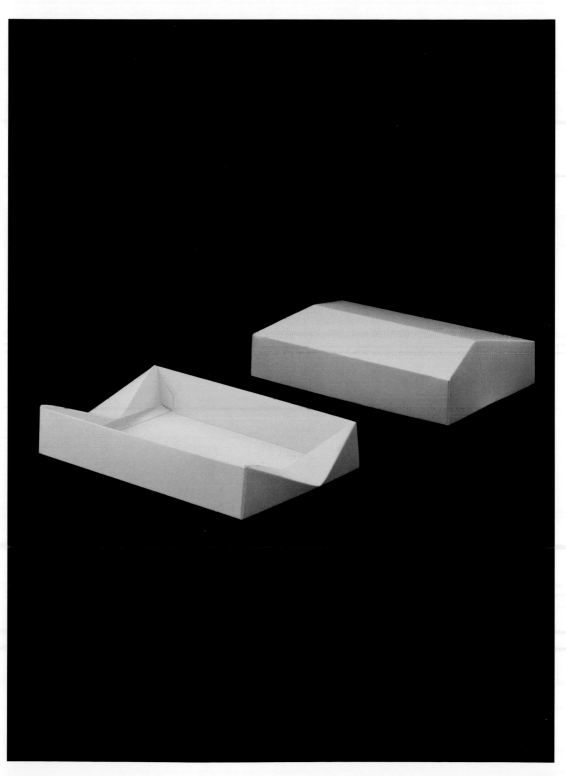

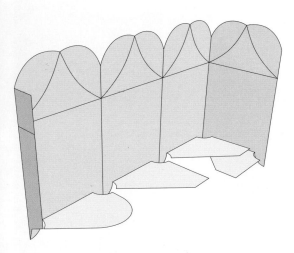

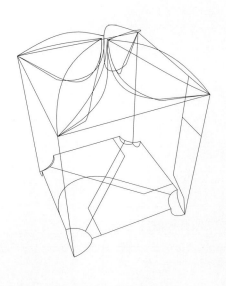

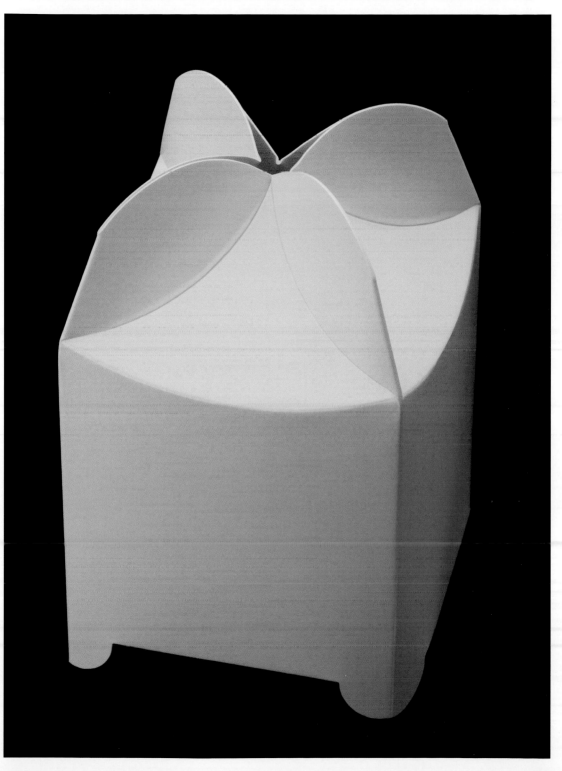

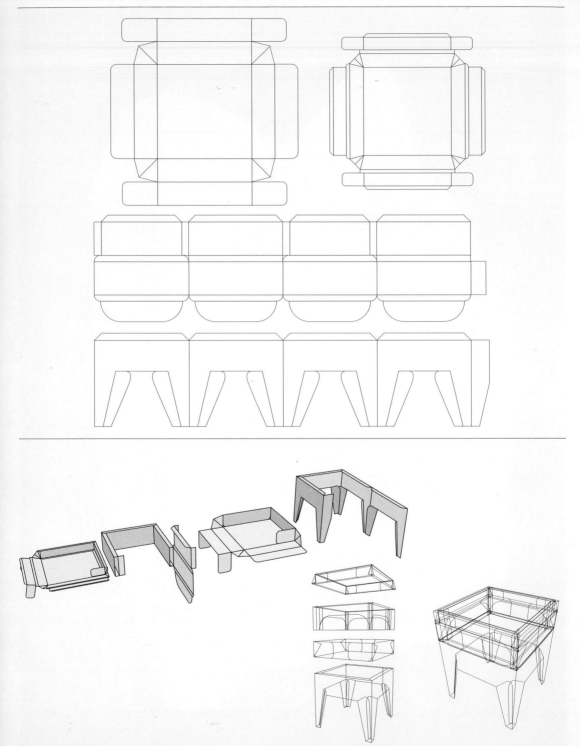

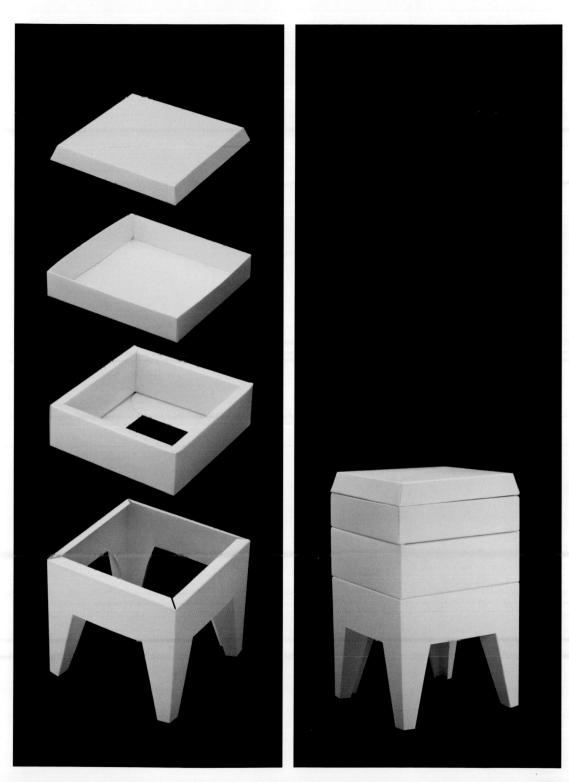

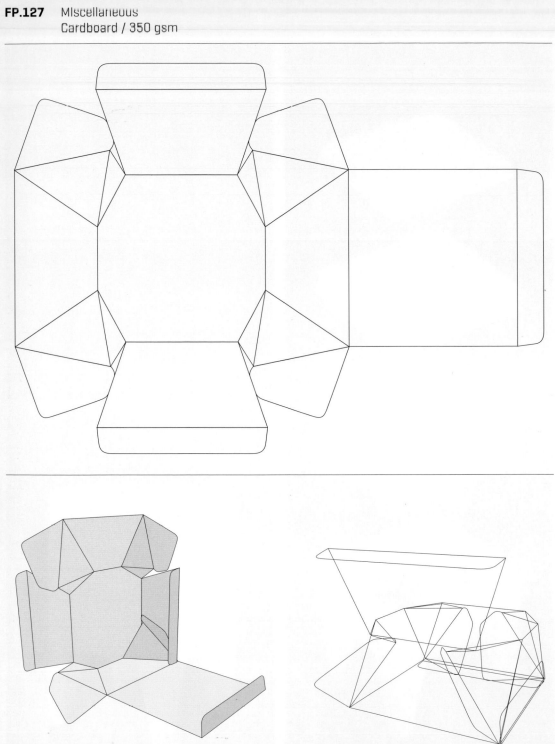

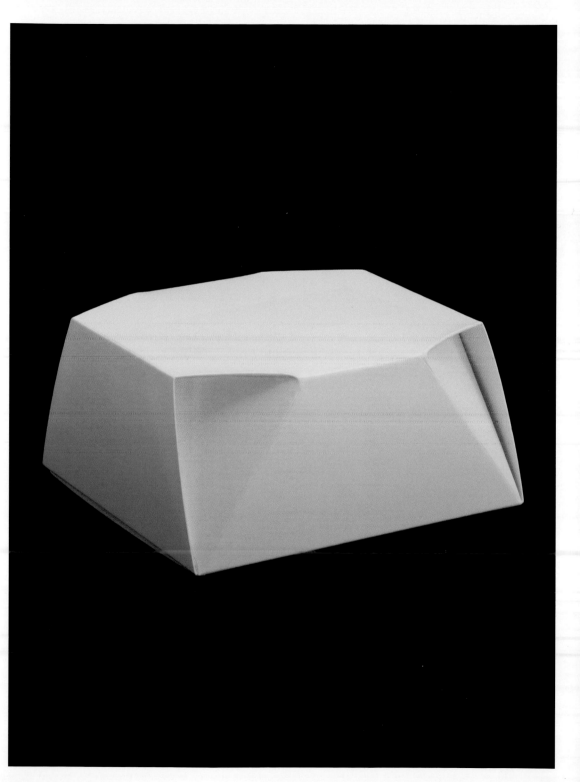

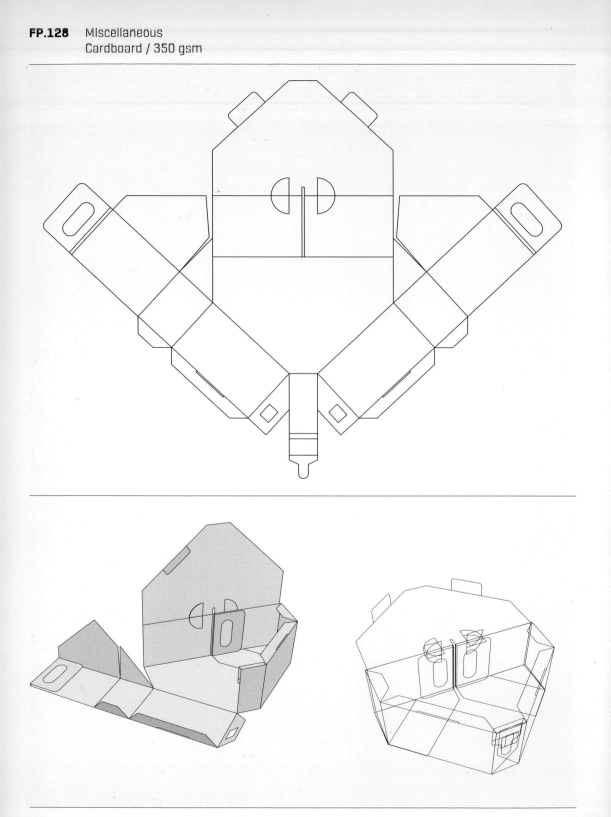

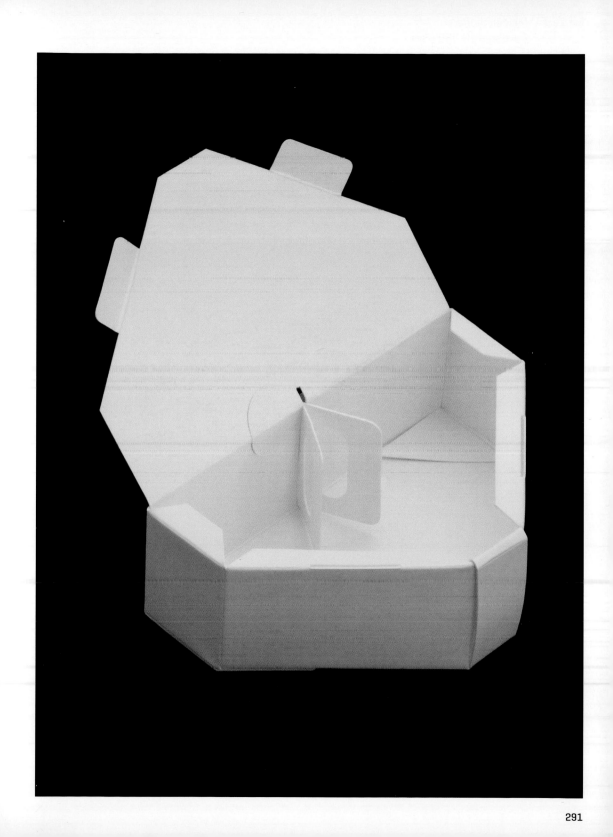

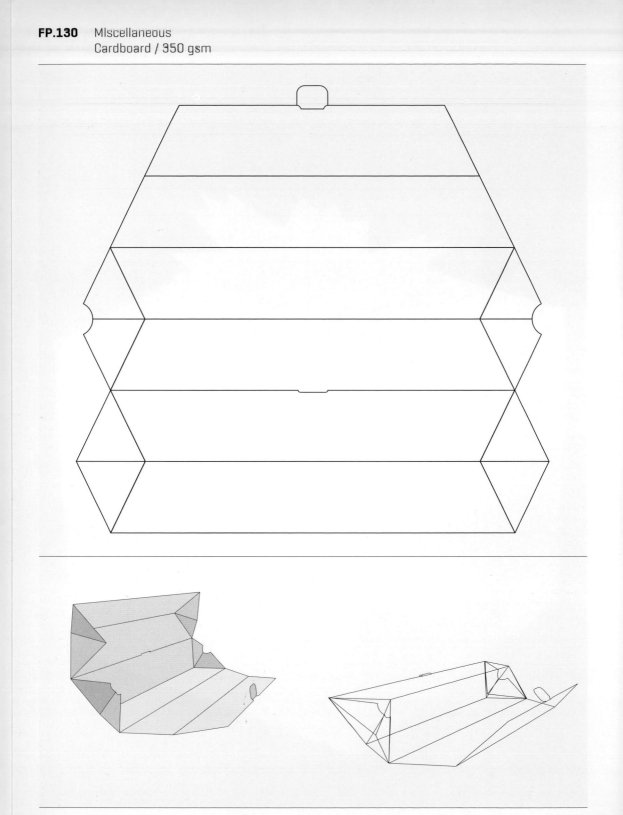

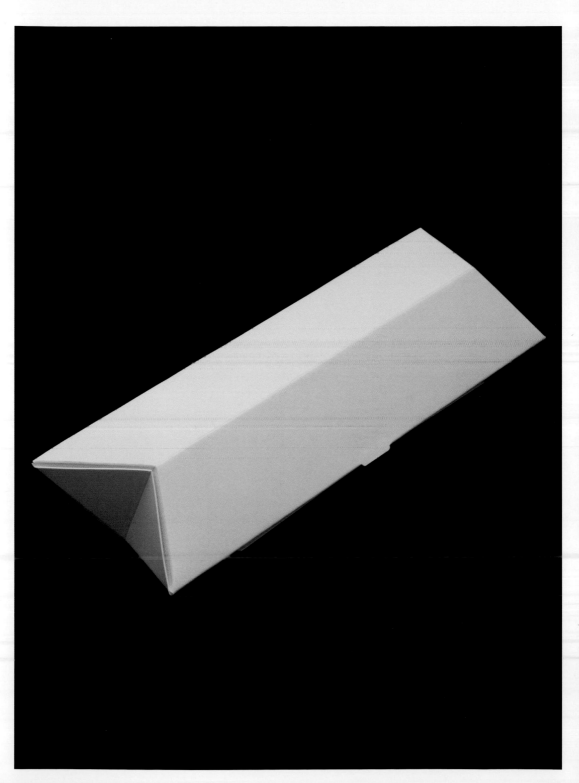

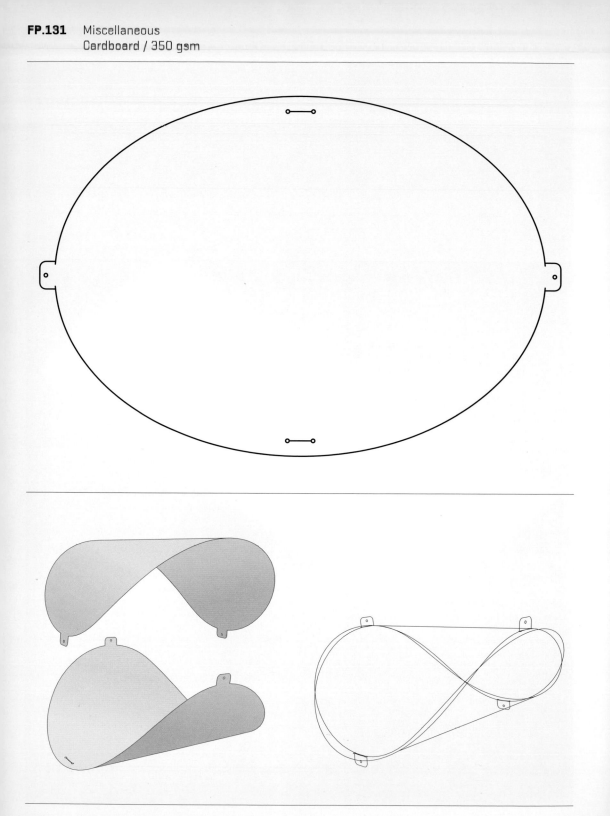

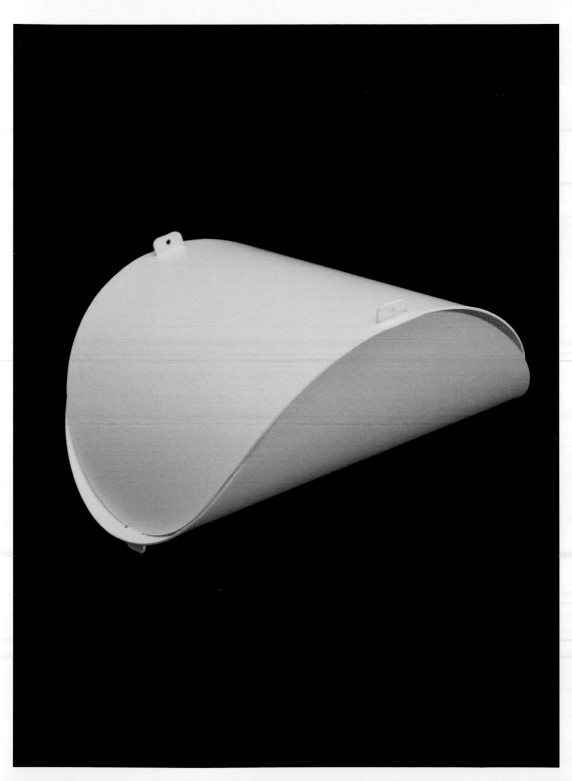

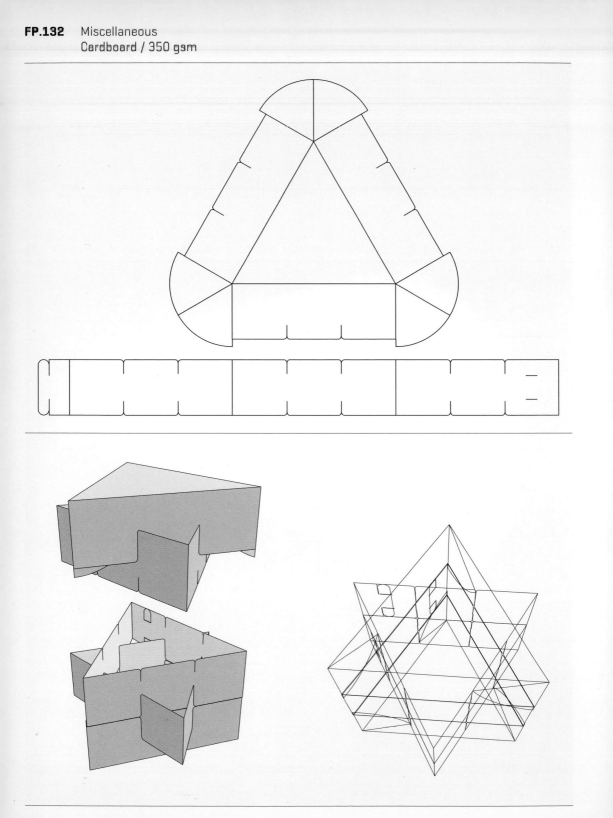

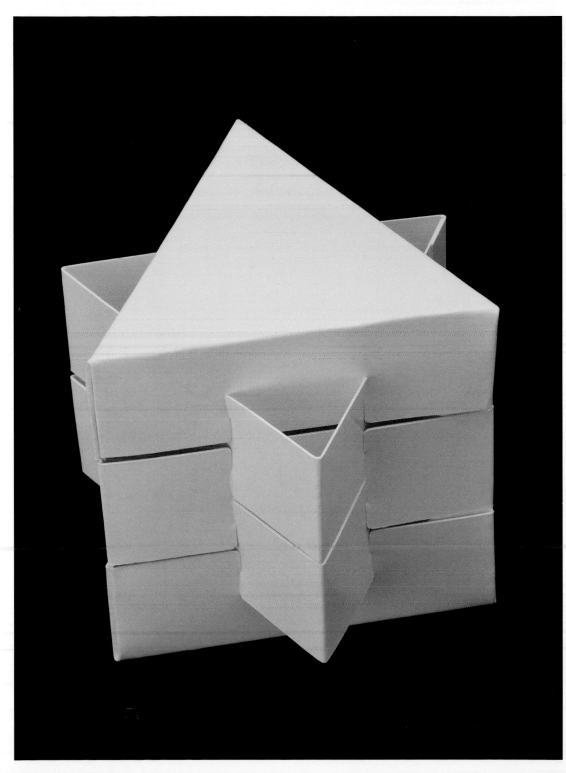

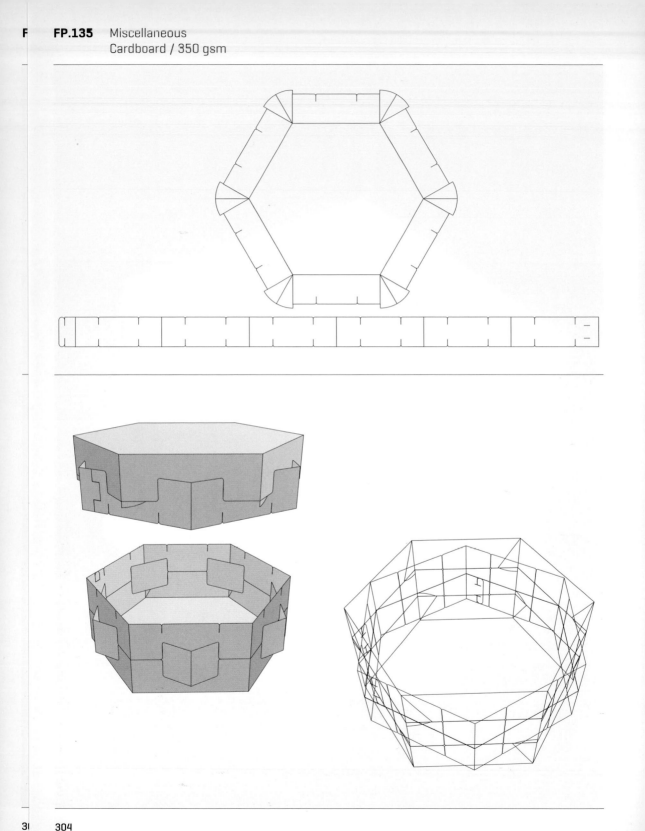

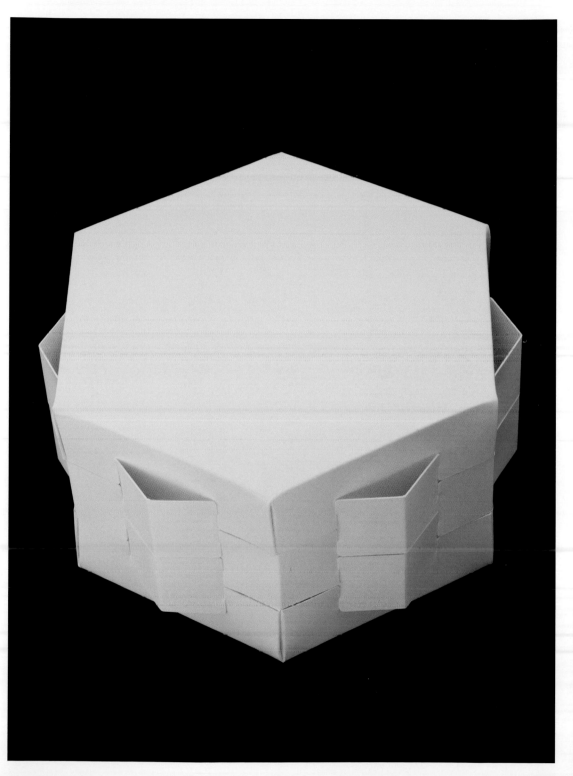

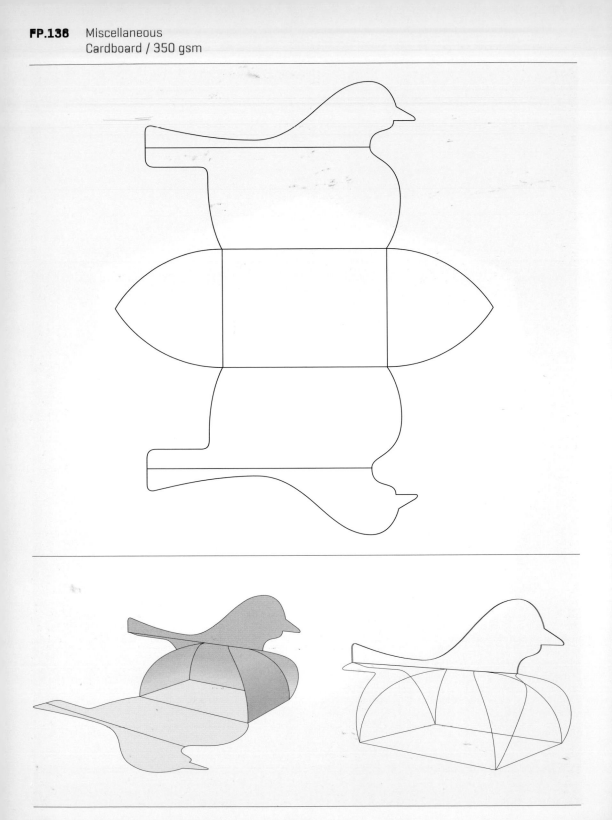

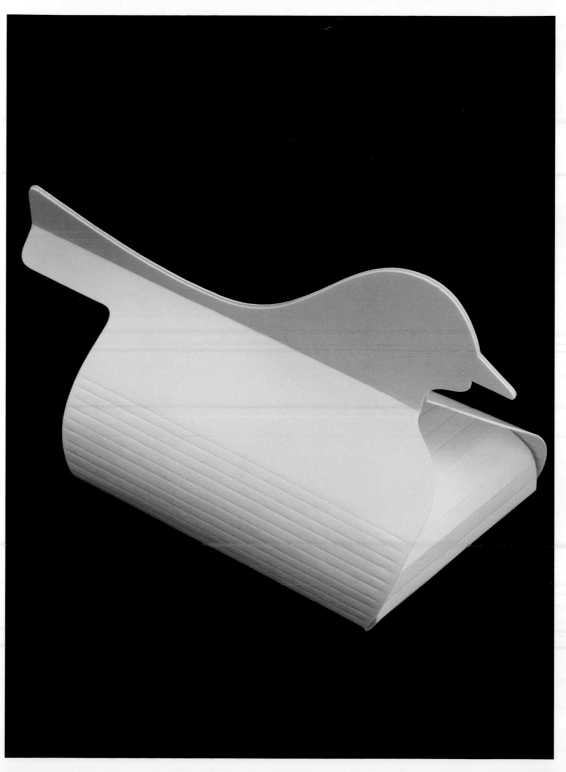

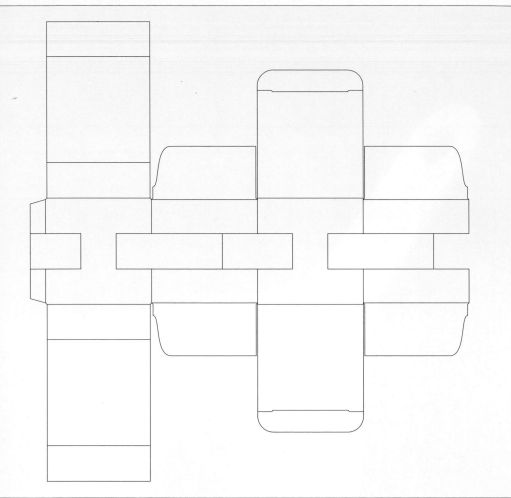

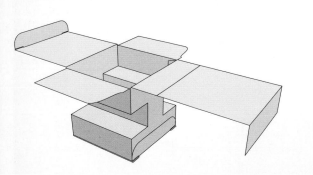

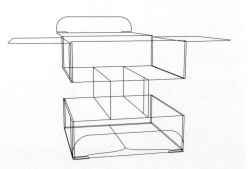

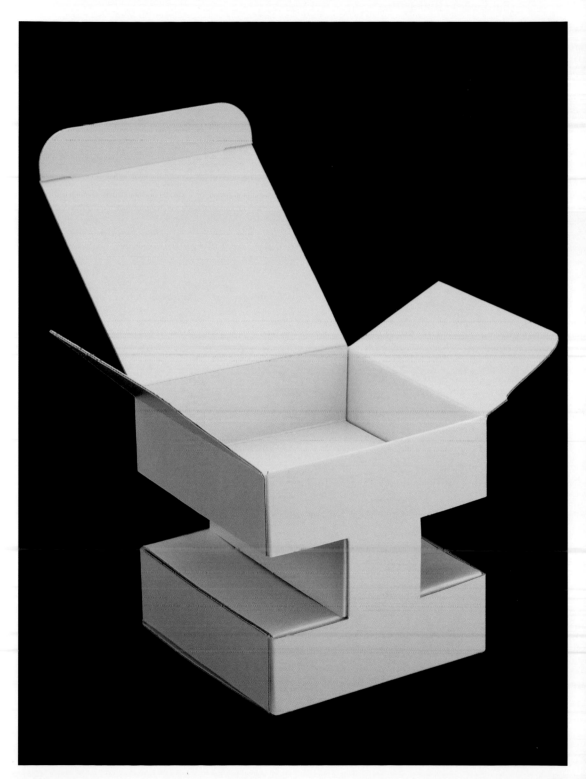

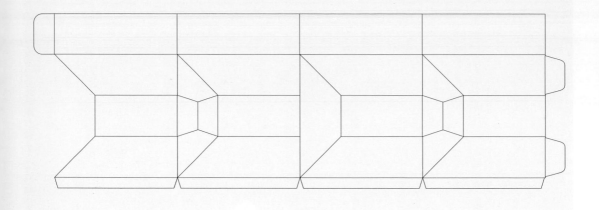

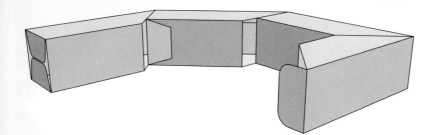

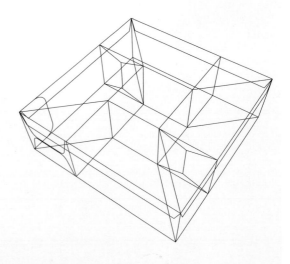

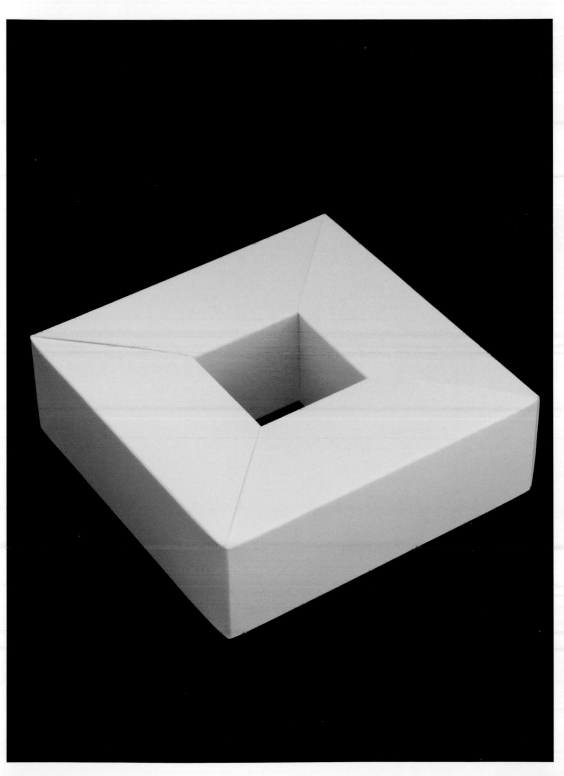

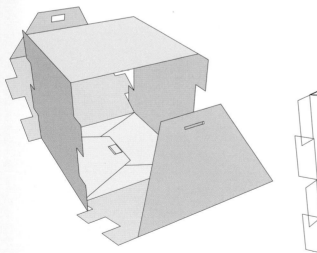

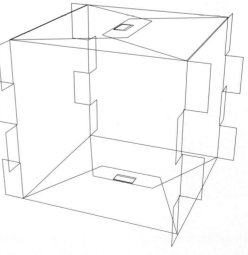

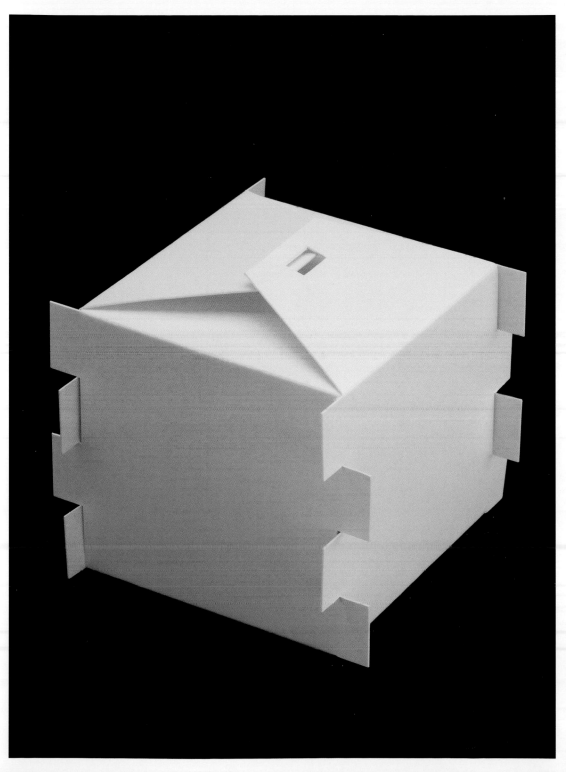

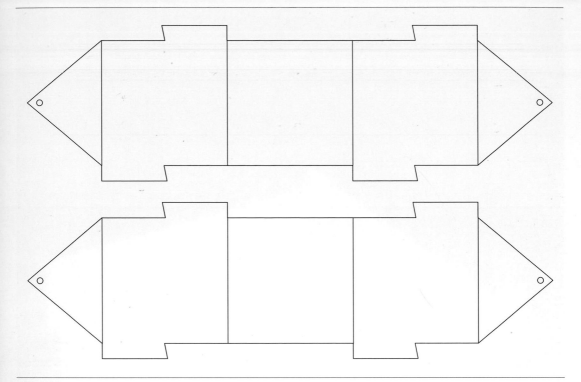

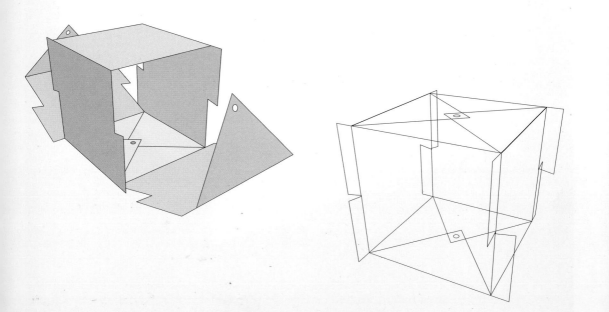

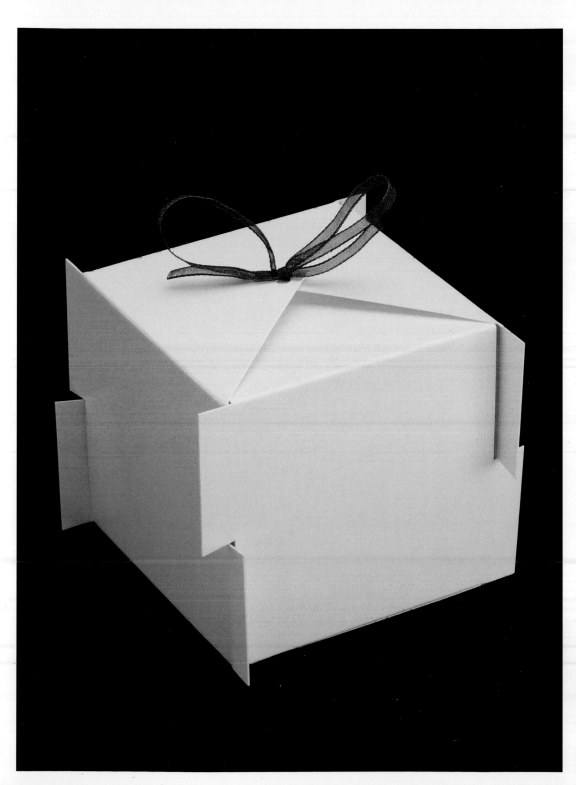

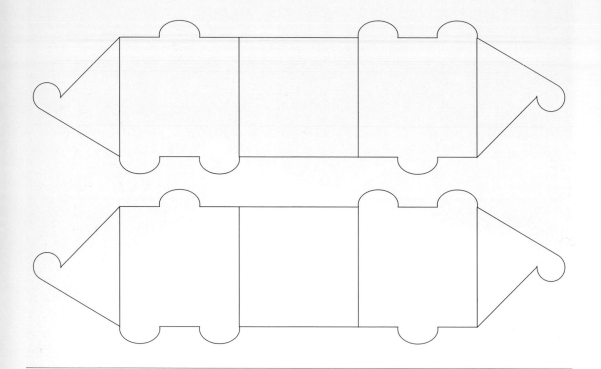

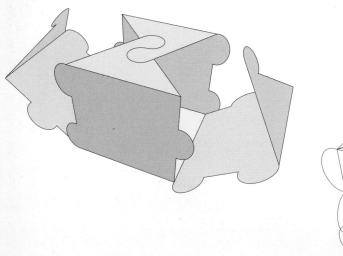

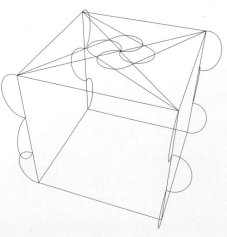

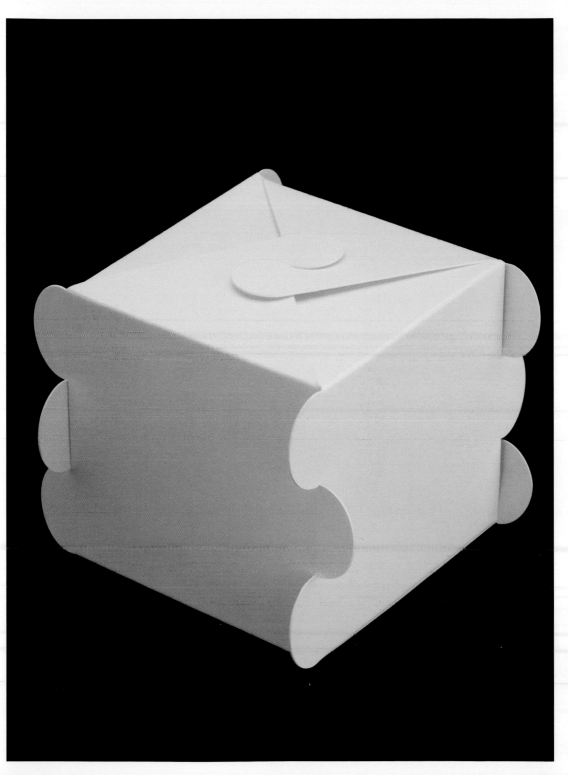

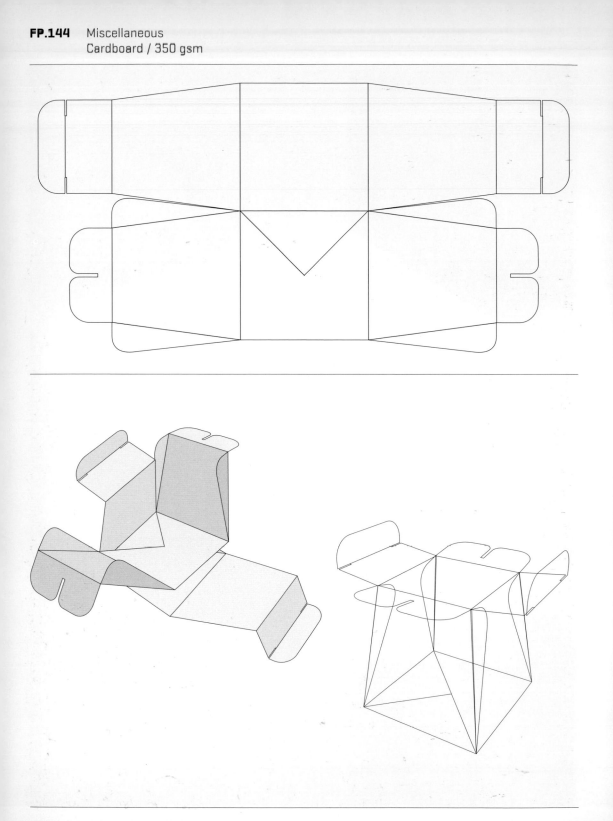

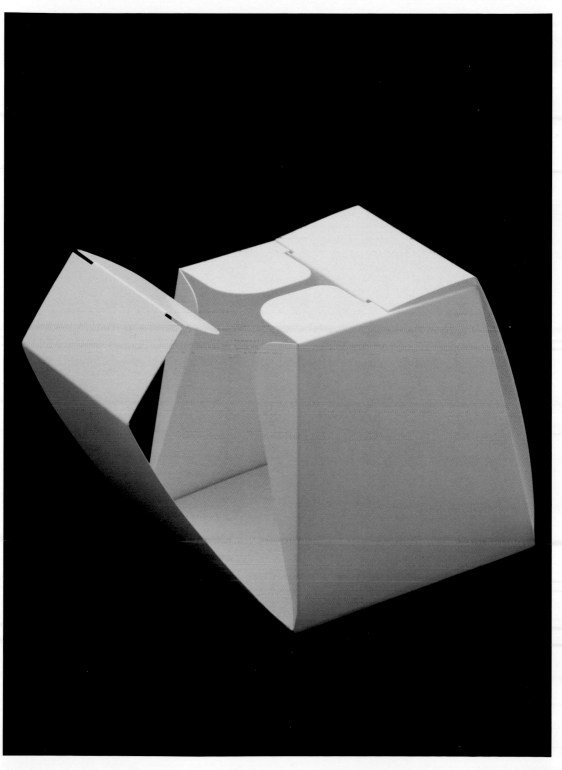

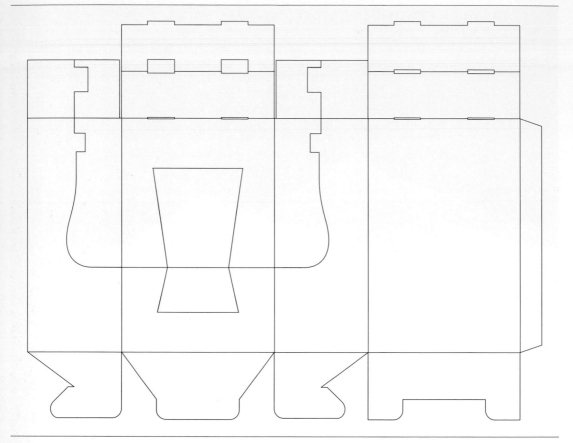

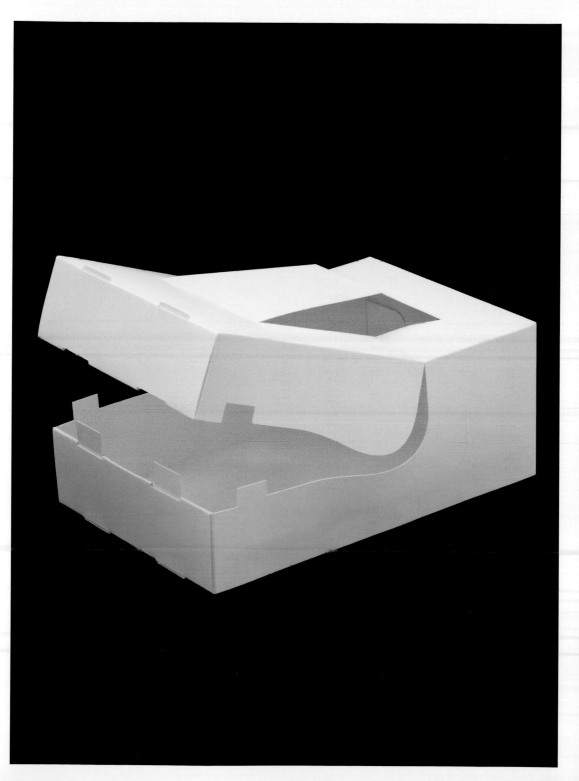

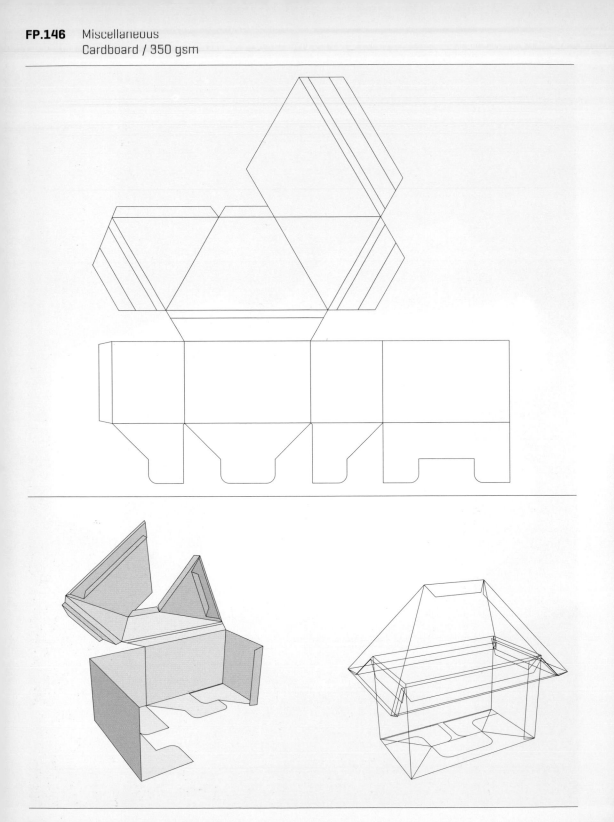

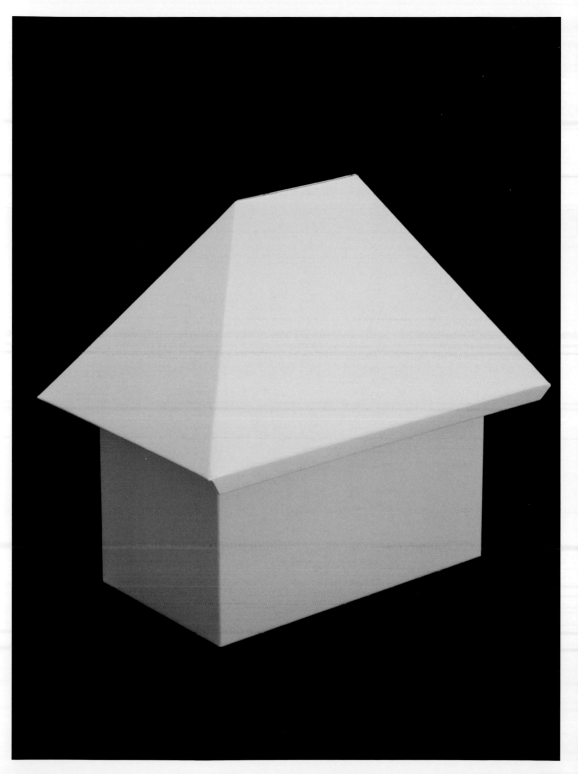

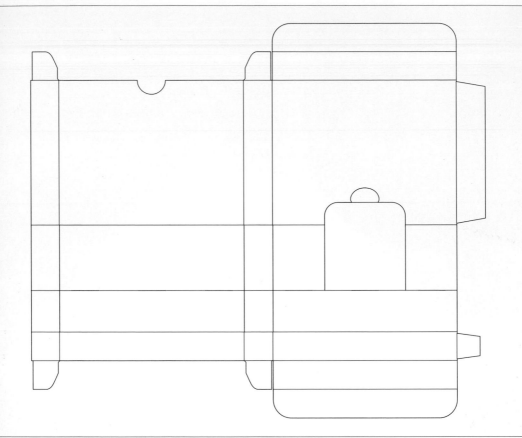

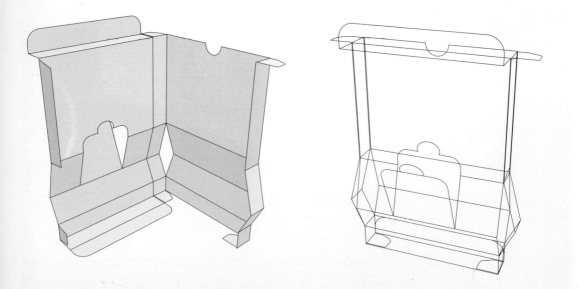

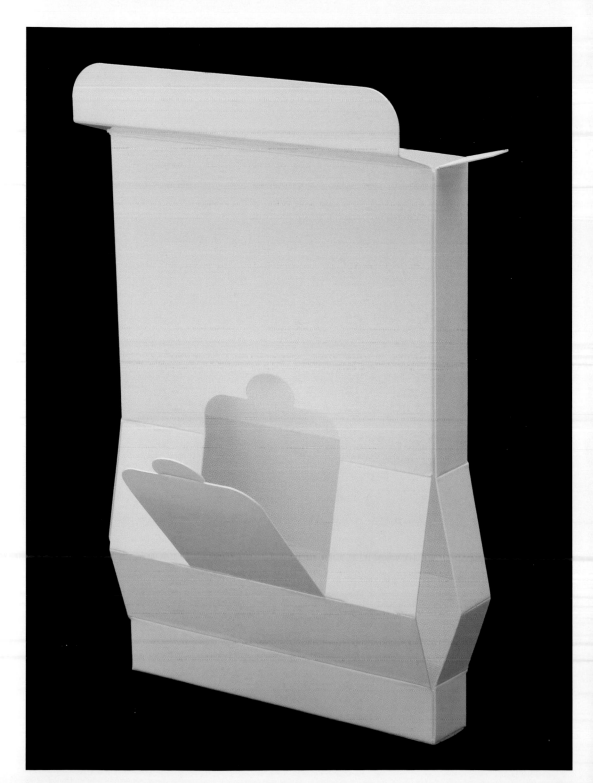

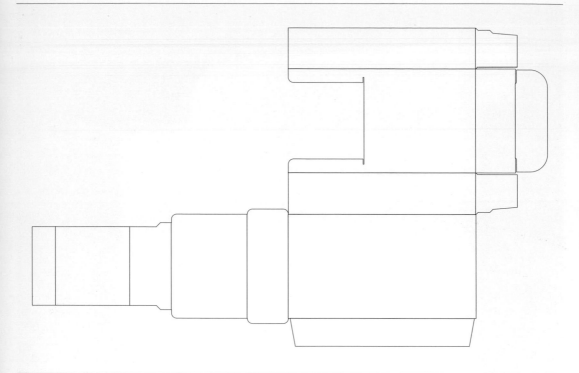

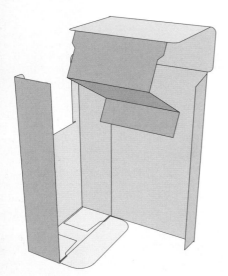

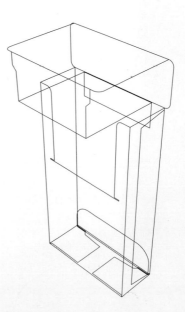

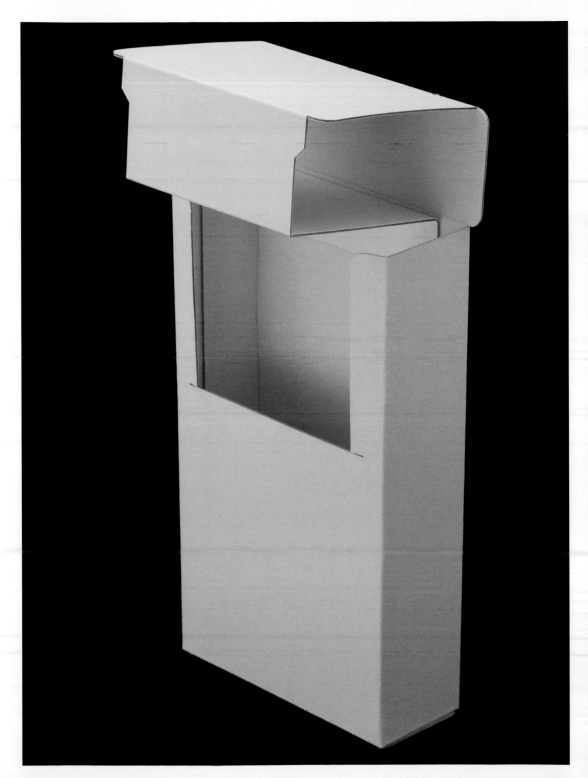

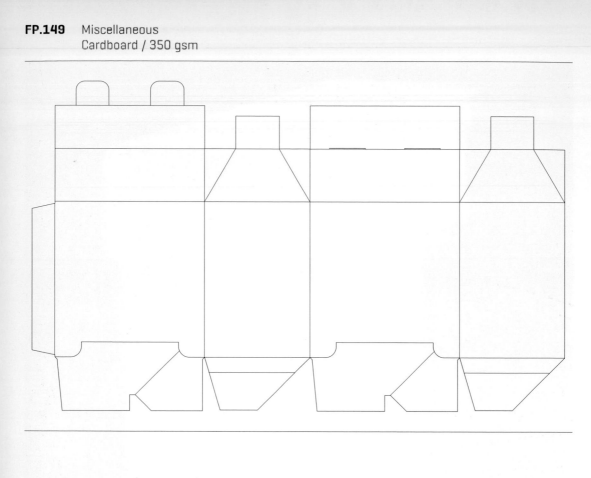

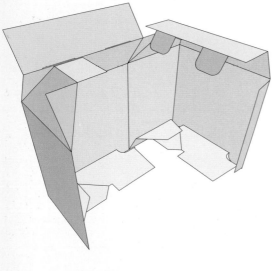

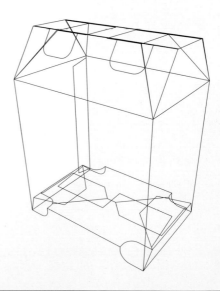

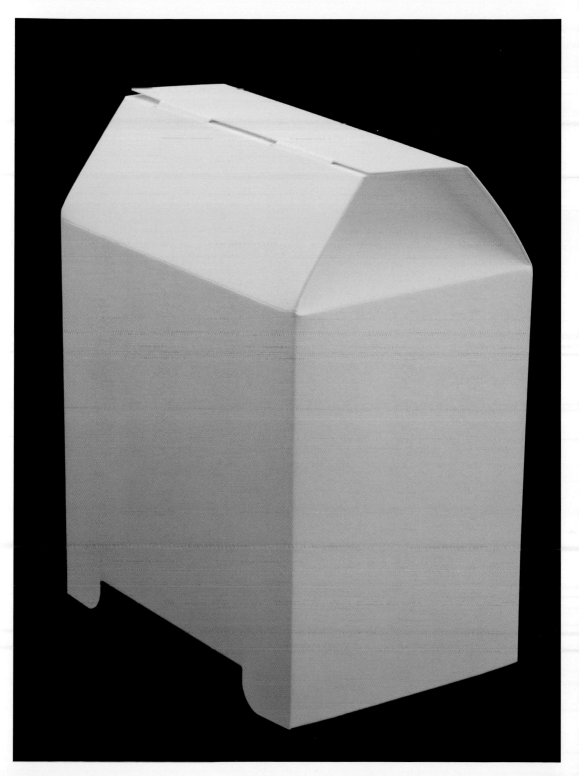

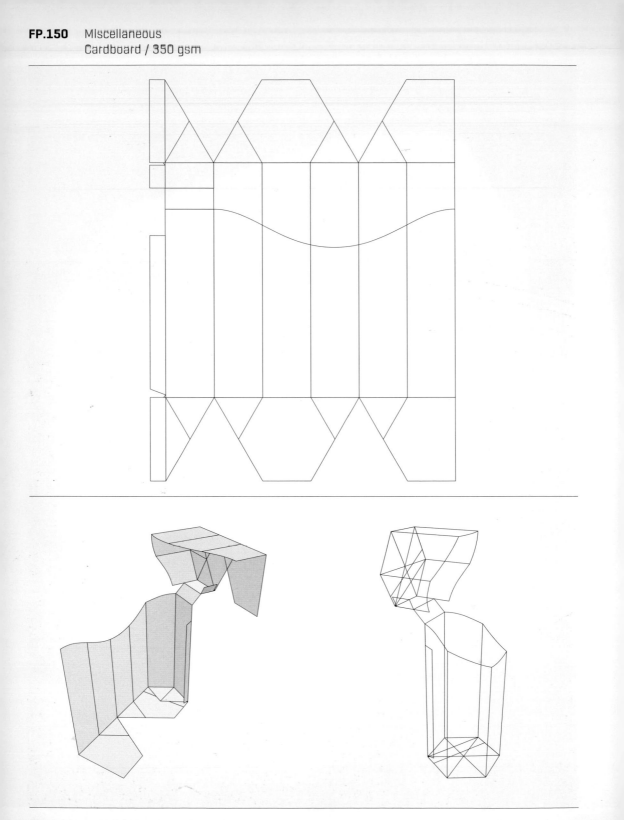

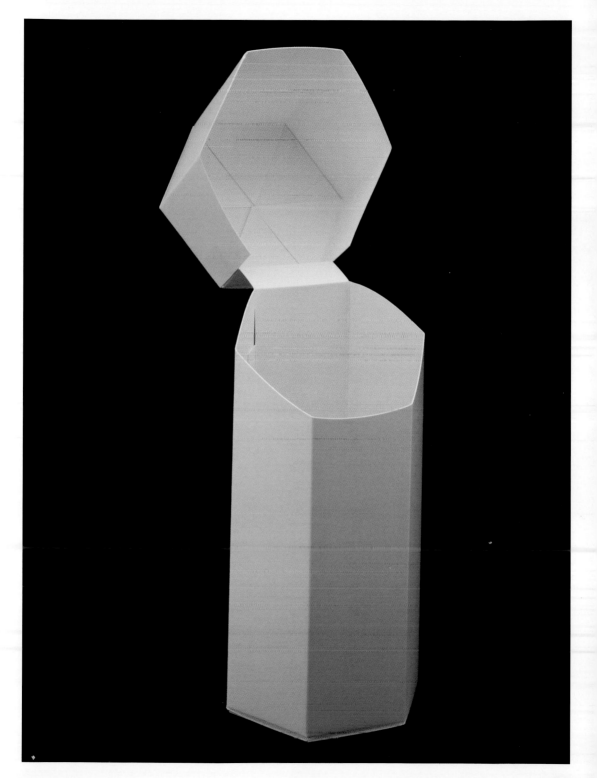

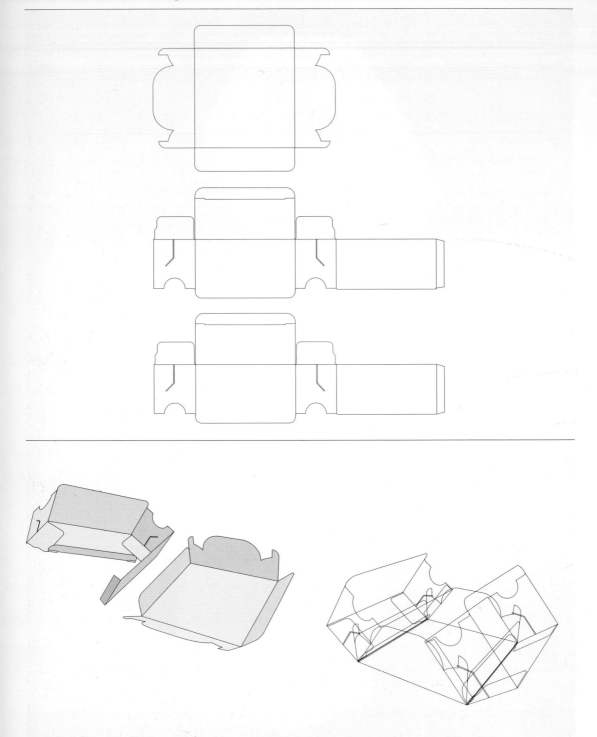

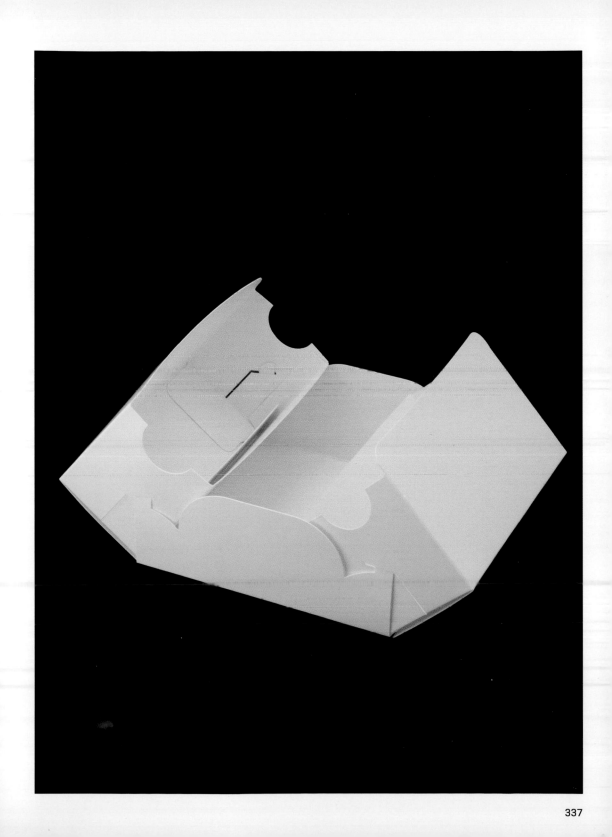

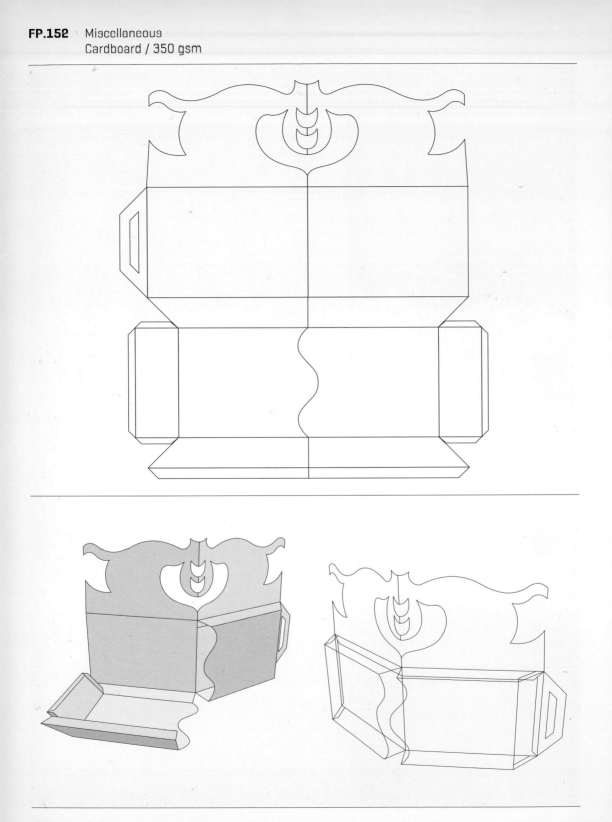

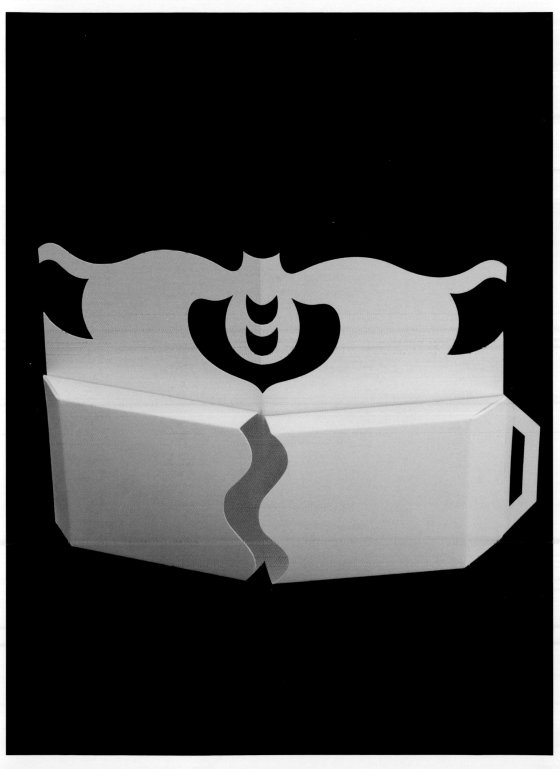

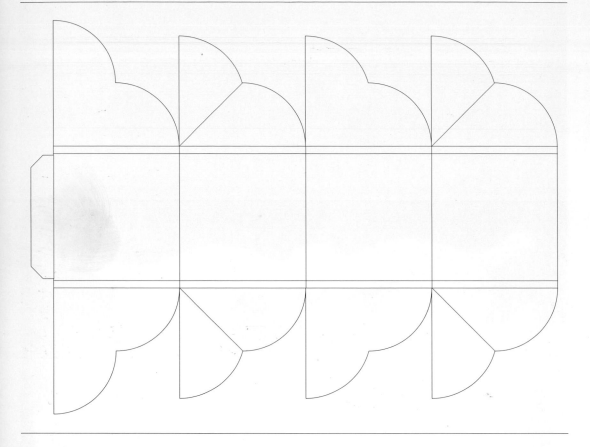

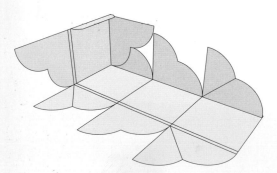

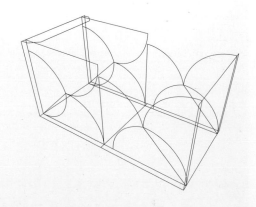

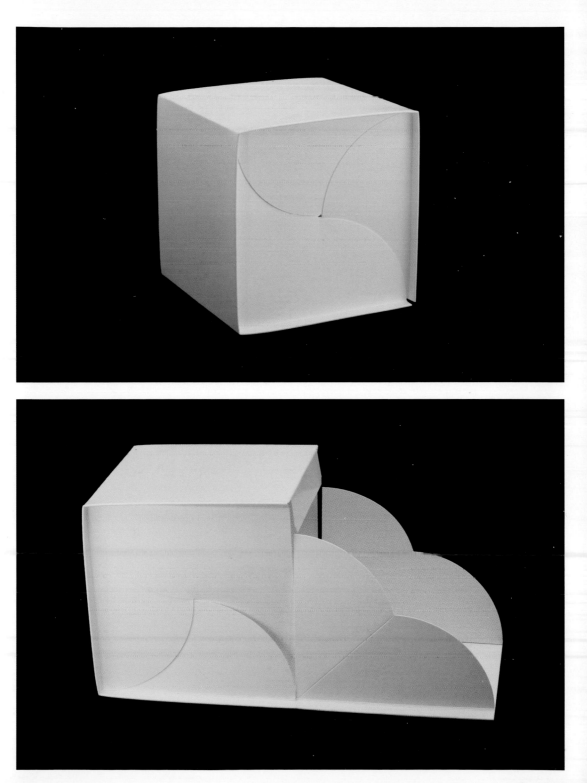

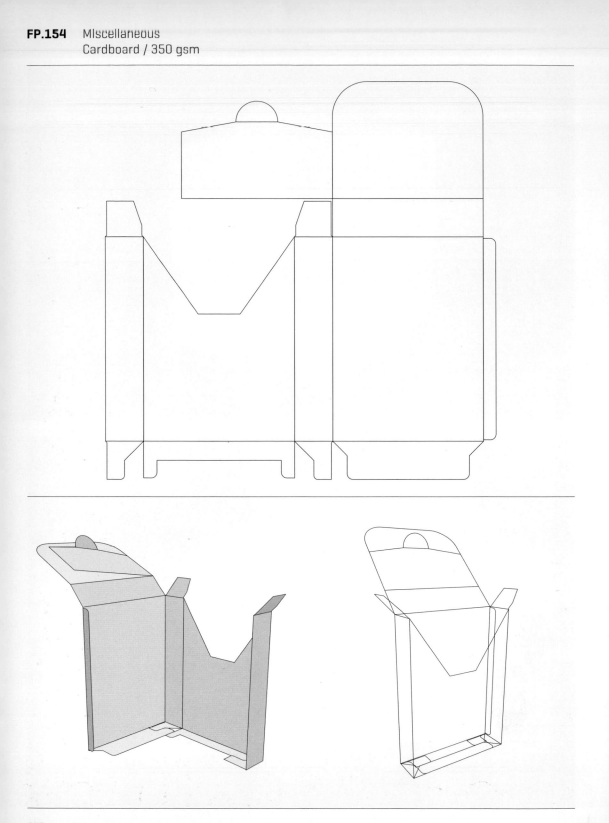

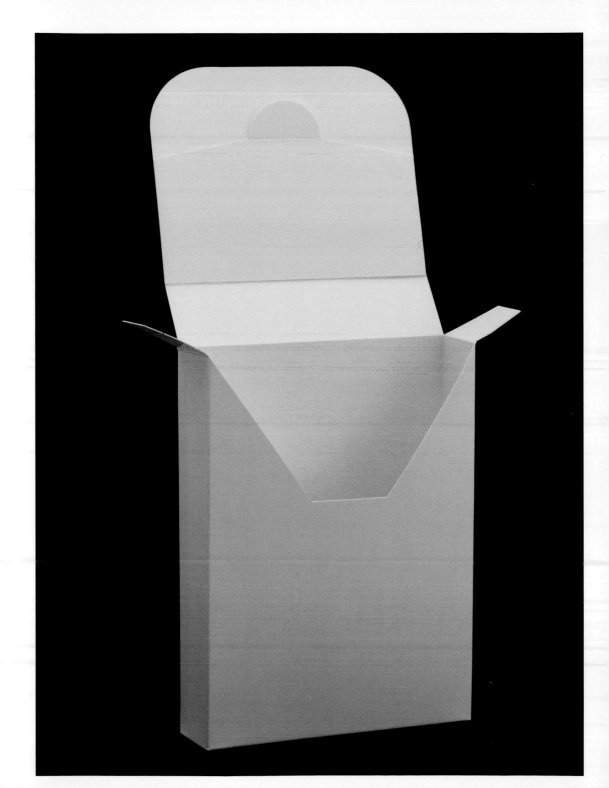

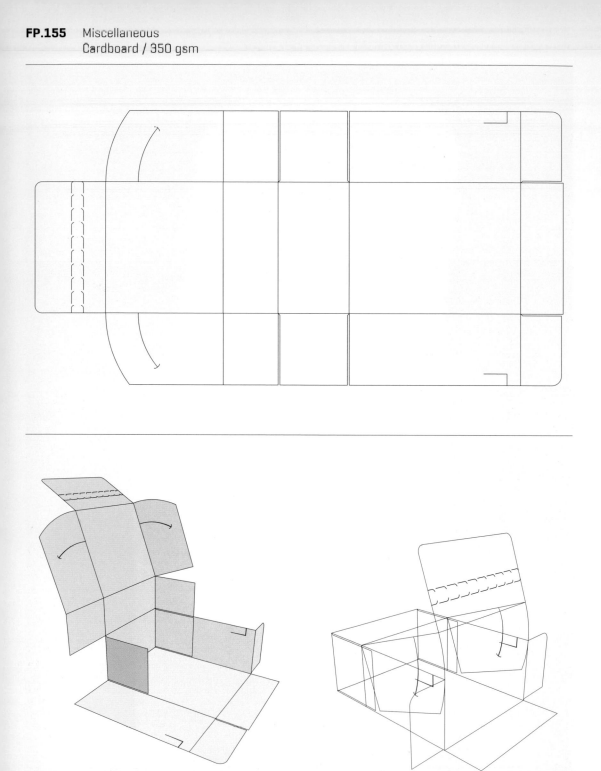

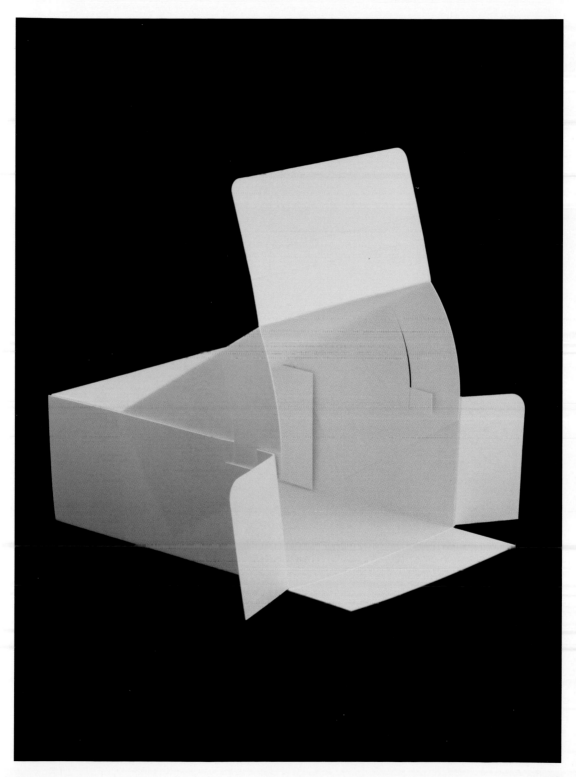

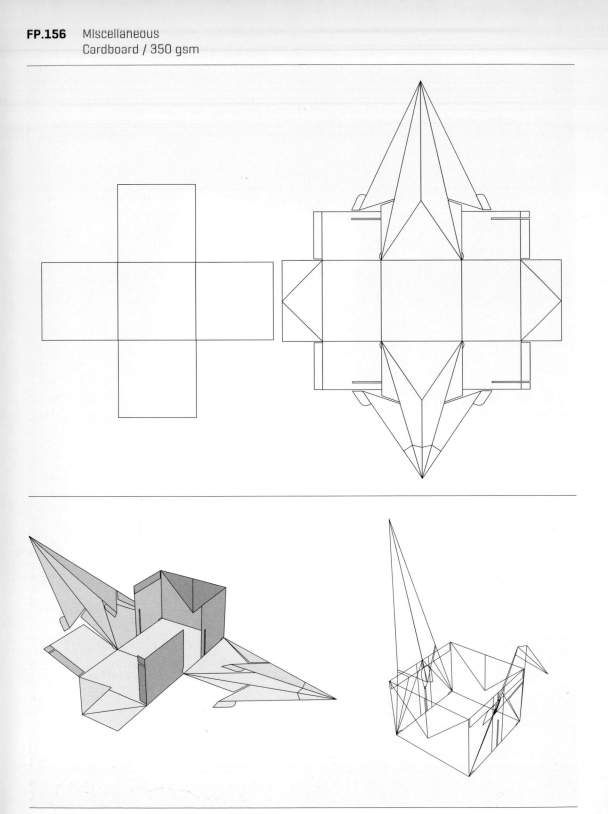

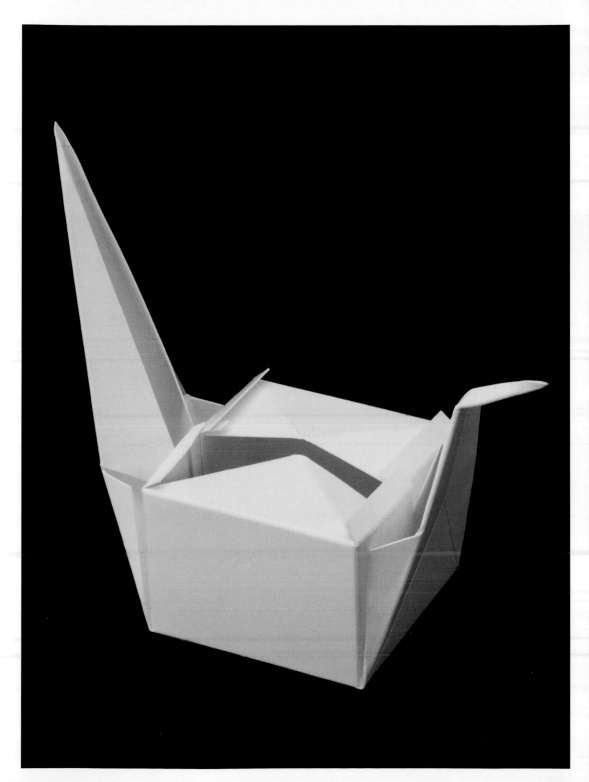

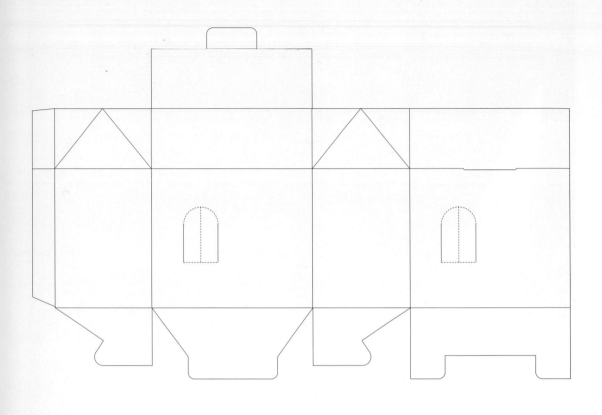

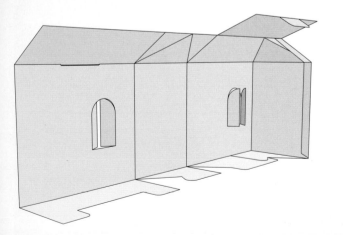

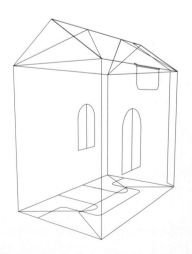

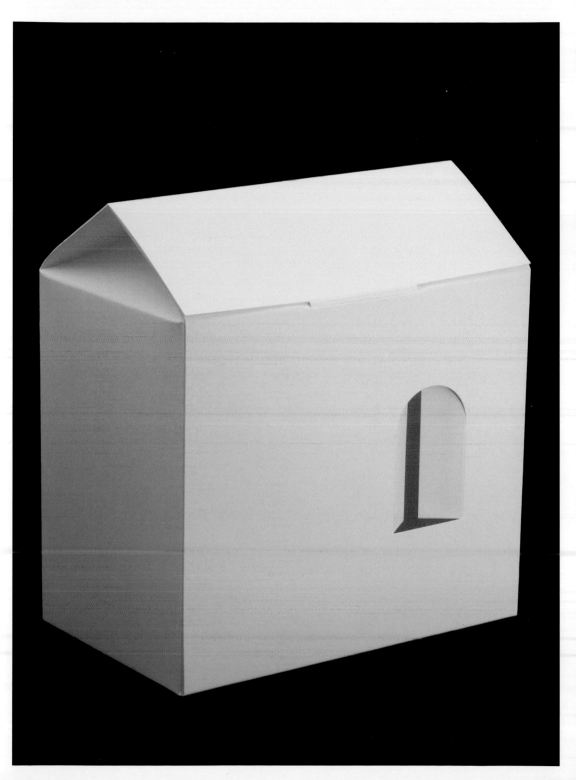

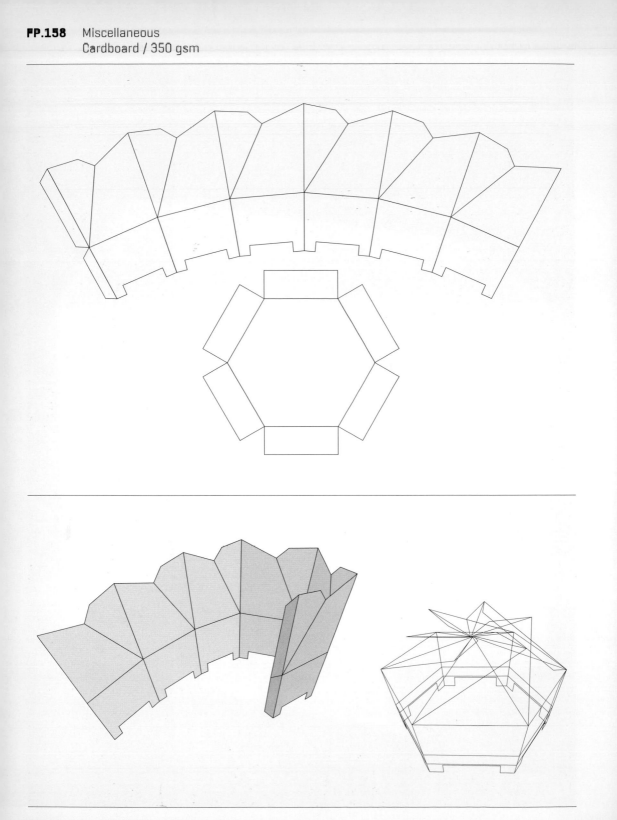

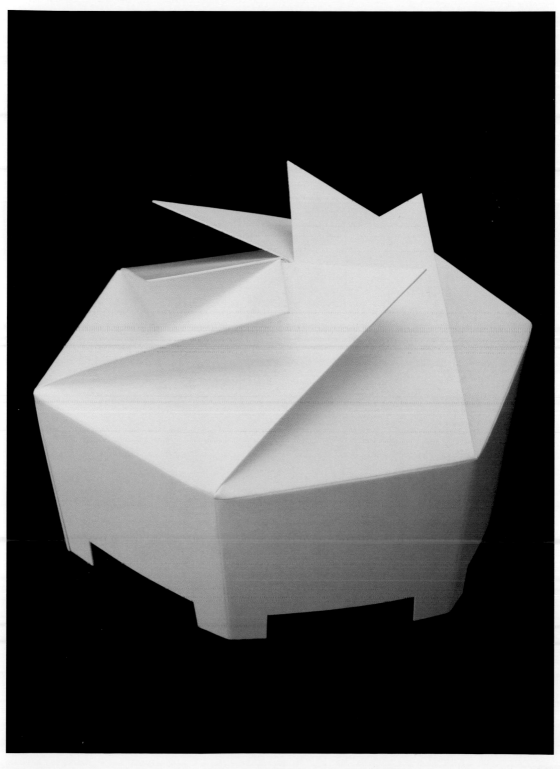

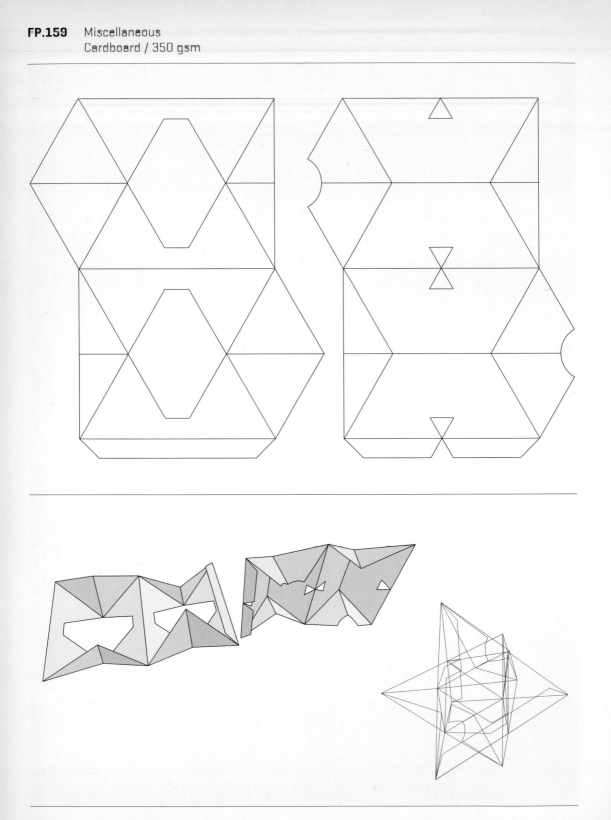

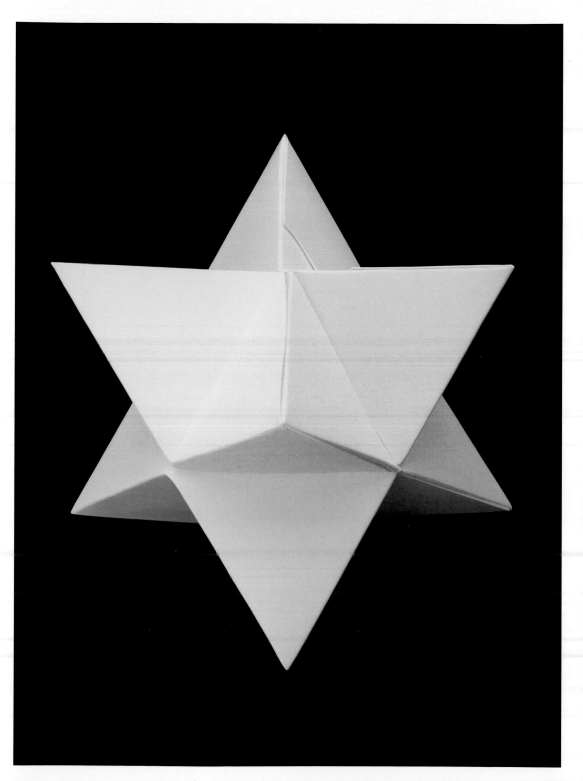

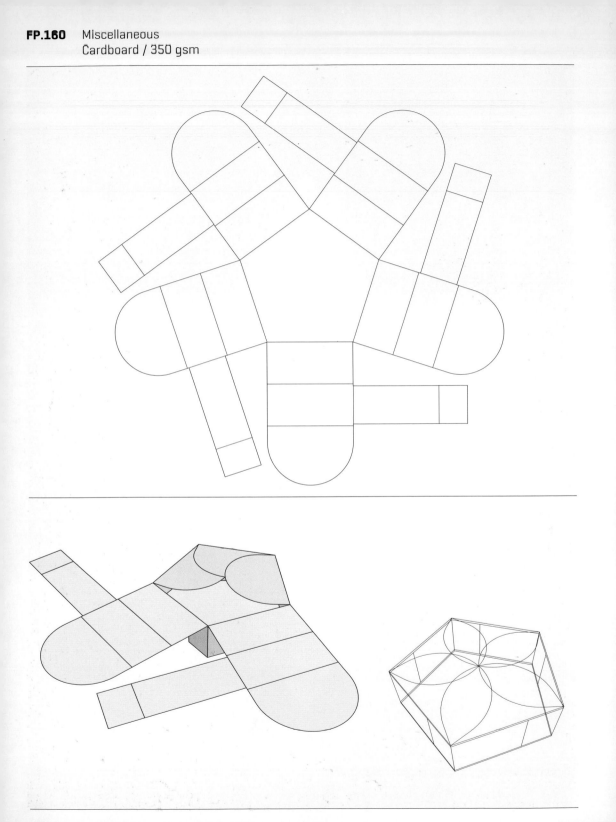

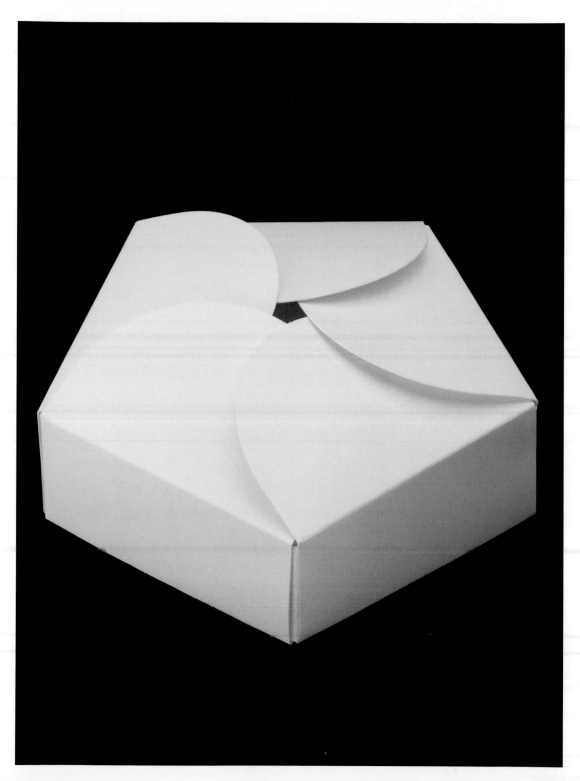

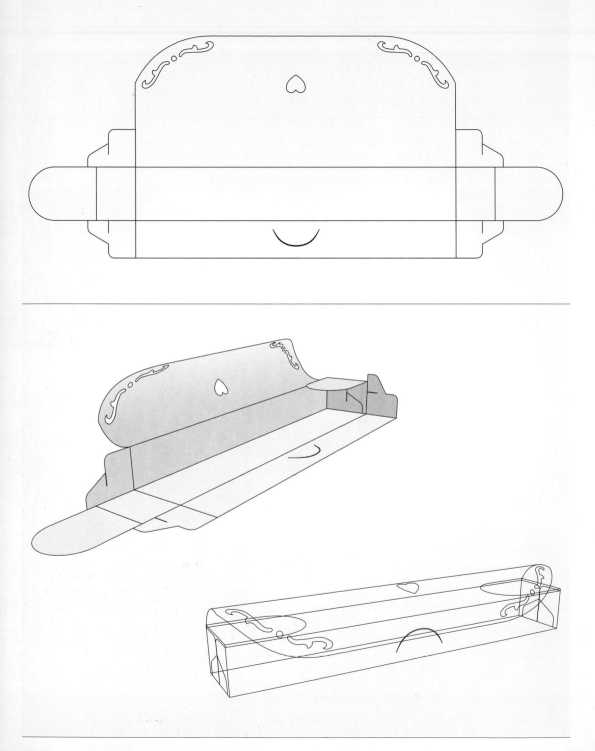

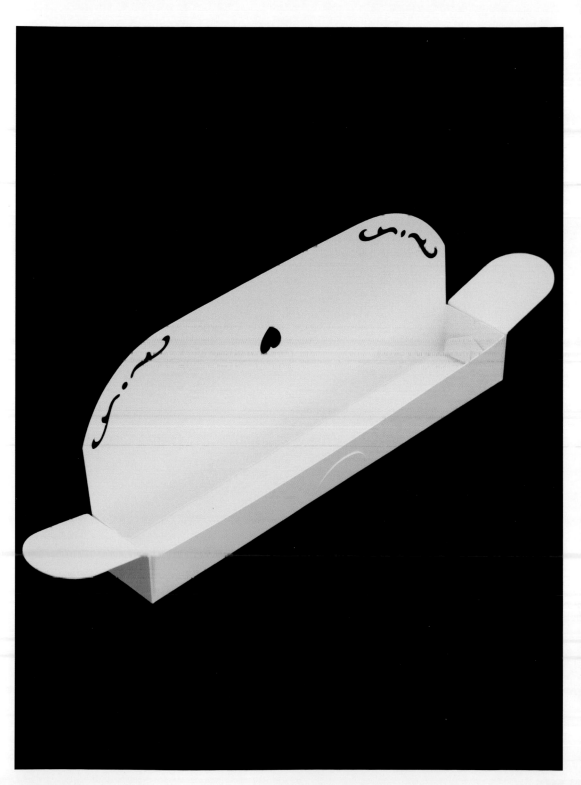

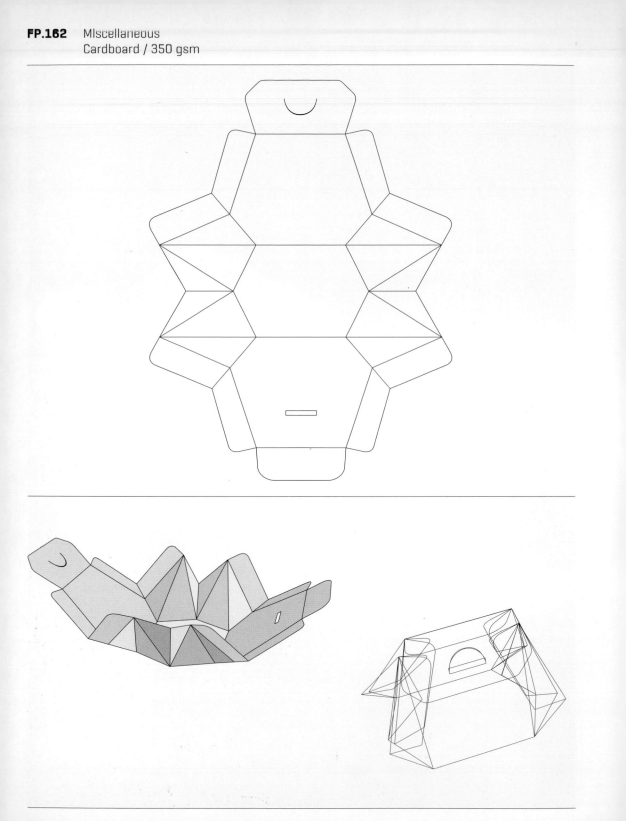

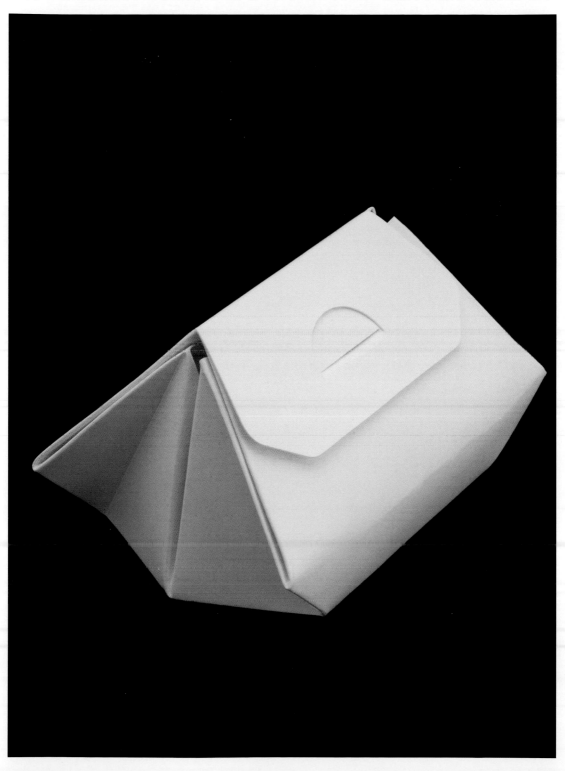

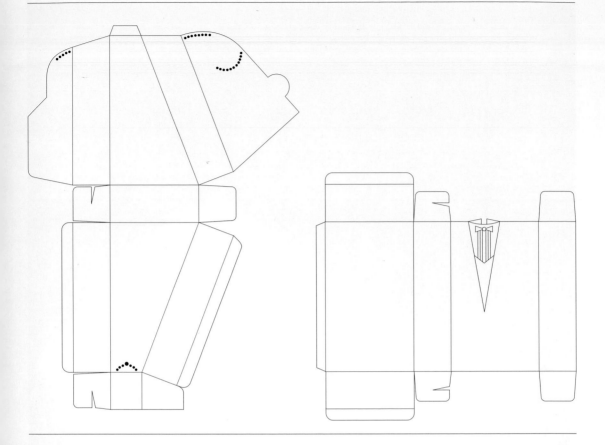

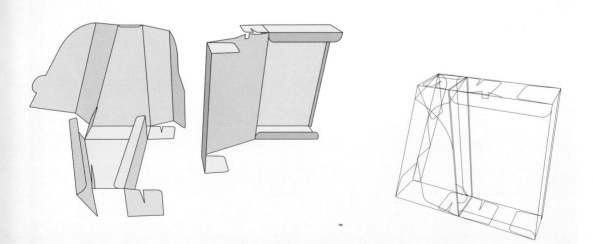

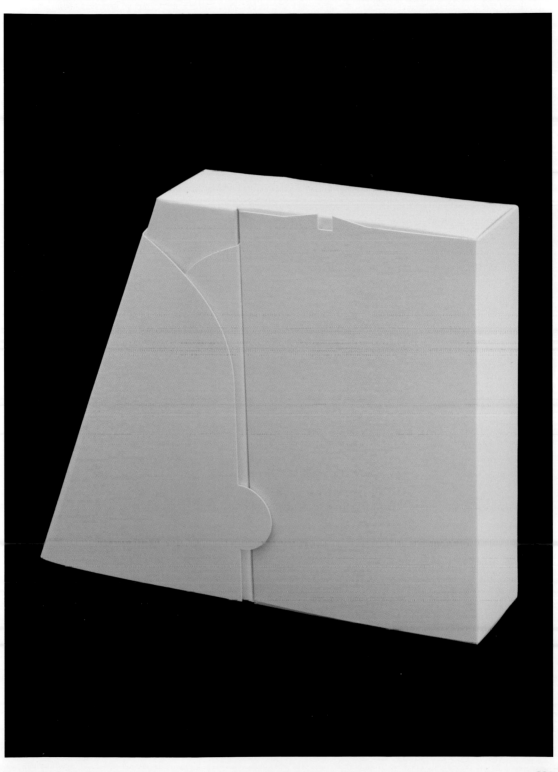

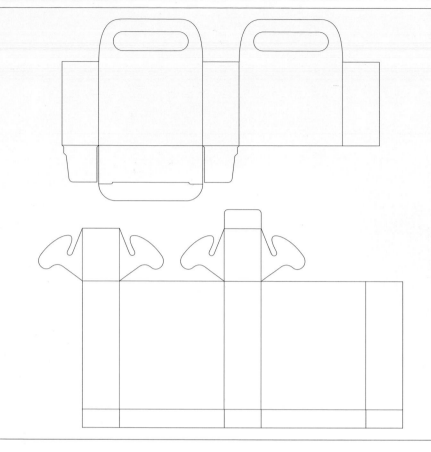

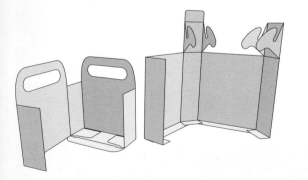

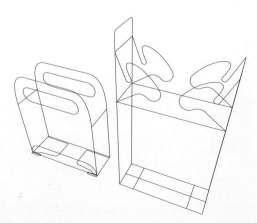

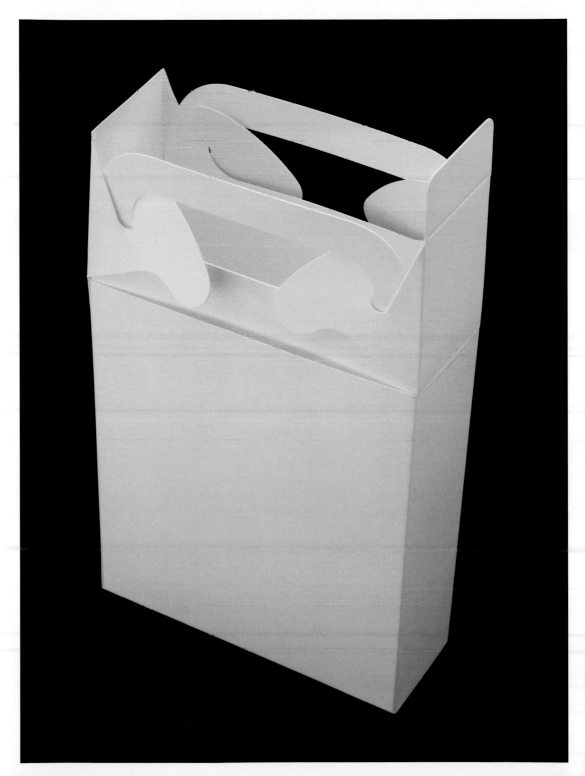

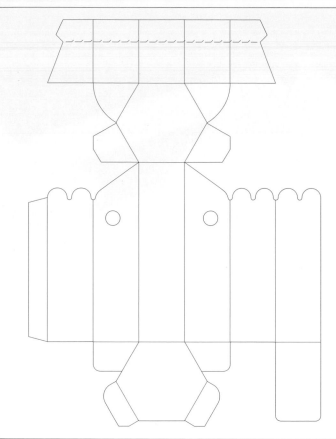

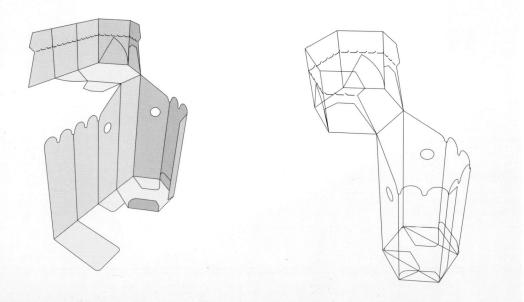

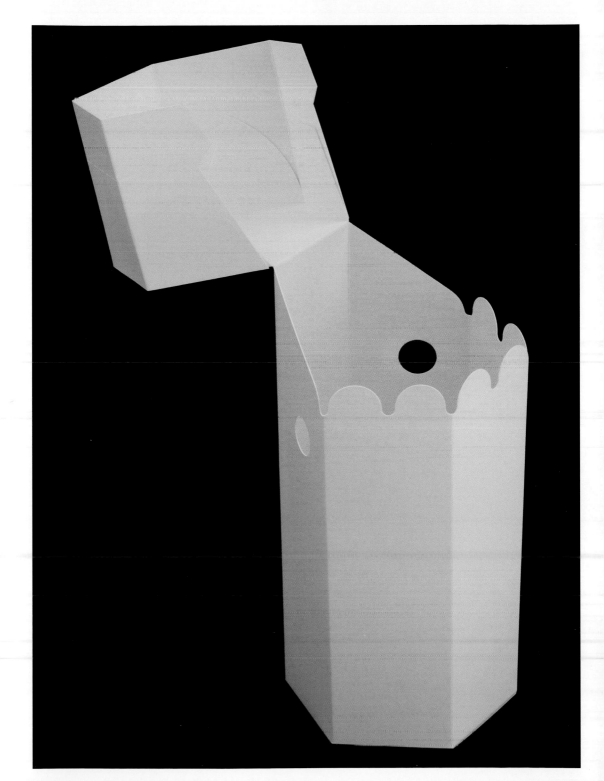

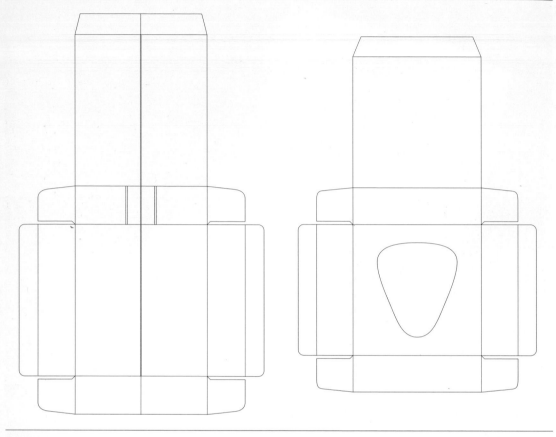

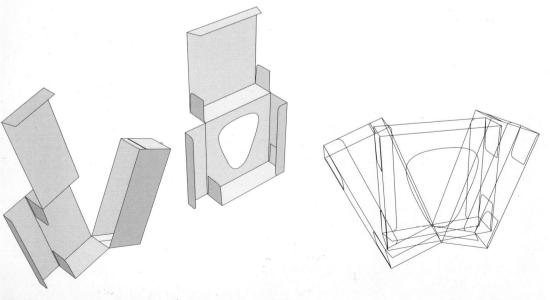

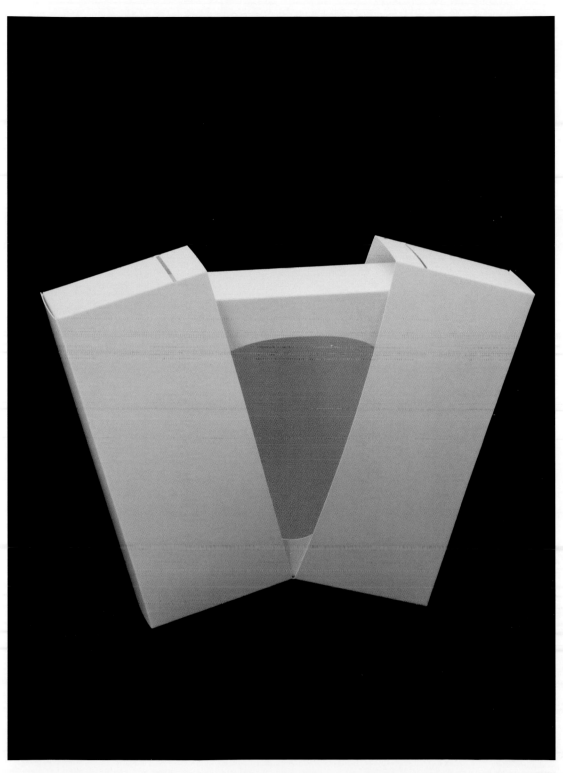

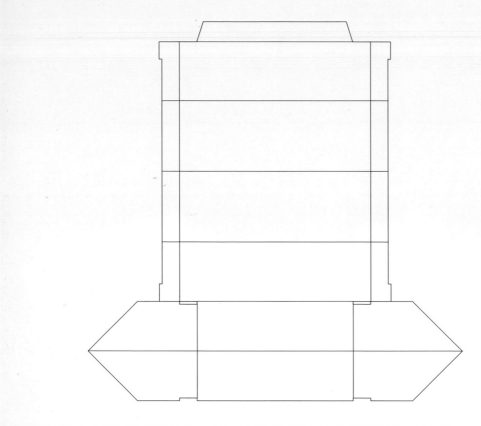

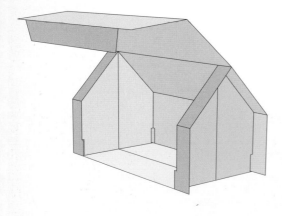

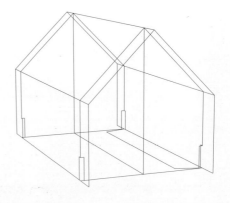

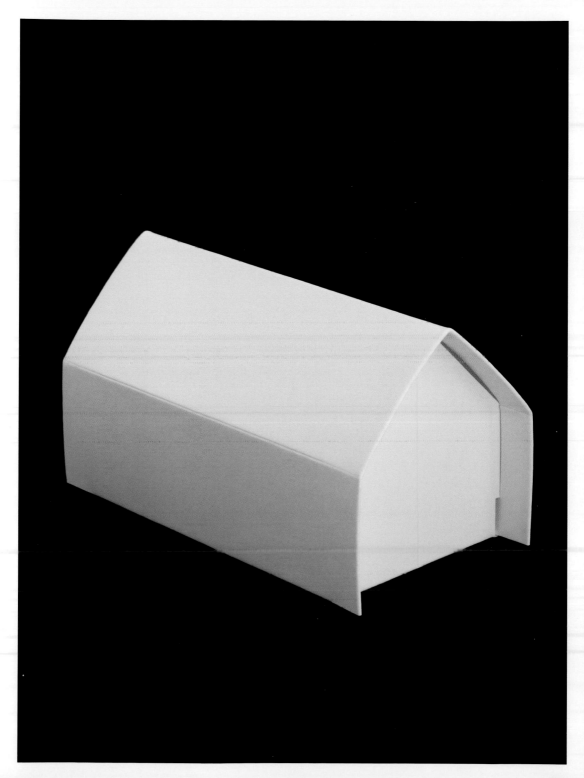

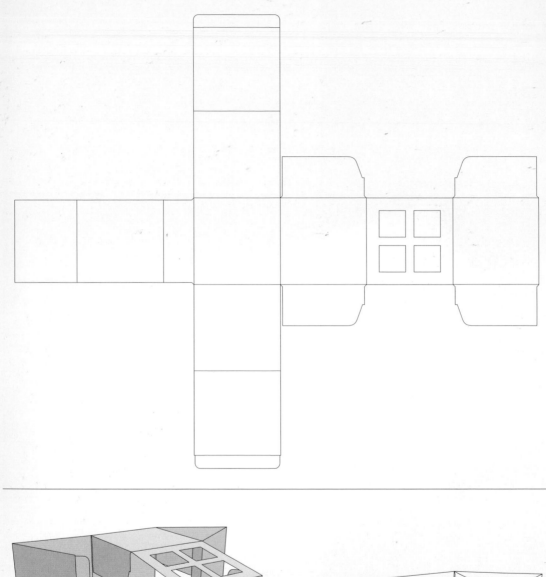

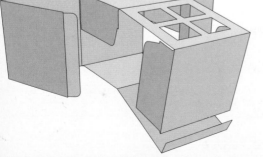

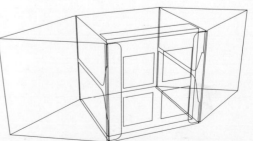

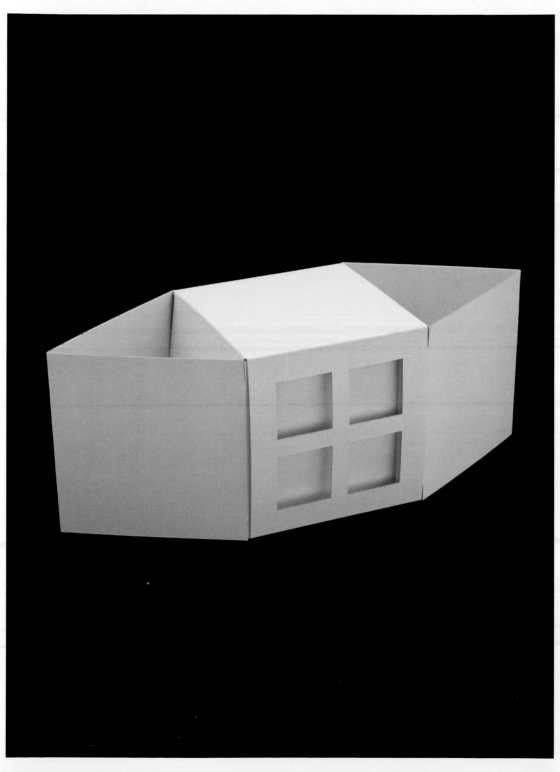

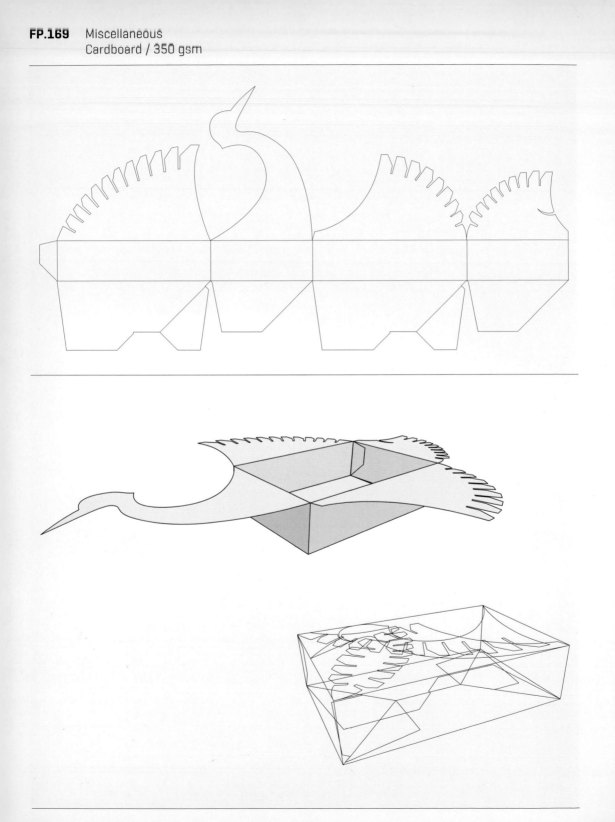

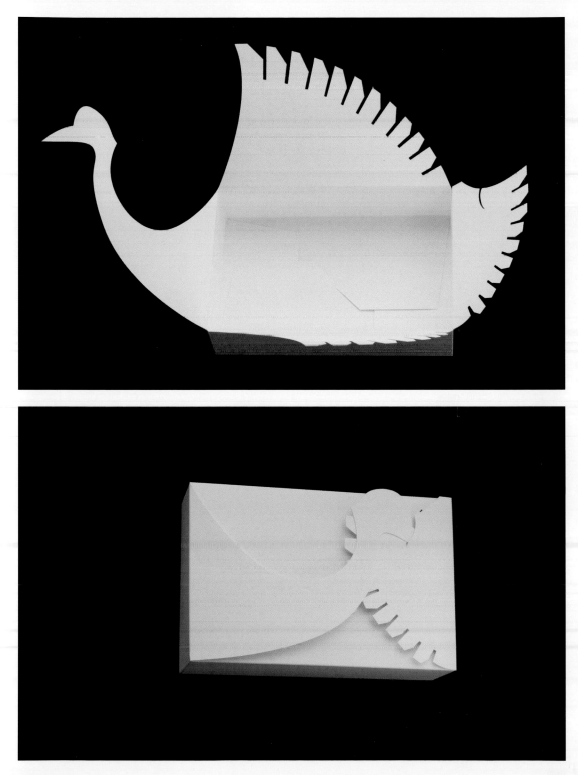

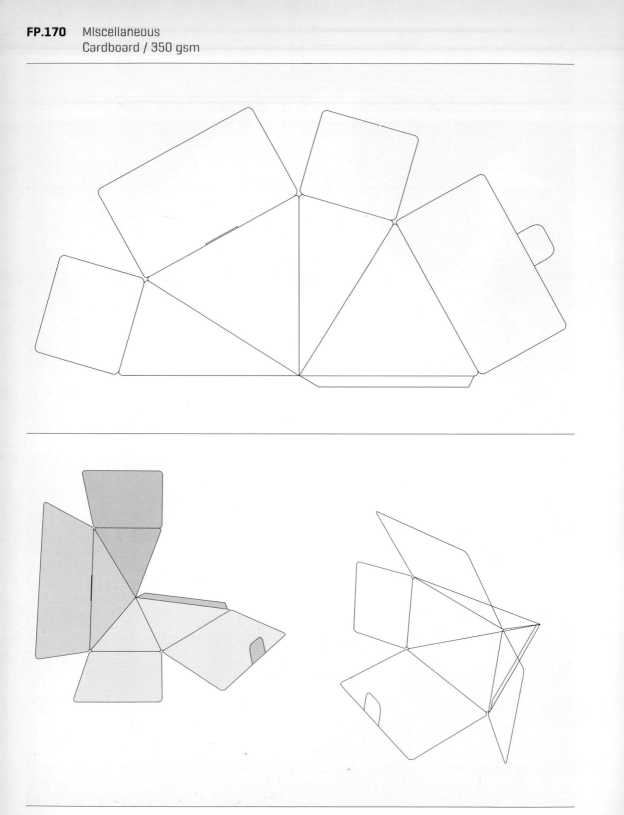

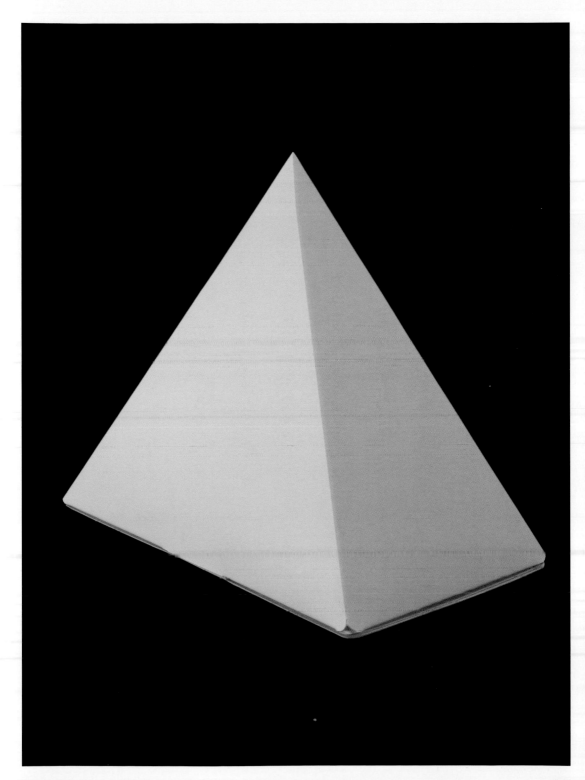

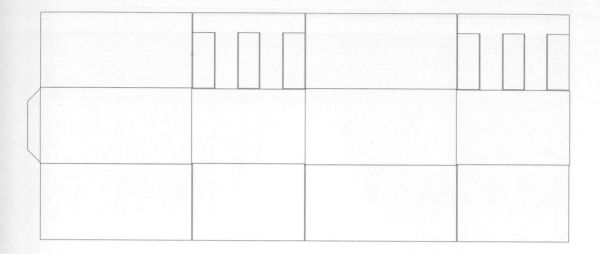

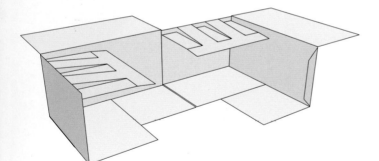

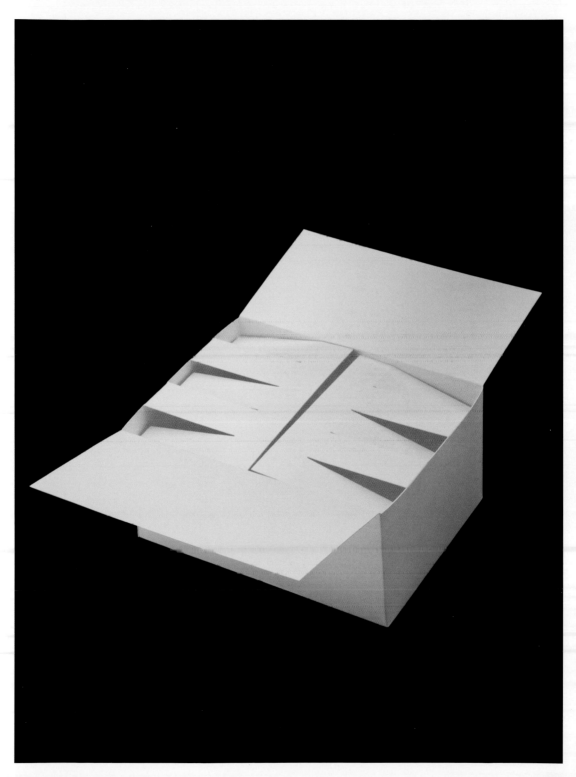

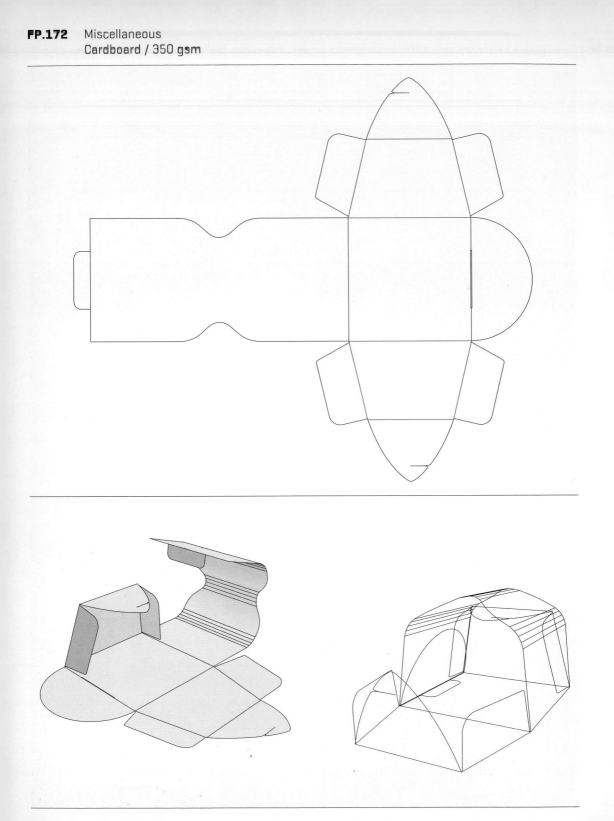

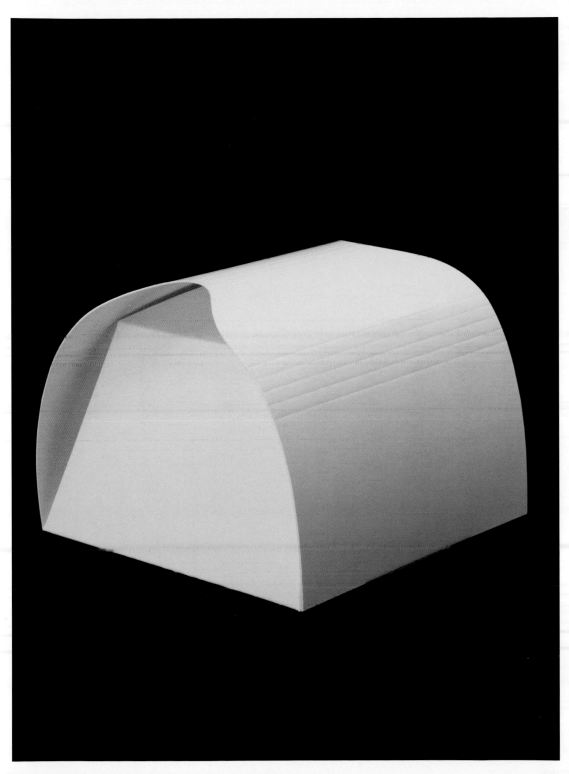

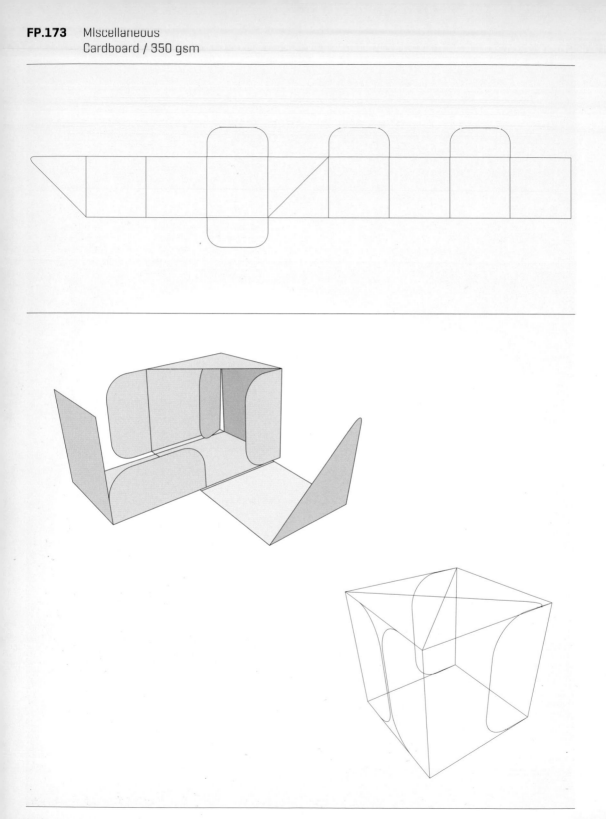

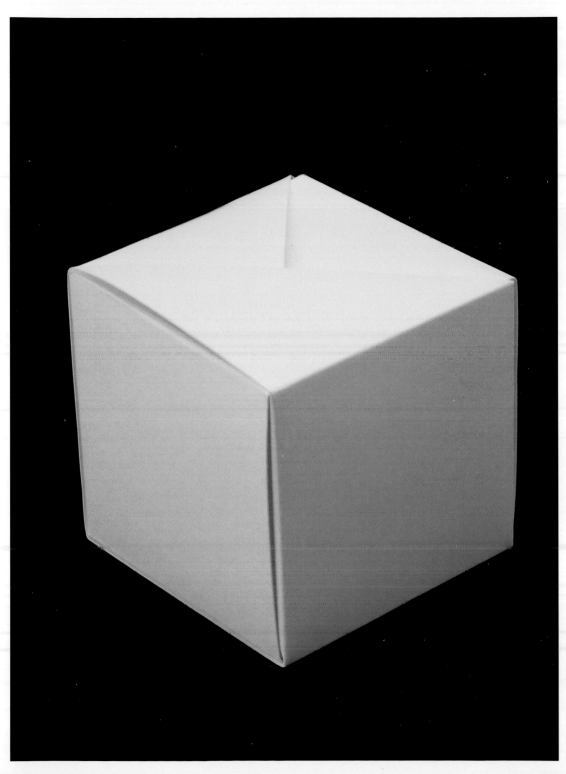

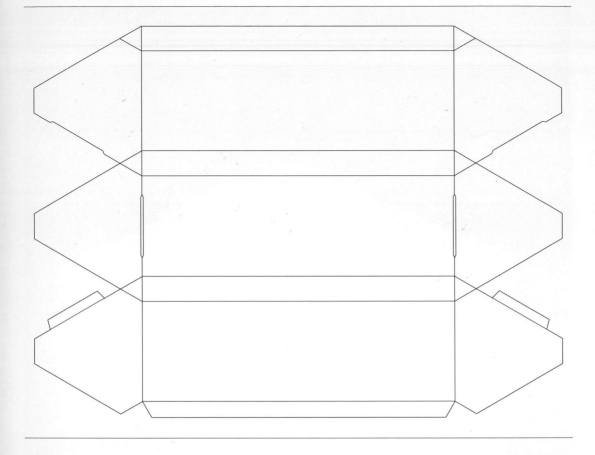

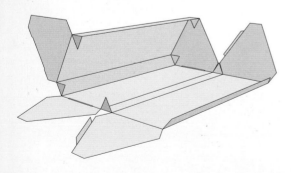

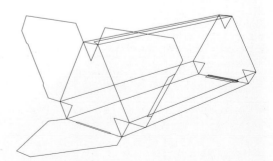

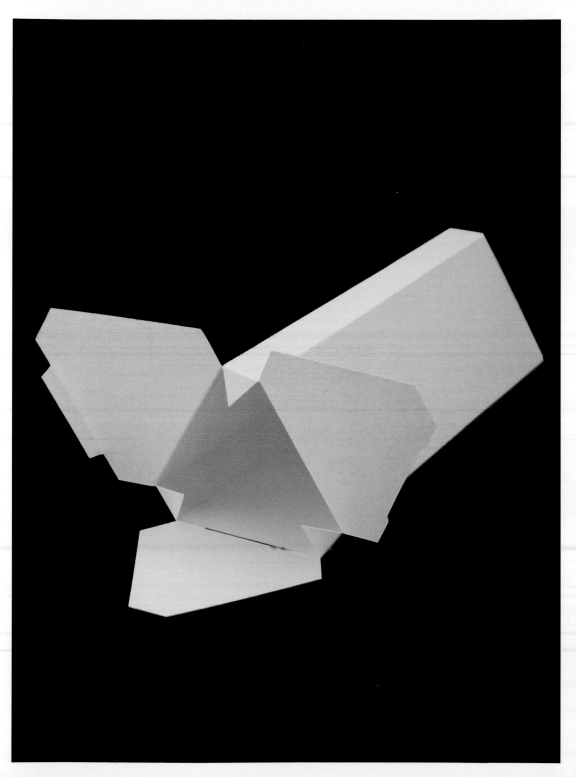

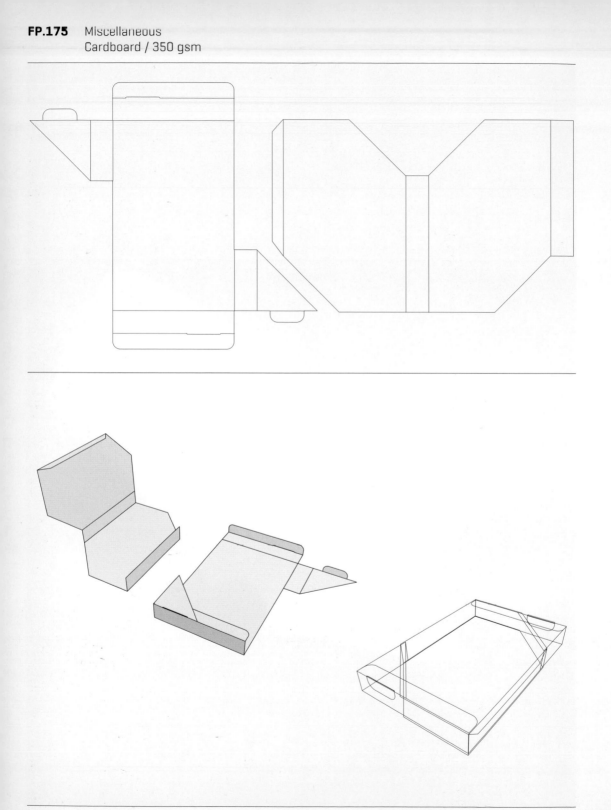

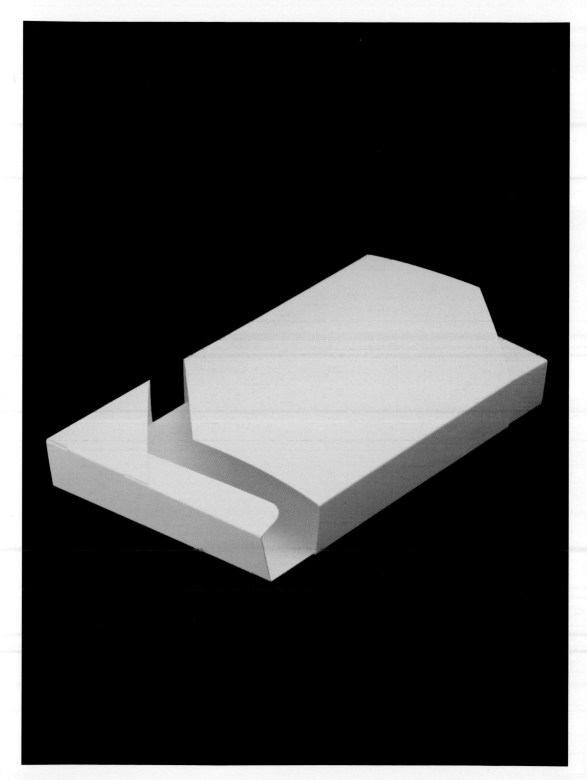

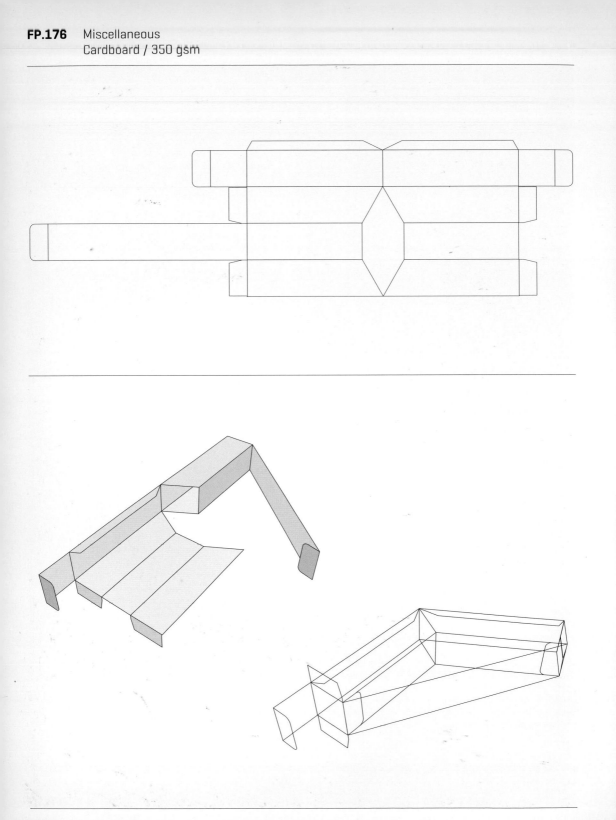

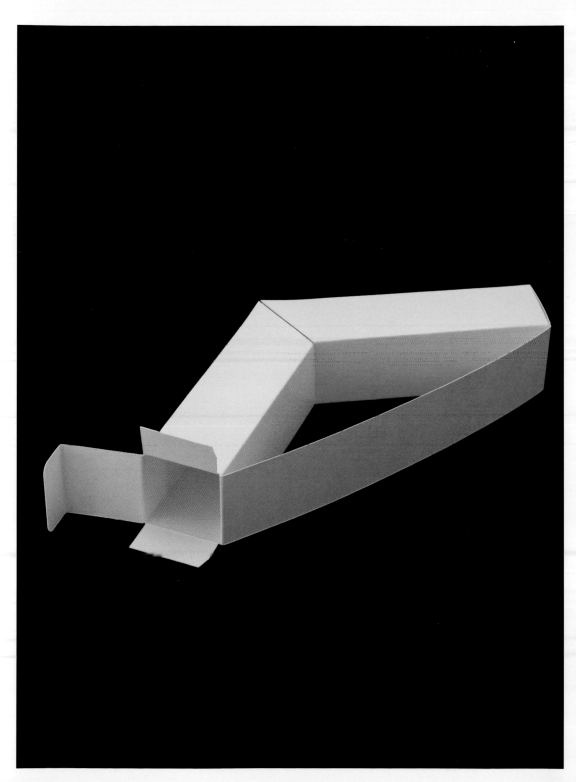

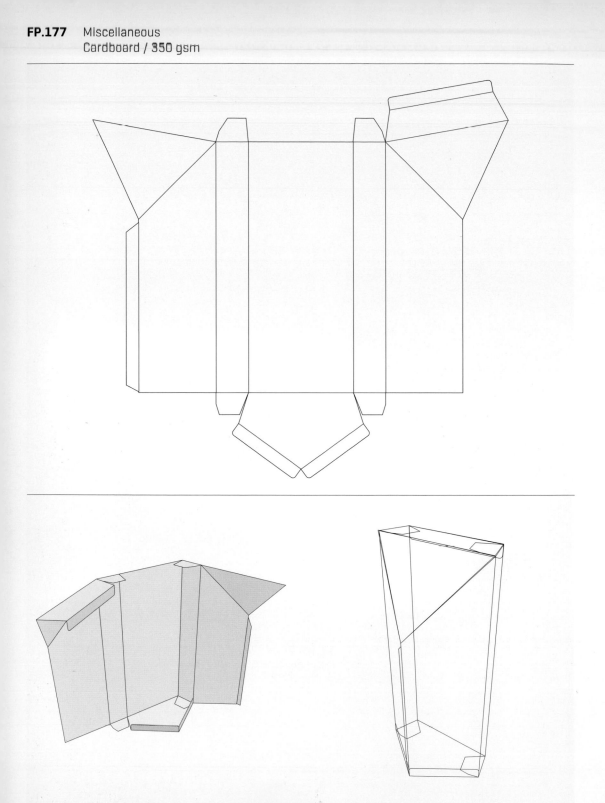

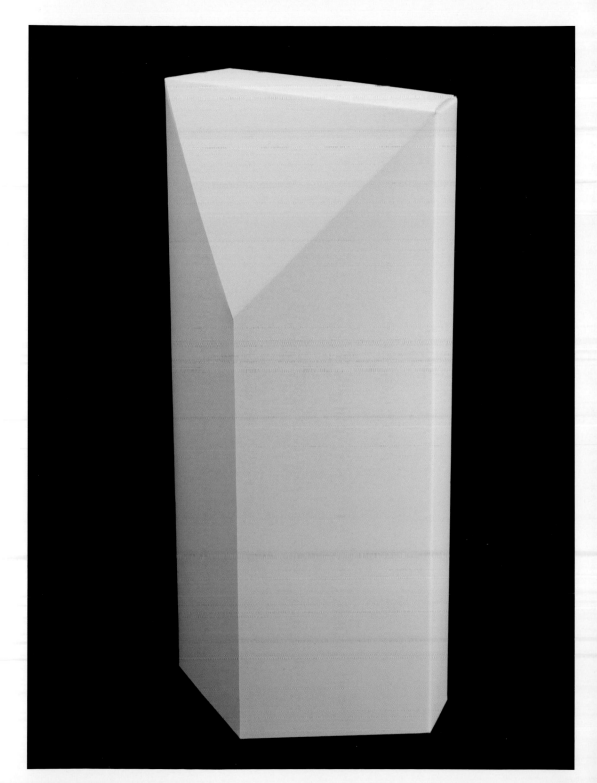

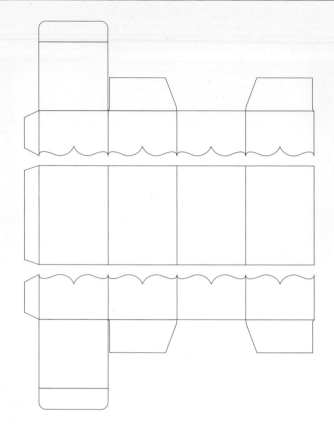

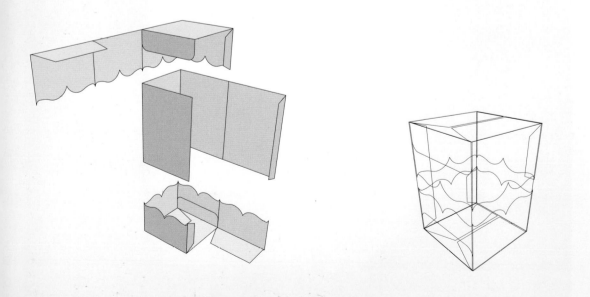

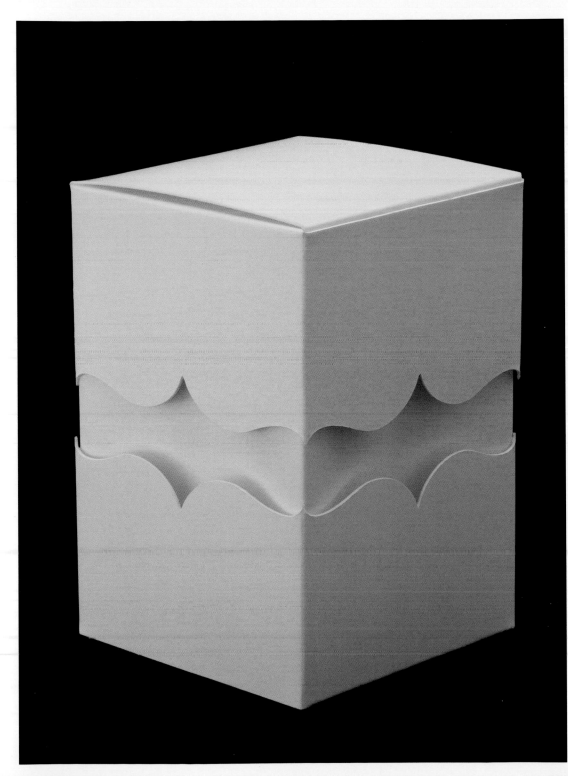

391

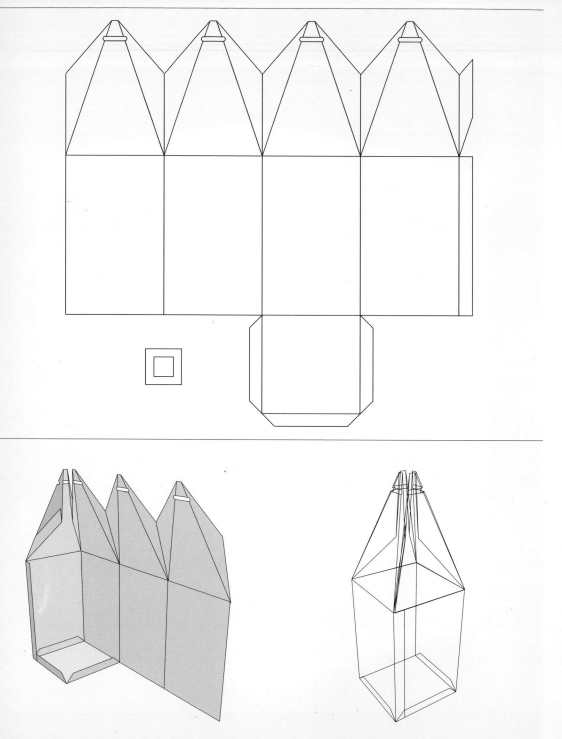

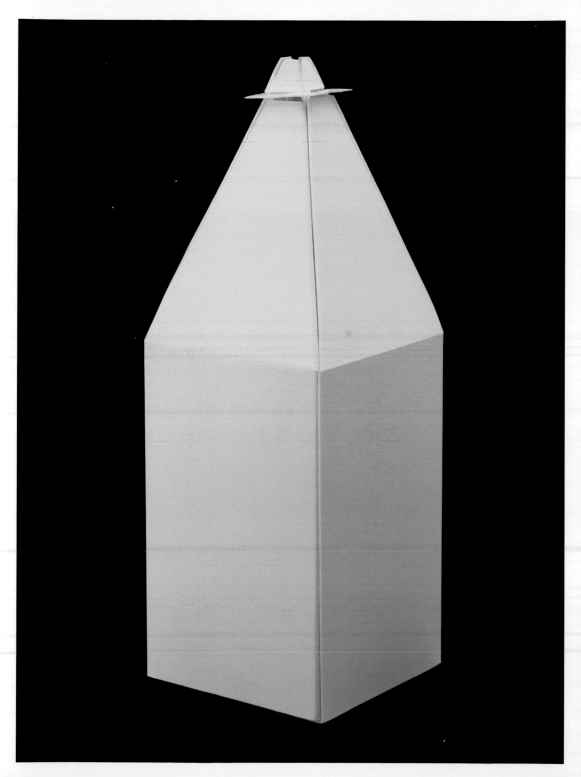

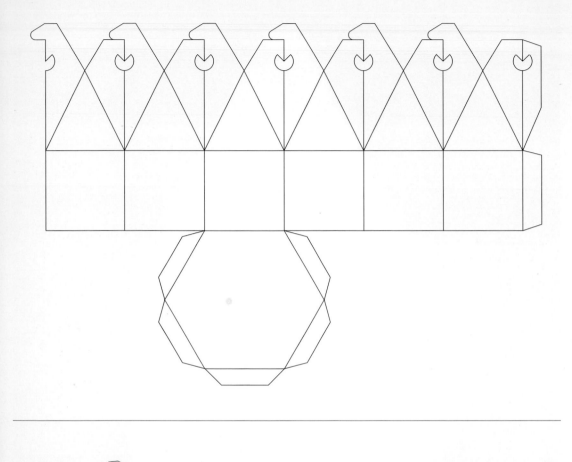

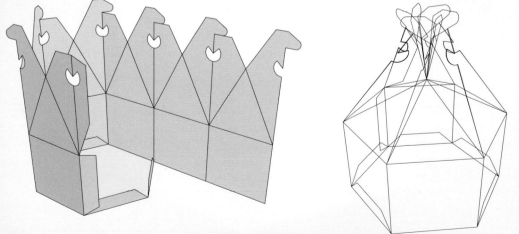

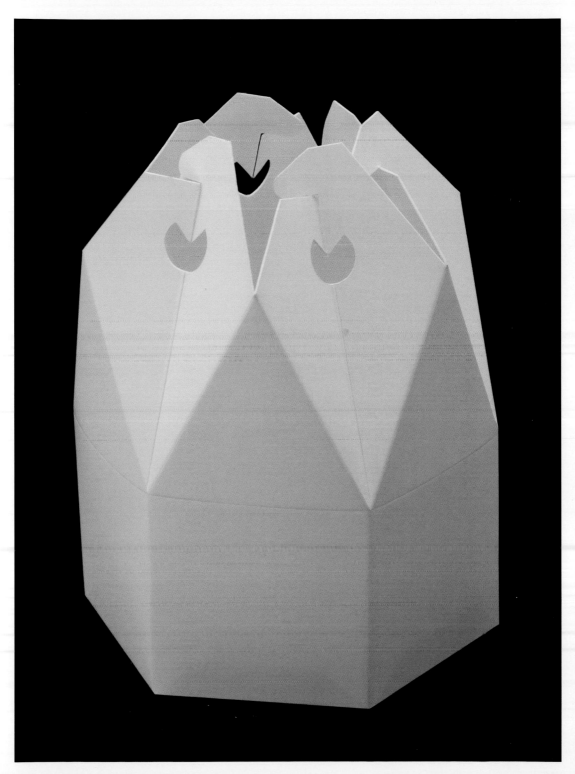

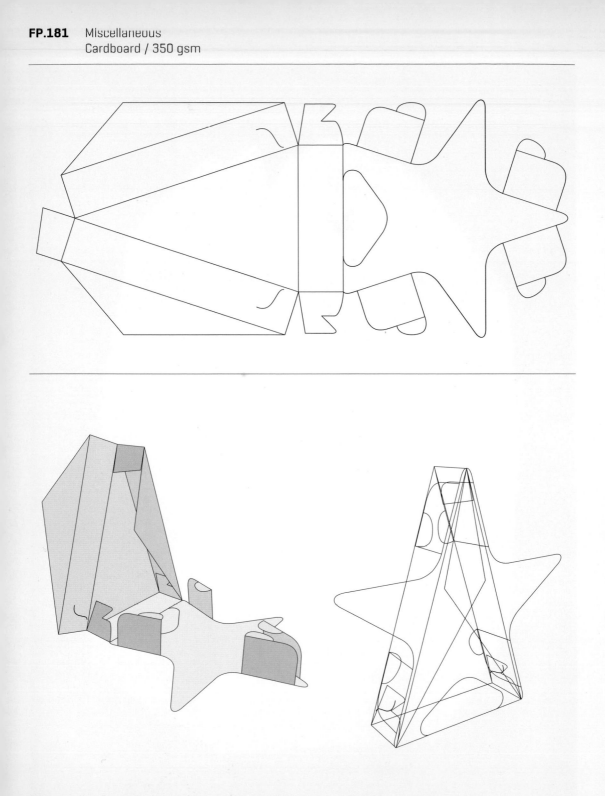

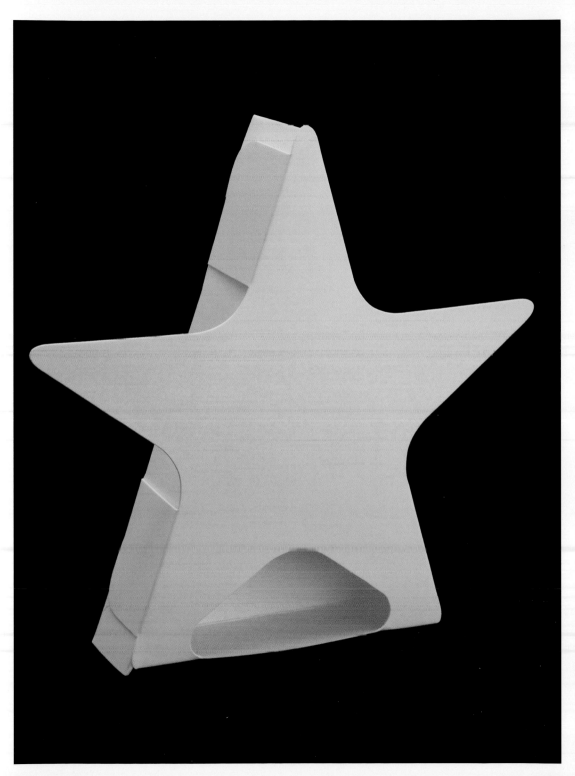

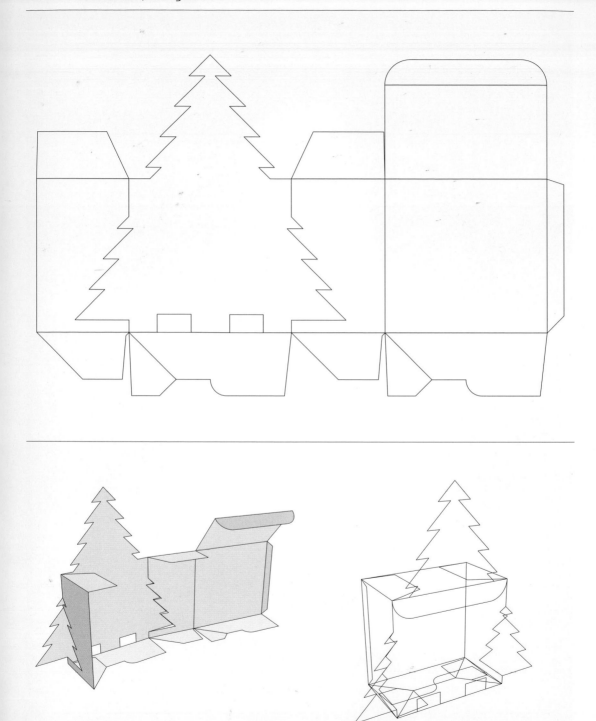

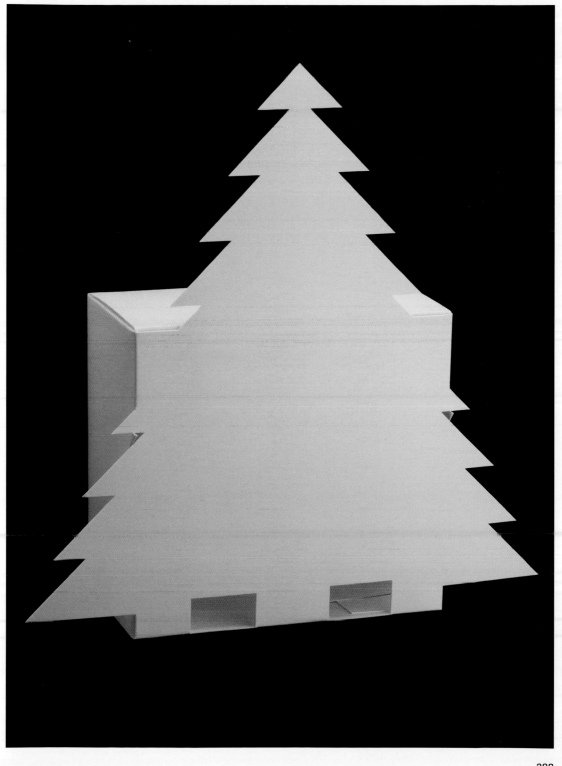

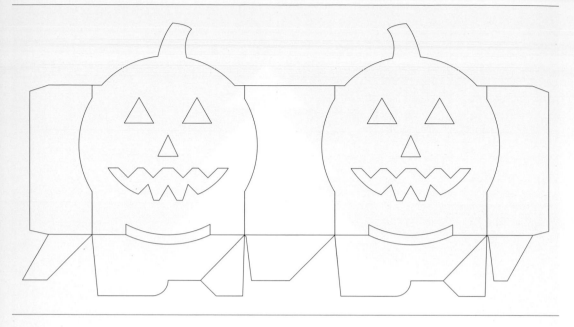

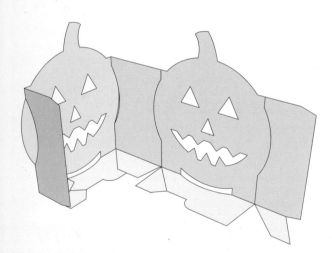

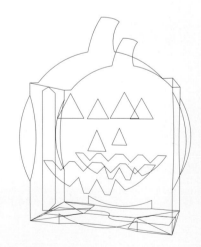

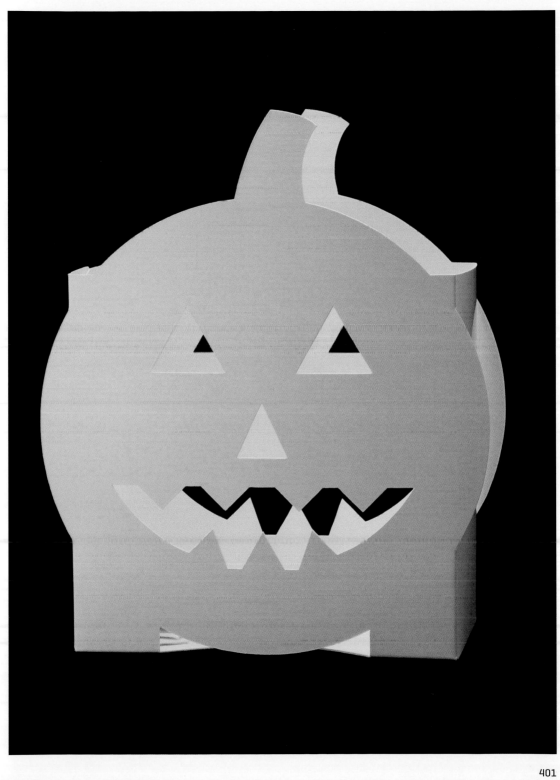

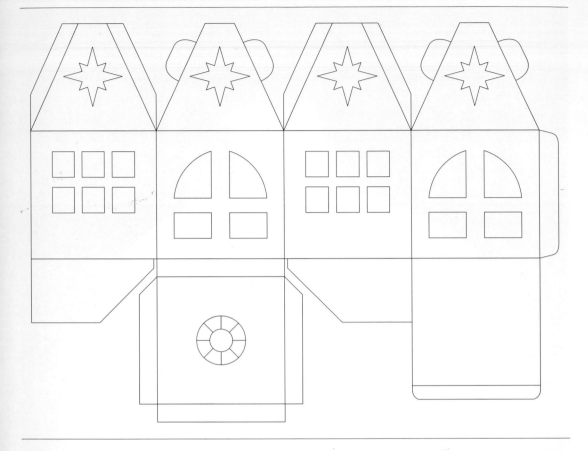

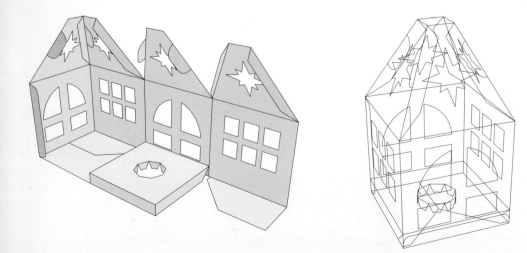

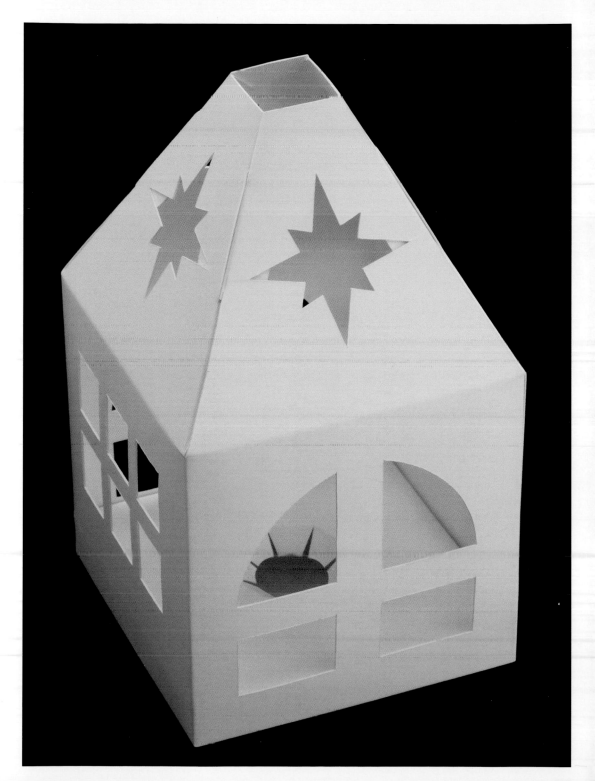

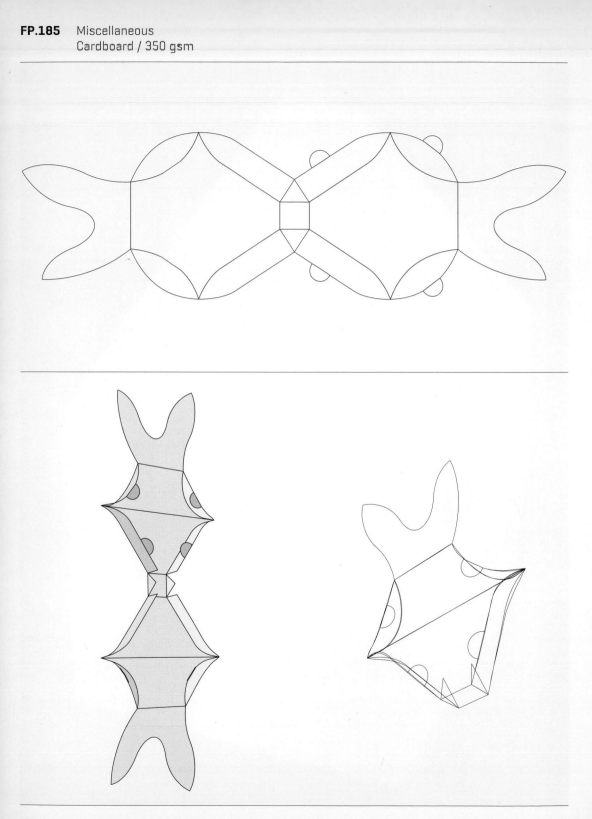

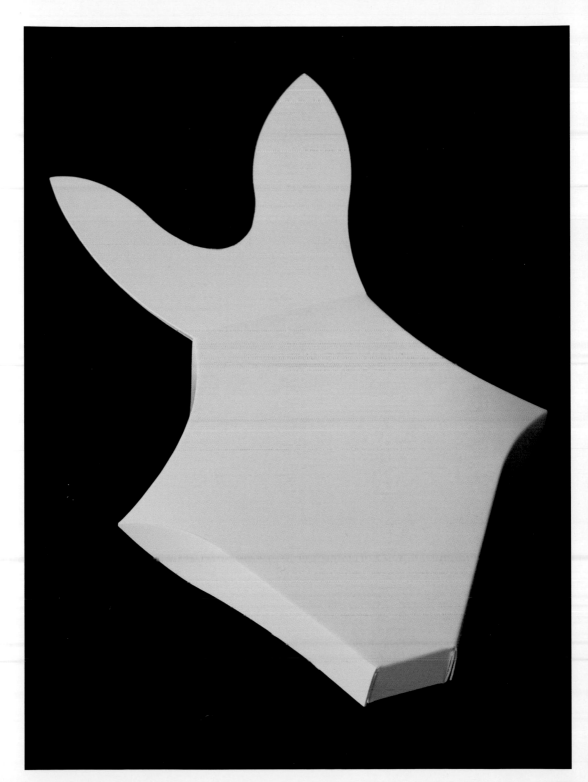

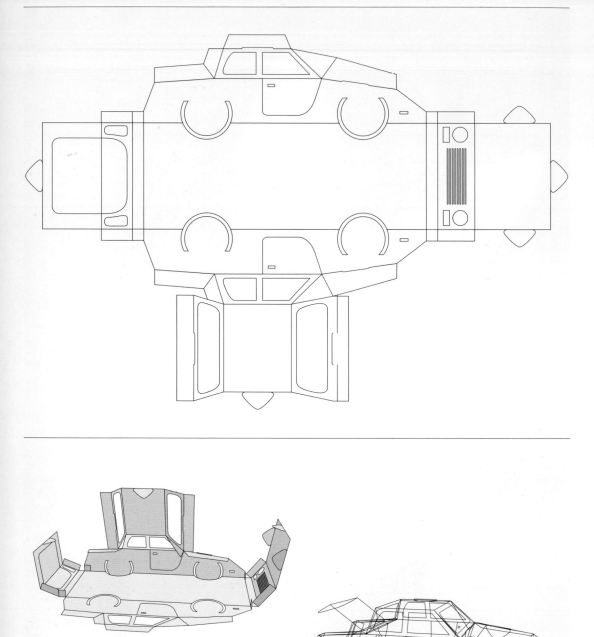

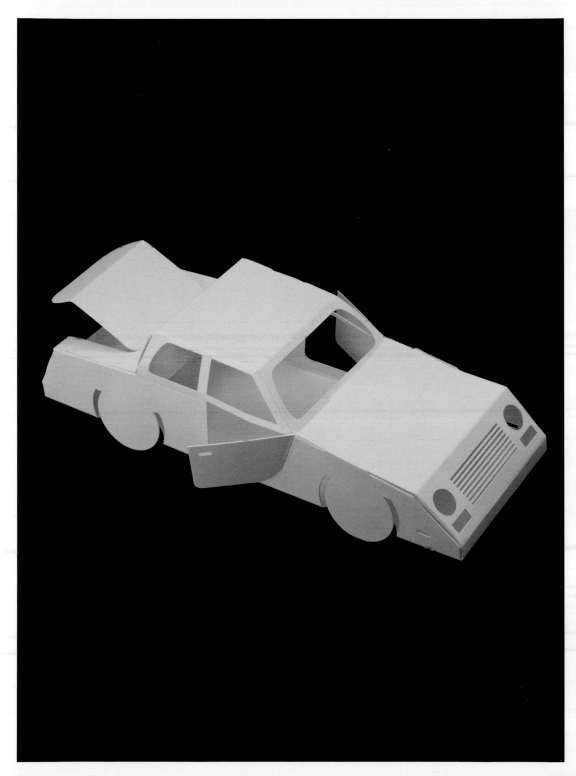

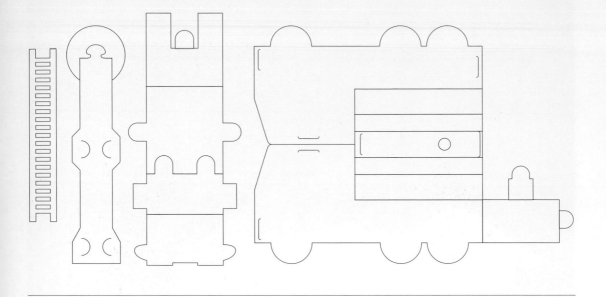

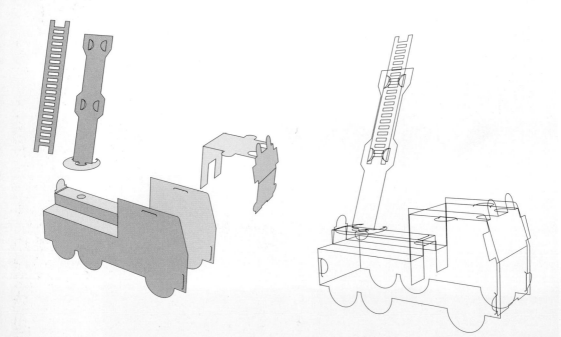

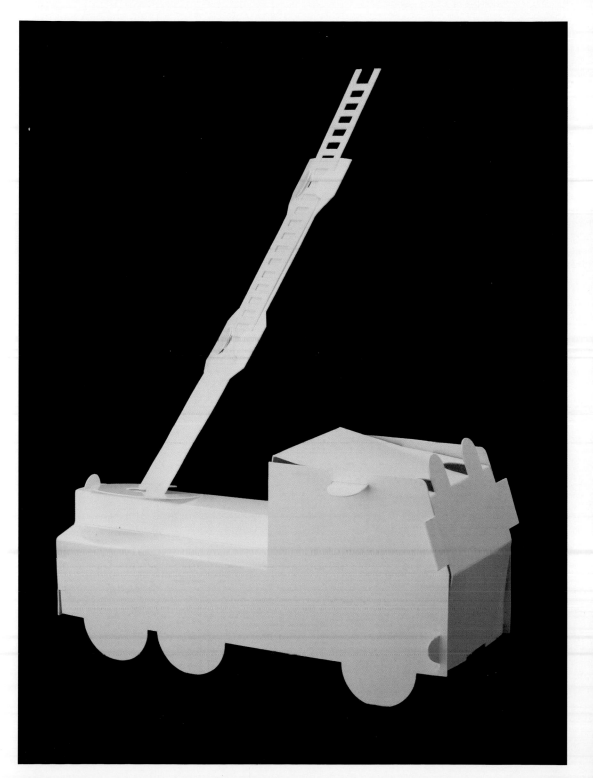

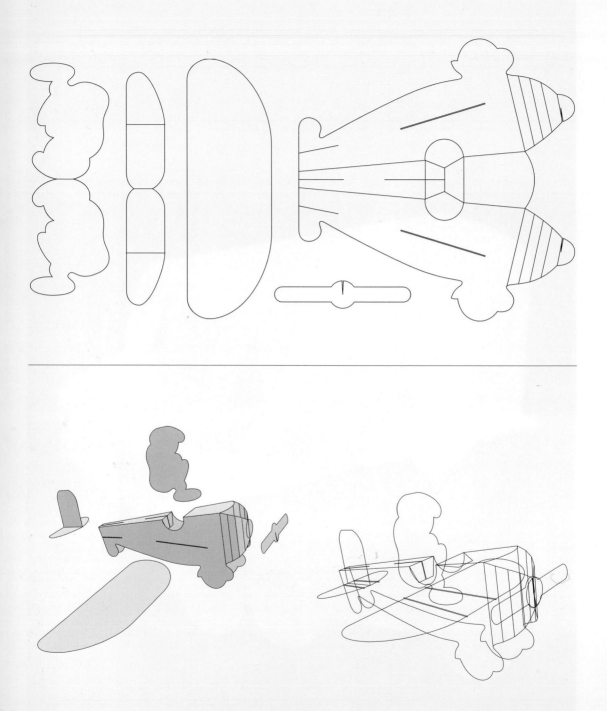

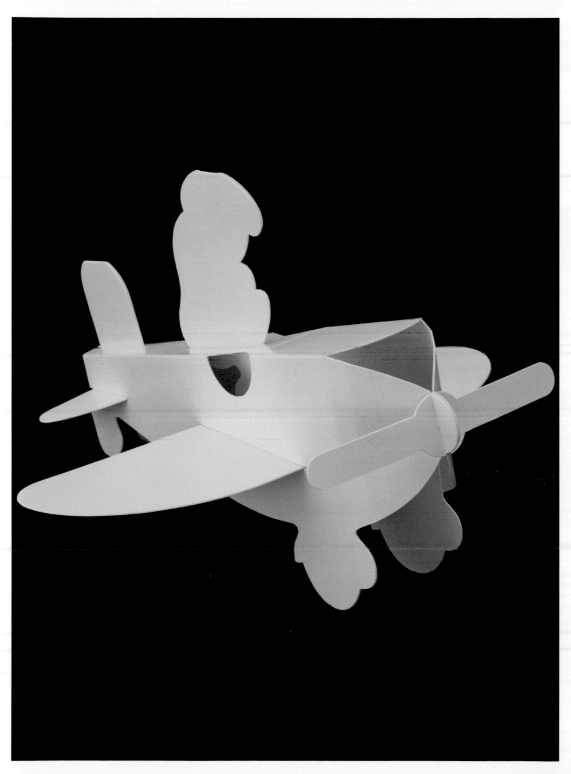

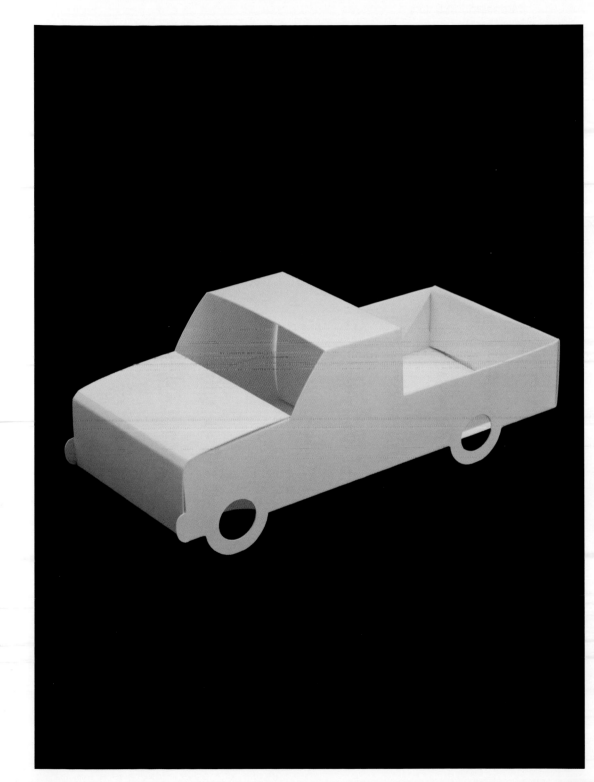

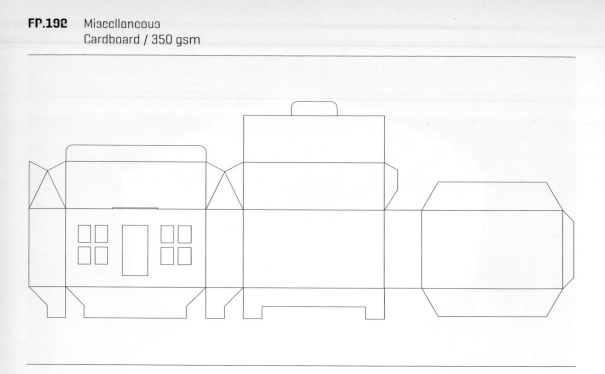

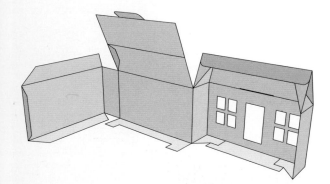

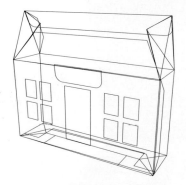

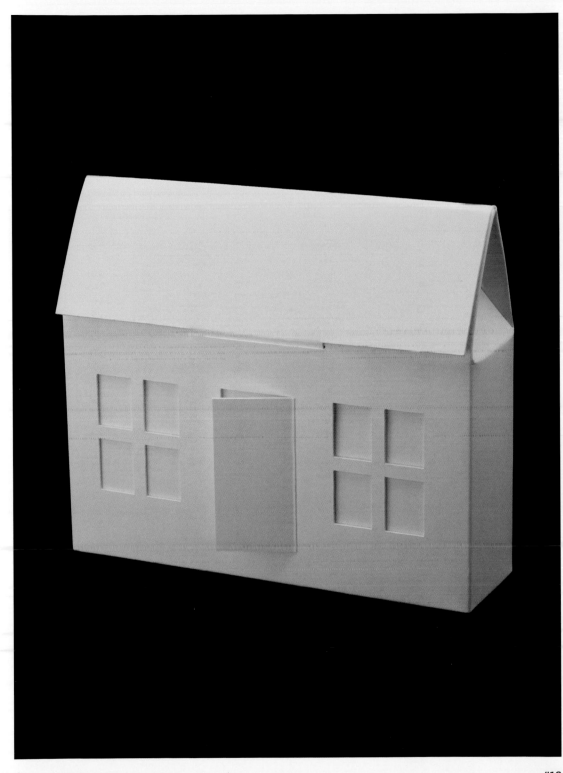

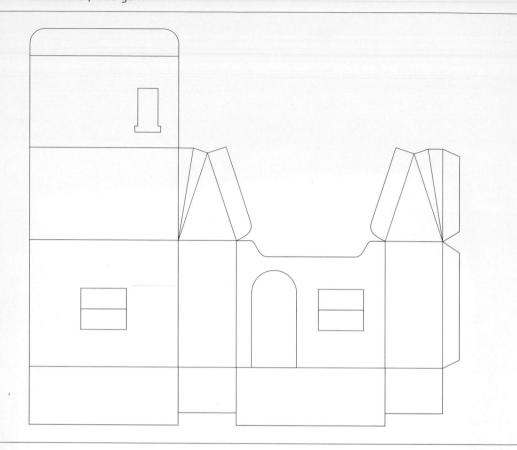

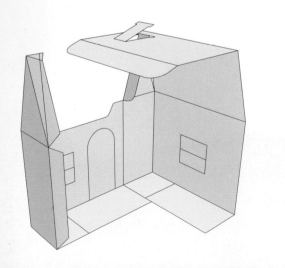

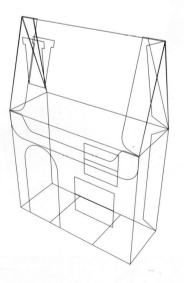

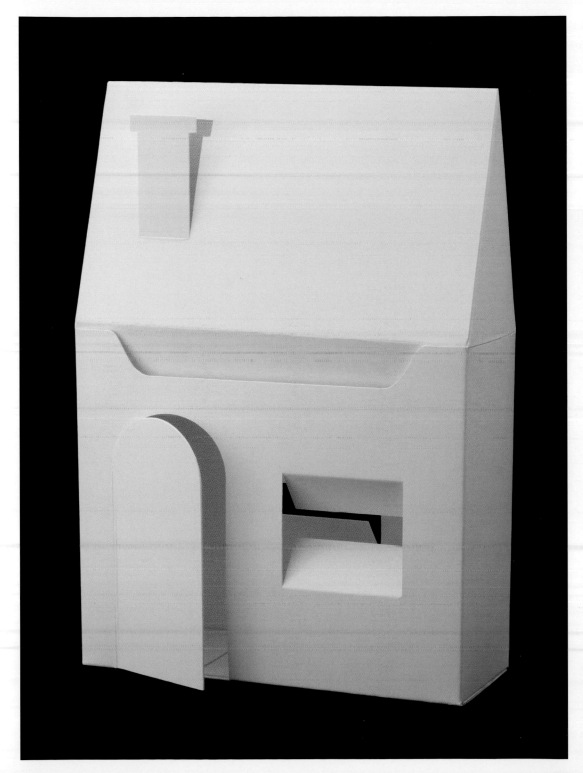

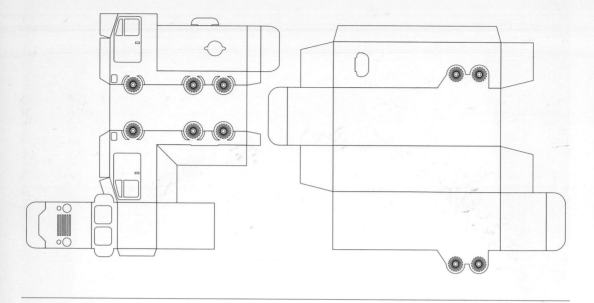

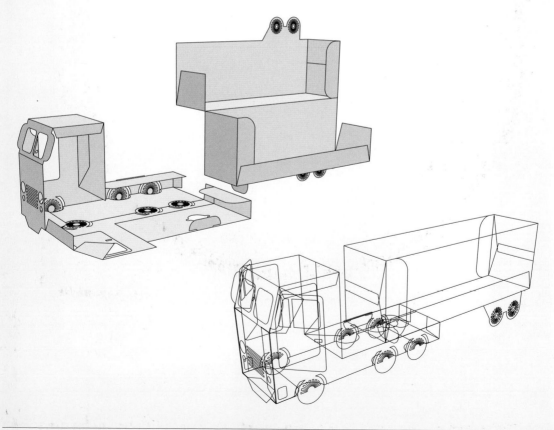

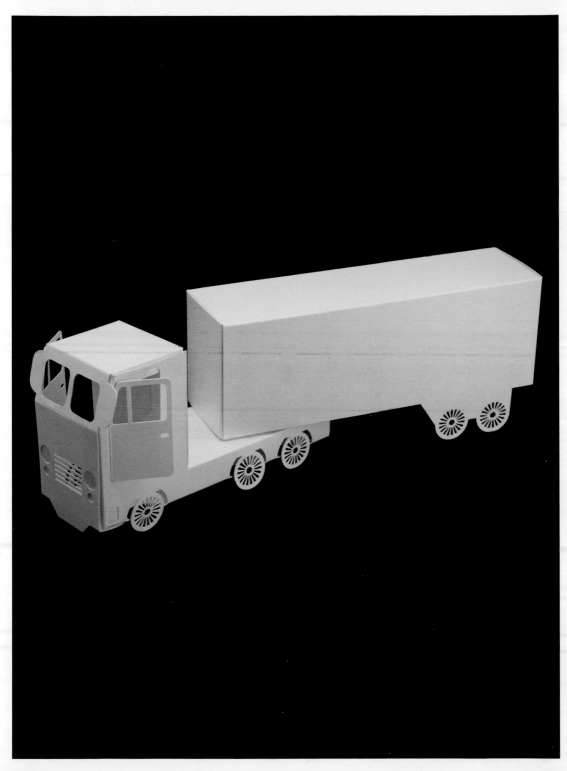